DUTCH AND FLEMISH PAINTING

In collaboration with:

Gerd Bauer
Peter Eikemeier
Claus Grimm
Ernst Wolfgang Huber
Ulla Krempel
Gottlieb Leinz
Gerd Unverfehrt

Herwig Guratzsch

DUTCH AND FLEMISH PAINTING

Vilo

New York

Author's Note

However much author and readers might wish it otherwise, a normal-size book about such a vast and diversified subject as the great age of painting in the Low Countries cannot hope to deal with every possible aspect. It is bound to speak of artists who are equally noteworthy for their drawings, copperplate engravings, or etchings, but those fields could be discussed only if we scanted the main topic. Illustrations showing interesting and enlightening parallels with Italian, German, and French art would be ideal, yet how include them except at the cost of a representative selection of Netherlandish works? And, for all the reasons anyone owning a camera or a publishing house knows too well, even the illustrations one does use to show the main lines of development cannot always be the most typical.

This book is intended chiefly as a general introduction to the subject. However, anyone wishing to delve more deeply into the work or particular aspects of the individual artists or their times will find excellent leads in the suggestions for further reading appended to the text. Likewise the details of the lives of most of the artists have by and large been kept to the succinct biographies at the end of the book, so as to leave space in the text proper for discussion of the larger questions.

As author and editor I must thank all those who have helped. Dr. Sylvia Hahn of Munich is responsible for a good deal of the documentation. Dr. Martina Herrmann of Freiburg im Breisgau and Drs. Peter Eikemeier and Claus Grimm offered many ideas and much encouragement. The production of the original edition owes more than I can say to the enthusiastic cooperation of Dr. Wolf Stadler of Herder Verlag, Freiburg im Breisgau, and Frau Vera Pokorny of Roto Smeets BV, Amsterdam, as does this English-language edition to the warm interest and suggestions of its editor, Miss Deborah Mintz, and translator, Dr. Robert Erich Wolf. For this edition the biographies were extensively revised by Ronald Forsyth Millen who also saw to the bibliography which, in line with the general character of the book, stresses as far as possible works in its readers' language and, for the most part, easily accessible. My greatest debt is of course to my collaborators and co-authors. Their contributions not only are an essential part of the book but have helped to shape its conception and purpose.

Herwig Guratzsch
Hannover

© 1981 Roto Smeets B.V. Amsterdam for illustrations and english version.
© 1981 Herder Verlag, Freiburg im Breisgau for original text.

Printed in the Netherlands by Royal Smeets Offset. b.v., Weert

ISBN: 0-86710-003-6

Contents

The Golden Age of Netherlandish Painting

"Low Countries" and "Netherlands" are not truly names of political entities now or in the past. These terms were first applied as a geographical description of the region bounded by the North Sea at the north and west, by Germany at the east, and by France at the south—an area for the most part not above sea level and known since medieval times as *terra inferior*. It is not identical with the present kingdom of the Netherlands, also called Holland, which was constituted only in 1831 and occupies only the northern part of a territory now further divided into Belgium (another creation of the 1830s) and Luxembourg. This entire area, roughly equivalent to the present-day Benelux, was made up of many states and provinces whose inhabitants possessed markedly individualized native characteristics. And yet, for centuries, the "Low Countries" embodied an unmistakable cultural unity.

Though this territory in its entirety is fifteen times smaller than, say, Egypt, between 1390 and 1720—the span covered in this book—it brought forth such a wealth of artistic personalities, groups, and schools that few writers have tried to cover them all in one book. Only the most foolhardy angel, and then only with the best of good will, would try to discuss all at one go such daunting names as Jan van Eyck, Hans Memling, Hieronymus Bosch, Pieter Bruegel, Frans Hals, Peter Paul Rubens, Anthony van Dyck, Rembrandt van Rijn, Jan Vermeer of Delft, and the many other painters of the period. And who could, at the same time, deal with such different stylistic concepts as Late Medieval, Mannerist, and Baroque? Authors and publishers have mostly concentrated on separate slices of the historical development, cut according to time or place, stressing not a continuity across the century-marks and modern boundaries but, instead, a few focal moments or major shifts in style which have, as a result, been given due or sometimes undue weight at the expense of others.

The fifteeneth century has been one of those key periods. An outstanding researcher working on his own, Max. J. Friedländer, brought out a fourteen-volume study, now a standard source wherever people study art of the past. The seventeenth century likewise has had particular attention, but it was so eventful and the historical situation was so complex that most often it has been treated under the separate headings of Dutch and Flemish painting. This treatment has fostered a good deal of confusion. Not everyone means the same thing by saying a painting is Flemish, Dutch, Netherlandish, or Belgian. And the thicket gets more tangled the moment one realizes that Flemish and Dutch art involve very different artistic criteria and are characterized too by a fundamental difference in religious conviction. Although in common use, all such terms involve a good deal of simplification, both geographical and political. Put bluntly, there never was a "Belgian" artist before the kingdom of Belgium was founded in 1830 (though as early as Caesar's time there was a people known as the Belgae); nor, strictly speaking, a "Netherlandish" artist before that date if we use the term to include the region that became Belgium (though it applies perfectly well to anyone from present-day Holland).

We can try another tack. Throughout our period there have been *Flemish* painters and *Dutch* painters. So far so good. But now our troubles take a new turn. The notions of "Flemish" and "Dutch" point to a particular origin, to the "Netherlandish" provinces of Flanders and Holland which, like Mecklenburg and Saxony in Germany, have survived down the centuries

as cultural entities quite apart from all the political changes. Because Flanders and Holland and their respective chief cities of Antwerp and Amsterdam were for a time of the utmost moment in the history of the divided Netherlands, the seventeenth century took to using the geographical designations of Flemish (Flanders) and Dutch (and the various equivalents in other languages of "Hollander") for what had by then become, through the changes of history, true political entities called respectively Southern and Northern Netherlands. Thus an artist from one of the northern provinces outside of what was then Holland, from Groningen or Gelderland for instance, was called a Hollander, while anyone from anywhere in the southern domain (and even parts of northern France) was known as a Fleming. It is fair to ask why, after 1648, when the Netherlands were definitively split in two politically, the term "Netherlandish" continued in use for both parts. Nothing justifies this politically, but, as we shall see, there are grounds for applying it culturally. There is no shortage of evidence of the links between the artists of north and south, of their resettling in one part or another, of their cooperation in larger undertakings even during the long struggle for freedom and separation and afterwards, so "Netherlandish art" does seem a reasonable term for the entire cultural scene even after 1648.

The fifteenth and the seventeenth centuries in Netherlandish painting have entered the history of European art as "golden ages." The overwhelming interest in those two brilliant periods has rather put the sixteenth century into the shade, yet it was an interesting time of transitions and influences from abroad. Netherlanders were then coming to terms with the art of Italy in particular. To what extent Northern artists submitted to such influences has been a matter of some debate, and if the national strengths and individualities survived almost unshaken by those new experiences, as Leo van Puyvelde has impressively argued, it seems scarcely to the point.

Because this book begins with the flowering of panel painting around 1390 and stops at 1720, it may seem that here again the full story is not being told. But the time limit has its justification: after 1700 there was a very real falling-off in what was still common to the arts of the southern and northern Low Countries. Little was seen that could be considered sufficiently "Netherlandish" to justify still treating them together. Certainly neither region suddenly left off producing art and artists around 1720, but after that date there was a certain decadence or at least decline, as well as a tendency to go along with fashions of the moment.

There followed somewhat bleak or sterile periods that went on too long to tie what preceded them to the entirely new art of Vincent van Gogh in the late nineteenth century, or to the even newer art of Piet Mondrian in our (or our fathers') time. What the eighteenth century did in the way of painting in the Netherlandish area is best understood as less a winding-up of what went before than a first step toward the nineteenth century when two new national cultures appeared on the scene. The creation of the new kingdoms of Belgium and the Netherlands brought in its wake very separate concepts of what each had achieved in the past and of their future goals, so different that no single term—and no one book—can embrace them both.

This granted, it makes just as little sense to try to write the story of Netherlandish painting on the basis of the present borders of two distinct countries, which would mean moving those frontiers—cultural as well as political—back into earlier times when they did not yet exist. To write about the last five hundred years of something still given the name of "Netherlandish paintings," as Onno ter Kuile did in a book brought out in 1976, and yet blithely pass over Jan van Eyck, Rogier van der Weyden, Peter Paul Rubens, and so many other "Netherlanders" of prime importance simply because they did not live within the boundaries of present-day Holland, is as wrongheaded as a German today would be if he wrote the history of his country's literature and excluded Goethe because he lived mostly in Weimar and therefore in present-day East Germany.

To grasp the full import and impact of the 330 years of painting presented here one needs some idea of the political events and cultural changes that were so intimately bound up with what the artists produced, even if that history has to be drastically abridged here. The notion that artistic expressions reflect political and social events is no invention of our day nor of a particular nineteenth-century ideology. People have always known that images have much to reveal of the personal, social, religious, and political factors that, on purpose or unconsciously, make their way into the pictures and constitute their background. What can be grasped of that background depends by and large on just how well we are able to read it. To be able to do so calls for a certain preparation. One cannot simply rely on one's good eye and spontaneous impressions. What we know has to match up with what the artist knew; we have to have, or develop, a certain sense and sensitivity for the forces that set it all into motion and also for the unexpressed aspirations of those long-past times. Not all of us have it, not all of us can build it up

on our own, not for all times and arts. All too often, to comprehend a picture in its past reality and to project its meaning into our own calls for a special skill in putting two and two together, and for a readiness to make the right associations.

Look at a picture by Geertgen tot Sint Jans (plate 30). Suppose we know nothing about the artist, his world of Christian conviction, and the tradition behind the theme; what can we make out of this picture of a saint lost in thought? Certainly we can describe what we see, give a faithful report of it and all in the right order: a man is seated in the foreground of a verdant countryside; the halo around his head tells us he is a saint, and so too does the lamb nearby; over a brown robe he wears a great flowing blue drapery. The entire situation and scene, looked at with twentieth-century eyes, is decidedly unrealistic. Is this a figment of the imagination of some early Hollander? Or is it making a concrete statement connected in some way with a particular task set the artist? These are questions which can at present (and perhaps in the future, too) be answered only in part because the point of connection between real life and work of art — the chain of meaning that links them together — has been forgotten.

Geertgen of Haarlem, who painted the picture in the last quarter of the fifteenth century, belonged to a house of the order of the Knights of Saint John. The theme of his picture has to do with the pictorial and biblical tradition concerning Saint John the Baptist who, as forerunner, prepared the way for Christ as "the Lamb of God, which taketh away the sin of the world" [John 1:29]. We know, then, the immediate significance of the saint and the lamb in the painting. It is also possible that the theme was particularly meaningful to Geertgen as a member of a congregation placed under the aegis of that saint. What we want to know — why John and the lamb were painted in proximity to each other and yet without any immediately significant connection (as likewise in a picture by Bosch in Madrid) — cannot be answered by the picture itself. We would like to know more about the traditions of the Order of St. John, among other things how they interpreted the declaration of the Baptist that Christ "must increase, but I must decrease" [John 3:30]. We must inquire if devotional practices of that particular order are brought out in the picture or if it embodies concepts derived from the *Imitatio Christi*, a book widely known throughout the Netherlands in that time and revered as much as the Bible. There are entire passages in the *Imitation of Christ*, whose author was apparently Thomas à Kempis (c. 1380-1471), which are remarkably close to the mood and spirit of our painting. When one reads a sentence like "O how soothing, how pleasant and sweet it is to sit and be silent and to speak with God," one feels close indeed to the hushed serenity of the painting, yet this does not entitle us to say that Geertgen based himself on this or any similar text.

There is another aspect which is easier to interpret. As the Bible tells it, John the Baptist was not a dweller in a green and fertile land, nor did he ever own such lavish drapery. His home was the wilderness, and he was "clothed with camel's hair, and with a girdle of a skin about his loins; and he did eat locusts and wild honey" [Mark 1:6]. This contradiction between the miserable circumstances described in biblical and legendary accounts and the ornateness with which artists pictured them is not personal to Geertgen. It runs through all the art of the time. As in the late medieval lives of the saints, the poverty of the first Christians that we read about in the Bible was transformed into something splendid and even lavish. No wonder, then, that in paintings of the time, the birth of Christ in a humble manger was transplanted into settings of noble architecture and attended by richly clad witnesses (plates 39, 63).

A key question remains: for whom did Geertgen paint this John the Baptist? The answer might well clear up all our uncertainties. Nothing tells us that Geertgen did this picture as a commission, that it was not something personal done on his own. But we know — and this must be kept firmly in mind — that well into the Baroque age art done without an order or commission, made by the artist for his own pleasure or interest, was rare indeed, though there were exceptions and they should not be overlooked. To understand to what extent the relationship between patron and artist was changing during our period, more or less along the lines of the dialectical reversal of the positions of master and serf that Hegel formulated in 1807 in his *Phenomenology of Mind*, a good deal of further investigation into the social history of the Netherlands is called for.

The results of such studies are modest so far, though the wide sweep of historical events does cast some light on the meaning of pictures. Fortunately, the special fascination of Netherlandish painting has made it a major concern of the experts for many years. This is no less true of the political history of the region, a history teeming with exciting incident. The triumphant outcome of the Netherlands' revolt against the domination of Spain still arouses admiration; those who waged the eighty-year struggle between 1568 and 1648 were rewarded by a freedom and a humanistic approach to life that many peoples in the world can still

only dream of.

At the end of the fourteenth century and the beginning of the fifteenth, the point at which this book begins, the Netherlandish world had a very different look. There was no hint yet of the mighty new impulses that would be set in motion by humanists like Erasmus of Rotterdam, by Hugo Grotius, who paved the way to an international law and the rights of peoples, by the great philosophers Rene Descartes and Baruch Spinoza, and by Antony van Leeuwenhoek, who discovered a new world through the microscope and thereby founded the science of microbiology.

The Netherlands were a patchwork of counties (Hainault, Namur, Guelders, Holland, Zeeland), duchies (Brabant, Limburg), and ecclesiastical territories (Liège, Utrecht, Cambrai). Small and separate, these were easily made the puppets and playthings of the greater political powers. Flanders and Artois had attached themselves to France and developed rapidly. In 1384 they came under the dominion of Burgundy, and this proved providential for the increasingly autonomous provinces. Through adroitly engineered acquisitions of small pockets of Netherlandish territories, the Burgundian dukes gradually pried them and themselves loose from the Holy Roman Empire and, by marriage, purchase, cession, or bequest added to their holdings the county of Namur in 1429, the duchy of Brabant and the county of Limburg the next year, and the counties of Holland, Zeeland, and Hainault in 1433. Their policy of consolidation started off the process by which the West came to think of the Netherlands as some sort of larger political and geographical entity. When a large part of Burgundy came into Hapsburg hands in 1477 through the marriage of the later Emperor Maximilian I to Mary of Burgundy, daughter of Charles the Bold, the trend toward autonomy became more, not less, pronounced. In 1512 Maximilian put most of the remaining independent provinces under the Burgundian aegis, and to these his grandson Charles V added, one after the other, Friesland, Utrecht, Overijssel, Groningen, Drenthe, and Guelders. Together, these and a few others made up the complex of seventeen provinces constituting the Low Countries which, in the time of Charles V, were endowed with special rights and would soon achieve a high economic and cultural level. When Charles V abdicated in 1555 and these flourishing northern possessions too passed to his son Philip II of Spain, there ensued frictions and crises that led inexorably to headstrong and doggedly fought struggles for freedom. Before we look at that dramatic moment, however, we must go back to the economic and cultural movements that characterized this first slice of political history in the Netherlands.

For our context there can scarcely be a more pertinent work than Johan Huizinga's *The Waning of the Middle Ages*, first published in 1919. That Dutch historian's exceptional sensitivity to the interweaving of thought and history and his gift for vivid and intelligent elucidation won him truly deserved fame in his lifetime (he died in 1945) and afterward. When one knows that his book was written in the endeavor "to arrive at a genuine understanding of the art of the brothers Van Eyck and their contemporaries, . . . to grasp its meaning by seeing it in connexion with the entire life of their times" (preface, English edition, 1924), it is clear how much this present volume, with its rich store of illustrations, must owe to his guidance.

The Burgundian dukes loved sumptuous display and a prodigal style of living. Their extravagant households included artists of every kind, whose tasks were not only to paint miniatures and portraits and altarpieces but also to decorate castles, festivities, tourneys, and ships. Philip the Bold, John the Fearless, Philip the Good, and Charles the Bold rivaled the famous Duke of Berry in lavishing fortunes on a patronage of art whose like has seldom been seen. The outstanding Netherlandish artists of the time flocked to them: Jean Malouel, Melchior Broederlam, Claus Sluter, the Limbourg brothers, the Van Eyck brothers, and many more besides. On their incessant travels the dukes carried their art treasures with them—entire collections of jewels, books, pictures, tapestries. At times the dukes' prestige and influence surpassed that of the French kings, and in this their possession of such inestimable treasures played no small part. Their entourage might include chancellors of real distinction—men like Nicolas Rolin (6) who commissioned the *Last Judgment* from Rogier van der Weyden (19)—and also the artists they admired and chose to encourage.

Not surprisingly, the works of those artists reflected the princely way of life in this age when the old world of knighthood was already on the wane. At the same time, the new self-confidence and self-awareness artists were acquiring, spurred on by new currents sweeping throughout Europe as well as by their patrons' enthusiasm, provided them with the incentive to experiment and innovate. Although their themes were still bound to a long religious tradition, they were being enriched by the discovery of the look and feel of the landscape in the Franco-Flemish regions: naturalism was assuming an aspect of real truth. A snowy landscape such as the Limbourg brothers painted (3) would not be done again half so convincingly until Pieter Bruegel took to his brushes a century and one-

half later (89). And the astronomical and zodiacal signs in the arch of the Limbourgs' miniatures testify too to an awakened interest in probing the reality of sky and earth. Old mingled with new, and all means—those of the painter's techniques as well—were developing and expanding toward a breakthrough into a modern world. At the time when Italy, under the impact of the Renaissance, was making great strides forward in inquiring into the inner laws that move the world and man, the early Netherlandish artists were (if we may simplify) addressing themselves more to the outward appearances of their fellowmen and their surroundings.

At first the concentration of artistic forces was in the south, in Burgundy itself. Artists from the north, like the sculptor Claus Sluter of Haarlem, found their way to the Burgundian capital of Dijon. In the south, in the second quarter of the fifteenth century, the economically flourishing cities of Flanders and Brabant—Ghent, Bruges, Antwerp, Brussels, Lille—became hives of cultural activity. There, in a development not to be looked for in Burgundy itself, where agriculture still dominated, a city-based middle class of entrepreneurs came to the fore, thanks especially to cloth manufacture and a flourishing commerce. No such great advances took place in the northern Low Countries, in such towns of Holland and Zeeland as Dordrecht, Leyden, Amsterdam, and Middelburg. Still, in the relatively small-scale commerce connected with herring fishing and in a slow but steady rise of industries like shipbuilding, weaving, and brewing there were some promising signs that should not be undervalued. Nonetheless, at no time in the fifteenth century were the circumstances there such as to attract many artists. The best local talents, Dirk Bouts, for example, took themselves off to Flanders. But in the north as in the south, although the old hierarchy continued in force, with the nobility always in first place, the new capitalism was already becoming consolidated and bringing important sociological changes. This, for artists, meant that there was a new social stratum eager for art and willing to pay for it—a prosperous bourgeoisie of commercial magnates, bankers, and merchants.

While various studies have cast light on the interconnections of the visual arts and political and economic factors, another important area where art and life met has never been sufficiently explored. Art was deeply linked to Netherlandish folk piety, both in the sense of a general phenomenon and as a specific Christian doctrine. The connection can at most be sketched out here. From the latter part of the fourteenth century and the start of the fifteenth, a religious revival movement began to spread among the Netherlandish populace. This was the so-called *devotio moderna*, the New Devotion, promoted by the Fleming Jan van Ruysbroek (d. 1381) and the Hollander Geert Groote who from 1379 was active in the bishopric of Utrecht. Its aim was to make religious life deeper and more truly contemplative by means of intensively practiced spiritual devotions along with elevating readings. An independent current within European mysticism, the movement reached out to laity and clergy alike, recruiting the former into the lay order of the Brethren of the Common Life and its feminine counterparts, the latter into the congregation of Augustinian Canons at Windesheim near Zwolle. In mid-fifteenth century the movement took on a strongly pedagogical cast, with remarkable response from the commonfolk. It soon attracted men of the caliber of Thomas à Kempis (of Kempen), Denis the Carthusian, and Jan Brugman. Entire generations were influenced by the *devotio moderna*, even thinkers like Nicholas of Cusa and Erasmus of Rotterdam.

It is hard to imagine that the Netherlandish artists of the fifteenth century remained indifferent to this current that swept through an entire era. But how its impact affected their works, even if only in some underlying thought or mood such as we find in the picture by Geertgen tot Sint Jans (30), is still an open question. Certainly themes and motifs from the devotional literature of the movement, the lives of the saints in particular, do appear in art as direct influences; nor can it be contested that the art of the time repeatedly mirrored this new preoccupation with models of saintliness and their (somewhat embellished) lives—of Mary Magdalen, for one (62, 74). "Passive" themes, such as the Man of Sorrows or the Lamentation over the Dead Christ, whose message is submission to God's will, also carried a new significance.

Meanwhile a radical upheaval in all religious convictions was brewing. As early as 1519 Martin Luther's criticisms of the Catholic Church reached Antwerp and spread into the Netherlands. In swift succession, movements and reactions came and went that were spread over decades in Germany and France. No sooner did unrest show itself than Charles V attempted to counter it with the harshest repression. In 1523 two Augustinian monks were the first to be put to death as heretics on the scaffold in Brussels. Counterreformatory forces quickly marshalled in the University of Louvain, and the powerful prince-bishop of Liège, Erard de la Marck (89), made himself their champion with no delay. Yet for all that Charles V could do in persecuting the foes of the Papacy and in banning the spread of their seditious writings, he was powerless to

stem the flood of converts to the new cause and the rise of yet more rebellious currents. Besides supporters of Luther there were now partisans of Zwingli and, soon after, of Calvin who, from France especially, chose to carry their movement into the Walloon cities of the southern Netherlands. In 1530 the Anabaptists burst violently on the scene, one of the most extravagant of the visionary and tumultous sects that made chaos of the next years. However much the many dissenting groups might differ on questions of detail, their common goal was a sweeping reform; in the struggle for it they smashed the unity of faith that had endured a millennium and a half.

Other, secular, tensions added to the unrest. In the industrial agglomerations of Flanders there were social problems, especially conflicts between hired workers and employers. By mid-century industrial growth had reached its peak. Northern Italy was surpassed: the world looked instead to the Southern Netherlands in whose ports goods from everywhere changed hands and ships. But not for long. The Spanish overlord had to impose levies and assessments to make up for losses in wars against England and France; these crippled the local vitality and proved to goad the existing bad temper. To some extent the political difficulties had their origin in the inequalities between the seventeen Netherlandish provinces whose linguistic barriers (Frisian, Flemish, Low German, French) and economic disproportions already supplied points of friction enough. The individual territories, each administered by a stadholder, were all subordinate to the central power in Brussels, the stadholder-general or regent. That authority was supported by three advisory bodies—the council of state, the privy council, and the council of finance—plus a superior court in Mechelen. The officials came chiefly from the high nobility, as did the stadholders of the provinces.

When Philip II of Spain came into possession of the Low Countries in 1556 he took steps to tighten the centralized political control, to reorganize church dioceses in a more rational and efficient manner, to unify and curtail the long-traditional privileges of the estates, and to have the edicts against heresy finally applied with uncompromising rigor. In a situation already in ferment, his efforts at reform inevitably met with violent opposition from the population, the more so since he governed not in person but from faraway Spain. A resistance movement took shape, and though composed of various social strata with their special interests at heart and at stake, it had a spark of consciousness of something above and beyond the concerns of the individual provinces or classes. That was enough to ensure the movement's unity through the

years of struggle for freedom yet to come. In the opposition there were traditional churchmen, angry at having had their dioceses chopped up, but also adherents of the Reformation apprehensive of the merciless edicts against heresy and of an Inquisition that knew no bounds; there were the nobility but also the citizens, and both groups were distressed because their longstanding freedoms had been narrowed down; finally, there were the new bourgeoisie, who felt themselves threatened by an ever more burdensome financial pressure. The conflicts that culminated in the great struggle for liberation have repeatedly given dramatic subjects to literature and the other arts: dramas like Goethe's *Egmont* and Schiller's *Don Carlos* (with incidents and emphases not always supported by the historical facts), the overture and incidental music by Beethoven for the former, Verdi's opera on the latter, the *Wallenstein* Golo Mann published in 1971, and other works in our times.

The first blows in the eighty-year war against Spain came from the southern provinces, where intially there was the greater sympathy for the movement and its determination to win whatever the cost. (A successful conclusion, however—freedom from foreign rule - was achieved only in the seven northern provinces.) When the revolt began, Antwerp was a metropolis of European rank, point of concentration of all the decisive economic and artistic driving forces in the Low Countries. To appreciate what the high position and wide-ranging influence of that great city meant for art one need think only of its great procession of painters from Quinten Massys to Peter Paul Rubens, Antwerp's prince of painters but equally the representative of a universal spirit, and the complete cosmopolite in his life as in his work. On the other hand, at the end of the sixteenth century and the beginning of the seventeenth, the Northern Netherlands (including the provinces of Holland and Zeeland) were still of little cultural or economic importance.

When the bloodshed ceased and the peace was sealed at Münster in 1648, Antwerp was ruined; not only outwardly, in its streets and edifices, but also destroyed financially. It was to Amsterdam, instead, that the world turned. Holland became the center for world trade, and what is more, for an incomparably flourishing culture whose artists bore names like Hals, Rembrandt, Ruisdael, and Vermeer. And if at the beginning of the wide span of time this book covers, painters from the Northern Netherlands were drawn to the south by everything that that region offered in the way of inspiration, now the current was reversed. Seen in retrospect, one can scarcely assess how very much seventeenth-century Holland was indebted both cul-

turally and economically to the Flemish refugees with their much greater experience. We shall see what that meant in one field in particular, that of Flemish and Dutch landscape painting.

There is still no satisfactory explanation of why the new borders were laid out to exclude the southern provinces from the fruits of their long struggle and to leave them still subject to Spanish rule. Most of the arguments adduced on religious and national grounds —that Calvinism, the aristocracy, and the middle classes were stronger in the north—are not by themselves convincing, for the simple reason that the dissident parties in the south were for long at least equal in strength with those of the north and at times even superior to them. Recently the emphasis has shifted to more geographical and strategic viewpoints (as with P. Geyl, for one). The thesis now is that the borders were a product of natural conditions, based on the large rivers—the Rhine, Mans (Meuse), Waal, and Lek—which were easier to defend. But that cannot exhaust all the reasons for those frontiers, and anyone who becomes caught up in the burning drama of the events of the revolt against Spain, who reviews the separate phases of the struggle for independence and sees the intricacy of historical factors that lie behind them, must view any interpretation from a single standpoint as dubious or worse.

In our context we can do no more than recall certain key moments: the 1560s, when the high nobility joined the cause and gave the best of itself in such men as Counts Egmont and Hoorn and Prince William of Orange: 1566, when the masses were excited to iconoclastic vandalism and sacked church altars, leaving the world so much poorer in early Netherlandish art, and when the minor nobility joined in the Compromise (or League) of Breda and petitioned for the suspension of the laws against heretics; 1567, the year of Philip's catastrophic appointment of the Duke of Alba as regent; 1568, Alba's inhuman execution of Egmont and Hoorn as rebels, followed by the flight of William of Orange to Germany; 1571, the imposition of a ten per cent tax on all goods sold; 1572, Orange's return to the fray as leader, and the many years of fighting that followed which took their inspiration from the unwavering opposition of Holland and Zeeland to the Spanish overlord; finally the Utrecht Union of 1579, a first alliance between the seven northern provinces that would later achieve their freedom; the murder of William of Orange in 1584; the war that continued with the support of England; finally, a truce in 1609, which held for twelve years and was already tantamount to recognition of the new Dutch Republic, a nascent state that would have as its first governors the stadholder Maurice of Nassau, son of William of Orange, along with the Grand Pensionary of Holland, Johan van Oldenbarneveldt.

What effect did this continuous state of war and all its attendant unrest have on art? The earlier Netherlandish painting—from Melchior Broederlam through Geertgen tot Sint Jans, Hans Memling, Hugo van der Goes, Gerard David, to Hieronymus Bosch—inevitably became a thing of the past. It is tempting to regard the break as occurring in the work of Bosch; in what H. Holländer describes as his visionary "world-pictures and dreamwork" had no precedent, but both time and fact argue against it. Bosch died in 1516, thus before Luther proclaimed his theses in Wittenberg; what is more, since 1486 or 1487 Bosch had belonged to a brotherhood whose principles are as good as impossible to relate to the revolutionary changes the future held in store.

The local developments in the sixteenth century after the time of Bosch did, however, leave their unmistakable mark on the work of the artists. With some simplification it can be said that all of the local approaches, though many and varied, involved coming to terms with Italian art. Some artists, Quinten Massys in particular, chose humanism, conceived as a comprehensive mode of thinking, as their fundamental orientation. The Reformation had a direct impact on the life and work of some: Massys' son Jan, for example, had to leave Flanders in 1544 because of his faith. In painting, changing times brought a change in style. Traditional forms went by the board, style and themes and iconology were all transformed. Artists took to specializing: there were portrait painters, landscape painters, and specialties within those specialties. With an artist so entirely unique as Pieter Bruegel, personal innovation reached a climax. In that respect his work also reflected the many-leveled character of the sixteenth century, as manifested in his native Flanders above all.

Toward the end of that century and in the early years of the next, the main stronghold of painting began to shift to Holland: one need only think of the Utrecht school. Not unexpectedly, Italian influences were making themselves felt there as well, though the Dutch did not look back to the Italian Renaissance like the Flemish, who, in the sixteenth century, had made that style and approach the main object of their study and the purpose of their journeys to Italy. Instead they looked to the harsh realism of Caravaggio, their contemporary (d. 1610), who had broken radically with everything decorative or prettifying in religious art. Utrecht Mannerism and Caravaggism, inspired by the newer Italian and French models, set the basic course

for seventeenth-century Dutch painting and helped divorce it from the native southern tradition.

The trend of Flemish artists to drift off to the liberated provinces was halted when Peter Paul Rubens took the stage. With his immense workshop and the interesting circles that grew up around him, Rubens brought about an extraordinary late flowering of Flemish art. Politically, this was connected with the end of hostilities. The Counter-Reformation in Flanders encouraged and influenced commissions for artworks. The churches that the Iconoclasts had stripped of art needed to be refurnished, not least in order to restore the general faith in a religion that had emerged from the conflict not unscathed. Yet, extensive as were the commissions awarded by the Church — and much as they explain Rubens' extraordinary productivity — this is far from the whole story as regards patronage in the Southern Netherlands. The court and nobility were no less prodigal. The large, often huge, canvases now favored were used to glorify the great events and personages of the Bible but also to cast in heroic mold those of secular history and mythology, and even everyday activities. The artists, who in preceding centuries had in selfless humility found satisfaction enough in the service of patrons or in their own pictorial ideas, now took to portraying themselves in self-sure poses with a virtually princely awareness of their own worth. Their elemental vitality found fullest expression in the sensuous emotionality of the Baroque, and the sovereign master of that style was Peter Paul Rubens. With his death in 1640 the entire intellectual and artistic revival was dealt a near-fatal blow: Flanders' contribution to Netherlandish painting was as good as over.

On the Dutch side of the border, however, ever since the start of the century and despite another forty years of war, there was an unprecedented economic upswing and cultural advance. Professional organizations — the guilds — entered their great era, and trade associations were founded. In Mediterranean trading the Dutch were soon vying with and outdoing their Spanish former overlords, and their ventures in the Indies, East and West, were if anything even more energetic. At the initiative of Oldenbarneveldt, the Dutch East India Company was founded in 1602 and in no time rose to be a mighty commercial power on the seas. Holland's successful colonial policy delivered deadly blows to the Spanish world empire and the Portuguese overseas possessions. The expansion of Dutch colonialism, especially in the East Indies and Indonesia, made it known that the new nation had become a great power to be taken seriously on the European scene as well. Domestically, the Republic of the United Provinces developed a bourgeois social organization with a strong middle class, the first of its sort. Its large body of merchants were the chief beneficiaries of the economic expansion. Financial enterprises with stocks and bonds and speculations of the most varied sorts flourished. The influx of capital was concentrated chiefly on Amsterdam, where a bank was built expressly for money-changing operations. The population increased, and the number of refugee immigrants, among them Portuguese and Spanish Jews, grew steadily thanks to a policy of widespread religious and political tolerance. Yet as regards the separate faiths, the Northern Netherlands were no more unified after the Peace of 1648 than before. Calvinism by no means ruled the field, as was so often claimed later. Among the many religious groups, bands of fanatical Anabaptists came at times to the fore, but Catholic congregations too continued as before. Among the Calvinists themselves tensions grew up between proponents of moderation and of more rigorous doctrines, culminating in the so-called Arminian Dispute. Oldenbarneveldt, as defender of liberal notions and advocate of increasing state intervention into church affairs, was unjustly condemned to death for treason and his adherent Hugo Grotius escaped life imprisonment only through flight. The danger of a rift in Calvinism, which would have been equivalent to weakening the entire political structure, was to some extent avoided, albeit with questionable methods that fit uncomfortably into the picture of the new republic.

In art, during this period, the dikes were burst open. With the verve and fire of a youthful creative force the entire artistic scene in the Northern Netherlands took on new life. If commissions from church authorities were practically nonexistent because of the Reformist opposition to religious images, this was more than made up for by the growing enthusiasm for art of the now much more numerous and ever wealthier middle class, opening up new possibilities in unprecedented number and variety. True, the change from the large-format altar painting to the small cabinet piece more to the taste of a middle-class clientele had begun long before: the miniature-like landscapes of Jan Bruegel the Elder were exactly what the wealthy Flemish private purchaser desired. But only now did such a development take root in Holland and become widespread. In the same way, the increasing specialization into portrait, landscape, genre, and still-life painting which had made considerable headway in sixteenth-century Flanders now caught on in the north. The artists found themselves faced, happily, with an insatiable demand. The number of Dutch masters and works in the seventeenth century is simply beyond

counting. New workshops mushroomed everywhere. An unrestrained passion for any and every thing the eyes could enjoy had opened the way, along with a fresh self-confidence and a happier general mood. In time, though, the market came to be literally suffocated with artworks, and then the situation was reversed: among the thousands of artists some of the greatest—among them Rembrandt, Jan Steen, and Vermeer—had to earn their bread in other and often meaner ways.

Yet what remains fascinating amid all this remarkable diversity of themes and the immense number of paintings produced is their almost unfailing high quality. The technical experience acquired in previous centuries and the deeply rooted Netherlandish need for believable rendering of nature were now united in an art of shaping pictures that could convincingly convey the illusion of reality. Never before, to such an extent, at any rate, had there been anything like this affectionate, deeply sympathetic depiction of everyday Dutch life in even the most seemingly insignificant details. When Vermeer shows us a woman pouring milk (210) or a master of still life like Jan Huysum devotes hours to contemplating and rendering a fallen petal or leaf (224), their subjects are not what anyone would call exciting. Yet that is only one dimension of their artistic capabilities. Never before nor since has European art known such a concentration of artistic events, events that range through all the spiritual breadth of Rembrandt's works, through the enthralling physiognomy of Frans Hals's portraits, the perfectly equilibrated compositions of colors and forms achieved by Vermeer, and the poetic landscapes that in the hands of a Ruisdael become tense with drama.

Precipitous as was the rise of Dutch art in the seventeenth century, and overwhelming as its impact was on posterity, it waned no less rapidly beginning in the 1660s. At that time the economic boom began to deflate and Holland experienced a series of setbacks on land and sea at the hands of an ever more dominant France and England. Only a few brilliant names cross the threshold of the eighteenth century. And even with these—Jan Huysum, for instance—painting dwindled to a refined but routine activity, relying more and more on a highly contrived perfectionism to veil a content that had gone hollow. Fashionable predilections and a certain pleasingly posed but superficial charm took over and tempt us to forget the solid core of greatness in the masterworks the Netherlands had given the world.

And then we come full circle, back to our first concerns and definitions: in the seventeenth century, what still bound Holland with Flanders, north with south, that justifies using the term "Netherlandish" for all this art? Their roots lie in the same or similar traditions, and old traditions die hard. No end of artists in Holland—Rembrandt's immediate predecessors among them—are commonly thought of as Protestant but were in fact still Catholic. Artists moved back and forth, from one part of the old Low Countries to the other. Some, like Adriaen Brouwer, many times; others, Jacob Jordaens for instance, were converted to the Reformed creed in Antwerp but continued to enjoy the favor of Flemish Catholic patrons; there were Dutch masters, among them Jan de Heem, who went the other way, from Holland to Flanders. In the thought and feeling of the time the separation of the Netherlands was by no means so sharp as history makes it seem. Long after the time of the political division, a sense of belonging together persisted as something elementary and taken for granted. Constantijn Huygens, secretary to the stadholder of Holland, named Dutch and Flemish artists in one breath without the slightest implication of any different origin, and painters on both sides of the border were commissioned by the Dutch court for joint projects. So, emphasize as we may one distinguishing trait or another, whether united or disunited politically the northern and southern provinces of the Low Countries did, in fact, share a common history through the three glorious centuries of their art of painting.

Early Panel Painters in the Southern Netherlands

If anyone still judged art on how felicitously it transposed the reality around us into a picture, the panel Melchior Broederlam painted at the close of the fourteenth century with the *Presentation of the Infant Jesus in the Temple* [after Luke 2:22-35] and the *Flight of the Holy Family into Egypt* [after Matthew 2:13-15] (plate 1) would show up poorly. Overlarge figures in the temple, obvious disproportions, muddled perspective in the pagan monument in the background, which is seen from both above and below: all completely unrealistic.

Nor would the pictures that follow it in these pages rate much better on that sort of scale: neither the calendar miniatures by the Limbourg brothers nor even the masterworks by Jan van Eyck, Robert Campin, and Rogier van der Weyden. Looking ahead we can gradually stop worrying about our hypothetical reality-scale; art did increasingly depict real things as we think we see them.

Certainly this is clear by the time we reach the Dutch landscapes of the seventeenth century, in something like Vermeer's *View of Delft* (208). Such pictures literally invite us to all but step into them; they make us aware through all our senses of the tangibility of air, land and water. Yet Broederlam too was part of the development, and if we begin with him, it is only because he is the earliest Netherlander to paint panel pictures to which we can attach an author's name. Compared with illustrations in manuscripts from the thirteenth and fourteen centuries, his pictures do show tendencies we can call "realistic." Looked at from the other side, from the standpoint of seventeenth-century Dutch landscapes, that is the last thing one can say of them. Are those later true-to-nature landscapes therefore "more real" than Broederlam's late-medieval scene with the Christ Child in the Temple? That depends on what we understand by "real" and by "reality." What is real is certainly something much more than what we can touch and see.

Every age has had its own notion of what is real. Not long before Broederlam's time philosophers could still hold up God as the ultimate reality (*ens realissimum*) and dismiss human existence as utterly remote from that real truth. And in Broederlam's time pictures were thought of as somehow containing the real essence, so that the powerful Duke Philip the Bold of Burgundy would, without ever questioning, bow his knee before the altarpiece he had himself commissioned, on whose weekday side he would have seen this panel and one other that has survived. At that altar in the church in Champmol near Dijon for which Broederlam painted these pictures, the Carthusian monks said mass each day. People worshipped their Maker in the presence of these pictures, and they associated with these images a faith and hope that for them were real. It was this, in essence, that the age expected of art. And to provide such images was all that was asked of an artist: otherwise he was to disappear behind his work, *sans* name, *sans* fame. It is only because documents concerning the commission have survived that we know Broederlam to be the author of the panels; not before Jan van Eyck did artists in northern Europe sign their paintings.

The problem of what is "real," or realistic in art, by now a familiar aesthetic subject, carries a special significance when we consider how people thought in earlier times. Saints, endowed with a spiritual reality that made them objects of veneration, were felt to transcend the world of men, and their boundless importance to man had to be embodied in the images men made of them. The medieval practice of depicting saints overlarge, in accord with their spiritual

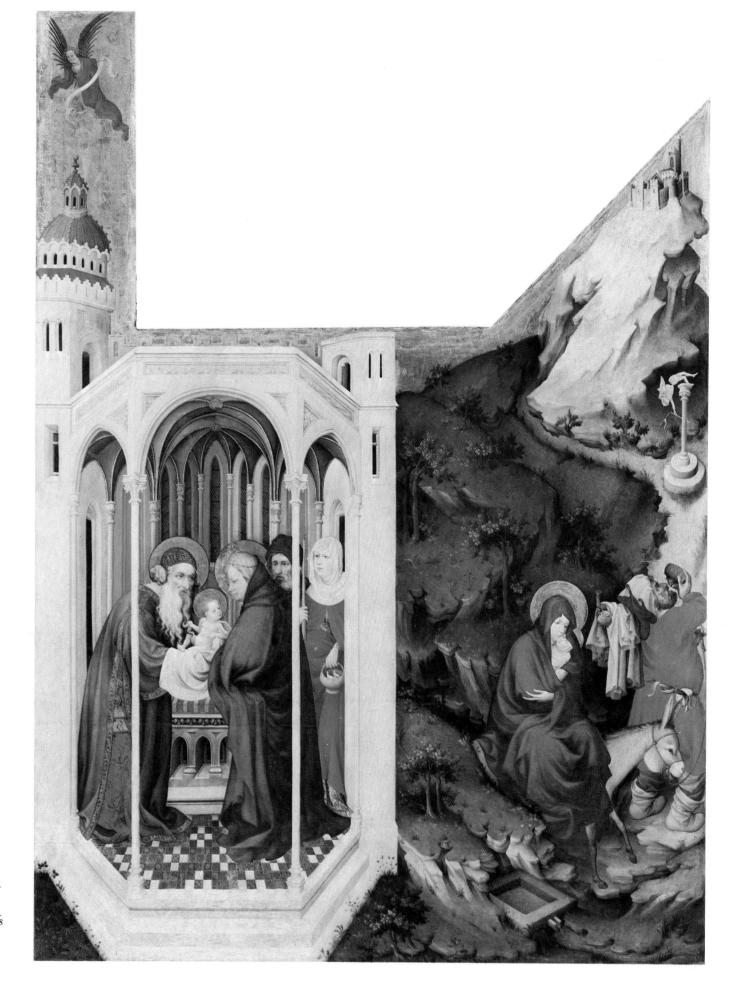

1 Melchior Broeder-
lam. *The Presentation
of the Infant Jesus in
the Temple* and *The
Flight into Egypt* (right
wing of an altarpiece
for the Carthusian
monastery at Champ-
mol). 1393-99. Tempera
and gold on panel, 162
× 130 cm (63¾ × 51⅛
in). Dijon, Musée des
Beaux-Arts

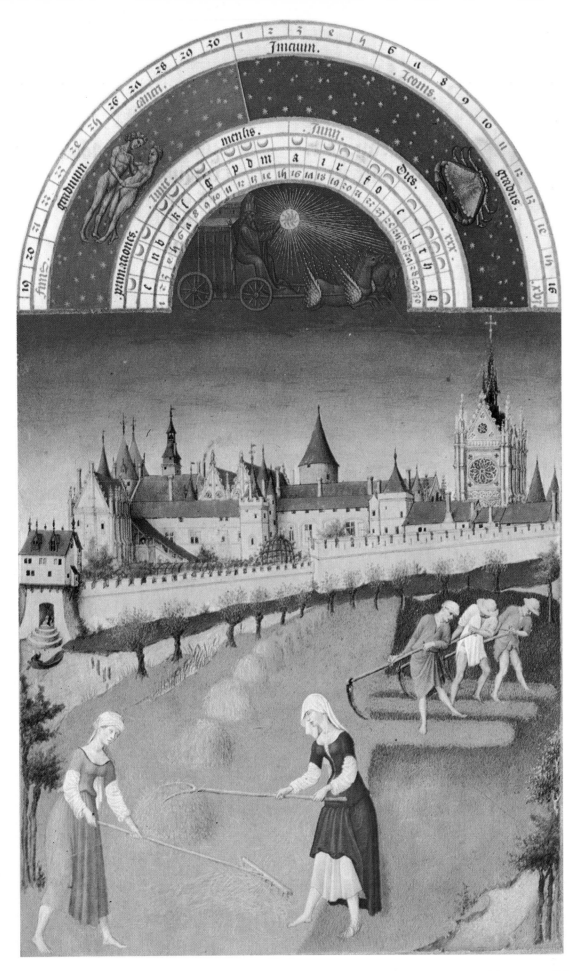

2 The Limbourg Brothers, *The Month of June* (from *Les Très Riches Heures du Duc de Berry*, folio 6 v°). 1413-16. Miniature on parchment, 22 × 13.5 cm (8⅝ × 5¼ in). Chantilly, Musée Condé

significance, was still the practice in Broederlam's time. This practice endured well into the fifteenth century, certainly long enough to set the key for the *Virgin and Child in a Church* by Van Eyck (5). Vastly exceeding the dimensions and proportions of the Gothic interior architecture, Mary and the Christ Child are brought far forward: in her own person she signifies the church, the Temple and House of God, because the Son of God took up His dwelling in her flesh. Similarly, in the side-wings of the great altar-

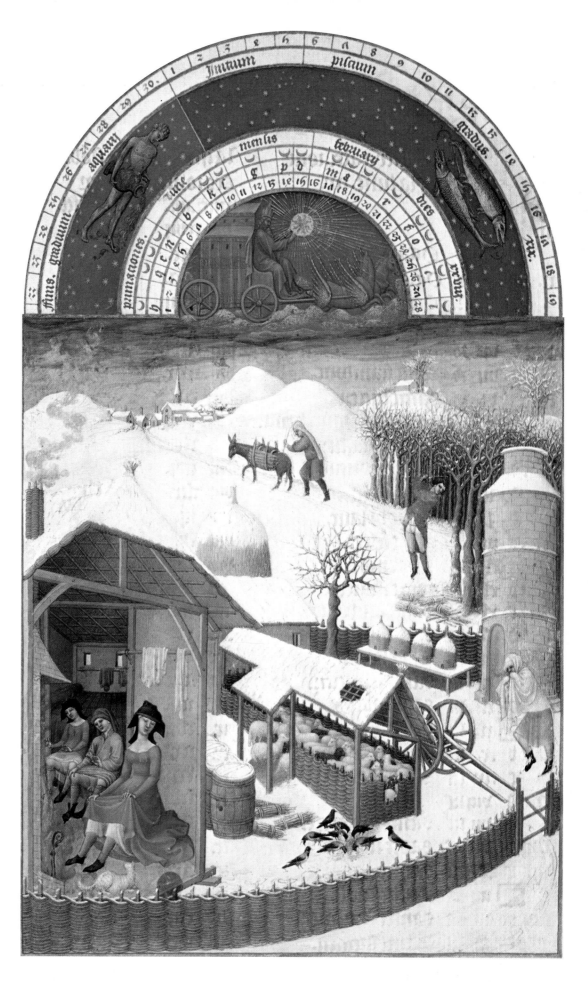

3 The Limbourg Brothers, *The Month of February* (from *Les Très Riches Heures du Duc de Berry*, folio 2 v°). 1413-16. Miniature on parchment, 22 × 13.5 cm (8⅝ × 5¼ in). Chantilly, Musée Condé

piece by Hugo van der Goes (40, 41), Saints Anthony, Thomas, Margaret, and Mary Magdalen — the name saints of the people who commissioned the painting — tower mightily above the members of the family of Tommaso Portinari.

And yet all these works stand at the threshold of a new age in art. Gone is the gold background which, for the medievals, was the solemn sign of a holiness beyond time and place. Instead, landscape helps to give shape and space. This change came about almost

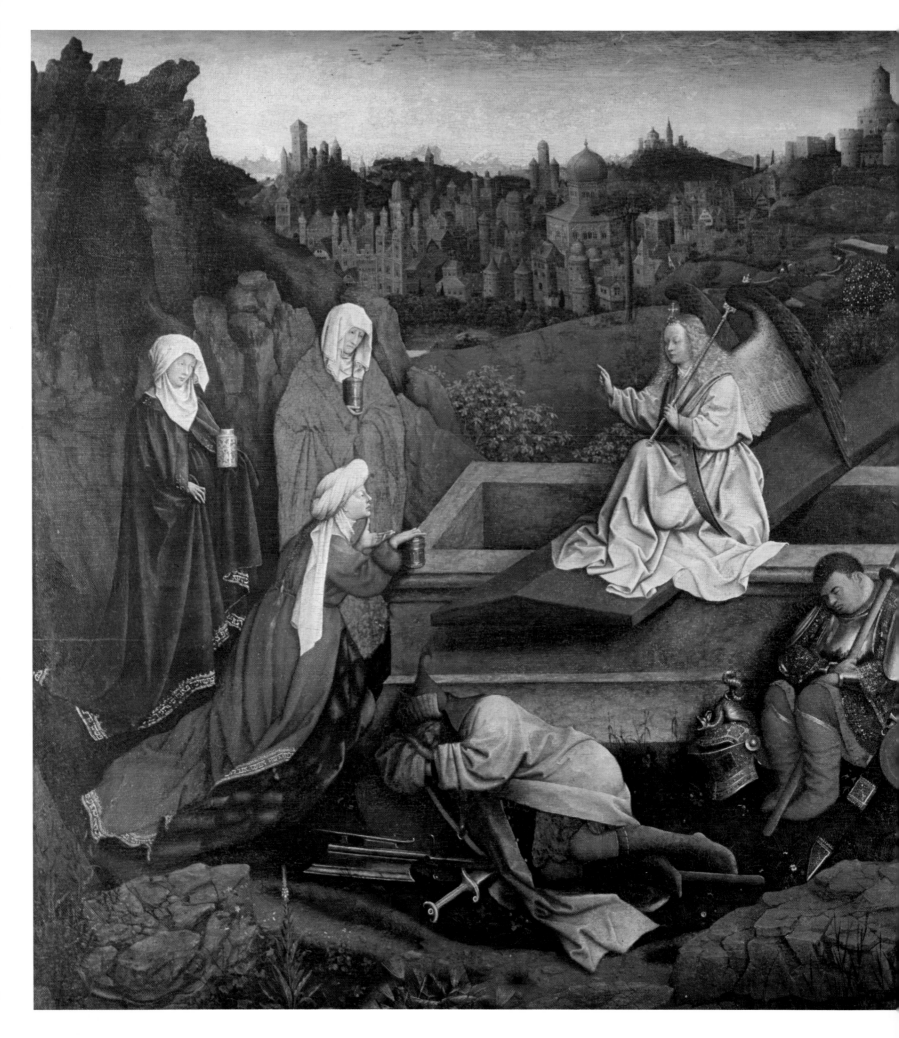

4 Hubert and Jan van Eyck, *The Three Marys at the Empty Grave of Christ*. Oil and tempera on panel, 72 × 89 cm (28⅜ × 35 in). Rotterdam, Museum Boymans van-Beuningen

in a flash. With breathtaking impetuousness the artists of the first decades of the fifteenth century mastered the problems set by a landscape background. As always at turning points when mankind makes its great discoveries, here too the die was cast not by one but many, and the really major achievements came at the outset, with the Limbourg brothers and Jan van Eyck. Once the picture was opened to careful observation of nature, perspective followed as the night the day, and with it the illusion of spatial depth (plate 6, for instance); then the human body was given more convincing form, as in the first two nudes to be painted in the North (9, 10), and along with this came a greater interest in the look of real individuals (11, 12). Art was coming ever closer to the nature of things and of living creatures. But in the Low Countries the point of departure and focus was the outward appearance, the effect made on the observing eye, and not, as in Italy in those years, the inner structure. Italian artists could draw on well-tested knowledge in the fields of proportion, central perspective, and anatomy, all of which could be worked out and verified in their pictorial compositions. In the Netherlands, despite early contacts with the South (probably one of the Limbourg brothers went to Italy, and Van der Weyden certainly did), those laws and principles were adopted only slowly. Thus early Netherlandish painting retained a certain "primitive" or at least inimitably "naive" quality which still touches viewers with its intimate appeal. In a time like ours in flight from all too oppressive *real* realities we give an eager welcome to whatever may still be innocent or naive (not, of course, in the pejorative sense of the word but in its true meaning: *nativus* = natural, original).

Something else, as well, unfailingly arouses our enthusiasm and admiration in these early pictures: the splendor of their coloring. Half a millenium has passed and their colors have retained a remarkable freshness. No one yet has arrived at a full scientific explanation of this sensational, even triumphant technical achievement. Questions still remain, especially about what binding agent was used, and how. No one now attributes the invention of oil painting to Jan van Eyck as Giorgio Vasari, artist and biographer of artists, asserted in the sixteenth century, but it is true that Van Eyck, right at the start, brought its use to a perfection scarcely ever matched again. The almost unbelievable luminosity and striking translucency were achieved in part by overlaying thin crystalline layers of opaque color with delicate oil glazes that permitted infinite tonal modulations not otherwise obtainable, and repeating this mixed or "tempered" process over and

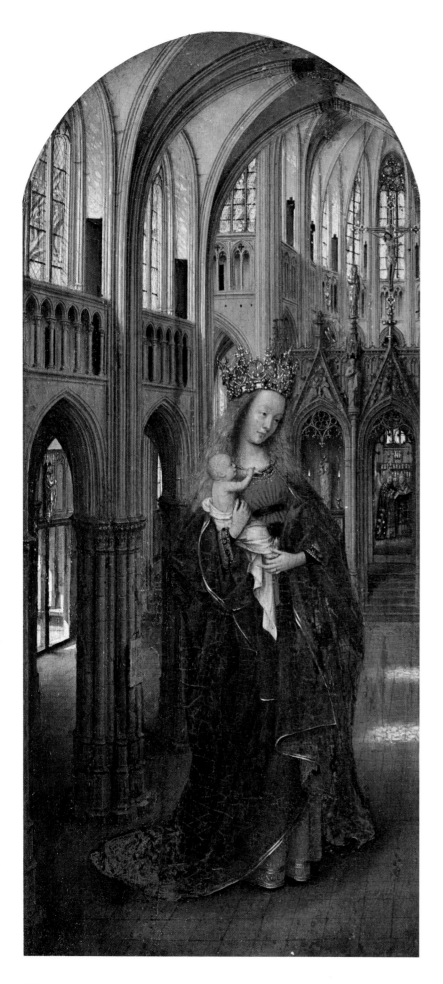

over with limitless patience. By these means light literally penetrates the picture in infinitely fine refractions right down to the ground itself. Because that underlying coat of color is bright as well as ivory-smooth, the light that enters is reflected back and passes once more through the very numerous layers of pigment, this time in reverse direction. What was entirely new, or certainly never before achieved in this measure, was the possibility of letting light *into* the picture and thereby catching the most sensitive nuances of mood and atmosphere.

Most of the pictures of the time were small, a consequence of the miniature painting which preceded and paralleled their development: see, for example, the calendar pictures of the Limbourg brothers (2,3). Van Eyck's remarkable delight in details, most often amassed within a very small space, led to astounding results: we need only look at the view into the far distance in the *Madonna of Chancellor Rolin* (6) or the tiny plants covering the terrain in the central panel of the Ghent altarpiece (7). The Dresden gallery owns a traveling altar with a *Virgin and Child in a Church* painted by Van Eyck in 1437, whose central panel is the exact size of a standard sheet of typing paper (28 × 22 cm. = 11 × 8½ in.). Everything, down to infinitesimal details, to strands of hair, is observed and painted with selfless patience and love, yet not without temperament. To appreciate to the full how extraordinary the achievement was, every last millimeter should be investigated and enjoyed with a hand-glass (if only there were not custodians in museums, though thank the Lord, too, that there are!), yet when we step away to a certain distance the impression is of something whole, a closed and perfect composition.

Nothing is left to chance in these paintings. Details that strike one at first as cleverly contrived arrangements that are there, in that particular form, only to make a balanced composition—the objects in the bedchamber of the newly married Arnolfini couple (11): the wooden clogs, the dog, the single candle burning in the chandelier, the mirror on the rear wall—all prove upon investigation to have their point and purpose.

5 Jan van Eyck, *The Virgin and Child in a Church*. c. 1426. Oil and tempera on panel, 31 × 14 cm (12¼ × 5½ in). Berlin-Dahlem, Gemäldegalerie

Behind what look like everyday things lurks a firm and essential *other* meaning. They tell us of something more than themselves, speak clearly of connections that are there for the grasping—if only we can connect. They are symbols, tokens of deeper meanings. Many of the significances in this particular painting are still familiar and recognizable: the bridal candle, the dog as sign of fidelity. Others have been forgotten and can be explained only when we reconstruct the iconography of that past time. Thus the wooden shoes, removed and set apart, refer to the sanctity of the marriage chamber, as when God said to Moses, "Put off thy shoes off they feet, for the place whereon thou standest is holy ground" [Exodus 3:5]. The mirror in the exact center of the picture, with its ten scenes of the Passion around its frame, draws on the medieval symbolism of Mary to assert the virginity of the bride (*speculum sime macula*: the unflawed mir-

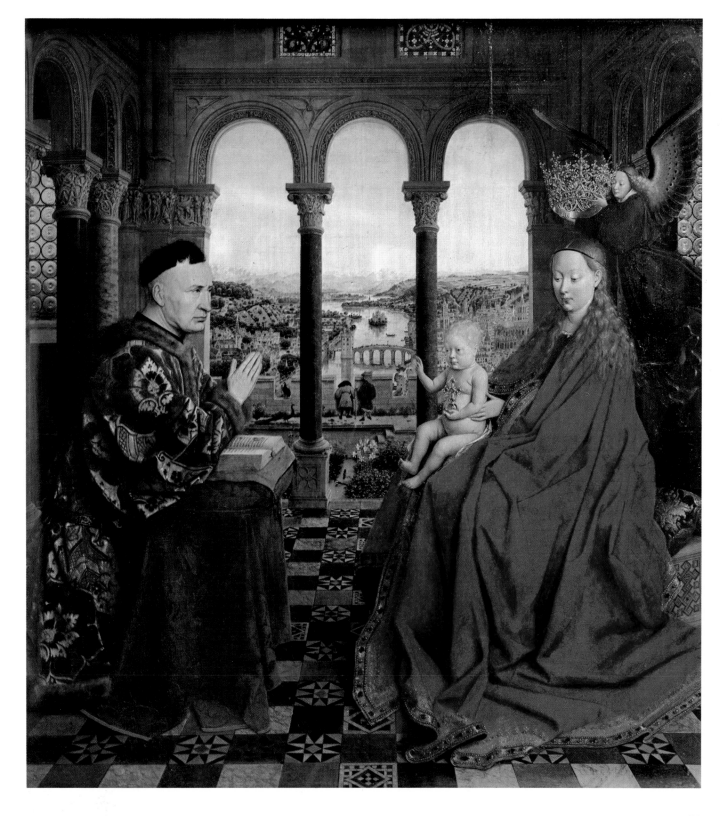

6 Jan van Eyck, *The Virgin and Child with Chancellor Rolin*. c. 1435. Oil and tempera on panel, 66 × 62 cm (26 × 24⅜ in). Paris, Musée National du Louvre

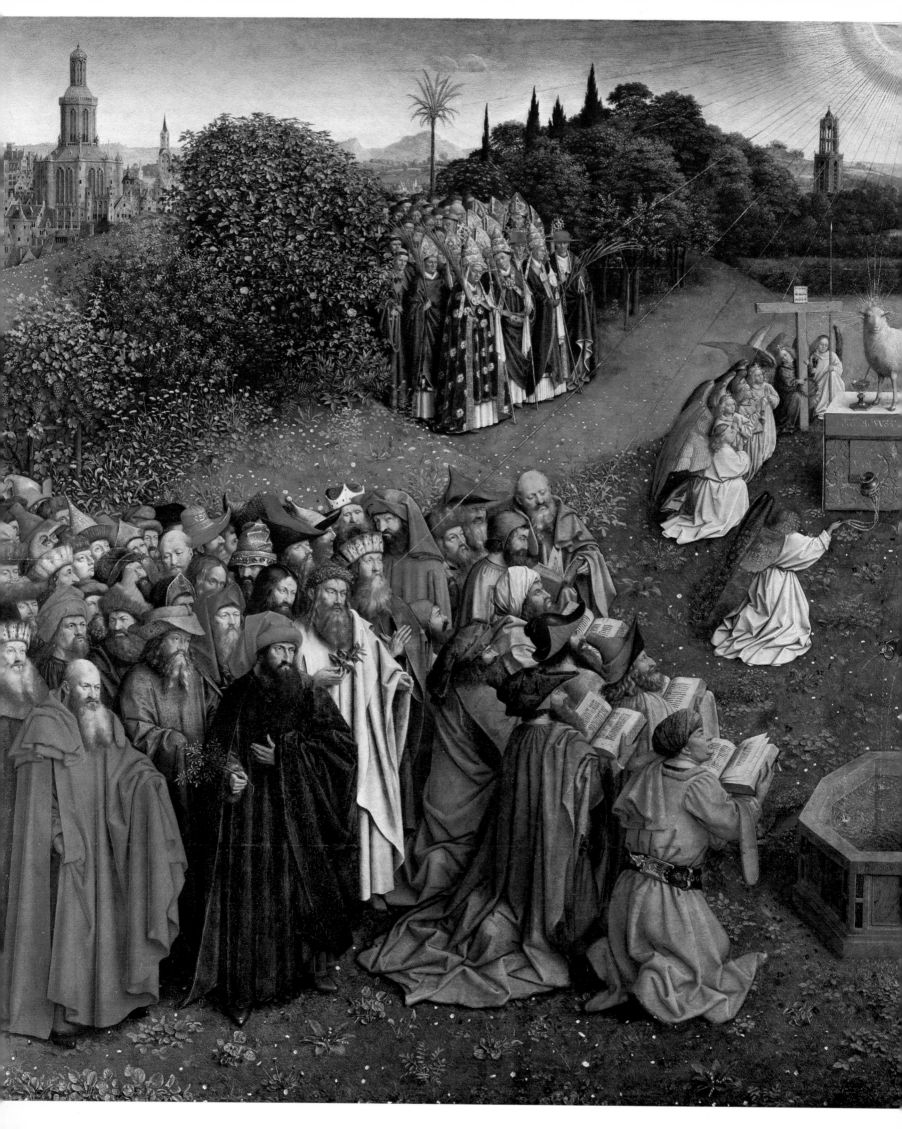

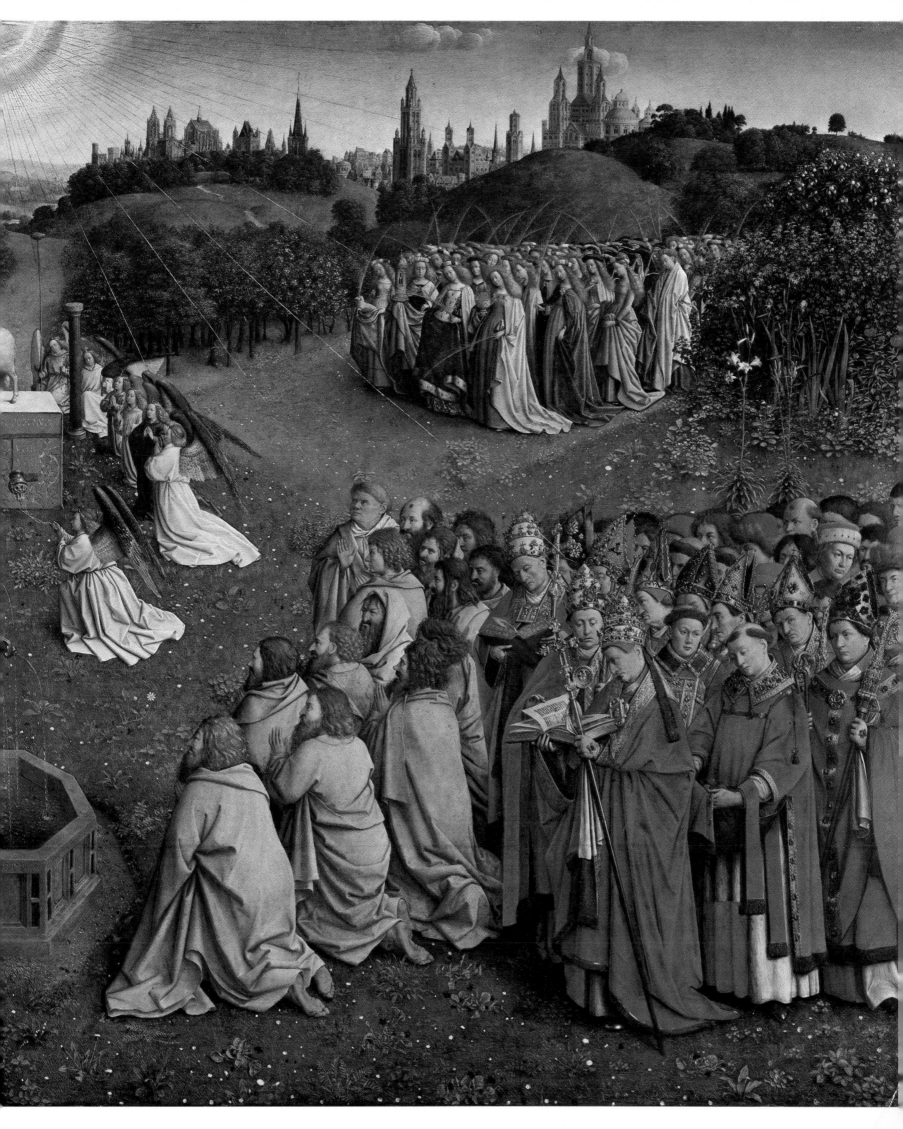

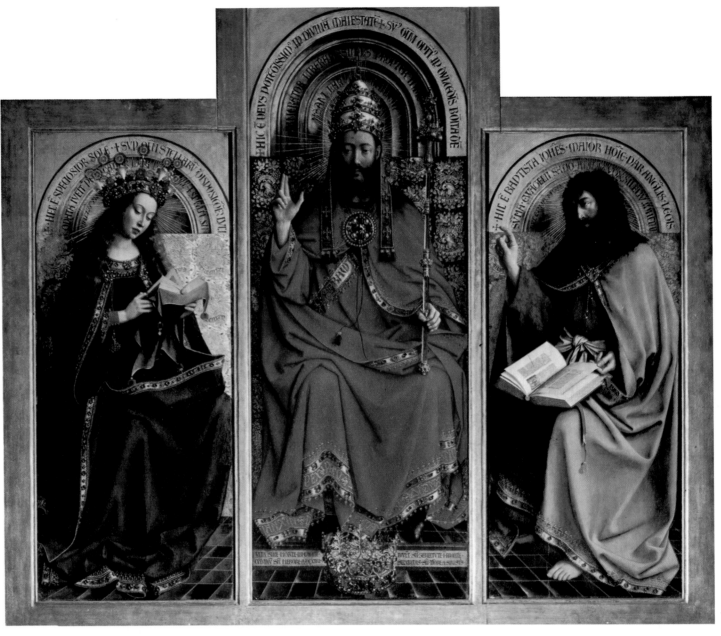

Preceding double-page:

7 Jan van Eyck,
*Adoration of the Mystic
Lamb* (lower center of
panel, inner face of the
Ghent altarpiece). 1425-
32. Tempera and oil on
panel, 137.7 × 242.3
cm (4 ft 6¼ in × 7 ft
9⅜ in). Ghent,
Cathedral of St. Bavo
Total dimensions of the
altarpiece: closed, 350
× 223 cm (11 ft 5¾ in
× 7 ft 3¾ in); open,
350 × 461 cm (11 ft 5¾
in × 15 ft 1½ in)

ror). But the convex mirror has another and less
solemn function: hanging on the rear wall of the room
that opens out before us, it reflects the two witnesses
to the marriage who enter through a door on *our* side,
and one of them seems to be the painter himself, be-
cause written on the wall above above the mirror is
Johannes de Eyck fuit hic, Jan van Eyck was here.

Thus a number of motifs associated with marriage,
among which the bridal bed is the most explicit, ac-
company the solemnly elevated ceremony and its ges-
tures that need no explaining: the couple clasp hands,
the bridegroom raises his right hand in pledge of faith.
Scarcely ever again was there a painting that expressed
such intimate stillness in a moment of great and all-
pervading solemnity, and it was also the first to por-
tray two identifiable persons full-length in that role.

The feeling for motifs rich in significance could go
so far as to make an entire picture a symbol, as in Van
Eyck's *Virgin and Child in a Church* (5). We have

already seen that Mary symbolizes the Temple of God
in this painting; we can show that every detail in the
picture insists on that meaning. The edge of her mantle
is embroidered with part of a verse from the apocry-
phal book of the Wisdom of Solomon [7:29] which is
also found on the arch framing the Virgin in the Ghent
altarpiece: "For she is more beautiful than the sun,
and above all the order of stars: being compared with
the light, she is found before it." The frame is now
lost, but once it too held a text from a medieval Nativi-
ty hymn: "Thou art the flower among flowers. This
Mother is the daughter, this Father is born. Who hath
heard the like? God born as Man!" Behind the choir
screen there is a statue of the Virgin that alludes to her
as the altar of Christ. The gables of the choir screen ar-
cade likewise have scenes from her life. Even the win-
dows through which light streams are a symbol: as the
light passes through glass without shattering it, so did
Mary bear a child though untouched by any man.

8　Jan and Hubert (?) van Eyck, *God the Father between the Virgin and John the Baptist* (upper central panel, inner face of the Ghent altarpiece). 1425-32. Tempera and oil on panel, center panel 212.2 × 83.1 cm (6 ft 11½ in × 2 ft 8¾ in), flanking panels each 168.7 × 75 cm (5 ft 6⅜ in × 2 ft 5½ in). Ghent, Cathedral of St. Bavo

9　Jan van Eyck, *Adam* (upper left panel, inner face of left wing of the Ghent altarpiece). 1425-32. Tempera and oil on panel, 212.9 × 37.1 cm (6 ft 9⅞ in × 1 ft 2⅝ in). Ghent, Cathedral of St. Bavo

10　Jan van Eyck, *Eve* (upper right panel, inner face of right wing of the Ghent altarpiece). 1425-32. Tempera and oil on panel, 213.3 × 32.3 cm (6 ft 10 in × 1 ft ¾ in). Ghent, Cathedral of St. Bavo

This is by no means the end of the meanings and associations. Everything here, as in other such paintings, is replete with significance. Yet none of it is over-prominent, nothing disturbs the finely balanced hierarchy of forms and values, and in this, as in the overall mood the colors create, one grasps the artistic mastery at work here.

The wealth of symbols was inherited from the Middle Ages, and well into the sixteenth century artists continued to draw on that tradition. Further motifs and themes came from the Christian legends translated into Netherlandish and from the fifteenth-century Passion plays. The spiritual significance of these fascinatingly recondite allusions was not the artists' only concern, for all their roots in the same religious traditions. Painters such as Van Eyck incorporated them into pictorial contexts in which purely artistic innovations made ever greater headway. The late fourteenth and early fifteenth century was a transitional

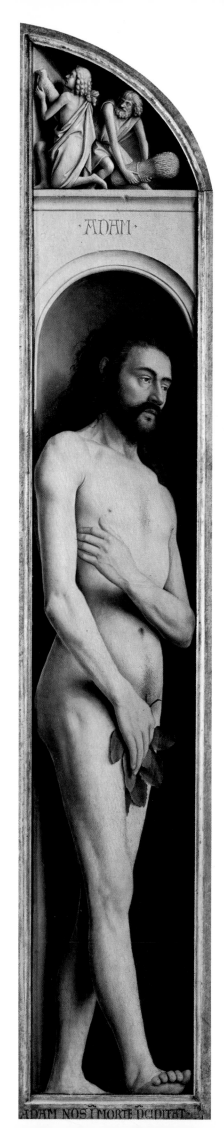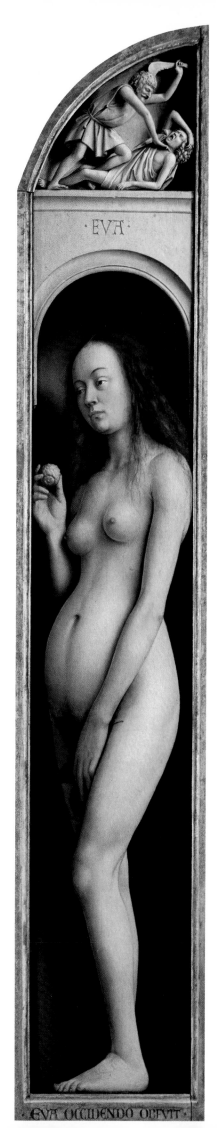

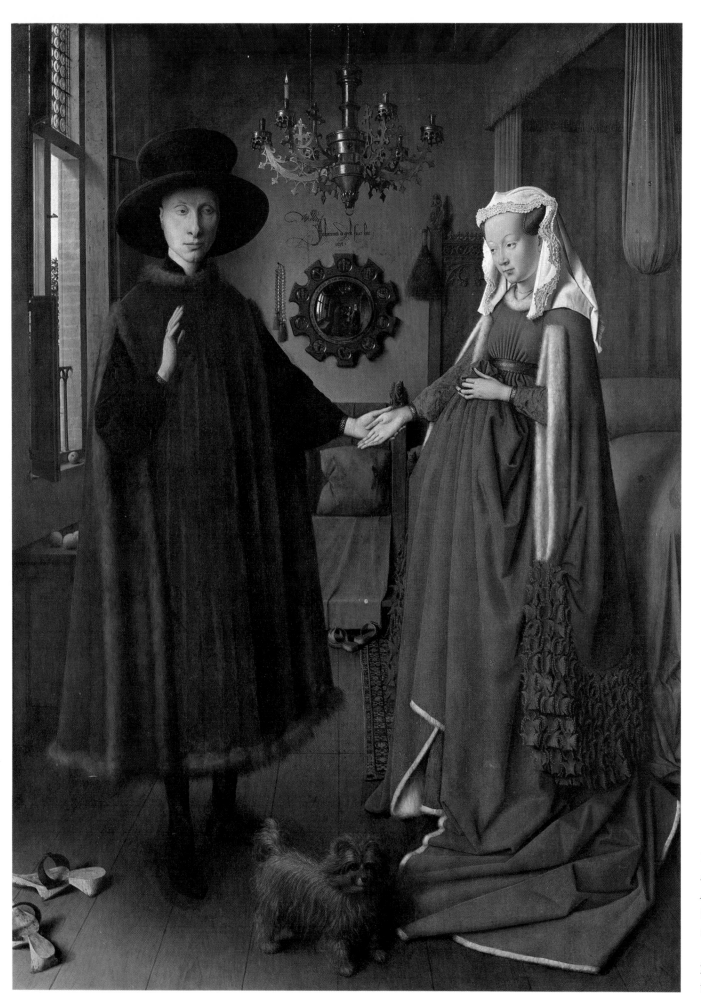

11　Jan van Eyck, *The Marriage of Giovanni Arnolfini and Giovanna Cenami.* 1434. Tempera and oil on panel, 81.8 × 59.7 cm (32¼ × 23½ in). London, National Gallery

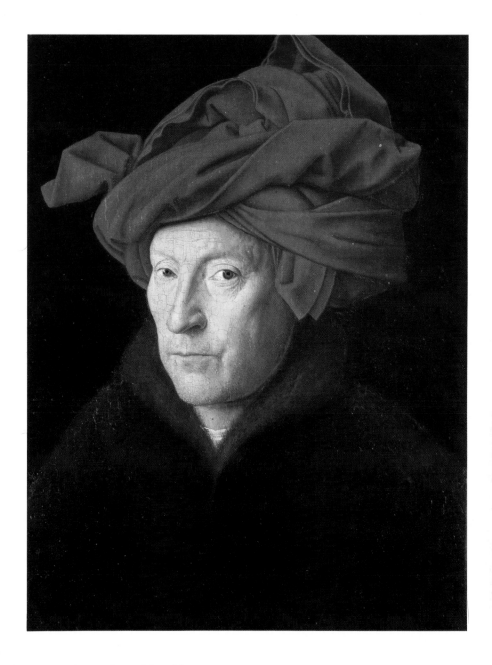

12 Jan van Eyck, *A Man in a Red Turban*. 1433. Tempera and oil on panel, 25.7 × 19 cm (10⅛ × 7½ in). London, National Gallery

period, and it is difficult to apply to it any ready-made formula: an "autumn of the Middle Ages" as Huizinga said, or, as others insist, the "springtime of a new age"? Convenient as such labels are, they resolve no problems and make it no easier to pinpoint the "beginnings" of a period and style that never existed, in a real sense, until later ages isolated it out of the flux of history.

Most books on early Netherlandish painting begin with Jan van Eyck and his major work, the Ghent altarpiece of 1432 whose *Adoration of the Mystic Lamb* is one of twenty-four separate pictures united in an imposing polyptych. But that was not a beginning but rather a high point reached early and which left its mark on all the art that came after it. Millions of people have made the pilgrimage to see this great altarpiece which is still in the church for which it was painted, the cathedral of St. Bavo in Ghent (originally called St. John's). Although a con-

siderable amount of information having to do with its creation and background is now documented—we know, for instance, that the donors were the churchwarden and town councilor Judocus Vijd and his wife Elisabeth Borluut—there are still more enigmas than answers. To begin with, there is the inscription by Jan van Eyck in which he hails his brother Hubert (who died in 1426) as "greatest of all painters" and refers to himself only as "second in art". This inscription has spawned booksful of dubious speculation, without a grain of fact, about what one brother did and what the other. In the absence of a single work that can be assigned to Hubert with any assurance, writers have attached his name to pictures like the *Three Marys at the Empty Grave of Christ* [after Matthew 28:1-7 and Mark 16:1-8] (4) which in certain respects and details do not evince the perfection of the later works.

More important is the total meaning of the Ghent

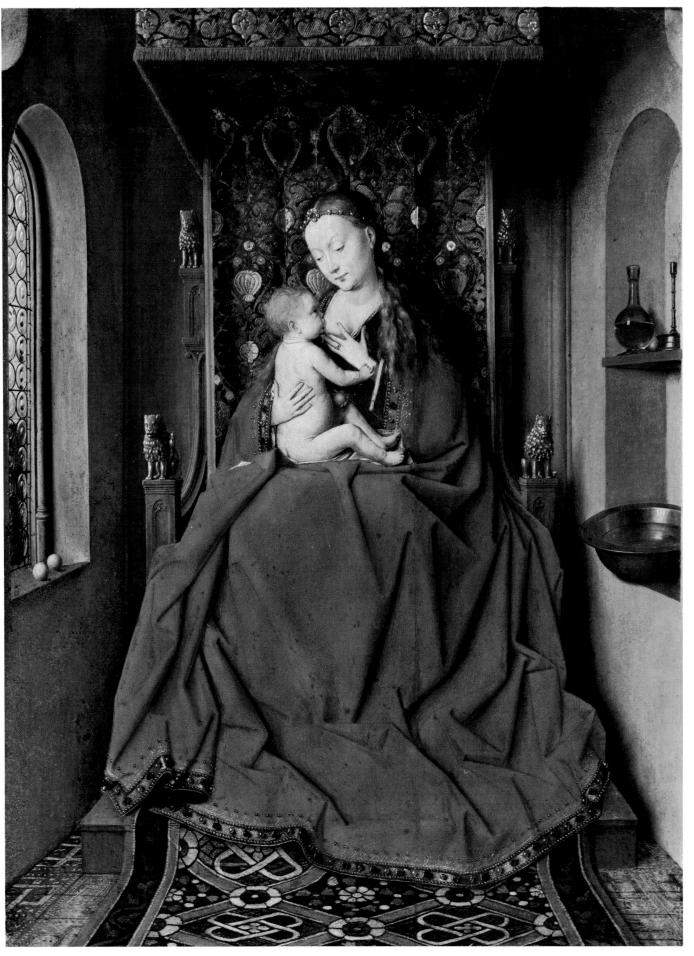

13 Jan van Eyck, *The Virgin Enthroned Nursing the Child (Madonna of Lucca)*. c. 1435. Tempera and oil on panel, 65.5 × 49.5 cm (25¾ × 19½ in). Frankfurt, Städelsches Kunstinstitut

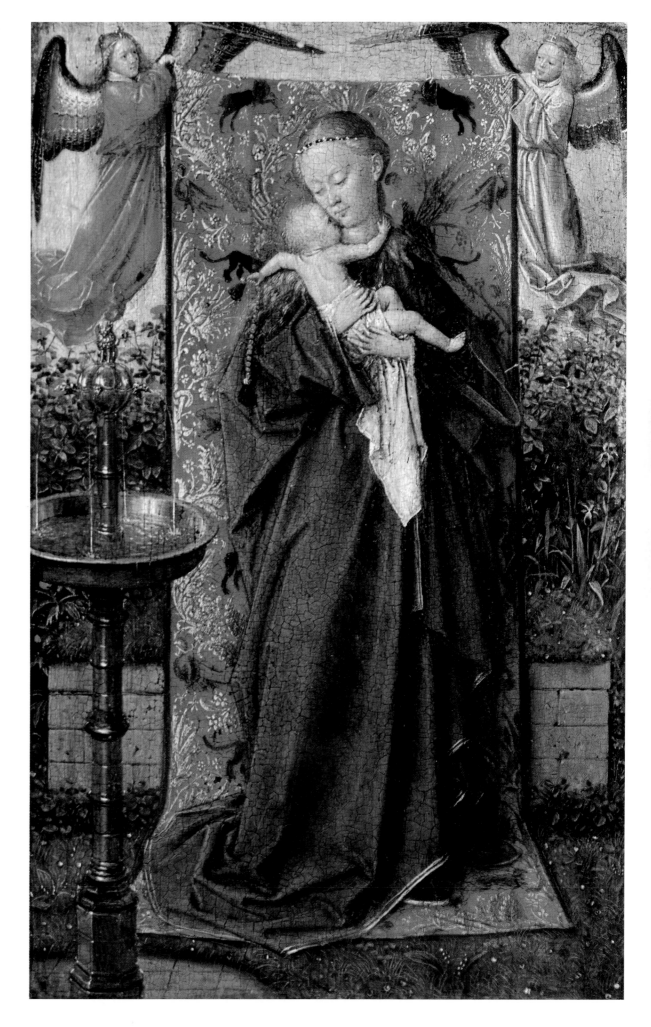

14 Jan van Eyck, *The Virgin and Child at the Fountain of Life*. 1439. Tempera and oil on panel, 19 × 12.2 cm (7½ × 4¾ in). Antwerp, Koninklijk Museum voor Schone Kunsten

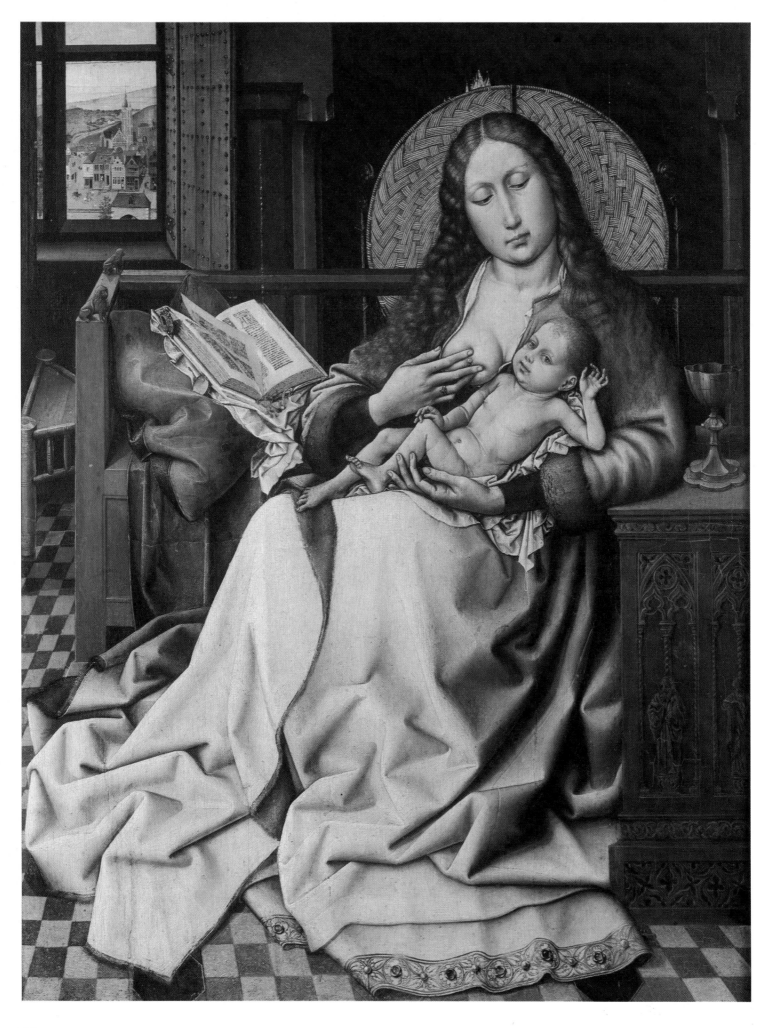

15 Robert Campin (The Master of Flémalle),
The Virgin and Child Before a Fire Screen. c. 1430.
Tempera and oil on panel, 63.5 × 49.5 cm
(25 × 19½ in). London, National Gallery

16 Robert Campin (The Master of Flémalle),
Adoration of the Child. c. 1430. Tempera and oil
on panel, 87 × 70 cm (34¼ × 27½ in). Dijon,
Musée des Beaux-Arts

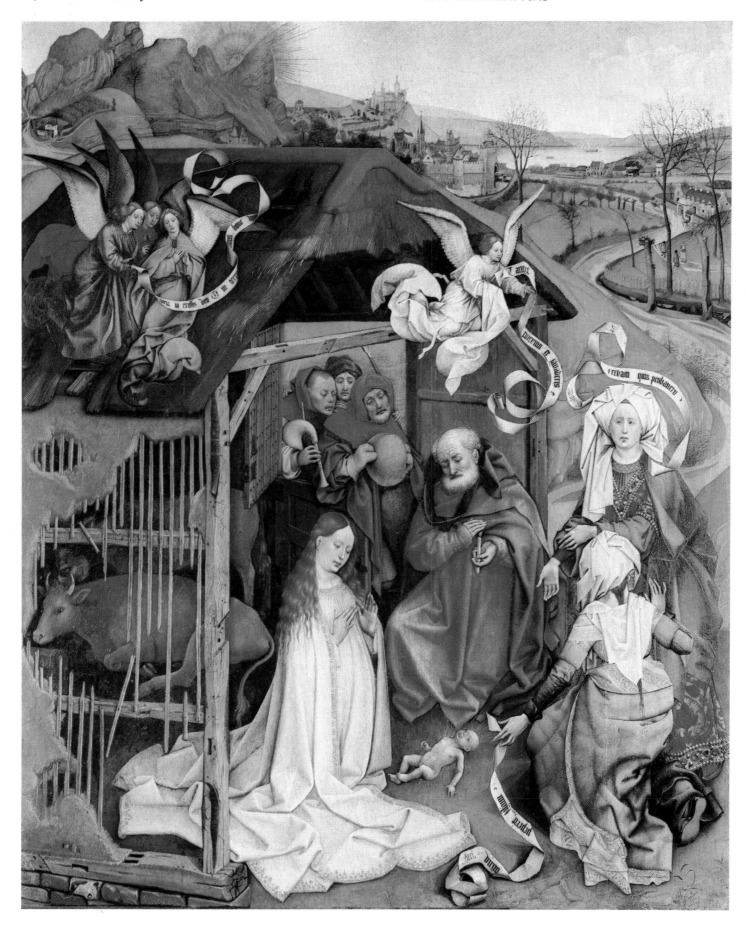

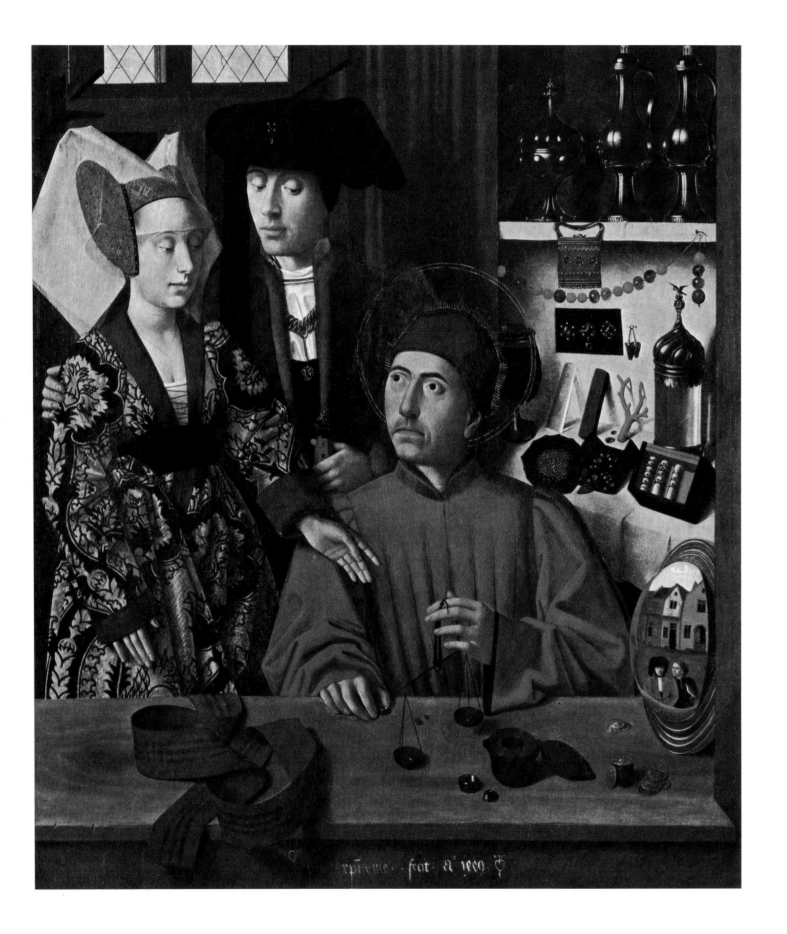

17 Petrus Christus, *Saint Eligius as Goldsmith
Gives a Ring to a Betrothed Couple.* c. 1449.
Tempera and oil on panel, 98 × 85 cm (38⅝ ×
33½ in). New York, Metropolitan Museum of Art,
Robert Lehman Collection

altarpiece, which has had all sorts of readings. Is it the case that all aspects of the whole, composed as it is of numerous separate panels, pertain to a single message, or are separate theological trains of thought merely set side by side? In the lower register of the central panel (7), the Lamb of God which, in shedding its blood, "takes on the sins of the world" is adored by angelic hosts and an army of saints. While there is no direct precedent for this scene in art, here at least we know the texts that must have inspired it: passages from the apocalyptic Revelation of Saint John the Divine, from the Epistles of John, and from exegeses of the Church Father, Saint Augustine (d. 430). So many questions remain unanswered even today. Meanwhile, and since early times, viewers have been content to delight in the living green freshness of this depiction of nature. The living meadow, as Behling put it, "is in its earthly garb the symbol of eternity, of paradise." One can add that motif after motif, each plant in its turn, has proved to have its symbolic significance.

While Jan van Eyck, for all his prestige, never created or left in Bruges anything that can be considered a school—only Petrus Christus was his follower there, and it was not until 1444 that he won the rank of master, three years after Van Eyck died—in Tournai at the same time Robert Campin, known also as the Master of Flémalle, built up an important workshop from which came Jacques Daret and also Rogier van der Weyden, the strongest artistic personality produced by the southern Netherlands. Campin never balanced a picture like Van Eyck. He coarsened details, rendered movement more stiffly, and seems to have handled what we can call his stage direction and characterization rather more self-consciously (15, 16). He gives nothing of the impression of effortless beauty that Van Eyck conveys with such sureness, yet his sculpturesque and forceful creative approach is highly impressive, as is the sensitivity to spatial depth that went with it.

These points of difference from Jan van Eyck, which became even more characteristic with Campin's pupil Rogier van der Weyden, were of enormous moment in the further development of Netherlandish painting. Unfortunately, there was no Rogier but only a Petrus Christus to take up the immediate succession of Van Eyck, and his means were not enough, Friedländer has pointed out, to keep alive that heritage. Not even his greater skill in perspective can gloss over that fact, and indeed, in a picture like that of Saint Eligius handing over a ring to a young betrothed couple which he painted in 1449, the naturalness of the pictorial space is if anything cramped thereby (17). This picture, done for the Antwerp goldsmiths' guild, is his best known work, and one cannot help but compare it with Van Eyck's marriage picture for the Arnolfini couple (11). Much of the atmosphere of the earlier painting—its circumspection, gentle poise, grave seriousness—is lost here. Although Van Eyck was depicting what was, after all, a merely human scene, while Petrus Christus brings on stage a saint complete with halo (though admittedly only subtly indicated), still his picture strikes a more everyday note, with more than a touch of genre painting. The later artist became so wrapped up in the stock-in-trade of the goldsmiths' patron saint that he set it in the brightest and clearest light, with the result that the workshop furnishings and materials are so numerous as to distract the eye from the real subject. What we judge somewhat negatively in comparison with Van Eyck, proves however full of promise for the future, even progressive in the light of later art. For the genre and still-life painters of the seventeenth century, this *Saint Eligius* must have seemed a bold-spirited early forerunner of what they were doing.

But the fifteenth century, at first at least, had other paths to travel. In its mid-years, and at its heart, stands the blazingly fervent, sternly ascetic Rogier van der Weyden. His works show none of the sensual delight in landscape of Broederlam, the Limbourgs, or Van Eyck. All his passion is concentrated in the religious conviction of figures and faces delineated with stringent psychological penetration. The faithful in Rogier's paintings experience the impulse toward salvation only through the path of utmost inwardness and the most intense concentration. Their expressions are rarely relaxed, most often they seem dammed up tight, rigidly condemned to a single look and pose. Where other painters strive to present the illusion of movement just begun and facial expression so real that it might change while we are looking, Rogier drastically checks such seeming dynamism and channels it into firmly delimited forms. It is this that makes his figural types so unforgettably impressive that later artists often cited them, consciously or not. Not one of the early Netherlandish artists was so often copied, though there were other grounds for this as well. His compositions must have made a great impact simply through the perfection of their forms. All details are filed and polished to fit together flawlessly. His figures bear individual traits with an astonishing breadth of variations. Every element is caught up in the thoroughly worked-out rhythm and ingenious organization. Nothing can be changed or omitted lest the overall web be fatally torn.

18 Rogier van der Weyden, *The Descent from the Cross*. c. 1435. Tempera and oil on panel, 220 × 262 cm (7 ft 2⅝ in × 8 ft 7⅛ in). Madrid, Museo del Prado

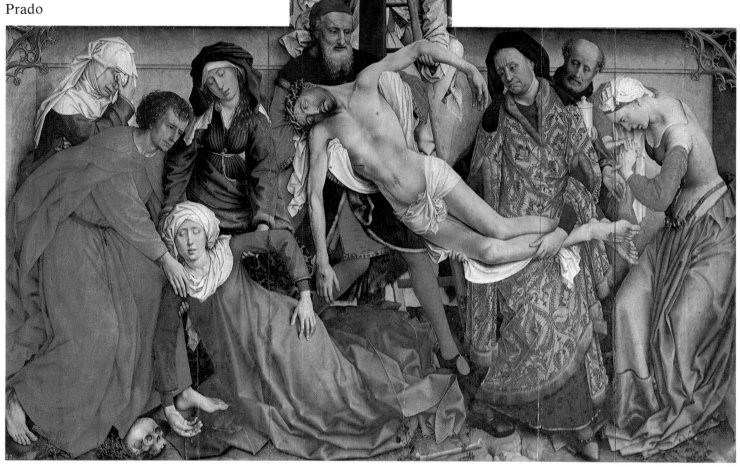

We know even less about this uncommonly influential artist than about Jan van Eyck. He signed not a single surviving work, yet he was never forgotten. As early as 1456 a book by the Italian Renaissance biographer Bartolomeo Facio listed Rogier and Van Eyck among the outstanding personalities of the time. Seventy-five years later Albrecht Dürer, journeying through the Low Countries in 1520-21, stood spellbound before Rogier's paintings. Centuries later, confronted with Rogier's altarpiece of the Three Kings, Goethe felt his own creative achievement dwarfed.

Born in Tournai in the southern Netherlands around 1400, Rogier was all of twenty-seven before he came to study with Robert Campin. After studying and working locally he entered the service of the city of Brussels, where he was commissioned to paint the panels on the theme of justice for the Golden Chamber of the Brussels town hall (destroyed in 1695). Only after this are there reliably documented larger works from his hand, commissions that testify to his international standing.

Among these are the *Descent from the Cross* [after John 19:38-42, Luke 23:55-55] (18), painted around 1435 for the Archers' Guild of Louvain and eventually acquired by Mary of Hungary, who left it to Philip II of Spain (whence its presence in the Prado, Madrid), and the *Last Judgment* [after Matthew 24, 25:31-46, Revelation 20:11 *et seq.*, and other sources] (19) that Rogier completed in 1451 as a commission from Nicolas Rolin, the powerful chancellor of Philip the Good, for the hospital in Beaune.

In the *Descent from the Cross* everything concentrates on the human drama. All the achievements in rendering landscape seem to have been forgotten. Before a gold wall, on a stage virtually without depth, the dead Christ is being lowered from the cross. Joseph of Aramathaea and Nicodemus hold the lifeless body. Mary Magdalen, at the right, wrings her hands in grief. John steps forward from the left to support the swooning mother, aided by her sister. An emotionally taut and concentrated scene has been

devised by the painter from what the Gospels recount in the barest and most sober outline. But the emotional tensions are not discharged, they are repressed, held in, as if frozen. Look at John: he rushes in, his left hand already grasps the unconscious Mary, yet his gaze is elsewhere, meditating on something beyond the event. As for the others, their solidly constructed figures compel us to visualize their highly contrived poses carrying action to completion. Yet the instant one looks at the expressions of the faces a new element enters, that of contemplation, of meditation, and nothing suggests that Rogier achieved this effect by pure chance.

Whatever the element that first captures our attention—color, linear structure, a detail (the hands, for instance)—we are immediately caught up in a chain of observations that ensue from it and that the eye compulsively follows through: the sinking diagonal of the Christ which resounds more faintly, echo-like, in the figure of Mary; His right arm hanging limply straight down, which has parallels in the right arm of His mother and in the shaft of the cross; the poses of the heads and the way they give rise to groupings of the sorrowing figures; the deliberate device of permitting only Mary's face to be fully frontal and therefore to speak more poignantly; the color scale with an emphatic red making three distinct accents at the sides and center; finally (and this is something extraor-

dinarily admirable in Van Eyck too) the brilliantly skillful treatment of elaborately draped garments in rich colors. This last point refers also to something beyond the picture: it testifies to the immense success of cloth manufacture and commerce and its importance in the economic upswing of the Low Countries. From the artistic standpoint drapery represents a kind of acid test of the painter's skill and also points to the subtle appreciation of the connoisseurs of the time for art of such delicacy.

One must keep in mind, too, that a painter of that time would have had to have a first-hand and thorough acquaintance with silks, brocades, and cloth of all kinds. No one lived by painting alone. Practical knowledge of all sorts of crafts in any way connected with painting was expected of an artist in the service of dukes, chancellors, or churches, and he could be happy indeed when occasionally allowed to ply his own trade and paint pictures. In 1439 or 1440 Rogier had to produce a relief for the Franciscan church in Brussels; a year later he was set to painting a processional banner. Between 1422 and 1424 Jan van Eyck took care of decorating the castle in the Hague for Johannes of Bavaria. Melchior Broederlam painted banners and decorated five armchairs for the Count of Flanders; in the service of Burgundy he devised the trappings for tourneys, took over the artistic arrangements for the castle at Hesdin, was kept busy with stained glass win-

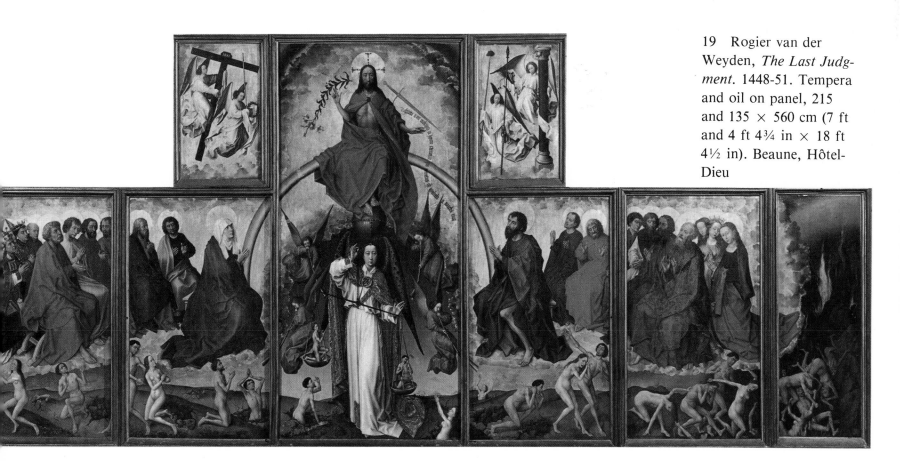

19 Rogier van der Weyden, *The Last Judgment*. 1448-51. Tempera and oil on panel, 215 and 135 × 560 cm (7 ft and 4 ft 4¾ in × 18 ft 4½ in). Beaune, Hôtel-Dieu

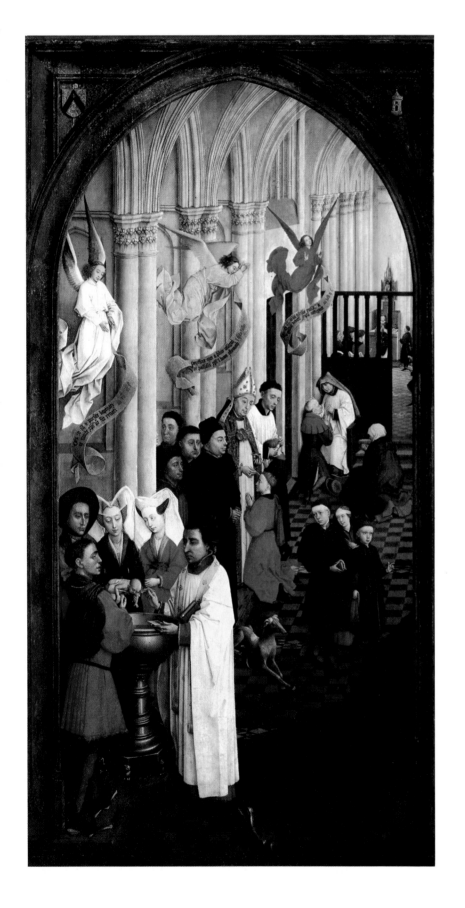

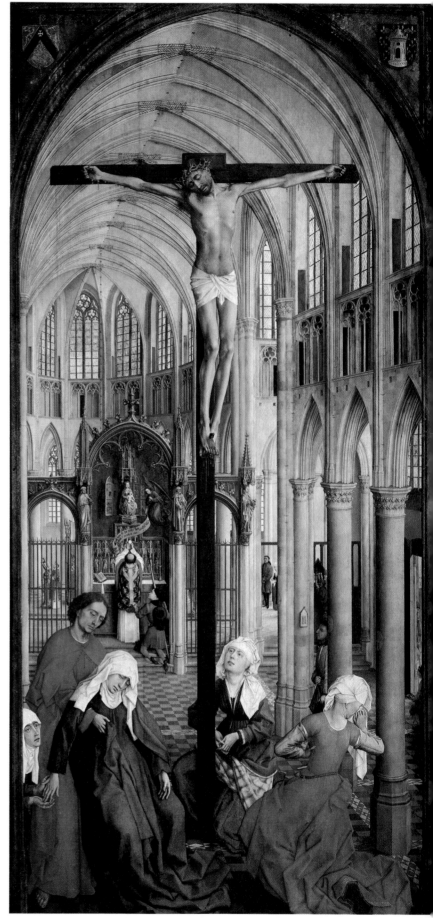

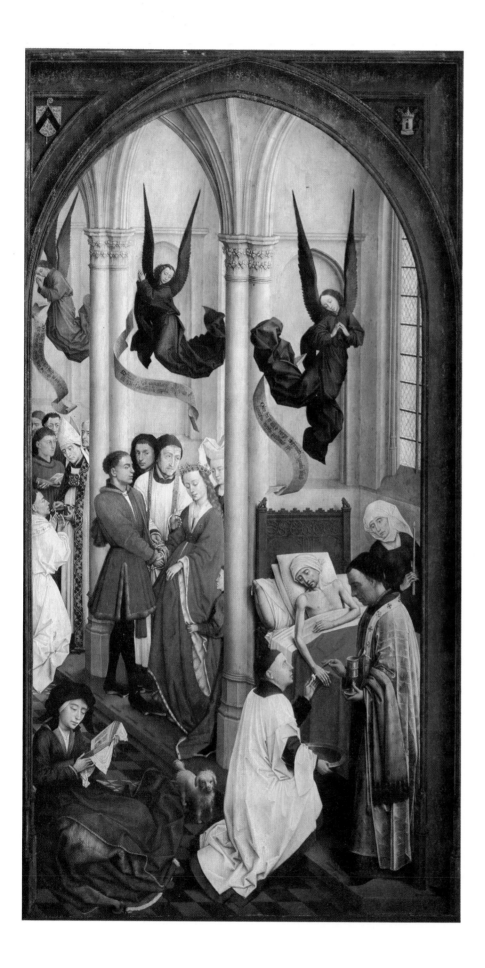

20-22 Rogier van der Weyden, *Triptych of the Seven Sacraments*. c. 1445. Tempera and oil on panel, center panel 200 × 97 cm (78¾ × 38¼ in), each wing 120 × 63 cm (47¼ × 24¾ in). Antwerp, Koninklijk Museum voor Schone Kunsten

dows and goldsmith works. He was knowledgeable about decorating ships, and he designed official robes and uniforms. And no artist felt such tasks beneath him. If nothing else, it was a way of acquainting oneself with all sorts of crafts and materials that could some day find a more prestigious place in a painting.

In the most monumental work by Rogier van der Weyden, the *Last Judgment* (19), the end or aim of Christian hope and fears is depicted with striking symmetry across an expanse more than eighteen feet wide. The Saved at the left and the Damned on the right stand out against a very low horizon and a narrow strip of sky above which, dominating, the holy authorities are grouped in hierarchical order, with the central vertical axis formed by the Lord of Judgment and the archangel Michael weighing souls.

The tradition of this apolcalyptic theme was carried on in miniatures primarily, mostly for prayer books (books of hours). It offered to artists the possibility of depicting fantasies and dreams in connection with theological doctrines that had gathered about them a rich adornment of imaginative literature. No one dared more in that direction than Hieronymus Bosch (47-49). But for all the extravagant and dazzling fantasy attached to the subject, there was also a certain canon of admissible images and motifs. Rogier deals with it almost ascetically, and again his strength lies in inner force and penetration.

The harshness of his *Last Judgment* is relaxed in the gentler cast of the sacramental altar for Bishop Jean Chevrot of Tournai (20-22). The seven sacraments of the Catholic Church are illustrated from left to right: baptism, confirmation, confession, communion, consecration, marriage, and extreme unction. A hundred years later such a document of faith might have been condemned by the Reformists and fallen victim to the iconclasts.

In 1450 Rogier went to Rome as a pilgrim. Whatever

23 Rogier van der Weyden, *Portrait of a Lady*. c. 1450. Tempera and oil on panel, 36.2 × 27.6 cm (14¼ × 10⅞ in). London, National Gallery

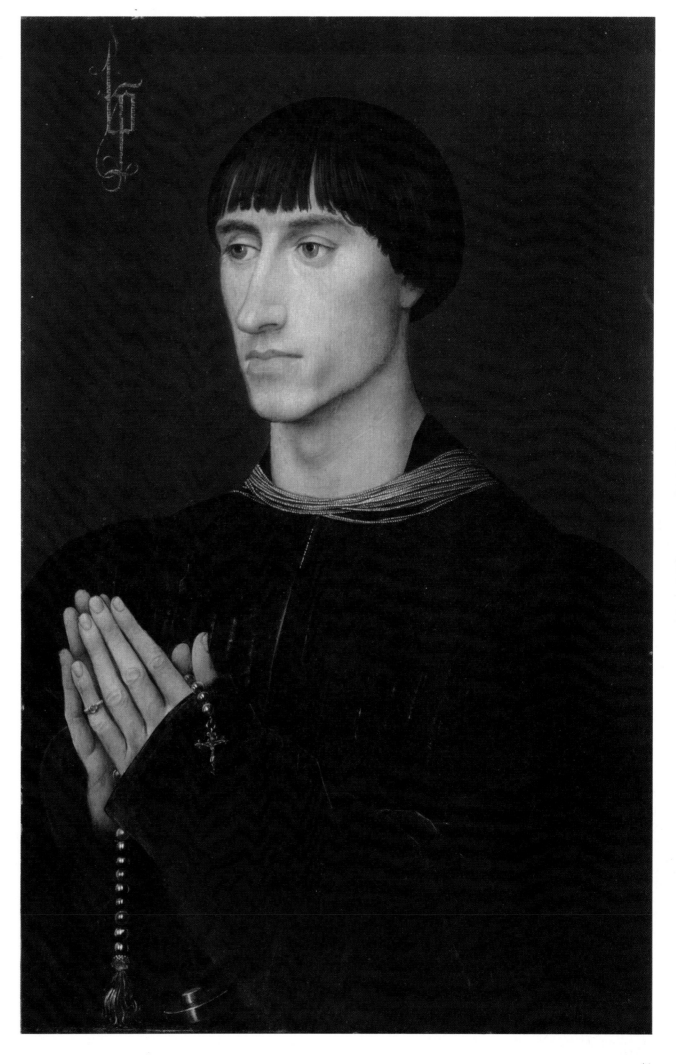

24 Rogier van der Weyden, *Philippe de Croy, Lord of Sempy*. c. 1460. Tempera and oil on panel, 49 × 30 cm (19¼ × 11¾ in). Antwerp, Koninklijk Museum voor Schone Kunsten

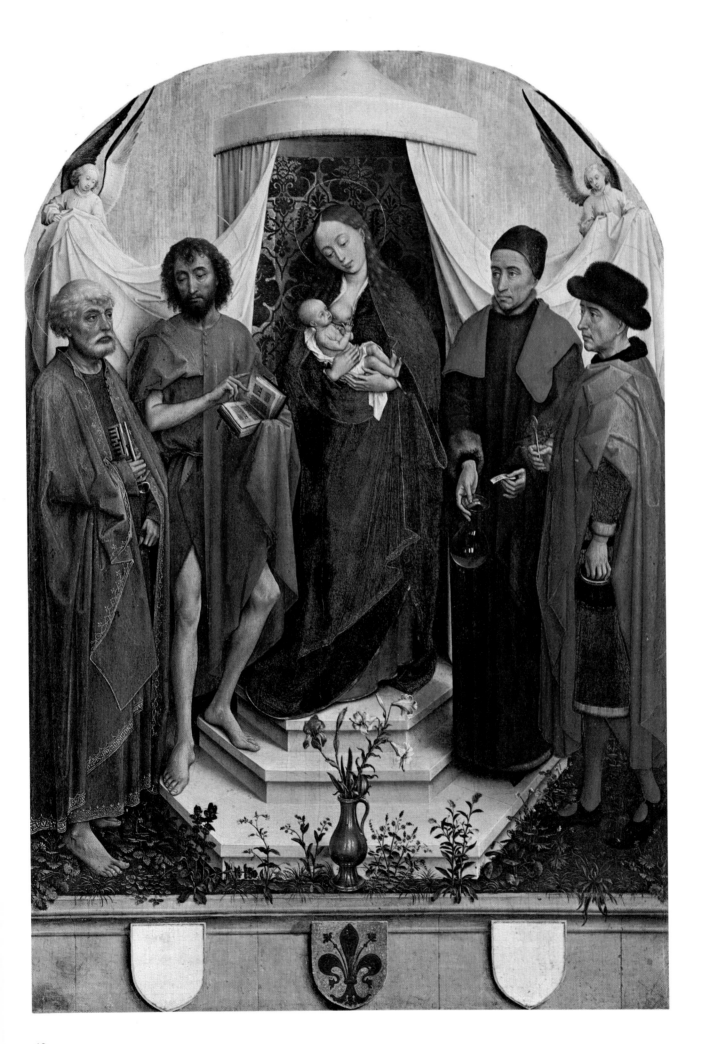

25 Rogier van der Weyden, *The Virgin and Child with Saints Peter, John the Baptist, Cosmas, and Damian.* c. 1450. Tempera and oil on panel, 53 × 38 cm (20⅞ × 15 in). Frankfurt, Städelsches Kunstinstitut

the journey brought him otherwise, it was also the opportunity for a serious confrontation with Italian art. Although nothing in his own painting became recognizably Italian, traces of Italian models and ideas, of Masaccio and Fra Angelico in particular, can be made out in the *Last Judgment* and the *Lamentation over the Dead Christ* (Florence, Uffizi). In the *Virgin and Child with Saints* (25) there are iconographical factors that likewise speak of Italy.

Rogier's impressive versatility appears in portraits as well. Works of phenomenal power and presence, they can be none the less delicate and extraordinarily pellucid, as in the *Portrait of a Lady* (23). In the likeness of Philippe de Croy (24) a withdrawn and dignified bearing is fused with an evident resoluteness of character. There are comparable portraits of the Burgundian dukes, and indeed, one senses the presence of those potentates—spurring the artist on, demanding much, yet protecting him too—behind this early master of panel painting in the southern Netherlands. Without their enthusiasm for art and passion for collecting, early Netherlandish painting would have been less vivid, less vital.

26 Rogier van der Weyden, *The Annunciation* (left wing of the Altarpiece of the Three Kings). Tempera and oil on panel, 138 × 70 cm (54⅜ × 27½ in). Munich, Alte Pinakothek

The Northern Netherlands in the Fifteenth Century

Since the significant political, economic, and cultural events of the fifteenth century in the Low Countries took place in the south, it is only natural that the first centers of panel painting should be there and that artists from the northern Netherlands should have worked chiefly there. A few exceptions aside, the north in those early years had no such fruitful artistic development as the south witnessed between Broederlam and Rogier van der Weyden. Some have argued that there was no lack of art but it was destroyed by the iconoclasts of the Reformation. Yet a mere hundred years later, in his book on the lives of the earlier Netherlandish artists (*Het Schilder-Boeck*, published in Alkmaar in 1604) Carel van Mander, then resident in Haarlem, could find nothing to say about Dutch painting before 1450. The only names he came up with were Aelbert van Ouwater and Geertgen tot Sint Jans, both of Haarlem and both isolated phenomena in the middle and the second half of the century in the north. The pages of that history are otherwise as good as blank, the more so since the *Raising of Lazarus* (27) is the only work known for sure to be by Ouwater, and Geertgen, dead at twenty-eight, was granted too little time to produce much.

Although Dirk Bouts and the so-called Master of the Virgo inter Virgines were Dutch, they scarcely fit neatly into the history of Dutch art. Bouts may have worked in Harrlem between 1448 and 1457, thus in Ouwater's time, but nothing is known for sure about what he may have painted there. His best attested work, the great *Last Supper* altarpiece [based on Mark 14:22-26, with parallel passages and Old Testament prefigurations] (28), was done in Louvain in the southern Netherlands. The painter for whom the name "Master of the Virgo inter Virgines" has been coined

on the basis of a picture on that theme (Rijksmuseum, Amsterdam) was apparently active in Delft between 1485 and 1500, and only stylistic grounds suggest him to be the author of the *Entombment* seen here [Mark 15:42-47, with parallel passages] (33).

Despite years of efforts to fill out the story with a few more names and facts, there is still little to go on as regards early painting in the northern Netherlands. The reasons for the search stem from the desire to locate the original well-spring of Dutch painting. Many scholars have supposed that art in what is now Holland must have been more truly native than the art of the south, which was influenced by close contacts with France and Italy. Then too, it was tempting to envision deep local roots, going far back in time, for the well-defined and characteristic art of the great seventeenth-century Dutch painters: Frans Hals in Haarlem, Rembrandt in Leyden and Amsterdam, Jacob Ruisdael in Haarlem, and Vermeer in Delft. It was taken for granted that Haarlem was the seedbed of a genuinely Dutch art. Other scholars, though, began to doubt the purely "Dutch" character of the art of the Haarlemers Ouwater and Geertgen and proposed to shift the place of their training and development to the southern Netherlands. And, true enough, a simple comparison of the work of Ouwater and Rogier van der Weyden reveals no sensational differences. Moreover, Haarlem was by no means culturally isolated. It was a town that increasingly attracted outsiders. Artists who had been active elsewhere settled there, as did Jan Jost van Kalkar in 1510, to name only one. In the first half of the fifteenth century the first block books, a pioneering form of book making, were printed there. For the block prints in the early books with pictorial parallels be-

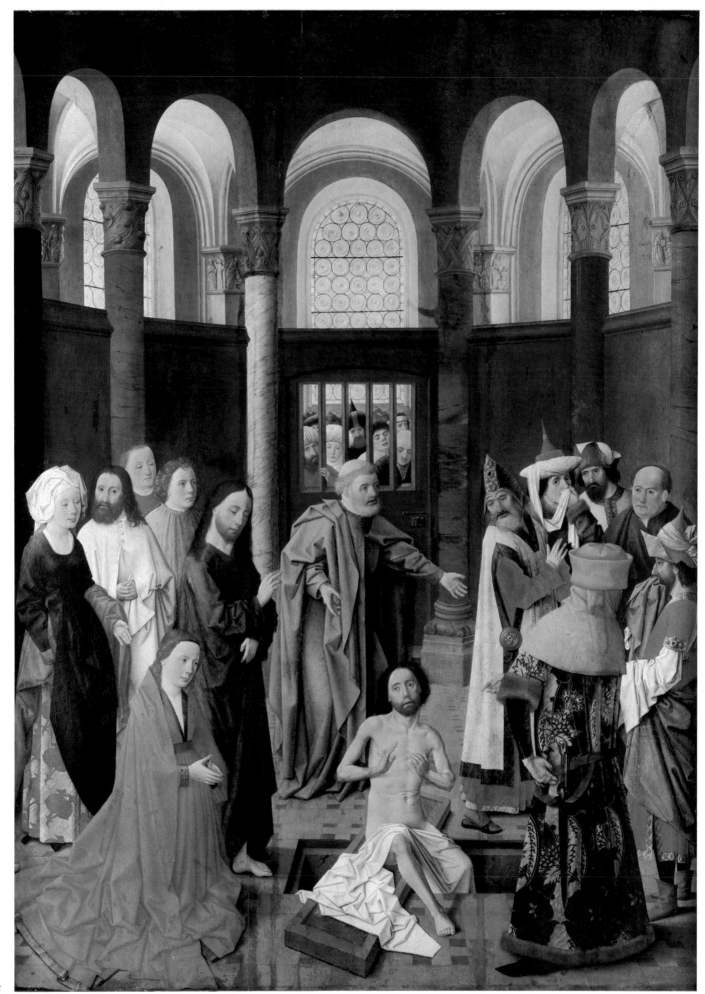

27 Aelbert van
Ouwater, *The Raising
of Lazarus.* c. 1450.
Tempera and oil on
panel, 122 × 92 cm (48
× 36¼ in). Berlin-
Dahlem, Gemäldegalerie

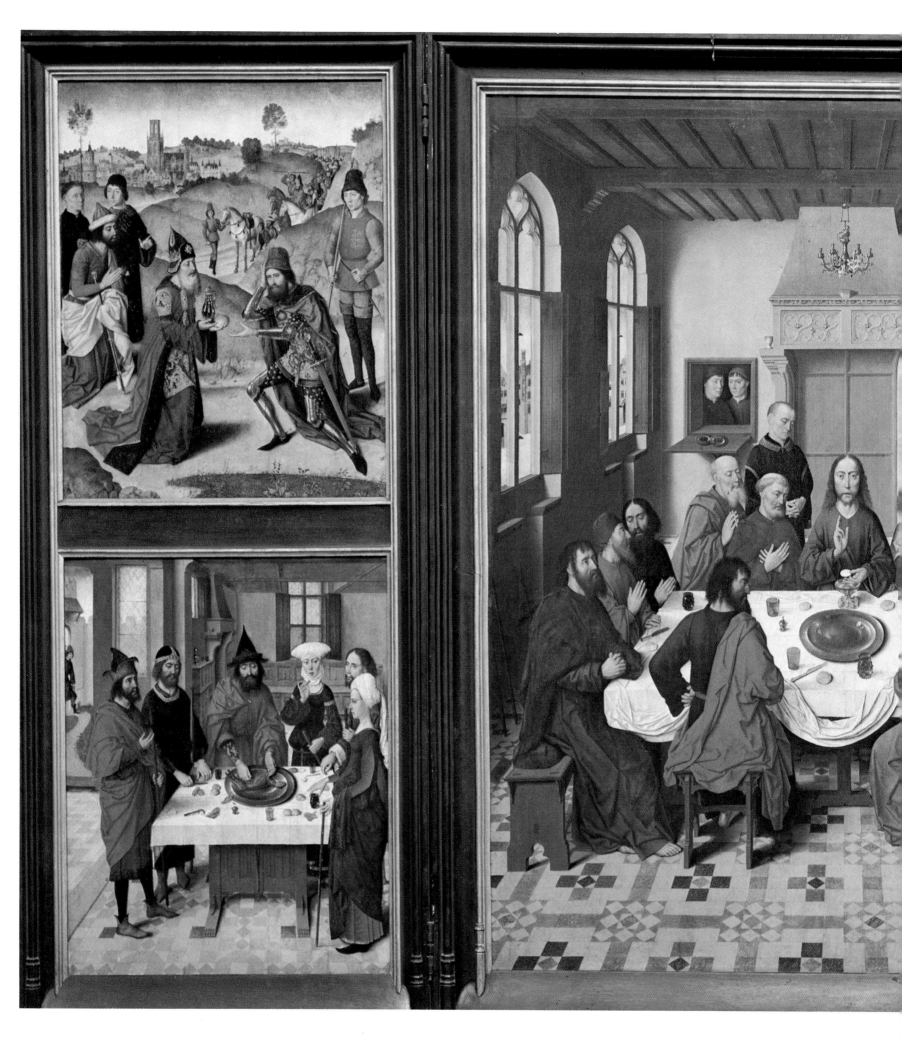

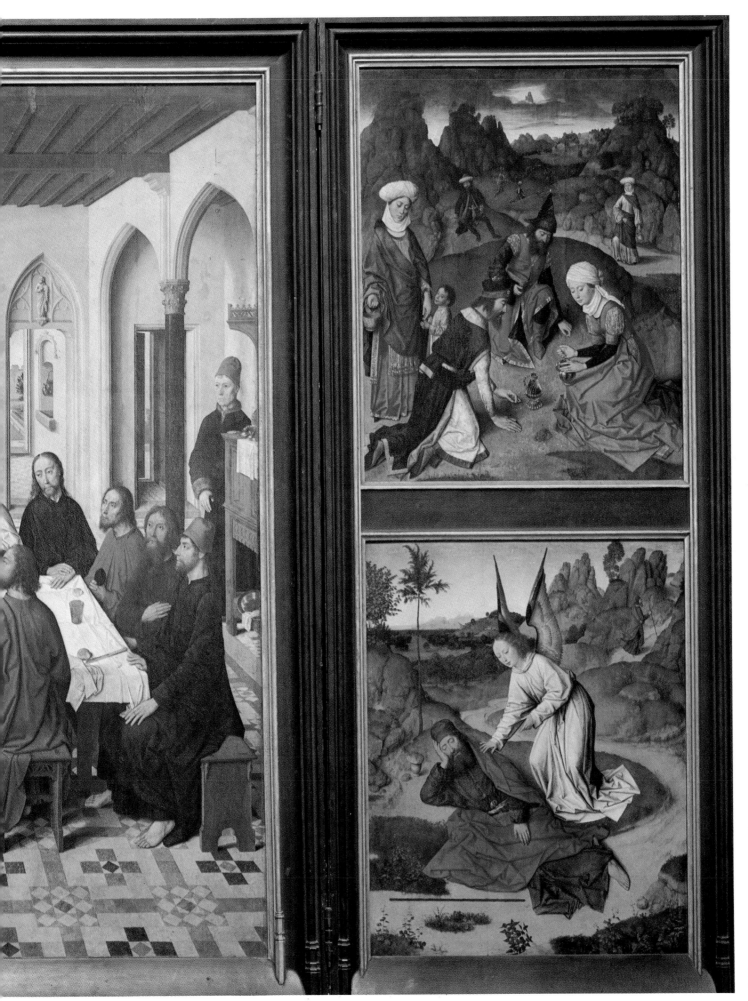

28 Dirk Bouts,
*The Last Supper
Altarpiece.* 1464-
67. Tempera and
oil on panel,
center panel 180
× 151 cm (70⅞
× 59½ in), each
wing 88.5 × 71.5
cm (34⅞ × 28⅛
in). Louvain, Sint
Pieterskerk

29 Dirk Bouts, *The Way to Heaven* (left wing of a triptych). c. 1470. Tempera and oil on panel, 115 × 69.5 cm (45¼ × 27⅜ in). Lille, Musée des Beaux-Arts

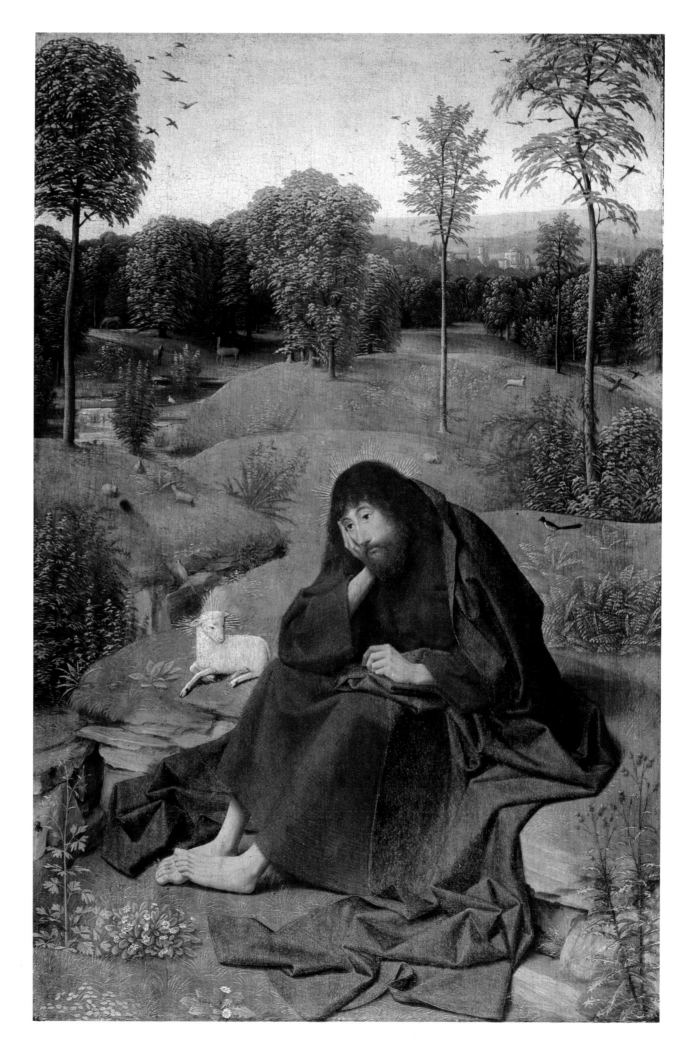

30 Geertgen Tot Sint Jans, *John the Baptist in the Wilderness*. 1485-90. Tempera and oil on panel, 42 × 28 cm (16½ × 11 in). Berlin-Dahlem, Gemäldegalerie

tween the Old and New Testaments, and for the illustrated Epistles and Gospels, compositions familiar from manuscript miniatures were used, and these must have been done by local talents.

In its approach to the figure Ouwater's *Raising of Lazarus* offers nothing new or essentially different from what was being done in the southern Netherlands. Yet the theme itself had never as yet been treated there, though it had been one of the standard subjects in the Occident since Early Christian times. What impelled the patron of this work to set Ouwater that subject is not known. The dramatic tale in the Gospel According to John that tells how a man was brought back to life after three days in the grave aroused the Christian hope of personal resurrection, and in this account of a miracle the believer could find solace and reassurance with which to face his death. Accordingly, the relevant texts and the pictures of Lazarus in the pages devoted to the mass for the dead were found in innumerable books of hours in circulation before Ouwater's time; it also became a frequent theme in altarpieces for funerary chapels.

True, as conceived by Ouwater there are unusual features that conform neither to the Biblical text nor to the pictorial tradition that has come down to us. To begin with, the miracle takes place in the chancel of a Romanesque chapel, not outdoors before a burial cave as in the Gospel [John 11:38]. While at the left Jesus and His adherents, among them the two sisters of the dead man, make up a group displaying their deep concern and involvement, the Jews suspicious of the miracle draw apart at the right, and two of the doubters hold their noses against the stench rising from the cadaver. Between the two groups, Peter energetically points to the resurrected Lazarus in the effort to convince the doubters of the truth of the miracle. Lazarus himself sits in the foreground on the slab laid diagonally across the floor-tomb, his gesture still tentative in the wonder of a return to life.

What is striking here is the central position allotted to Peter and also the un-biblical choice of setting. It is not impossible that there may be concrete grounds for these anomalies and therefore for the picture itself. Were there schisms within the Christian community of Haarlem? Or was the picture conceived as visual propaganda for the papal pronouncement of 1460 that insisted on the absolute monarchical power of the Pope, the successor to Peter, against other bodies pretending to sit in judgment? Whatever the cause, either the patron or, less likely, the painter must have considered the missionary role of the Prince of the Apostles of such prime importance as to turn the maker of the miracle Himself into an almost secondary figure.

Significantly, it is only in pictures from Haarlem that this tendency is found. Elsewhere Christ is always dominant and the raising of Lazarus is almost always set outdoors.

As for Geertgen tot Sint Jans, according to Carel van Mander writing in 1604, he learned his art from Ouwater and was the true founder of Dutch painting. Scarcely more is known of this short-lived artist than what his name tells: Geertgen tot Sint Jans, the little Gerrit who lives with the Johannites. Very likely some of his pictures were done for the monastery of the Order of St. John in Haarlem, in particular the richly detailed *Holy Kinship in a Church* (31) which includes not only the infant John the Baptist but also his parents and other relatives, and the *History of the Relics of Saint John the Baptist* (32). Geertgen was a master at the late-medieval method of combining several episodes occurring at different times into a single meaningful narrative. In recounting the story of the Baptist's bones (not biblical but found in Christian legends) he shows us Herod's wife in the background burying the Baptist's head in a rocky cave; then at the left and a little closer to us, the entombment of the decapitated body; in the foreground, the burning of his mortal remains at the command of the Roman emperor known as Julian the Apostate; finally, the reception of the rescued relics by the Johannites in solemn procession. In one respect we moderns were outdone by the medievals: in telling a story in pictures our comic strips must make do with separate frames, one after the other, whereas this fifteenth-century artist had a way of showing all the events at once and in meaningful relationships. If the picture can hold so many very different episodes and not come to pieces, it is thanks to Geertgen's capacity to organize and shape his images.

His small panel with *John the Baptist in the Wilderness* (30), painted perhaps for a member of the Johannite monastery as a devotional image on which to meditate, is among the wholly enthralling treasures of early Dutch art. We have already had something to say about this picture of the saint plunged in deep thought with head propped on hand. His brown cloak of camel's hair [Mark 1:6] and a blue drape cover him down to the bare feet depicted in a strangely disturbing yet touching pose. Near him, the Lamb of God whose true herald and harbinger he is [John 1:29]; behind and around him, a blissfully pleasant, vividly observed landscape: not the desert wilderness in which biblical tradition places the ascetic preacher of repentance but lush meadows and woods rich in leafy trees with their Eden-like complement of animals disporting themselves in peace. The meanders of the brook lead the eye into the

31 Geertgen Tot Sint Jans, *The Holy Kinship in a Church*. c. 1480. Tempera and oil on panel, 137.5 × 105 cm (54⅛ × 41⅜ in). Amsterdam, Rijksmuseum

distance, to a high horizon.

The great charm of the picture comes from the invigorating strength of its light colors, its affectionate rendering of the saint, and the harmonious union of man and nature. One would like to divine the thoughts that seem to stir the meditating Baptist so deeply: perhaps, "and now also the axe is laid unto the root of the trees" [Luke3:9], or another of the unforgettable

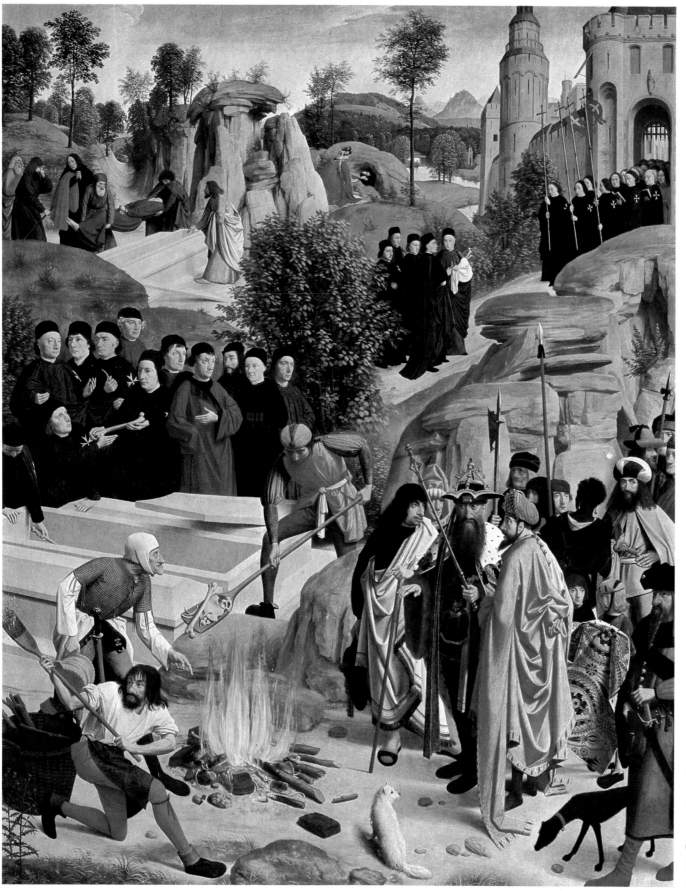

32 Geertgen Tot Sint Jans, *History of the Relics of Saint John the Baptist* (exterior of the right wing of the high altar triptych in the Johannite church, Haarlem; other panels destroyed by the Iconoclasts). c. 1480-85. Tempera and oil on panel, 172 × 139 cm (67¾ × 54¾ in). Vienna, Kunsthistorisches Museum

phrases the New Testament ascribes to the preacher who spared neither himself nor others. But if we feel impelled to raise such questions, if the picture arouses that sort of interest, it is due to the feeling with which the artist has *staged* the depth of meaning here: the Baptist is far from where the viewer's eye perceives him, remote. His physical presence, the flesh and blood of this bodily existence, is transcended, enveloped in an eloquent silence. The painting radiates a kind of emanation that holds us fast, a spiritual tension such as would not appear again until a century and one-half later: in Rembrandt's *Saint Jerome Meditating over the Destruction of Jerusalem* of 1630 (Amsterdam, Rijskmuseum) or his *Saint Paul* from around 1629 with the saint absorbed in his writing Nuremberg, Germanisches Nationalmuseum) are pictures that give rise to the same sort of questions.

Geertgen, Albrecht Dürer said, was already a painter in his mother's womb, and he set the course for an entire school. His exemplary treatment of space and his intimate feeling for nature appear in such anonymous painters of his immediate circle as the Master of the Braunschweig Diptych, and their effects were still making themselves felt in later painters like Jan Mostaert (64).

Well before Geertgen, Dirk Bouts had lived for some years in Haarlem, though his earliest identifiable works were done later, in Louvain, and by then he could move ahead logically and consistently from what had been achieved by such southern Netherlanders as Petrus Christus and Rogier van der Weyden. Bouts's large altarpiece of the *Last Supper* (28), painted between 1464 and 1467 for the Confraternity of the Holy Sacrament of the Louvain Sint Pieterskerk (and still in that church), has a central panel with the *Institution of the Last Supper through Jesus Christ* [after Mark 14:22-26] flanked by side wings each containing two Old Testament scenes considered to prefigure the New Testament communion meal: on the left, the *Meeting of Abraham and Melchizedek* [Genesis 14:18-20] and the *Passover Feast* [Exodus 12]; on the right, the *Gathering of the Manna* [Exodus 16] and the *Feeding of the Prophet Elijah* [I Kings 19:5-8].

Medieval and late-medieval writings customarily drew parallels from the Old Testament for such significant events in the New Testament as the Last Supper. Behind this lay the belief that whatever Christ offered the faithful, whether instructive parables or His own acts, had been planned by God aeons before. Before the Son of God appeared, His way to salvation was already traced out. Though concealed or disguised, it could have been deciphered from the Old Testa-

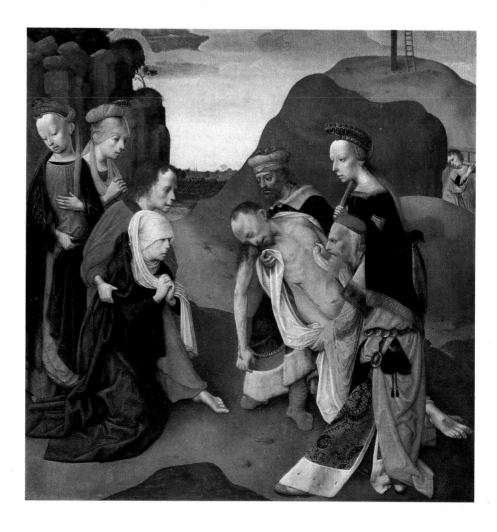

ment. Once the Christian epic had run its course, the veils fell away from the prophetic parallels and their true meanings stood clear. Whatever could be somehow made to seem a parallel or forerunner (*typos*, in Greek) for Christ (the *antitypos*) was pressed into service to confirm and support His message. This ingenious net of cross-relations between the Old and New Testaments, known to scholars as "typology," was given enormous diffusion in illustrated books circulating among the not necessarily highly educated masses, books like the *Biblia pauperum* (Bible of the Poor), *Concordantia caritatis* (Concordance of God's Love), or the *Speculum humanae salvationis* (The Mirror of Man's Salvation).

The latter book was probably the source of Dirk Bouts's Louvain altarpiece, and the three typological events described there were rounded out by the *Feeding of Elijah* to make four small panels grouped around the large central painting of the Last Supper. Although typological literature was very popular in the late Middle Ages, few art works with such a compact demonstration of Christian event and Hebrew forerunner have survived — in the Netherlands only a Marian altarpiece of Rogier van der Weyden of

33 The Master of the Virgo Inter Virgines, *The Entombment.* c. 1480-90. Tempera and oil on panel, 55 × 54.8 cm (21⅝ × 21⅝ in). Liverpool, Walker Art Gallery

1450/52 (Berlin-Dahlem) — so that the Bouts polyptych constitutes also a valuable historical document.

In terms of creative procedures, Bouts represents a felicitous union of the two significant traditions founded by Jan van Eyck and Rogier van der Weyden. He mastered the lucent and enchanting landscape so epoch-making in the hands of Van Eyck (compare also plate 29), and from Rogier he took that extraordinary gift of conveying human significance and the meaning of meditation above all. What sets him well apart from Rogier, though, is the unconstrained repose and quiet movement of his figures. They are not frozen in the moment of most intense dynamic drama but, instead, become stable and even static concentrations of an action which nonetheless communicates mood and purpose. In addition, he went beyond his predecessors' still experimental use of perspective and controlled it more firmly. For our purposes here, though, two questions remain: we cannot judge how much his impressive artistic qualities may owe to his Haarlem origins, nor can we even be sure that Bouts has a place by rights in this chapter on northern Netherlandish painting.

The End of the Century: Ghent and Bruges

Another major artist of the generation following Rogier shows more clearly than Bouts his debt to the earlier master. Hans Memling was German by birth, from the Middle Rhine region which in the late medieval period emerged with a distinctive artistic character of its own. Memling was born probably around 1435-40 in Seligenstadt on the Main River, and the family name appears to be connected with the village of Mömlingen in the Odenwald; he died in 1491 in Bruges. An equilibrium of feeling unrippled by anything dramatic, a sense of harmony, a serene uncomplicated relation to the here-and-now expressed through a naive pleasure in telling a story: this was the heritage of his homeland that the young Memling brought with him as mental baggage when he went down the Rhine, passed through Cologne, and made his way to a new home in the Low Countries. There he must have had a close connection with Rogier, and was apparently active in his Brussels workshop for some years. The encounter with the art of such a very different temperament was his second decisive step toward finding his own pictorial language. Bruges was at the time a city of high culture whose commerce had brought about an apparently solid prosperity, and though its star was sinking it shed an even more radiant light in decline. There the young German found the ideal condition for becoming himself. His art was not aristocratic like Rogier's but thoroughly middle-class. Still its gentle but euphonious quality found a sympathetic reception among the educated patricians of the city and, thanks to the numerous foreign connections of the commercial metropolis, became known abroad as well through the foreign merchants whose business took them to Bruges.

Certainly the young man Memling portrayed holding a coin of the Roman emperor Nero was no Fleming (34) but, to judge by the curly dark hair and facial traits, a meridional. Who he was, however, is still uncertain: an Italian who made medals for the Burgundian court? A collector of coins and antiquities? Or, as has recently been proposed, someone with a name to which the coin in some way alludes? Tightly filling the picture space, he seems to meet us face to face, to close in "right on top of us". Nothing

34 Hans Memling, *Man with a Roman Coin*. c. 1480. Tempera and oil on parchment fixed to panel, 29 × 22 cm (11⅜ × 8⅝ in). Antwerp, Koninklijk Museum voor Schone Kunsten

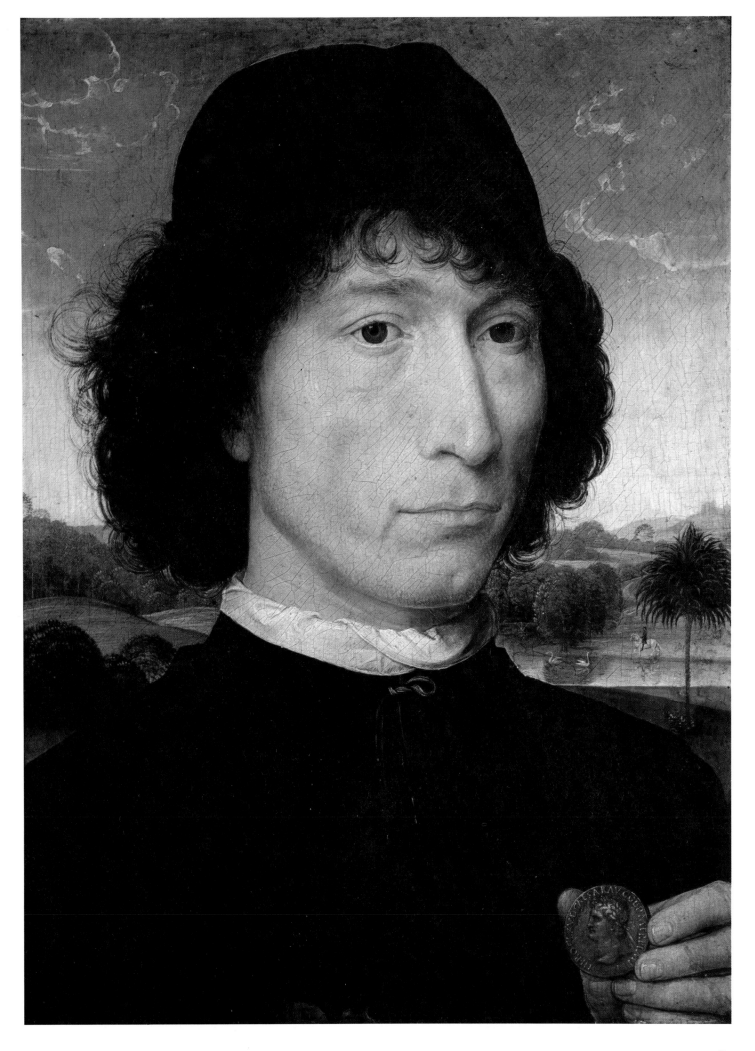

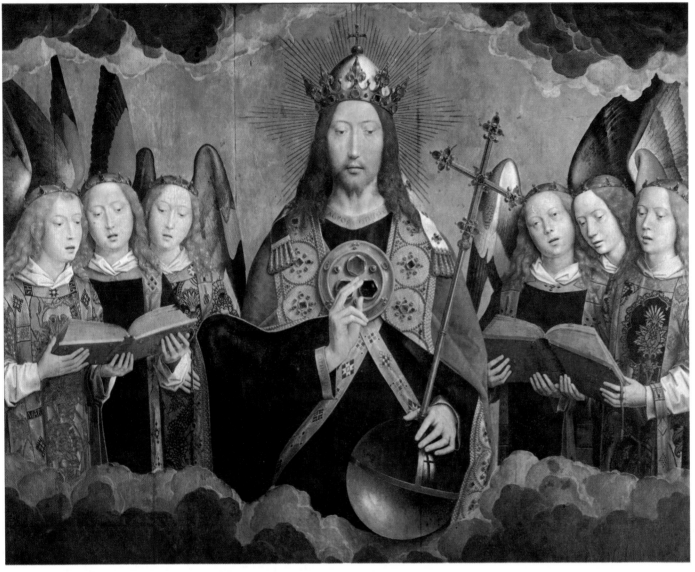

35 Hans Memling, *Christ with Singing Angels* (center panel of the Najera triptych). c. 1490. Tempera and oil on panel, 165 × 212 cm (65 × 83½ in). Antwerp, Koninklijk Museum voor Schone Kunsten

here of the cool, intellectualized distancing of Rogier's portraits, but a presence warm as life, a physical person scarcely less palpably real than the viewer. An image of the outer man, if you wish, and not a character study (something not yet to be looked for in the fifteenth century), yet a distinctive and unmistakable personality has been pinned down here and communicates its uniqueness to the viewer. And in contrast to the almost uniform dark backgrounds in portraits by Jan van Eyck and Rogier van der Weyden, here nature and the world of real things are brought into the picture. Man has come out of his isolation, is now thought of as part of the world-picture. It is not that Memling invented this pictorial form; the earlier masters had used it in their religious paintings if not in their portraits. One finds something similar in Italy, but for a time when there was such an intensive give-and-take it scarcely pays to argue about who influenced whom. In the North, at any rate, it was Memling who gave the decided cast to this type of portrait which would persist into the sixteenth century and have its effect even beyond.

Memling did not only paint portraits of his fellow-citizens of Bruges and their guests and business associates. He owed his recognition and fame to his religious paintings even more. A good number of these survive in their original frames and in the place for which they were done—which is rare indeed. If his large and elaborately imaged altarpieces arouse our admiration, we find ourselves attracted even more by his numerous small and simple house-altars. In these images meant for private devotions and silent communion with God and the saints, Memling's special gift for the intimate and serene was most at home.

Before looking at the paintings which were his most personal expression we must at least glance at a work rather more marginal to his real forte. It was probably some Spaniard resident in Bruges who acted as intermediary for a commission in which Memling could display his considerable talent for decoration on the organ case of the church of Santa Maria la Real in Najera, Castile. For this he produced three large paintings with angels singing and playing instruments. In the middle panel (35) Christ appears in priestly robes

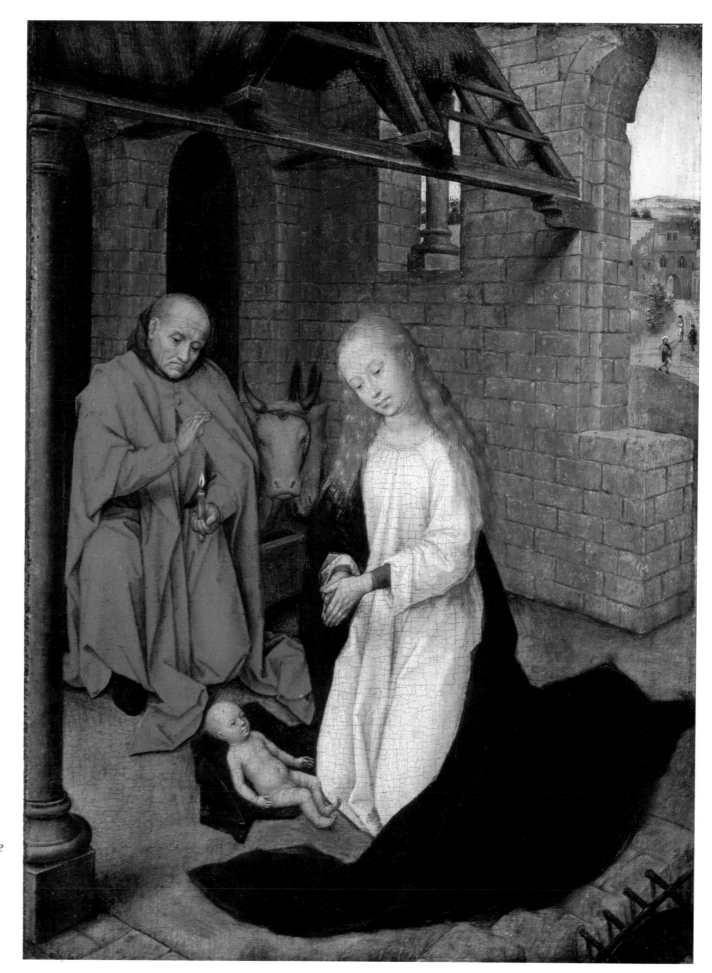

36 Hans Memling, *The Nativity*. c. 1470. Tempera and oil on panel, 95 × 60.5 cm (37⅜ × 23⅞ in). Madrid, Museo del Prado

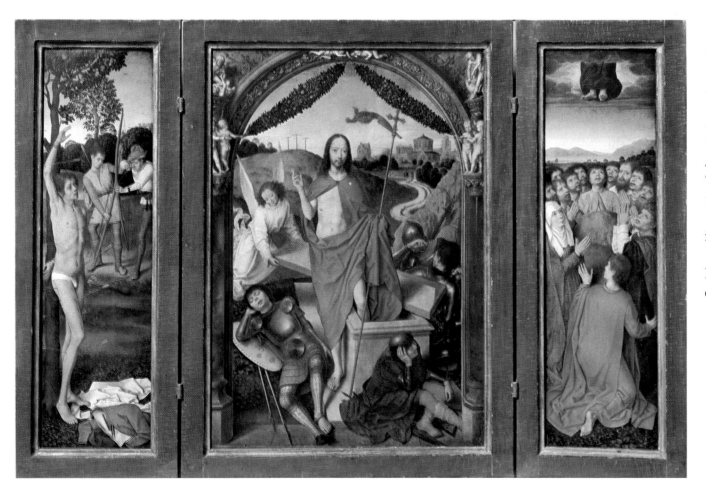

37 Hans Memling, *The Resurrection Triptych* (center panel, *The Resurrection of Christ;* left wing, *The Martyrdom of Saint Sebastian;* right wing, *The Ascension of Christ*). c. 1490. Tempera and oil on panel, center panel 61 × 43 cm (24 × 16⅞ in), each wing 61 × 17.5 cm (24 × 6⅞ in). Paris, Musée National du Louvre

as sovereign of the world, poised among clouds, the golden glow of infinity behind Him, to either side a trio of singing angels. While the theme and presentation were obviously inspired by the Ghent altarpiece of the Van Eyck brothers, the solution here is rather more deliberately attractive and harmonious. Such minor awkwardnesses as the open mouths of the singing angels that Van Eyck consented to in the interests of a more realistic expression were deftly avoided by Memling. Against the naive charm of the Ghent altarpiece Memling brings into play an internal stylistic harmoniousness and restraint in expression that make these large paintings seem almost routine when compared with the imaginativeness and emotional depth of the earlier work.

On the other hand, in Memling's small and intimate works there is an originality and depth of sensitivity that surpasses the other masters of his time, and this is true of even such an outwardly unprepossessing picture as his *Nativity* (36). The theme of the adoration of the Christ Child by Mary and Joseph was very frequent in fifteenth-century Netherlandish painting. The direct model for Memling must have been a major work of Rogier van der Weyden, the middle panel of the so-called Bladelin Altarpiece (Berlin-Dahlem), yet for all the external similarity the differences are fundamental. What is an aristocratic, even courtly sacred ac-

tion with Rogier is treated here as a homely, unpretentious, almost middle-class domestic scene full of warmth and an easy poetry. We feel ourselves somehow drawn into it, invited to join in kneeling before the divine Infant. As imagined by Memling the scene does not derive directly from the biblical accounts, but takes it inspiration from the mystical visions of Saint Bridget of Sweden and other medieval philosophers and poets whose writings had widespread influence on the thought of the time. Mary wears a white gown as sign of her purity, of her freedom from the original sin to which the rest of mankind is subject. Jesus lies naked on the ground, for in Him God accepted the humility and humiliation of becoming the least among men. But the radiance that streams from the Child (the rays are difficult to see in reproduction) eclipses the light that Joseph's candle sheds. The column at the left margin served Mary as support in the hour of giving birth, but it also foretells the column at which Christ would endure flagellation and thereafter His Passion. Likewise of double significance is the opening covered by a grating in the lower right corner: a cave to be born in, and to be laid away in — the beginning and end of the work of salvation given emblematic expression. Christianity and Judaism are represented by the ox and ass, and the antiquated Romanesque architectural forms of the ruined church can be interpreted as an

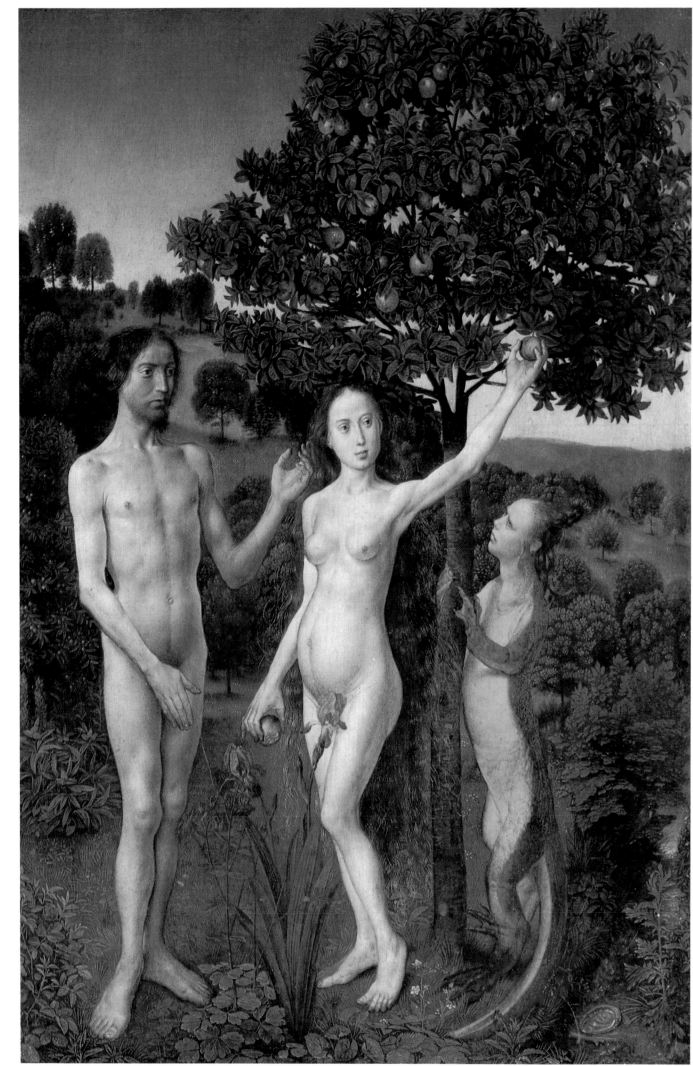

38 Hugo van der
Goes, *The Fall of Man*
(left panel of a diptych).
Before 1475. Tempera
and oil on panel, 33.8
× 23 cm (13¼ × 9 in).
Vienna,
Kunsthistorisches
Museum

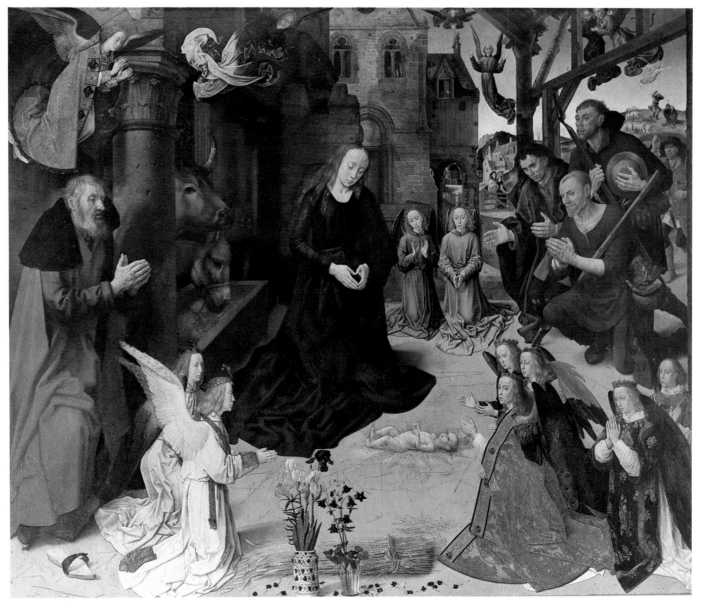

39 Hugo van der Goes, *Adoration of the Shepherds* (center panel of the Portinari Altarpiece). c. 1476. Tempera and oil on panel, 253 × 304 cm (8 ft 3⅝ in × 9 ft 11⅝ in). Florence, Galleria degli Uffizi

allusion to the synagogue left behind in the new faith. Yet however rich in relationships and allusions the picture may be, the intellectual element in no way affects the natural grace with which Memling was able to infuse the scene. Doubtless this small panel was conceived not as an an isolated work but as part of a larger ensemble, probably the right wing of a triptych whose other parts have disappeared but whose original effect would have been much like that of many similar small house altars that have survived intact (37).

Nothing could be more unlike Memling's tranquil, candid, open-hearted delight in telling a story than the work of his contemporary Hugo van der Goes of nearby Ghent, an introverted personality much given to melancholy. Hugo took nothing lightly and was, literally, possessed when it came to setting down in paint images reflecting his deep inner conflicts. Born in Ghent around 1435 or 1440, in 1475 he entered a monastery near Brussels as a lay brother and died

there in 1482 after attacks of religious mania and profound depression.

The people he depicts follow resignedly the path set them in God's great scheme of salvation. Adam and Eve in the Garden of Eden (38) seem to sense something of the tragic consequences of their action. They sin without pleasure and not because they wish to. If there is a hint of coquettishness and independence of spirit in Eve's mouth and chin, it is overshadowed by the sadness of her eyes. Even the Tempter, a creature like a salamander with a woman's head, goes about its appointed task with neither pleasure nor lust and seems more appalled than triumphant at the success of its ingratiating wiles. Even nature, in what would seem a late-afternoon peace, sounds an elegiac tone no less heavy-hearted in mood than that of the human protagonists.

This landscape and these figures clearly recall the example of the Van Eycks' Ghent altarpiece, yet here

too, as in almost all cases where younger masters test their strength against some all-important work, the differences outweigh the similarities. Characteristic of Van der Goes are the slender, sinewy figures with elongated limbs and overlarge hands and feet. Here again symbols convey the deeper meaning of what the eye perceives: the rose, columbine, and iris are all connected with the Passion of Christ in medieval tradition, as is also the coral in the right foreground which is a charm against devil and demons and whose red color recalls the blood shed by the Redeemer. This painting was originally the left-hand panel of a diptych whose pendant (in the same museum) has a *Lamentation over the Dead Christ*, so that what is alluded to symbolically in the picture of the Fall of Man is shown in the companion-piece as its ultimate consequence.

Hugo's major work, one of the outstanding achievements of early painting in the Low Countries, is a large three-part altarpiece that the Florentine patrician Tommaso Portinari, head of the Bruges branch of the Medici commercial firm, commissioned for the church of the Florentine hospital of Santa Maria Nuova founded by one of his forbears. On the basis of the age and number of the donor's children depicted on it, the date of the Portinari altarpiece has been set at around 1476. Seldom has the birth of the Saviour been represented more solemnly and hieratically than on its center panel (39) with the newborn Infant lying naked on the ground, Mary alongside, and Joseph with the shepherds and angels somewhat removed: the Mystery of Mysteries at the center of a circle of awed worshippers. Joseph and the shepherds act only through dull instinct, can sense but not grasp the significance of the event, though Joseph has already removed one shoe as if unconsciously perceiving the holiness of the place. Never before did any painter grasp and render so

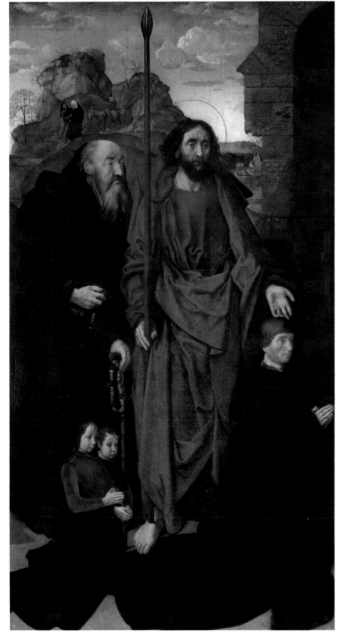 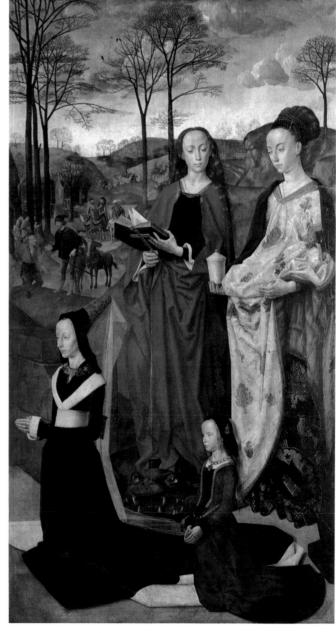

40, 41 Hugo van der Goes, *Saints Anthony and Thomas with Tommaso Portinari and two Sons* and *Saints Margaret and Mary Magdalen with Maria Portinari and a Daughter* (left and right wings of the Portinari Altarpiece). c. 1476. Tempera and oil on panel, each wing 253 × 141 cm (8 ft 3⅝ in × 4 ft 7½ in). Florence, Galleria degli Uffizi

perceptively the astonishment, devoutness, and unquestioning devotion of these simple men of good will, nor was the wonder and miracle of faith ever portrayed so convincingly and unforgettably. In contrast, the faces of Mary and the angels clearly reveal their grave awareness of what has come about. Quietly, with inward composure, the mother gazes at her child: it is the same surrender to the will of God that she will show at the foot of the cross when her son has gone His way to the bitter end. But it is the angels who differ most from the usual depictions of the Nativity: not a rejoicing multitude singing hosannas and glories but, earnest and solemn, wearing the liturgical vestments of the Mass, they are here as witnesses to a sacrifice.

Something of the mystery of the event, the infusion of spirit into the materiality and everydayness of earthly existence, was somehow translated by the painter into a reality our senses can apprehend. The extraordinary measure of spirituality and concentration in the scene is attained from the significance attributed to even the most seemingly insignificant detail, so that artistic effect and symbolic content are inseparably interwoven. Of the countless symbolic allusions, some of which we have already encountered elsewhere, the most important here is the sheaf of wheat conspicuously placed in the foreground as reference to the "bread of life". It signifies the eucharistic transformation of the body of Christ and at the same time is a symbol of the Resurrection since the grain, when it falls, rises in the earth to new life. Our modern

42 Justus van Gent, *The Institution of the Eucharist*. 1473/75. Tempera and oil on panel, 287 × 312 cm (9 ft 5 in × 10 ft 2⅞ in). Urbino, Galleria Nazionale delle Marche

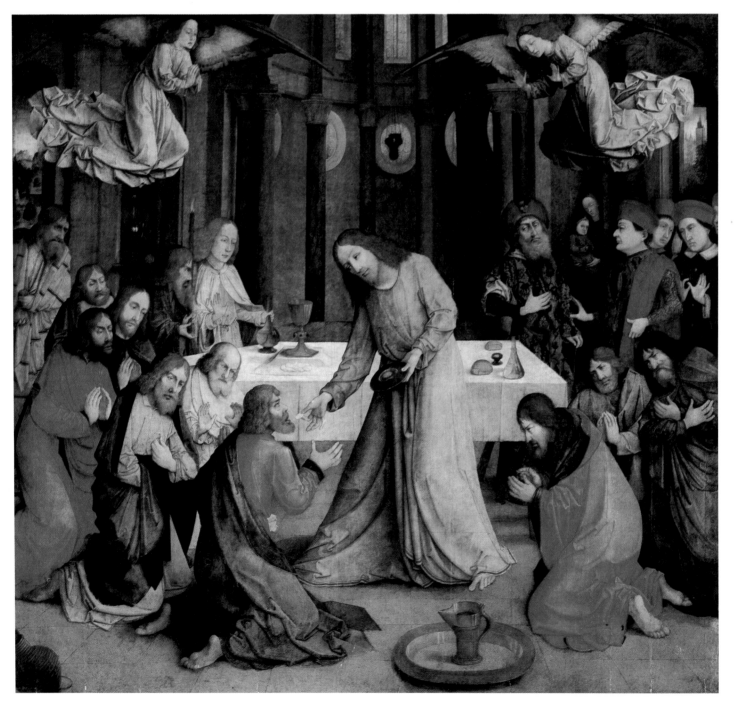

eyes and minds, alas, can scarcely decipher all the multiplicity and depth of allusions and symbolic relationships in this complex work. Thus the harp over the portal of the Romanesque edifice in the background identifies the real site of the birth, Bethlehem, the city of David the Harpist, but it signifies also the relationship of the event to the history of the people of Israel, to the messianic predictions of the prophets now to be fulfilled.

The inner circle of veneration and adoration is completed on the wings by the donors and their patron saints (40, 41). The worldly-wise and prosperous merchant Tommaso Portinari, his wife, and their children join the humble shepherds in awed homage to the divine Infant. As was customary in the Middle Ages, though the practice was already old-fashioned in the Netherlands when this triptych was painted, the human donors are depicted on a smaller scale than the saints whose attributes identify them as Anthony Abbot (with rosary, bell, and T-headed staff), Thomas (with lance), Margaret (with cross, book, and dragon), and Mary Magdalen (with ointment jar).

Because of its very large dimensions and, even more, its extraordinarily convincing artistic and spiritual conception, the altarpiece must have aroused the greatest interest when it arrived in Florence. It was a time when Netherlandish painting in general was widely admired in the South, and countless works of Italian artists bear the marks of their effort to come to terms with it. Northern masters were enticed to Italian princely courts, among them Justus van Ghent (probably identical with Joos van Wassenhove), a painter very close to the circles around Hugo van der Goes and whose activity in Urbino between 1473 and 1475 is documented. The large altarpiece of the *Institution of the Eucharist (The Communion of the Apostles)* (42) that he painted for the Confraternity of Corpus Domini in Urbino is his only firmly documented work and serves as basis for attribution of other works. In general effect it is more old-fashioned than the Portinari altarpiece from those same years but clearly comes from the same mental and spiritual world. What is depicted is not the single historical event but the sacramental act universalized and beyond time. Not a priest but Christ administers the host to the kneeling faithful, the table has become an altar in the chancel of a church and angels hover overhead. The institution of the sacrament of communion is witnessed and attested by contemporaries of the artist, among them, recognizable by his characteristic hook-nosed profile, Federigo da Montefeltro, Duke of Urbino, the humanist and great patron of the

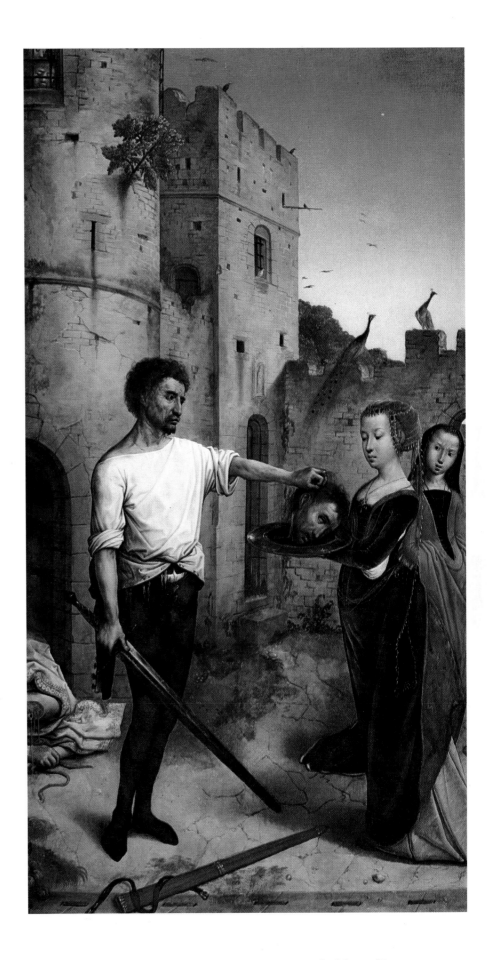

43 Juan de Flandes, *The Beheading of Saint John the Baptist.* Tempera and oil on panel, 88 × 47 cm (34⅝ × 18½ in). Geneva, Musée d'Art et d'Histoire

arts who had invited the Flemish artist to his court. The duke is in the company of his counselors, and the Quattrocento nobles and first-century disciples form dense groups to either side of a center in which the tall figure of Christ looms in isolation over all. He is made to seem even taller by columns of colored marble in the background. Through this latter artistic device, medieval perspective—based not on visual perception and rules of proportion as in later art but on the relative spiritual or temporal significance of figures and structures—re-enters fifteenth-century painting through the back door, so to speak.

Hugo van der Goes was a profoundly serious religious artist who probably found the ascetic monastic life suited to his temperament. For Hans Memling, a more worldly artist, the artistic climate of Bruges seemed well attuned to his way of perceiving things. That the pleasantly contemplative element of his art found a ready reception and influence is evident from a look at his contemporaries and followers there. If

the city and its art had, and have, a certain lyrical quality, it is because of the special veneration accorded to the Virgin Mary within its walls. Consider for example, the work of an anonymous artist known only as the Master of the St. Lucy Legend, after an altar painting he did in the church of Sint Jacob in Bruges. His *Madonna with Female Saints* (44) offers a theme much favored in Bruges and closely related to the Italian *sacra conversazione*. The picture was done for the altar of the lay organization known as *De Drie Sanctinnen* in the Church of Our Lady (Onze Lieve Vrouwekerk) and set up there in 1489. The three female saints to whom the chapel was dedicated— Catherine, Mary Magdalen, and Barbara—are given pride of place in the painting and are the only ones to be in direct contact with the Child and the Madonna. Their attributes identify them: Catherine's gown is embroidered with the wheel of her martyrdom; Barbara's mantle has her symbol, the tower in which her wicked unbelieving father imprisoned her; Mary Magdalen as

44 The Master of the St. Lucy Legend, *Madonna and Child with Female Saints*. c. 1489. Tempera and oil on panel, 108 × 171 cm. (42½ × 67⅜ in). Brussels, Musée d'Art Ancien

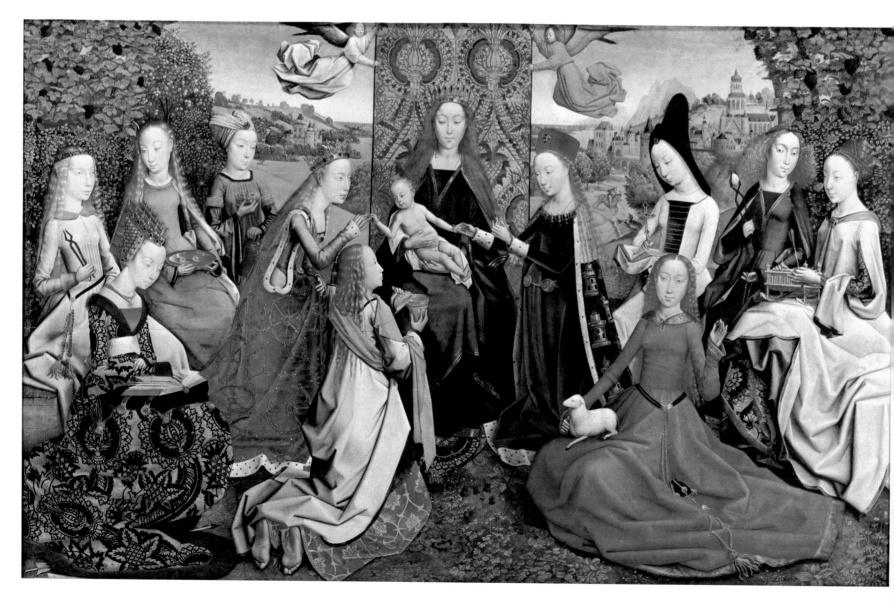

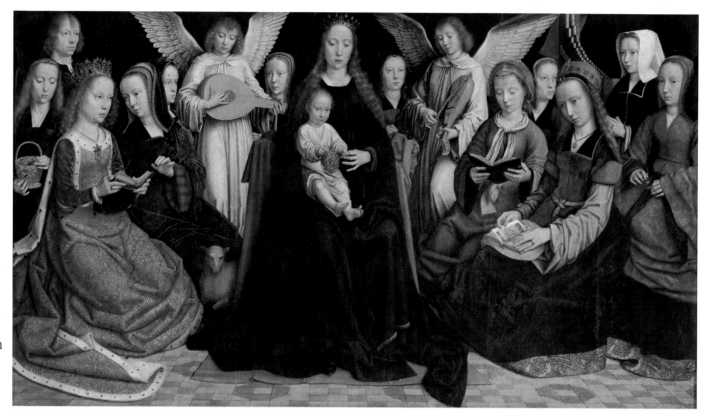

45 Gerard David, *Madonna and Child with Female Saints and the Artist and his Wife.* 1509. Tempera and oil on panel, 120 × 213 cm (47¼ × 83⅞ in). Rouen, Musée des Beaux-Arts

usual holds her ointment jar. Besides them one recognizes Saints Ursula, Appollonia (with her tooth), Lucy, Margaret, Agatha, Kunera (?), and Agnes who sit about, for all the world, like ladies in a court audience. But while the artist went to great pains to give this scene everything one would expect in a real or even realistic setting — foliage, flowers, lush grass, an idyllic landscape with a city in the background (a fantasy, to be sure), no one could mistake this for a real-world gathering. What we are meant to see, instead, is the heavenly paradise where these witnesses to the Faith (who lived in very different epochs) are united with Jesus and His mother as reward for the fidelity, self-sacrificing devotion, and the tribulations of their lives on earth: thus we infer a promise of equivalent reward to the devout viewer.

In depicting nature and landscape the anonymous artist shows himself equal to the best in a time that valued a keen eye for the particular, when a picture was essentially the sum of details observed with razor-sharp precision. On the other hand, his figures with their elongated proportions, angular movements, and spider-thin fingers belong to the past: creatures not of flesh and blood but of pure spirit, they still conform to the Gothic ideal.

When the last of the great early Netherlandish masters of the Bruges school, Gerard David, took up the same theme twenty years later, everything became incomparably more solid, sturdier, more convincingly

"real" (45). His figures certainly look more alive and three-dimensional and are grouped in a less constrained and more natural manner, but most of all his female saints strike us because essentially, they differ in no way from portraits of real persons. David himself donated this panel in 1509 to the Carmelite convent of Sion in Bruges and portrayed his wife and himself in the background at the left and right, certainly in idealized form but nonetheless in a way that makes them real likenesses: "The generalized elements are not set off sharply from the portraitlike, the two being carefully blended" (Friedländer).

The impression of solid bodies full of life comes also, and in so small measure, from the way the picture surface is densely packed with figures right to the upper edge, and from the emphasis on a broad and comfortable plumpness in most of them (so unlike those of the Master of the St. Lucy Legend) which avoids anything like vertical accents. With pleasant ladies like these, the attributes of martyrdom might strike us as disturbing intrusions, but they are so ingeniously introduced that it takes some effort to pick them out. Saint Catherine's wheel and Saint Barbara's tower are discreetly incorporated into their headdresses. Dorothy, Agnes, Godelive, Cecilia and other saints who cannot be identified (or are these portraits of real people?) close the ranks. Mary is not given any majestic distancing but is within the reach of most of the women, yet it is precisely the simplicity, even plain-

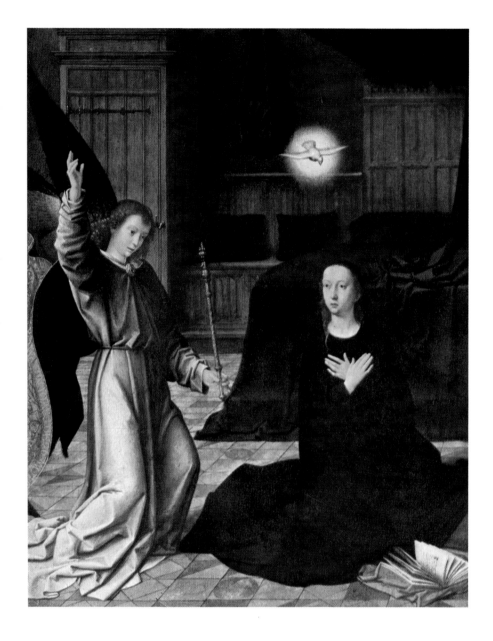

46 Gerard David, *The Annunciation*. c. 1520. Tempera and oil on panel, 40 × 32 cm (15¾ × 12⅝ in). Frankfurt, Städelsches Kunstinstitut

ness, of her appearance that lends her dignity and a superior nobility. She is the immovable pole, a still center of repose, a tower of confidence and security. Her statue-like tranquility and blocklike compactness are characteristic of Gerard David's approach to the human figure. His pictures are peopled with short and thickset figures comprised within plain and simple contour lines; their communication with what surrounds them remains at an irreducible minimum. The unconstrained grace and charm of Memling were deepened with his follower to a somewhat phlegmatic seriousness expressed also in his restrained color. But it should be kept in mind too that just as Memling never lost the mark of his origins long the Middle Rhine, so too David, born around 1460 in Oudewater near Gouda and not documented before 1484 in Bruges, where he died in 1523, never forgot his Dutch roots.

Hieronymus Bosch

"Bosch is one master who tends to throw art historians into a dither, because he seems to resist being fitted into any orderly scheme of evolution." So Max Friedländer, one of the most knowledgeable experts on early Netherlandish painting. Bosch was quite simply an outsider who put his entirely personal approach to the test in techniques of painting, in treatment of form, and above all in his themes. His work shows not an iota of connection with that of any of his famous predecessors or contemporaries. He lived well apart from any great art center, in 's-Hertogenbosch in Holland where his family, they too mostly artists, had lived for generations. He must have been born in the mid-fifteenth century and probably learned his art in his father's workshop. Married to a woman of property, Aleyt van der Mervenne, he obviously enjoyed a considerable social status in his home town since he belonged to the illustrious Confraternity of Our Lady, an association of ecclesiastical and lay gentlemen who saw to providing the church with music and art works for festive occasions as well as performances of religious plays and the like. The brotherhood commissioned a number of art works from their fellow member, though none have survived. Nor have other works of his mentioned in written sources, such as the triptych on the Last Judgment ordered in 1504 by Philip the Handsome, Duke of Burgundy. But, if nothing else, the surviving written records tell us that during his lifetime, and even after his death in 1516, Bosch was highly appreciated. Leading members of the nobility and the church were among the first to collect his paintings. And all the documents that have come down to us, few as they may be, show that Jeroen van Aken, named thus from his native city though he signed his works Jheronimus Bosch, was fully integrated into the society of his time as a respected citizen and much esteemed painter. Nor is there the slightest evidence that he was in any way an outsider in his life—supporter, say, of some heretical sect—as has too hastily been presumed from his seemingly unorthodox and even revolutionary pictures.

The fantastic element so unique to his pictures has also often been misinterpreted as the expression of an eccentric or even abnormal personality. Yet it is obvious that, however odd his images, they expressed meaningful aspects of the ideas of his time and answered the needs of his public—a broad public, it should be noted, and not a small coterie of odd sectarians. His fame, which spread rapidly across Europe and gave rise to no end of imitators, offers ultimate proof of his popularity.

Though Bosch owed virtually nothing to any of the schools of early Netherlandish painting, intentionally or not he was himself the originator of a truly vast school. The inexhaustible wealth of invention in his pictures of Hell and the temptation of Saint Anthony and in his satires on human foolishness spurred other artists to similar fantasies even long after his death. Pupils, copyists, and even—as Felipe de Guevara remarked around 1560—outright fakers exploited his fame and produced works in his manner, and in such numbers and with such fidelity that today it is often very difficult to tell the real from the pseudo-Bosch paintings and, even more, to decide to what extent the often numerous copies of one and the same original, which may differ in this detail or that, provide authentic information about some lost or unknown Bosch. The sixteenth-century Bosch-factories made great capital out of the master, and did it with a good deal of imagination and invention, to the confusion of the

47-49 Hieronymus Bosch, *The Garden of Delights* (center panel, *The Garden of Delights;* left wing, *Paradise: The Garden of Eden*; right wing, *Hell*). 1503-04. Tempera and oil on panel, center panel 220 × 195 cm (86⅝ × 76¾ in), each wing 220 × 97 cm (86⅝ × 38¼ in). Madrid, Museo del Prado

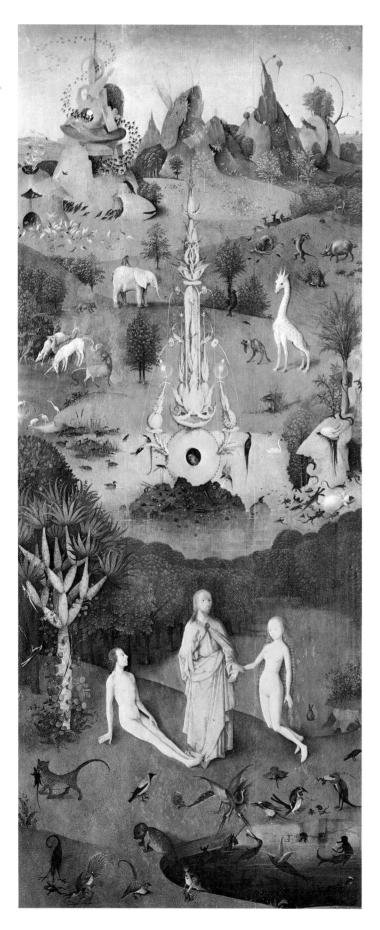

collectors of the time and, even more, of today's art historians who are still trying to sift through Bosch's *oeuvre* and put it into some order.

With not a single dated painting to go by, the efforts so far to establish a chronology on stylistic criteria have not come up with anything that can be generally accepted. True, there are some signed works—but among them are some that certainly never felt the

master's hand on or even near them. A case in point is the small panel titled *The Conjurer* (50, 50a). No fewer than five variants on the theme are known, besides a drawing and a later copperplate engraving. In all of them a conjurer entertains an audience of whom one man is pressed into service as demonstration object while another pickpockets his purse, but in all other respects there are considerable differences between the

various versions. When it comes to deciding if one of them is in fact from the master's hand or, at any rate, if one is more faithful to his original than the others, there is an embarrassment of very different answers to choose from. Probably all the surviving pictures are copies and reproduce the original with one difference or another.

We are more fortunate as regards the source of Bosch's idea, for this theme at least. The same scene with a man performing the well known magic trick using cups or beakers appears regularly in the depictions of the Children of Luna — people born under the moon's influence — in the popular astrological pictures of the time showing the effect of the planets (among whom the moon was reckoned) on human activities and the social order. Here Bosch made use of those depictions of folk beliefs to create a satire in the key of the *Narrenschiff*, *The Ship of Fools*, published by Sebastian Brant in 1494, a widely diffused and much read book in which, among other ills and foolishness castigated, there is talk of "the world that asks to be deceived". Evidently for his imaginative pictorial inventions Bosch owed less to traditional painting than to books, popular broadsheets with folkstyle engravings, and his own everyday encounters with proverbs, literature, and the theatre. Which means that to understand his often enigmatic works we must reconstruct as precisely as possible what ordinary people thought and said and did in his time — a far from easy task! It means too that the interpretations we do have of his satirical depictions of mankind's doings, with their entirely unusual — though not, we see, personal — themes, are for the most part still controversial and contradictory.

Besides such ostensibly moralistic paintings (in which we can class also the great triptych of the *Garden of Delights*) three other main themes take an important place in Bosch's work: scenes from the life of Christ, the saints, and the Last Judgment. It was naturally enough in scenes from the life of Christ that the painter was held within the narrowest limits, yet even there he repeatedly introduced decidely unusual

50 Hieronymus Bosch, *The Conjurer*. 1475-80. Tempera and oil on panel, 53 × 65 cm (20⅞ × 25⅝ in). St.-Germain-en-Laye, Musée Municipal

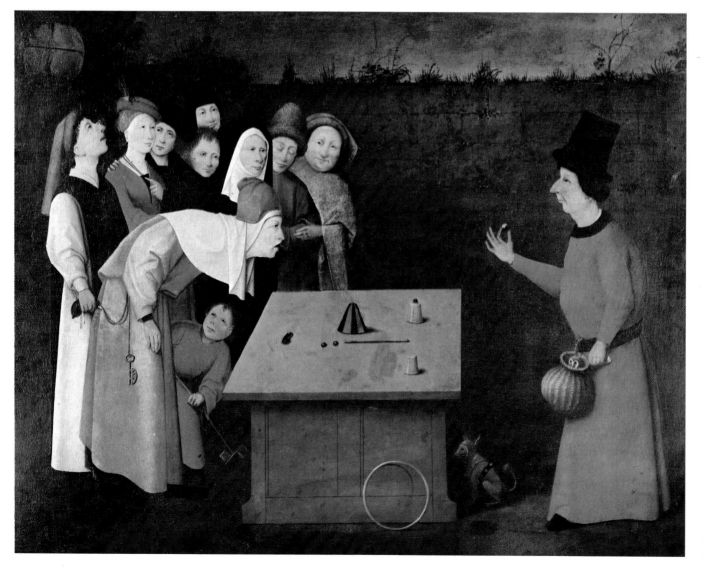

50a Hieronymus Bosch, *The Conjurer* (detail)

70

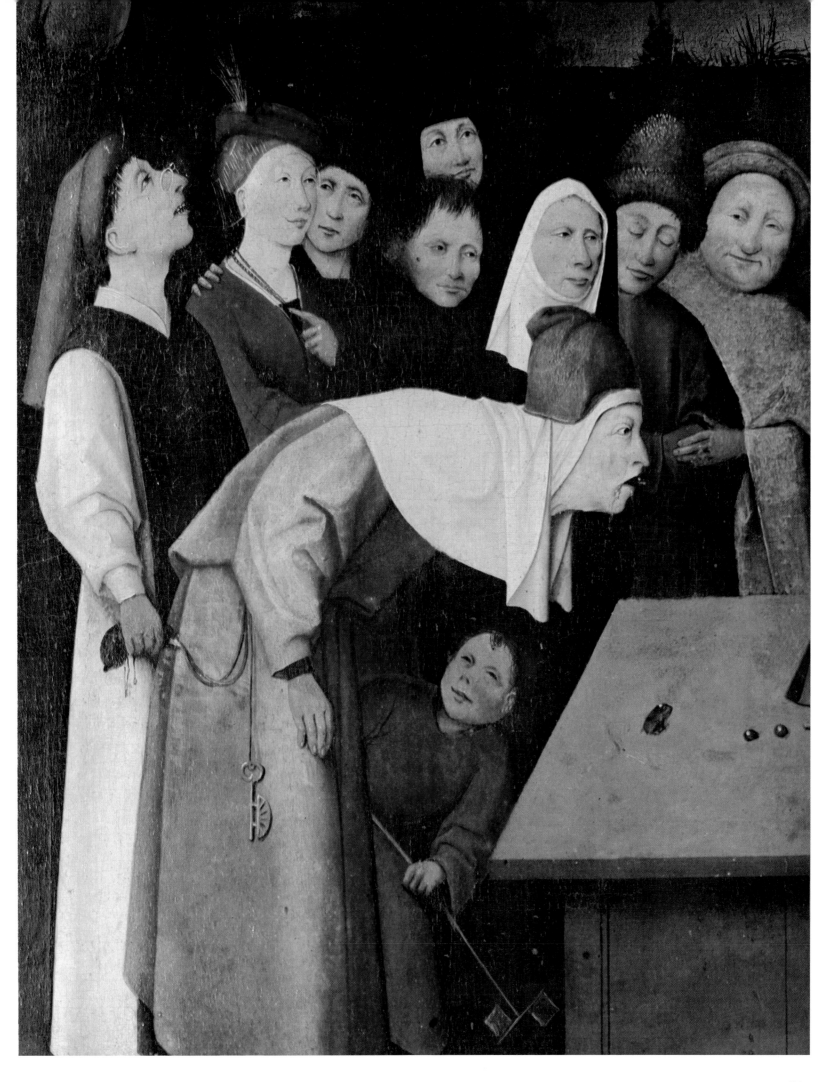

personal features which likewise have often given rise to divergent readings.

In the triptych with the *Adoration of the Magi* [Matthew 2:1-12] (52-54) there is such perfection in conception and rendering of the landscape and in treatment of color and light that it has always delighted even viewers repulsed by the bizarre fantasy of other works by Bosch. Yet it too has its weird quirks: look at the peculiar half-naked man stepping out of the manger. You will not find his like in any other artist's picture on this subject. An eldritch apparition for sure, is he a member of the retinue of the three kings (whose garments and gifts are decorated with Old Testament scenes that pertain typologically to the event depicted here)? Or, some say, the Messiah of the Jews introduced as counterpart and antagonist to the Christian Messiah and therefore shown as a parody of the Man of Sorrows complete with crown of thorns, or could he

even be the Antichrist? And in Bosch's *Marriage at Cana* [John 2:1-11] (55) there are other such still untangled knots. Who or what is the child seen from the rear with upraised chalice? A wedding guest's youngster wearing something a bit special in the way of party togs? A symbol of the Church? Something to do with the secret Semitic Gnostic cults? Fascinating speculations, but in this same picture there is a warning against letting our fancies run riot: the man with staff in the background has been explained as an occult mystagogue and magic-worker, but in plain fact is no more than the master of ceremonies responsible for organizing the feast, as is perfectly clear in banquet scenes in manuscript miniatures. Like the inquisitive shepherds in the Epiphany triptych, here the master of ceremonies, the servants, and the musician on the platform (whose companion fell victim to a later overpainting) serve to introduce an element of genre into

52-54 Hieronymus Bosch, *The Triptych of the Epiphany* (center panel, *The Adoration of the Magi;* left wing, *Saint Peter and the Donor;* right wing, *Saint Agnes and the Donor's Wife*). c. 1510. Tempera and oil on panel, center panel 138 × 72 cm (54⅜ × 28⅜ in), each wing 138 × 33 cm (54⅜ × 13 in). Madrid, Museo del Prado

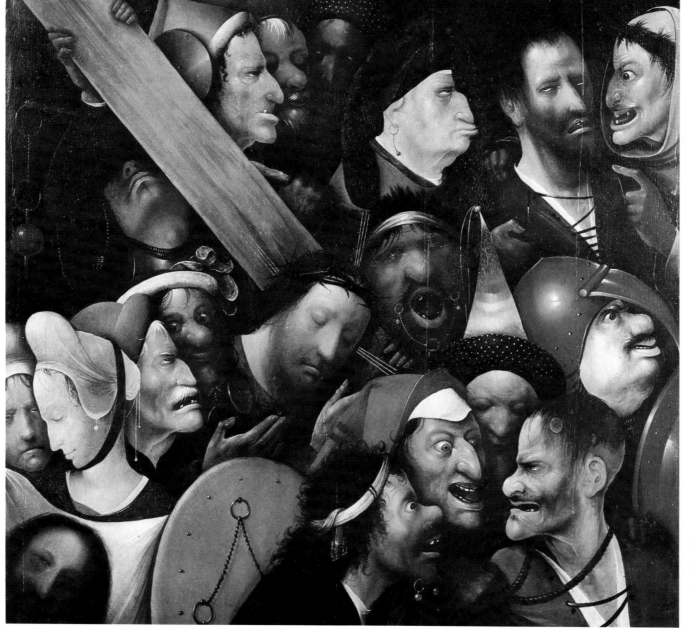

51 Hieronymus Bosch, *Christ Carrying the Cross.* 1515-16. Tempera and oil on panel, 74.1 × 81 cm (29⅛ × 31⅞ in). Ghent, Museum voor Schone Kunsten

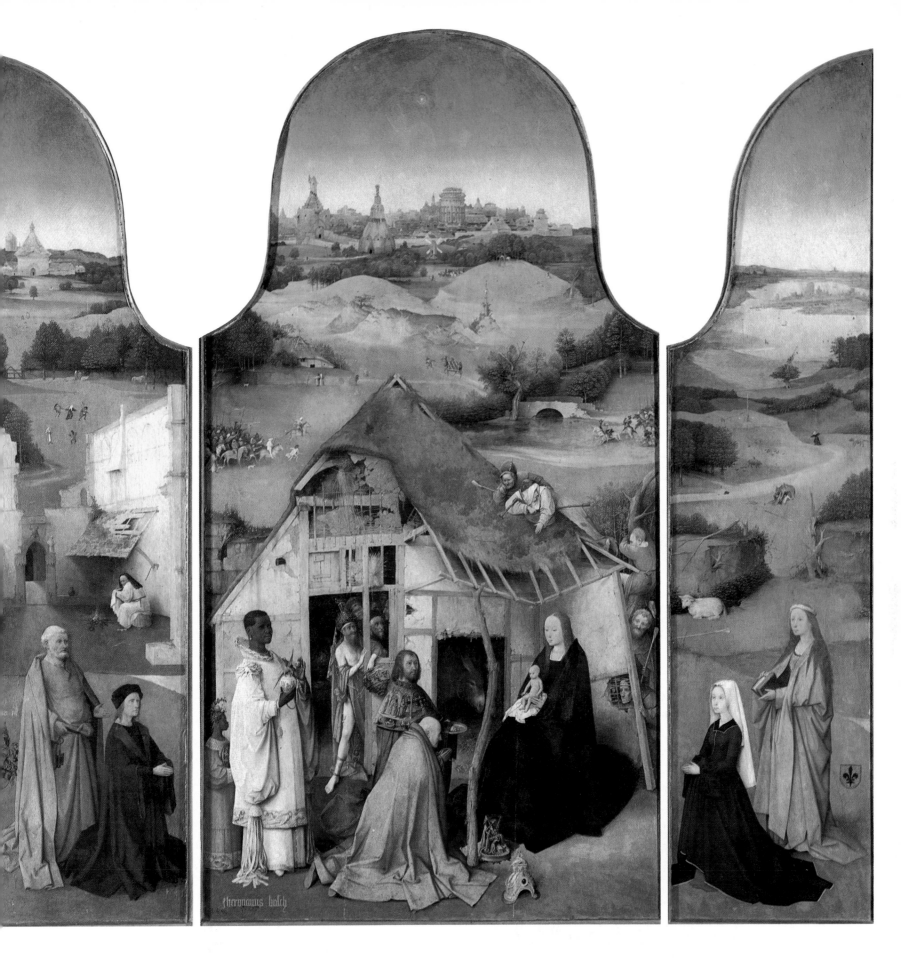

the picture. This is carried to the point of burlesque in the two putti: the one on the column draws his bow while the other takes refuge in a round niche in the wall; this was the sort of detail Bosch delighted in and which is so easily overlooked if one does not pore over every inch of his pictures. His taste for the grotesque was given free rein in paintings like the *Christ Carrying the Cross* [John 19:17] (51) where he relied chiefly on caricatural distortion of the faces to bring out the cruelty and ignorance of Christ's tormentors, who

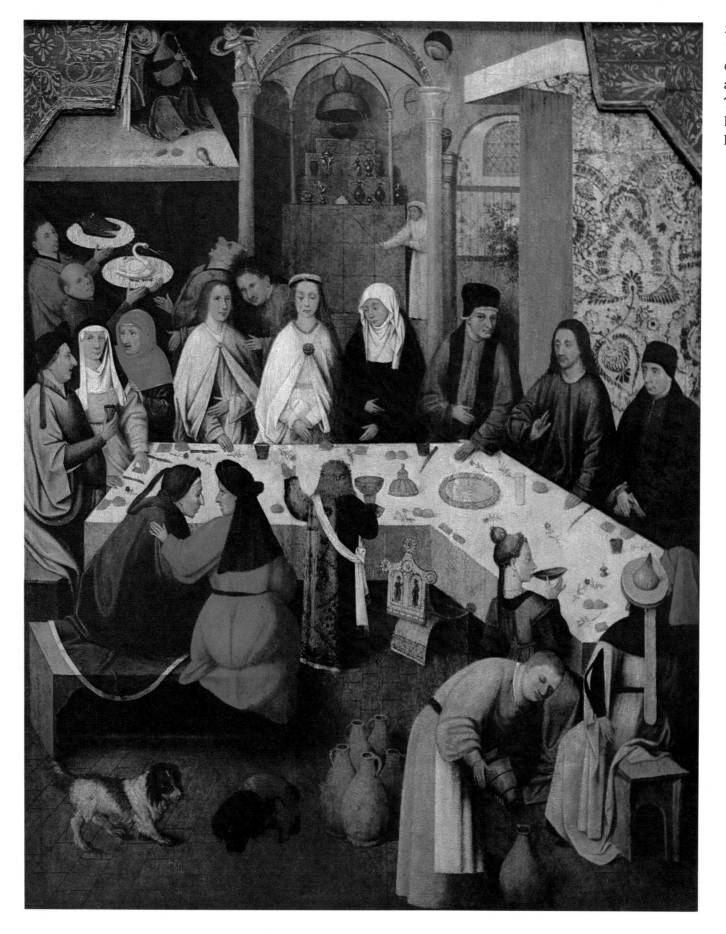

55 Hieronymus Bosch,
The Marriage at Cana.
c. 1475-80. Tempera
and oil on panel, 93 ×
72 cm (36⅝ × 28⅜ in).
Rotterdam, Museum
Boymans-van Beuningen

56 Hieronymus Bosch, *The Temptation of Saint Anthony* (center panel of a triptych). 1505-06. Tempera and oil on panel, 131.5 × 119 cm (51⅝ × 46⅞ in). Lisbon, Museu Nacional de Arte Antiga

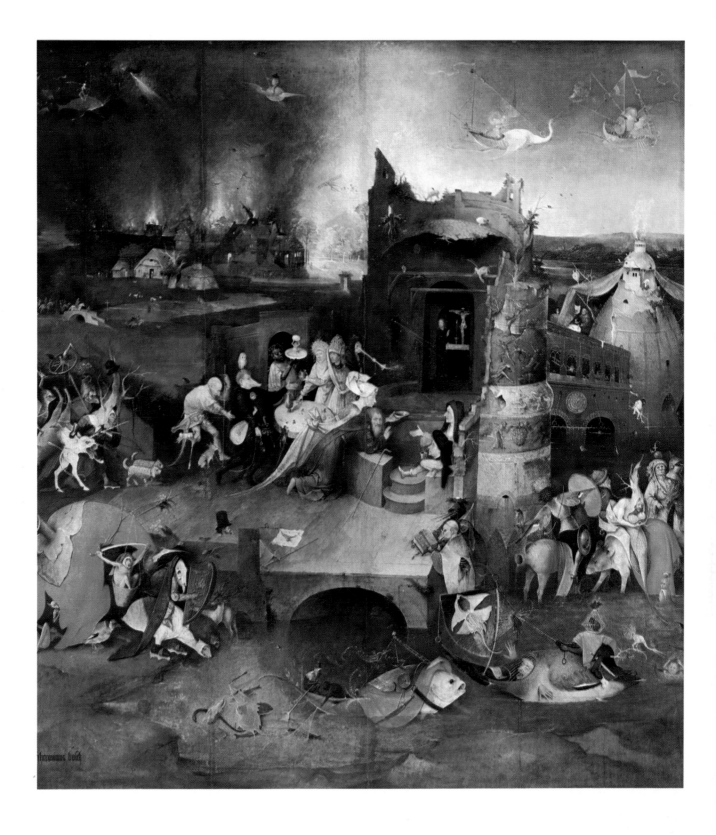

pack the entire picture space tightly to the margins. The traditional notion that ugliness and the demoniac are identical was expressed here with uncommonly dramatic violence and an entirely new representational means.

When it came to picturing the lives of the saints, Bosch simply ignored tradition. In the *Temptation of Saint Anthony* (56) nothing was permitted to hobble his boundless powers of invention, and despite valiant efforts, the meaning of most of its countless details re-

mains unfathomed. One thing, though, is certain: Bosch did not merely transpose the legends to do with the saint's tribulations into his pictures. Instead, he let their already fantastic approach to the story spur his own imagination to conjure up a dizzying profusion of the most extraordinary creatures and carryings-on that ever peopled anyone's nightmares. Human beings and ordinary things suffer horrendous metamorphoses, plunge and plummet and push from all sides at the kneeling saint in the center of the picture who points to

the Christ in the background niche as the sole salvation from all this demoniac assault. Demons, after all, in Bosch's time were by no means thought of as spooks and bugbears with which to frighten children; their foul and unholy work could be sniffed out everywhere, as Bosch would have known, if from nothing else, from a book of 1487 on witchcraft, the Hexenhammer, which proved one of the—can we say?—bibles for the innumerable trials instituted by the Inquisition in the next century.

Bosch was the predestined illustrator of the whole range of vile actions of the devilish powers. For his pictures of Hell and the Last Judgment he dreamed up—"nightmared" would be a better word—the most terrifying frights and torments, no doubt stimulated by the many medieval depictions of Hell but leaving them all behind in wealth of sheer invention. The "tree-man" and the "musicians hell" on the right wing of the *Garden of Delights* (49) are only the most impressive examples of that special genius, and their undoubtedly complex meaning has so far defied unraveling, unlike other scenes on that panel which are to be understood as allusions to the Seven Deadly Sins. Thus below the throne of a bird-monster is a woman whose face is mirrored in the hind parts of some sort of arboreal horror: a traditional personification of Pride; alongside her is Avarice, with a miser losing his ducats in a scarcely conventional manner; Gluttony comes next, with a man paying the price of overindulgence in food and drink. Crime—or at least sin—and punishment are immediately connected in all these details, so that as in Dante's *Inferno*, Bosch's depictions of Hell constitute a criticism of everything degenerate and debased in his time. His painting is a mirror-image of a topsy-turvy world where, because of vice and sin, the natural order of things established by God is turned upside down, and if anyone doubts this, look again: Bosch has made a hunter out of a hare.

This *Hell* is part of a triptych that has been given the name *The Garden of Delights*. Scarcely a work in all the history of art has had more numerous and more contradictory interpretations than its central panel (48). The earliest description that survives is from as early as 1517, one year after the artist's death. Antonio de Beatis, who accompanied Cardinal Louis of Aragon on his journey through Europe, noted in his diary under the date of July 30, 1517, that in the Brussels palace of Count Henry III of Nassau he saw a painting with an exceptional wealth of imaginative details, with nude men and women in great number and both black and white, with birds, animals of all sorts, and everything so true to nature that one simply could

not describe all the fantastic and entertaining things in it to someone who had not himself seen the picture. Less than a century later the picture made a very different impression on Fray José de Sigüença who in 1605 described the work which had meanwhile come into the hands of King Philip II of Spain. He saw it as a warning against frittering away one's life in earthly pleasures, a message he found concretely embodied in the leitmotiv of the picture, a gigantically enlarged strawberry: its taste may be lost as soon as one becomes aware of it, and thus also all the vanity of the world will vanish before the thought of Eternity.

These two entirely opposite readings recur, with various changes rung on them, in all discussions of the picture right up to recent times. For some it is and ideal world to be dreamed and desired, for others a grim warning. Carl Justi saw it as "a kind of earthly paradise," Walter S. Gibson as a false paradise; Walter Schürmeyer spoke of "most dubious pornography" but did at least sense "a breath of chastity" that lies across it all. Max Friedländer expressed his conflicting feelings in the phrase "an apotheosis of sinfulness," and Charles de Tolnay on the one hand wrote of it as a "labyrinth of delights" and a "nightmare of humanity," on the other hand as a "depiction of the sweet beauty of the collective dream of mankind of an earthly paradise." The most astonishing proposal for interpreting the picture came in 1947 from Wilhelm Fraenger who, in a scholarly study of more than a hundred pages, attempted to work through its pictorial language to prove that Bosch was an adherent of an Adamite sect for whose orgiastic gatherings he provided this as altarpiece celebrating the thousand-year reign of peace which, according to the views of certain circles in the Middle Ages, must be created before the coming of the Antichrist and the end of man's time on earth. That interpretation sparked off veritable religious wars between Bosch scholars, with great flights of eloquence flung like weapons between proponents and champions of the theory whose details, unfortunately, we cannot go into here.

The decisive and, so far, undecided question remains: did Bosch intend a warning to man to mend his ways and act in a manner pleasing to the eyes of God by showing mankind wasting itself in its greed for earthly delights? Or did he wish to make clear how men can live free of toil and trouble in peaceful harmony with each other and with nature? This latter interpretation would make the central panel (48), whose composition, as is always stressed, is so closely connected with that of the left-hand Paradise wing as to appear a continuation of it, a counterpole or

57 Hieronymus Bosch, *The Prodigal Son.* 1510. Tempera and oil on panel, diameter 64.6 cm (25⅜ in). Rotterdam, Museum Boymans-van Beuningen

countertheme to the *Hell* wing where the achievements of civilization, the instruments and commodities of every sort used in daily living, are transformed into tools of martydom for their inventors. Such apparently modern thinking, with its criticism of civilization, has always played a role in the European tradition. In the early sixteenth century it led explorers and travelers to describe previously unknown "primitive" peoples with a mixture of discontent, sentimental yearning, and humanistic neoclassical enthusiasm.

They borrowed their descriptions from the classical poets' accounts of the Age of Gold, when peace still reigned between all living creatures and nature provided man with all he needed and more at no expense of his own sweat, as Ovid, for one, recounts in the first book of his *Metamorphoses*. It can still be only speculation, but such descriptions could well have inspired a painter like Bosch who was unrivaled in the art of translating literary or verbal sources into painted images.

The Sixteenth Century: The Rise of New Centers and Styles

In the early 1600s, as a consequence of economic and social changes in the course of the preceding half-century, Bruges had to concede to Antwerp its place as chief art center of the Low Countries. When it was no longer possible to halt the sanding-up of the Zwin River, Bruges lost its harbor and therefore its importance. At roughly the same time, exceptionally high tides driven by storms so widened the western arm of the Schelde that what had been a modest harbor at Antwerp was able to accommodate the largest vessels. But it was not only accidents of nature that hastened the economic and cultural rise of Antwerp. In the young commercial city, unlike Bruges, new initiatives were not hobbled by outworn regulations and restrictions imposed by the craft and trade guilds. No wonder, then, that in the liberal atmosphere of Antwerp, open to everything new, art likewise was given fresh impulses and a new variety of painting could arise—the landscape—which previously had played only a more or less subordinate role in figural compositions.

That development was decisively influenced by Joachim Patinir (around 1485-1524). While his landscapes still had to have some sort of religious pretext,

58　Joachim Patinir, *Rest on the Flight into Egypt.* Oil on panel, 37 × 59 cm (14⅝ × 23¼ in). Darmstadt, Hessisches Landes-museum

59 Joachim Patinir, *The Passage of the Styx*. Oil on panel, 64 × 103 cm 25¼ × 40½ in). Madrid, Museo del Prado

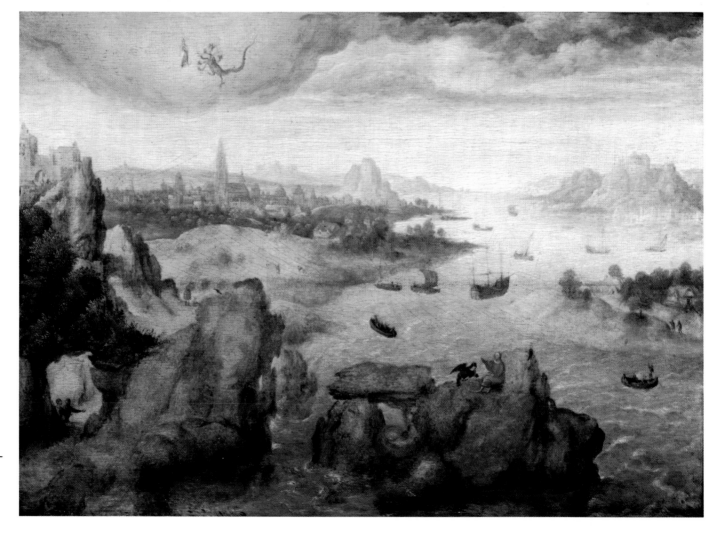

60 Herri met de Bles, *Saint John the Evangelist on Patmos*. Oil on panel, 33 × 47 cm (13 × 18½ in). Antwerp, Koninklijk Museum voor Schone Kunsten

61 Quinten Massys, *Christ as Salvator Mundi*. Before 1505. Tempera and oil on panel, 39 × 29 cm (15⅜ × 11⅜ in). Antwerp, Koninklijk Museum voor Schone Kunsten

in a painting like his *Rest on the Flight into Egypt* (58) the figures are for the first time fully integrated into a natural setting. The landscape is no longer only a sort of foil or backing for disproportionately large figures in the foreground as in a work like the *Fall of Man* by Hugo van der Goes (38). It takes only a glance, though, to see that Patinir's landscapes are not topographically accurate scenes of some particular place but fantasies put together from many carefully and lovingly observed separate elements. The miniature world he composed out of bizarre mountains, rivers, and cities must have struck his first viewers as very much a new marvel.

The illusion of spatial depth is achieved not by applying the laws of linear perspective (as in plate 59) but by a particular use of paint in what is called coloristic perspective. In practice this means grading the color scale from warm brownish green in the foreground to a cool bluish green in the most remote parts of the scene (58). A further step was taken by Herri met de Bles (c. 1505/10-c. 1584), probably a nephew and pupil of Patinir, who laid on the paint in his backgrounds in the form of thin and delicate glazes and took into account the effect of the atmosphere, thereby following Leonardo's advice to let distant objects fade away in mist in order to achieve an atmospheric perspective (60).

The foremost and most influential master in Antwerp during the first third of the sixteenth century was Quinten Massys, a painter involved in the very active intellectual life of the city and well acquainted with the humanistic thought of his time. Man is at the core of his art, depicted in portraits, religious scenes, and even a kind of early genre picture with a forcefulness and freedom from constraint unprecedented in the Low Countries. No longer instruments of some will from outside, divine or otherwise, nor interchangeable ciphers within a firmly fixed order, his figures are individuals acting on their own and enduring or enjoying their personal destiny. A contemporary of Dürer—Massys was born around 1465 in Louvain and died in Antwerp in 1530—he expressed in his works a sublimated humanness of a radiance and personal impact that has never since failed to arouse admiration. Along with this, he was also one of the most sensitive colorists among the Netherlandish painters.

His two major works, the triptych for the Louvain Confraternity of Saint Anne completed in 1509 (Brussels, Musées Royaux des Beaux-Arts) and the triptych with the burial of Christ and scenes from the life of John the Baptist, begun around the same time and completed two years later (Antwerp, Koninklijk Museum voor Schone Kunsten), are impressive for

62 Quinten Massys,
Saint Mary Magdalen.
c. 1520. Tempera and
oil on panel, 45 × 29
cm (17¾ × 11⅜ in).
Antwerp, Koninklijk
Museum voor Schone
Kunsten

their expressive depth, religious and human alike, no less than for the beautifully calculated equilibrium of their artistic form. While those two works count among the most mature achievements of Northern art in the time, Massys' greatness and importance are just as evident in less demanding works like the almost life-sized *Christ as Salvator Mundi*, as saviour and deliverer of the world (61). Such full-face heads of Christ were frequent in the Netherlands since Jan van Eyck, mostly (as here) as companion-piece to a picture of the Virgin Mary in adoration. The presentation is tight, compressed, the cross cut off at the margin, the gesture of blessing no more than suggested by the fingers of one hand (and it is certain that the panel was not cut down at any point in its history). The already very impressive symmetrical frontal depiction is thus heightened to a virtually omnipotent majesty. Yet the gaze of the brown eyes and the slightly parted lips con-

vey a great human presence and warmth as well. Seldom, indeed, has the union of the divine and the human essence been given such tangible form.

There is something of the same blend of opposites in the humility and yet dignity of the Mary Magdalen (62) who raises the lid of her ointment jar as if wishing to share with us the precious fragrance of its balsam. Her look is reserved, a little remote: she is not one to make a display of grief. Such restraint in the expression of emotion and such euphony of line correspond to the humanist and artistic ideal of the Italian Renaissance to which Massys was in many respects indebted.

But there was far to go still before medieval forms and thinking could be left fully behind. Far into the sixteenth century the conflict between tradition and progress would mark artistic activity in the Low Countries. In Antwerp, and also in the Dutch centers, it

63 Jacob Cornelisz. van Oostsanen, *The Christ Child Adored.* 1512. Oil on panel, 128 × 179 cm (50⅜ × 70½ in). Naples, Museo e Gallerie Nazionali di Campodimonte

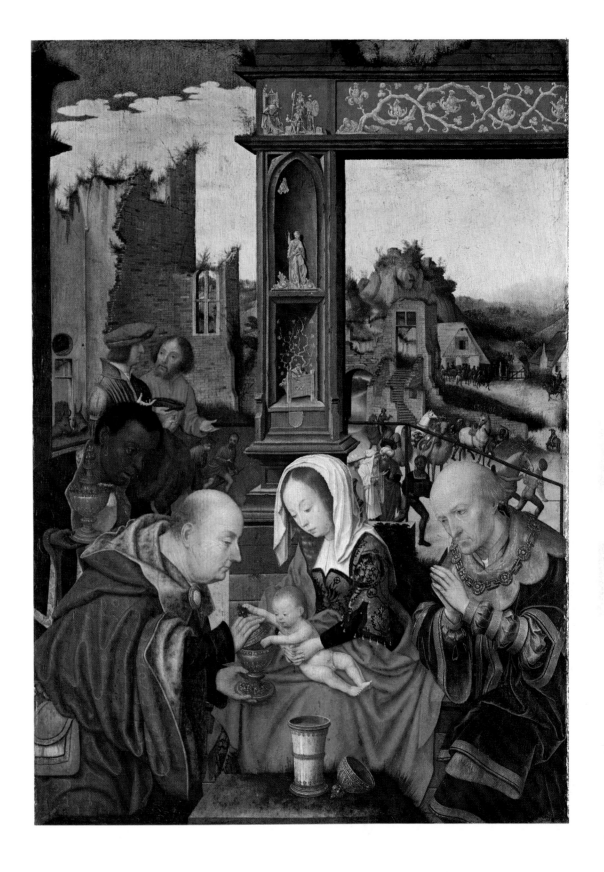

would lead to a kind of mannerism that often has no more than the name in common with what in Italian art is more or less felicitiously thrust together under that stylistic term. In the Low Countries it led not seldom to truly enchanting creations, to a fascinating mélange of bizarreness with naivety, of boldness with a comfortable traditionalism. With someone like Jacob Cornelisz. van Oostsanen (63), who lived from around 1470 to 1533 and was active in Amsterdam, the by no means original, almost monotonously uninventive alignment of the figures crowding much too close around the newborn Child contrasts with the weightlessness and broad spaciousness of the decorative Renaissance architecture and especially with the remarkably realistic rendering of a harbor crisscrossed by numerous boats, itself one of the earliest marine

64 Jan Mostaert, *Adoration of the Magi.* c. 1515. Oil on panel, 49 × 35 cm (19¼ × 13¾ in). Amsterdam, Rijksmuseum

views with a real feeling for nature.

One aspect of the spirit of the times was a penchant for the grotesque and artificial. This is reflected in works like the *Adoration of the Magi* (64) in which the Haarlem painter Jan Mostaert (1472/73-1555/56) lumped together the most heterogeneous elements. The innate Netherlandish feeling for grasping and portraying real things is overlaid here with foreign and even alien influences, and it only occasionally breaks through in something like the strongly characterized heads of the two kings or the peasant farm in the background. Here we see not a striving after naturalness and the free development of figures and space but, instead, an emphasis on intellectual interconnections: the reality of thought takes precedence over that of the eye. Note, for instance, the pier rising behind Mary in the center of the composition. Devoid of any practical function, it is there only because of the reliefs on it which allude, by typological parallels, to the advent of the Saviour: the dream of Pharaoh's chief butler [Genesis 40:9-15]; the Tiburtine Sibyl's interpretation of the vision of Emperor Augustus; the three "mighty men" who broke through the host of the Philistines to bring King David water from the well of Bethlehem [2 Samuel 23:15-18]; the Tree of Jesse. Typical of the predilection of the times for the curious and devious is also the fact that the traditional and universally understood symbols and allusions are set aside here in favor of the most unlikely sources fraught with complicated significances only a theologian could grasp.

Barend van Orley (1488-1541), the court painter active in Brussels and Mechelen for the Hapsburg regents Margaret of Austria and Mary of Hungary, also chose unusual themes and even more unusual ways of presenting them.

In his major work, a triptych on the tribulations of Job completed in 1521 (Brussels, Musées Royaux des Beaux-Arts), the central panel is filled with plunging bodies and twisted limbs: the children of the infinitely patient and believing Job, killed when the house in which they were dining fell in upon them [Job 1:18,19]. The exteriors of the altarpiece wings show a parallel to Job's rewards for bearing his trials with patience: the story of Lazarus and the Rich Man [Luke 16:19-31] including the scene of the Rich Man's death (65). Cramped within a space marked out by sturdy thick columns—man beset and imprisoned in forbidding or even menacing architecture is another leitmotiv of the time—is the deathbed with the dying man attended by a doctor examining a flask of urine against the light and by his young mistress who holds a golden goblet: his last sight is of the vanity of earthly learning, beauty, youth, and wealth. The lower half of

65 Barend van Orley, *The Death of the Wicked Rich Man* (detail of the exterior, right wing, of the Altarpiece of the *Afflictions of Job*). 1521. Oil on panel, 174 × 80 cm (68½ × 31½ in). Brussels, Musées Royaux des Beaux-Arts

that wing shows the Rich Man in Hell being served by devils with the most loathsome foods: a grim antithesis to his earthly banqueting from which he drove away the poor Lazarus who now rests in eternal bliss in Abraham's bosom.

Rich in invention, gifted with a strain of fantasy, Van Orley was a seeker in that century of insecurity and upheaval, and his work gave expression to his era's oscillation between obligation and freedom, between patient expectation of the end of time and impetuous departures for unexplored horizons.

A painter more traditonal in choice of themes and execution was Cornelis Engelbrechtsz. (1468-1533), who lived all his life in Leyden, and outside those centers that so far had set the artistic key. With him there was a return to the late-medieval ideal of the elongated figure with small head and doll-like face whose affected fragility is almost smothered under fantastic finery. He is reckoned among the foremost exponents of a Gothic-oriented mannerism practiced by a number of artists active in Antwerp but which was also an international phenomenon seen in Cranach among others. His *Crucifixion* (66), the central panel of an altarpiece, is in the tradition of the Calvary scenes packed with figures so widely diffused in the fourteenth and fifteenth centuries, a type in which the tragedy is given a commentary through the reactions of the numerous paricipants and onlookers. As in the medieval prototypes, movements and gestures carry the expressive message. Medieval too are certain symbolic elements. Through the body of the dead Adam in the predella, flanked by portraits of the donors, grows the legendary tree that sprouted from a seed of the forbidden fruit of man's first sin and which provided the wood for the cross of Christ, the New Adam. The inner faces of the side wings have depictions of the Sacrifice of Isaac and the Brazen Serpent, as prefigurations of Christ's bearing the cross and His crucifixion. Yet all such factors aside, in his treatment of space and landscape Engelbrechtsz. shows himself thoroughly familiar with the new achievements of his time.

Engelbrechtsz. appears to have been a very capable teacher. A number of talented painters came from his workshop, among them Lucas van Leyden, an exceptionally gifted and precocious artist who would quickly grow beyond his teacher's horizons and would far surpass in versatility all of his contemporaries north of the Alps except Dürer. He was, in fact, no less skilled in drawing, copperplate engraving, and woodcarving than in painting. Unlike Engelbrechtsz. and most of the artists of his circle, Lucas did not stagnate in traditional approaches but welcomed influences from out-

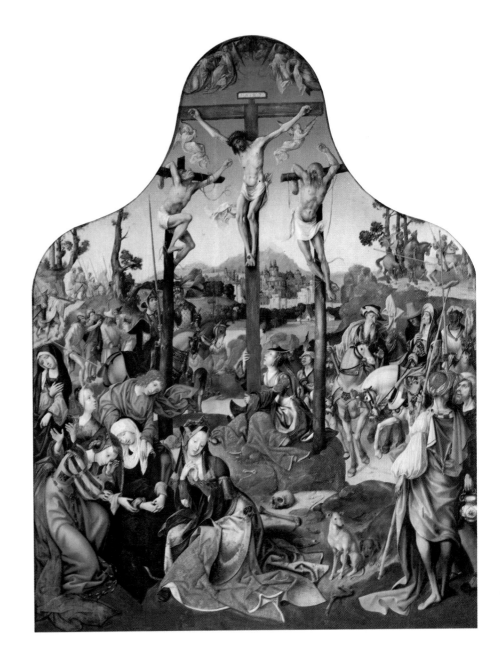

66 Cornelis Engebrechtsz., *The Crucifixion* (center panel of a triptych). c. 1512. Oil on panel, 198.2 × 146 cm (78 × 57½ in). Leyden, Stedelijk Museum "De Lakenhal"

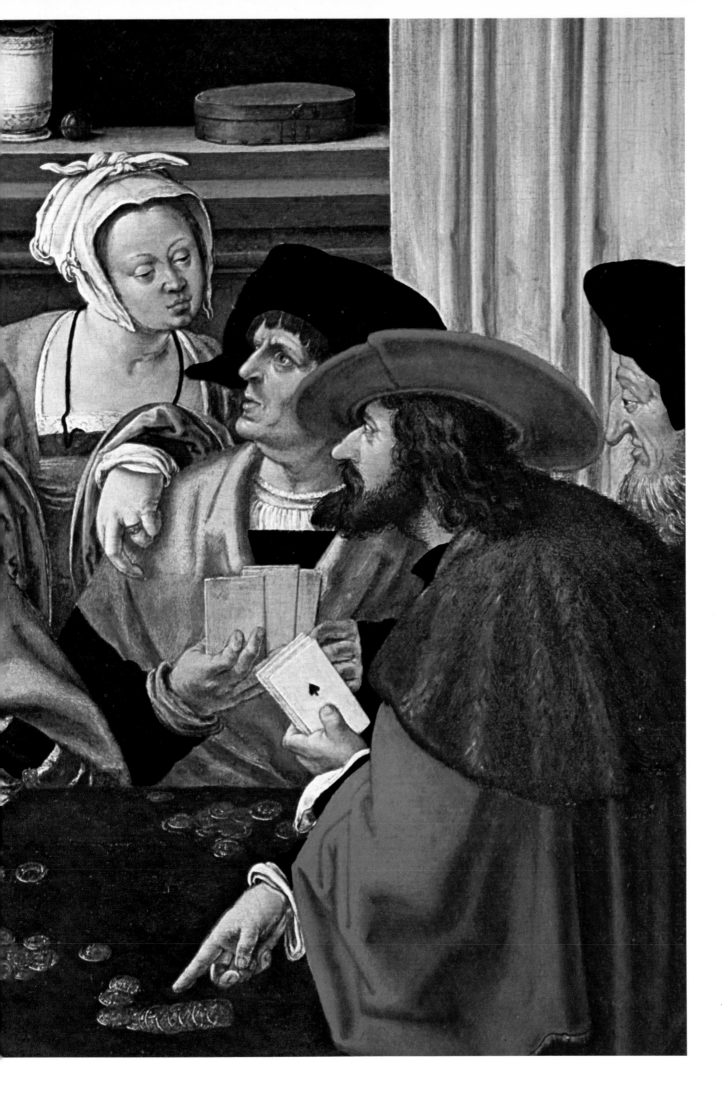

67 Lucas van Leyden, *The Card Players* (detail). c. 1508-10. Oil on panel, full dimensions 56.4 × 60.9 cm (22⅛ × 24 in). Washington, National Gallery, Samuel H. Kress Collection

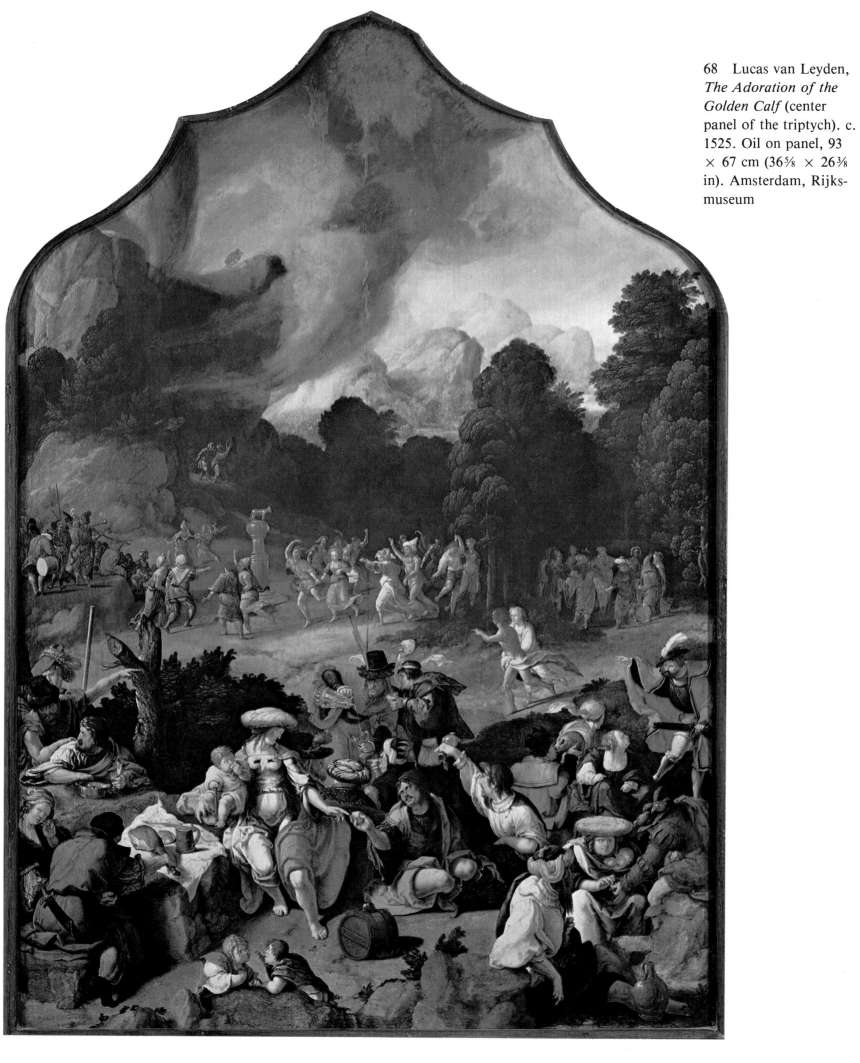

68 Lucas van Leyden, *The Adoration of the Golden Calf* (center panel of the triptych). c. 1525. Oil on panel, 93 × 67 cm (36⅜ × 26⅜ in). Amsterdam, Rijksmuseum

69, 70 Lucas van Leyden, *The Adoration of the Golden Calf* (wings of the triptych). c. 1525. Oil on panel, each 91 × 30 cm (35⅞ × 11¾ in). Amsterdam, Rijksmuseum

side — which reached him in the form of Italian and German engravings, notably those of Dürer — without becoming an imitator. Then too, in his work the sober Netherlandish feeling for reality — that eye for details and the outward circumstances of human life which in the Middle Ages had been masked and overlaid by allegorical interpretation and speculation — again came powerfully to the fore. Pictures like his *Card Players* (67) count among the earliest examples of pure genre

painting on non-religious subjects, the start of a long development that would culminate in Holland in the seventeenth century. Physiognomy and gestures are used here to convey a lively action and a feeling of real communication between the personages. No doubt behind this seemingly straightforward scene there lurks some moralizing meaning, as so often in genre paintings (less in these years than later): the emblem books of the sixteenth and seventeenth centuries de-

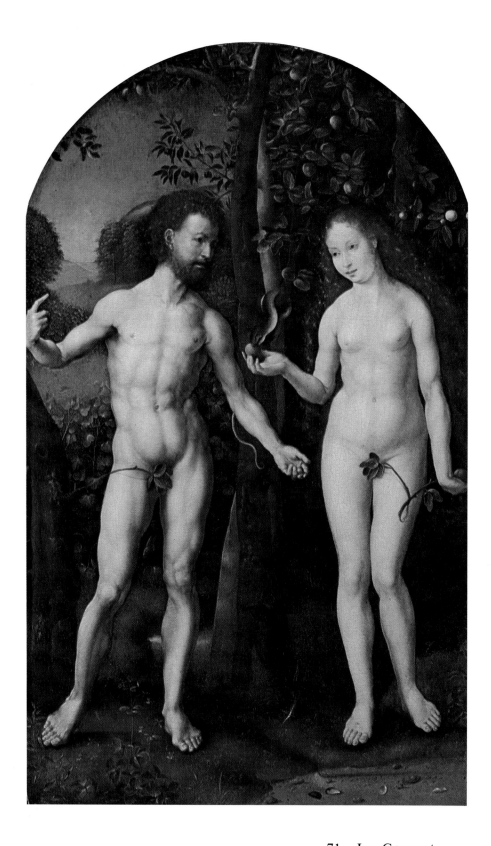

71 Jan Gossaert
(Mabuse), *Adam and
Eve.* c. 1508-09. Oil on
panel, 56.5 × 37 cm
(22¼ × 14⅝ in).
Castagnola, Villa
Favorita, Thyssen-
Bornemisza Collection

nounce card playing as a vain and dissolute pastime
for idlers, a first step toward moral and spiritual ruin.

Even in works on ostensibly more solemn subjects
such as the *Adoration of the Golden Calf* (68-70)
Lucas was no less interested in the way people comport
themselves in everyday reality: look at the figures
eating and drinking in the foreground of all three
panels. The subject, unusal in an altarpiece, refers to
the people of Israel who, discouraged by the years in
the desert on their journey into the Promised Land,
made a golden calf as idol and worshipped it while
Moses was away on Mount Sinai receiving the com-
mandments of the Lord. The painting is to be inter-
preted as a warning against the indulgence in pleasure
and the laxness in morals that ensue from worship of
gold and the pursuit of other such false idols. (The
forms of worship may have changed, but the fact is as
old as mankind and just as much to the point today).

The way space is opened up and articulated in the
central panel is of special note. Festoons of movement
lead the eye across diagonally disposed groups of
figures from foreground to midground. At the same
time, by alternate light and dark areas we are likewise
carried, step by step, into the depth of the picture. This
sort of division by spatial planes was a favorite com-
positional principle of later Mannerist painting, based
on inventions of the Italian Renaissance. Here it ap-
pears in the North in a comparatively early variant.

In the mere forty-four years or less of his life — he
died in 1533 in his native Leyden — Lucas could pro-
duce no great store of works. Fewer than twenty are
known, and of these the most important is the large
triptych on the Last Judgment that he painted in
1526/27 as epitaph for a Leyden burgher (Leyden,
Stedelijk Museum "De Lakenhal"). The influence his
works exerted far exceeds their number: it can be fol-
lowed well into the seventeenth century in Holland,
thanks to his graphic work as well.

If so far we have had little to say about Italian in-
fluences, now they become of key importance. Artists
and their patrons in the Low Countries took up enthu-
siastically the Renaissance and humanist proposal of
a return to Antiquity as model, and the way the
masters of the Italian Renaissance took over and
reshaped classical forms not only excited their admir-
ation but spurred them to emulation.

The compulsion to learn from the source and to see
for themselves the great exemplars of the past in the
land of their origin soon led young Netherlandish ar-
tists to consider an extended study period in Italy as
virtually obligatory. Italy became the promised land
of art, and would remain so for something like three

centuries: Rome above all, and in lesser degree Venice and Florence.

In the first half of the sixteenth century a group of artists, chiefly from the southern Netherlands, so rigorously overlaid the native approach with an imitation of classical art as to amply earn the name of Romanists that has been given them. One of the first of these was Jan Gossaert, known also as Malbodius

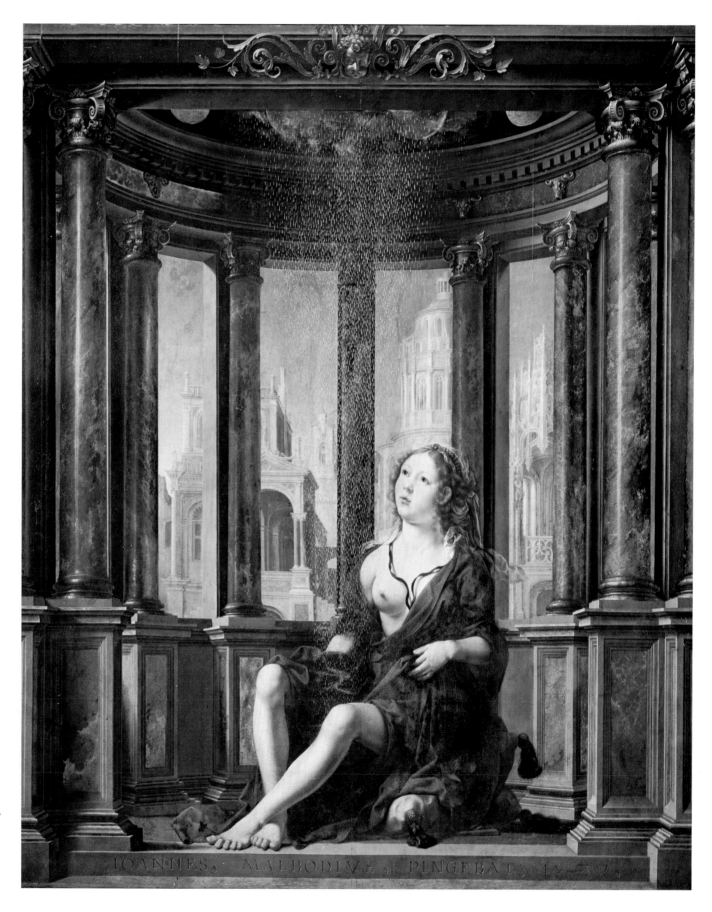

72 Jan Gossaert (Mabuse), *Danaë*. 1527. Oil on panel, 114 × 95 cm (44⅞ × 37⅜ in). Munich, Alte Pinakothek

or, more often, Mabuse after his birthplace of Maubeuge in Hainault. In 1508 and 1509, in the company of his humanistically educated patron Philip of Burgundy, a natural son of Duke Philip the Good, he visited Rome, Venice, Padua, and Verona with the express purpose of studying the ancient monuments and recording them in drawings (of which a few have survived). The course was set for all of his subsequent art, and the Florentine Lodovico Guicciardini, in the description of the Low Countries he published in 1567, could write that Gossaert "was the first to bring to this country from Italy the art of painting narrative and mythological pictures with nude figures."

Certainly, as we have seen with Jan van Eyck and others, the nude had been acceptable earlier as well, if the subject called for it. Now though, in accord with the ideas of Antiquity and of the Italian Renaissance, the depiction of the unclothed human body in and for itself became one of the chief themes in art. In pictures of the Fall of Man, the figures of Adam and Eve were now conformed more closely to the classical canon as regards harmonious proportions of the body and proper balance in movement (71). The revolutionary force of that innovation is obvious when we look back to how Hugo van der Goes handled the theme (38). With him the sinning pair are of significance only for their role in the biblical story, not for their own beauty. With Gossaert, on the other hand, it is the sheer physical presence of the figures that holds the eye. This was not, true enough, a sensuous physicality—the times were not ready for that—but an idealized *artistic* presence in which the incident ostensibly depicted is

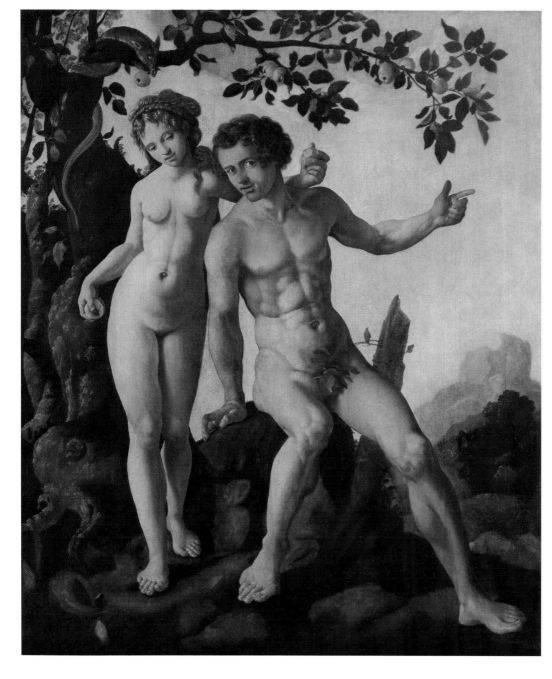

73 Jan van Scorel, *Adam and Eve.* c. 1527-28. Oil on panel, 169.5 × 144 cm (66¾ × 56¾ in). Hatfield House, Hertfordshire, Collection The Marquess of Salisbury

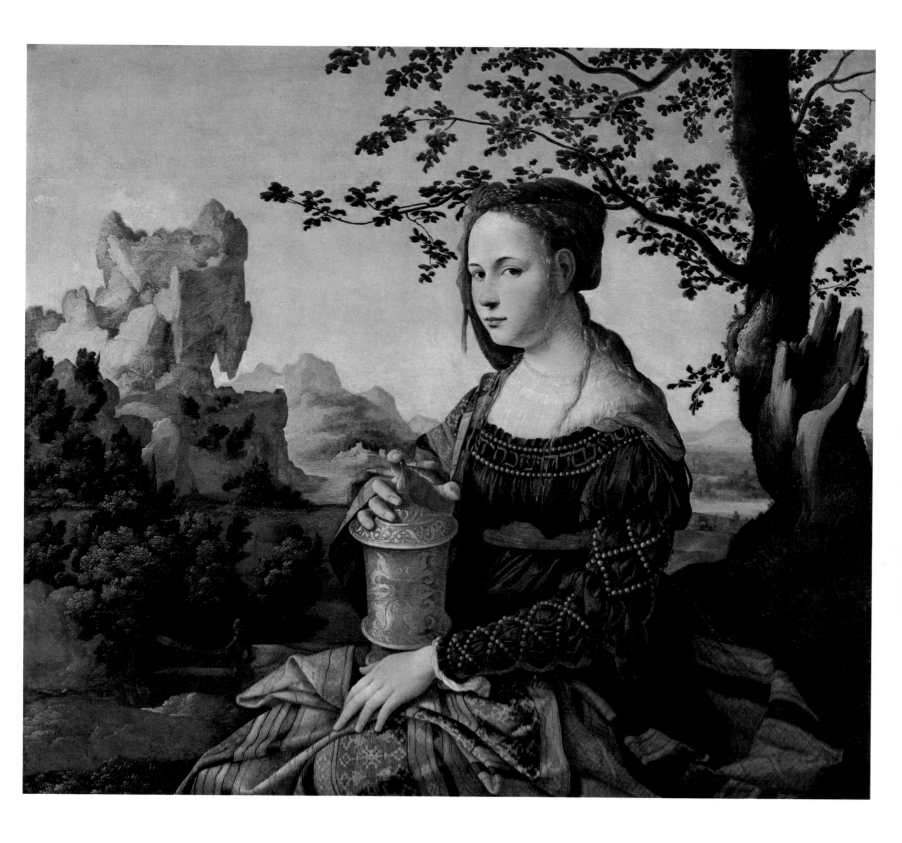

74 Jan van Scorel, *Mary Magdalen*. c. 1529. Oil on panel, 67 × 76.5 cm (26⅜ × 30⅛ in). Amsterdam, Rijksmuseum

relegated to secondary importance. Man as measure of all things—that basic tenet of the Renaissance—applies here too. Gossaert seems to have worked from Dürer's copperplate engraving of 1504, disciplining and simplifying its multifarious and complicated composition on the basis of what he had learned in Italy, making the figures even more dominant.

Compared with such lapidary formulations achieved under the direct impact of Roman antiquities, Gossaert's later works mark a certain retreat. The

movements of his figures become more complicated and sometimes end up in exaggerations. Their freedom is hemmed in by an architecturally defined space that surrounds them too closely. They strike us as constrained by a yoke, though in the *Danaë* (72) that constraint is justified by the story. The daughter of the king of Argos was imprisoned by her father in a brazen tower out of reach of any man because the Delphic oracle had prophesied that he would die at the hand of this grandson. But gods laugh at such

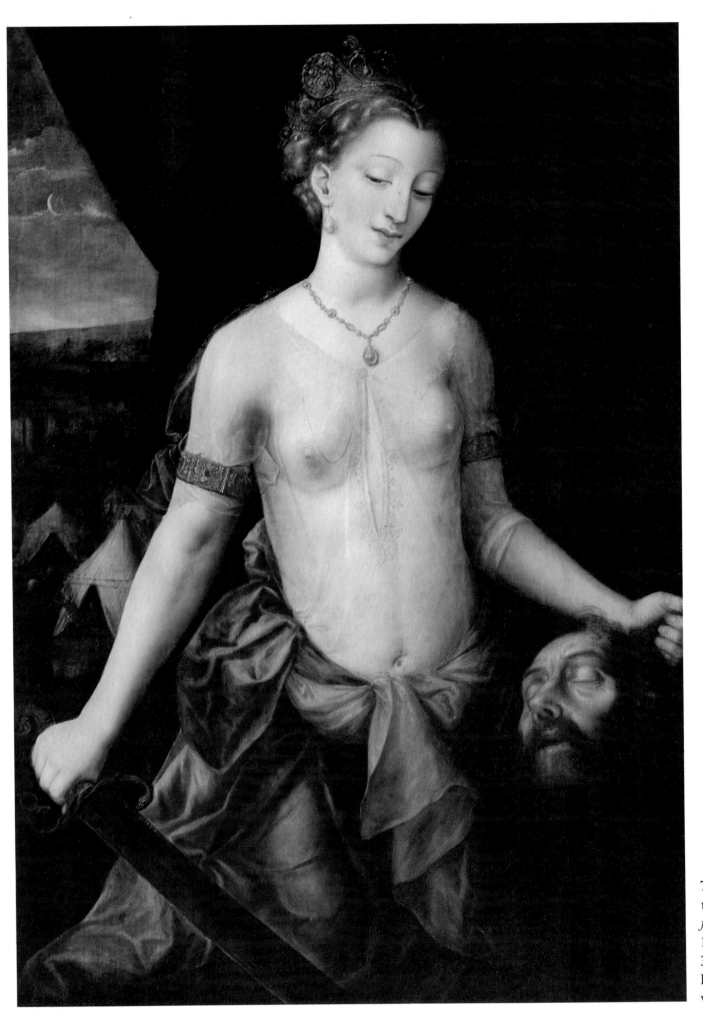

75 Jan Massys, *Judith with the Head of Holofernes*. Oil on panel, 115 × 80.5 cm (45¼ × 31¾ in). Antwerp, Koninklijk Museum voor Schone Kunsten

obstacles, and Jupiter fell in love with her and entered the impregnable tower metamorphosed into a shower of golden rain. In proper time Danaë bore Perseus who, quite by accident, one day killed his grandfather while practicing discus throwing.

Gossaert's is one of the earliest treatments of a theme that was to enjoy vast popularity in Italian painting of the sixteenth and seventeenth centuries, though there Danaë would be depicted mostly nude and reclining, with full acceptance of the erotic aspect of the tale. Gossaert, however, was working from the medieval interpretation in which the princess was the allegorical embodiment of virtue imperiled: gold corrupts. There was also a completely opposite medieval interpretation: Danaë was paralleled with the Virgin Mary who conceived through the Holy Spirit just as the Argive princess through Jupiter's golden rain.

A cool enamel-smooth polish of painting and a perfection in drawing are characteristic of the mature work of Gossaert. Also typical is the complicated and overstudied pose of the figure which no longer embodies the Renaissance postulate of free development of the individual but, instead, is almost a parody of the human image handed down from Antiquity. This work provides a key to the ambivalent and even ambiguous position of Gossaert and his time: open to the new, but still not wholly free from the medieval. The liberating watchword of human freedom was taken up but not understood. Danaë does not meet what is

happening to her as an independent personality with a mind and will of her own who could, if she wished, turn away the god as readily as any merely mortal suitor. Instead, she sits in her airy cage, like any small and frightened girl, a submissive instrument who in dumb amazement lets the unfathomable purposes of the god have their way with her.

But there is an inner tension that forever threatens to lacerate the late works of Gossaert, and here it operates between the cool, unapproachable, almost inhuman symmetry of the architecture, the majestically inviolable ordering of the whole, and the merely human creature imprisoned in it who lacks even a hint of the grandeur of soul such a setting calls for. And it is precisely that duality that brings the work closer to us, makes it understandable to us and even sympathetic, because it is more in tune with our present-day state of being than is the self-willed, self-sure, self-conscious unambiguity of the Renaissance. Gossaert was born sometime between 1478 and 1488, died in 1532, worked in Antwerp, Utrecht, Brussels, and Middelburg, never leaving the court service of one noble or another. The great of the time who awarded him commissions—he was also a portraitist of quality much sought after—must have found in his art an expression and reflection of their own understanding of themselves and their world, and for us he remains one of the most significant exponents of his age.

Although the Italian examples gained steadily in in-

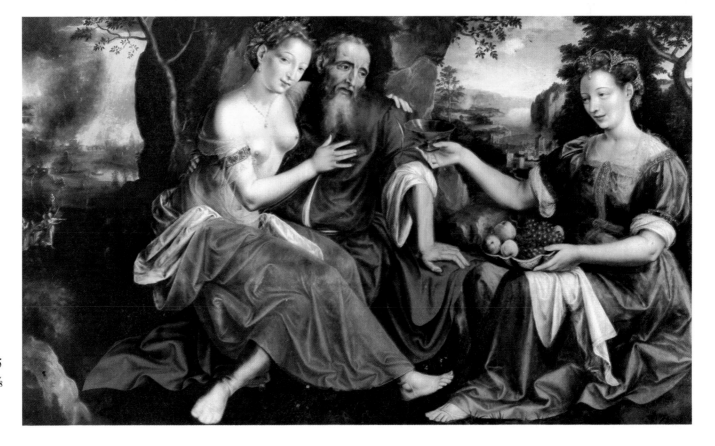

76 Jan Massys, *Lot and his Daughters*. c. 1565. Oil on panel, 92.5 × 154 cm (36⅜ × 60⅝ in). Cognac, Musée Municipal

fluence, the classical measure of Gossaert's Adam and Eve remained an isolated episode in Netherlandish painting during the sixteenth century. Younger painters, such as Jan van Scorel, developed the Italian models in other directions. Scorel may have known Gossaert in Utrecht and perhaps even joined his workshop, but in any case was for a time under his influence. Born in Holland in 1495, Scorel was drawn to Italy, to Venice first, though he left it for some months in 1520 to join a pilgrimage to Jerusalem. Through the protection of Pope Hadrian VI, a Hollander from Utrecht, in 1522 he was appointed curator of the papal art collections in Rome, a position once held by Raphael, but when his patron died in the following year he returned north. It was evidently Raphael, Michelangelo, and the Venetians who made the greatest impression on him. Raphael's fresco of the temptation of Adam and Eve in the Vatican Stanza della Segnatura was doubtless the model for Scorel's almost lifesized panel on that subject (73), but a world lies between them. The harmonious terseness of the Italian's form is broken down; the equilibrium in movement, characteristic also of Gossaert's early

work, gives way to an aggressive outward pathos. The action no longer takes place in a serene world apart from anything the viewer can experience but, with overt gestures, pushes over and out from the borders of the pictorial field. In the overemphasis on the physical qualities and in the drastic perspective foreshortening one is made aware of an approach conceived to take hold of the viewer by persuasion or, if need be, by force of surprise.

There is a certain distancing in the *Mary Magdalen* (74) posed with her ointment jar before a bizarre landscape. But when one looks again she loses that touch of restraint and almost pushes herself at us. Her gaze is coquettish, she swanks self-confidently in attire as sumptuous as that of the Venetian demimondaines Scorel would have encountered if not in the flesh at least in pictures by Palma Vecchio, Bernardino Licinio, and other painters of modes and manners in the lagoon-city. The indolent sensuality and comfortable spread of the woman, expressed too in the format of the picture itself, corresponds to the Venetian taste of the time, as does the landscape which could be lifted from a picture by Cariani. Not that the

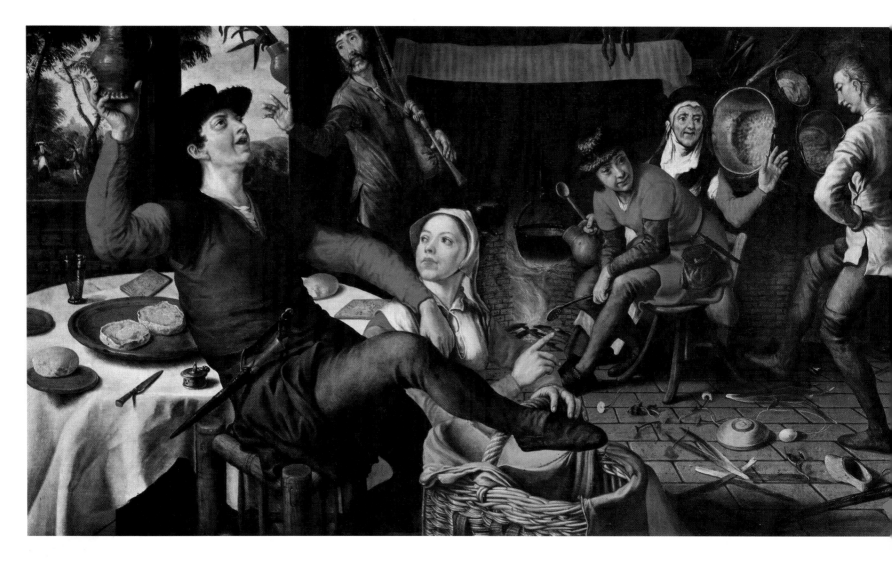

subject itself did not invite such approaches: the Magdalen scarcely led an impeccable life before joining the company of Jesus. In any case, before Scorel died in Utrecht in 1562 he came under all sorts of new stimuli, though the Italian influence remained decisive.

In none of his works did Jan Massys (1508-1575) attain the artistic rank of his father Quinten, though that influence had an abiding effect on everything he did. The year 1544 marked a caesura in Jan's work: as supporter of the Reformation he had to flee to Paris, and fourteen years had to go by before he could return to Antwerp. In France the school of Fontainebleau left its indelible mark on his style. He was partial to such Old Testament subjects as *Judith* [from the apocryphal book of Judith, especially 13:1-10] (75) with its possiblities for depicting feminine beauty and erotic appeal. Motionless, with sunken head, the Hebrew heroine stands at the entrance of the tent of the Assyrian general Holofernes whom she had approached through a ruse and then, when he lay in drunken sleep, decapitated. Though she holds the severed head in her left hand, the enigmatic gaze of her

77 Pieter Aertsen, *The Dance Over the Eggs.* 1557. Oil on panel, 84 × 172 cm (33⅛ × 67¾ in). Amsterdam, Rijksmuseum

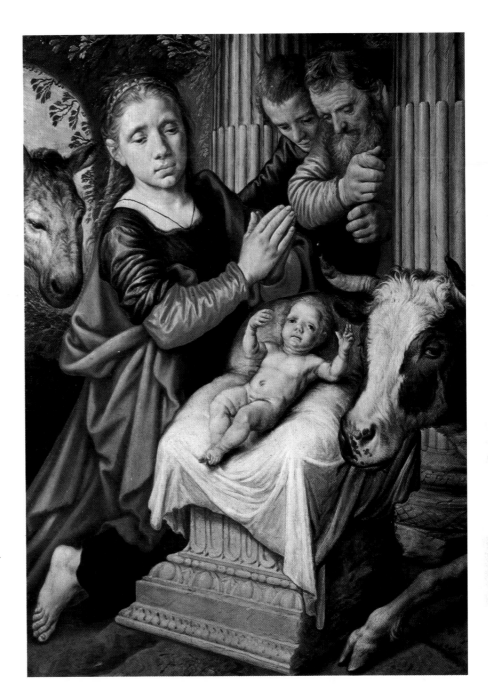

78 Pieter Aertsen, attributed. *The Adoration of the Shepherds.* Oil on panel, 87 × 63 cm (34¼ × 24¾ in). Rouen, Musée des Beaux-Arts

almond-eyes betrays no emotion. She seems, if anything, deep in thought. In the moonlight her upper body in its transparent veiling gleams against the dark tent wall. Her marble-cold beauty, her equivocal look that recalls Leonardo's portraits of women, speak clearly of the precious courtly style of Fontainebleau. Such paintings were obviously to the taste of collectors of the time: many of Massys' works survive in numerous almost identical versions.

An artistic personality second only to Pieter Bruegel the Elder—with whom he shared virtual independence from Italian influence—was Pieter Aertsen of Amsterdam (1508-1575). Admitted into the Antwerp painter's guild as master in 1535, Aertsen did not return to his native city until 1560. Like Bruegel he found subjects for innumerable paintings in the everyday life of the Netherlandish people, and even his

religious pictures scarcely step out of that contemporary milieu (78, 79). His highly animated compositions characteristically use strong warm coloring and large figures whose broad and sometimes almost uncontrolled gestures threaten to burst out of the picture space. The strong contrasts in light and shadow that make his figures stand out almost three-dimensionally anticipate certain effects of Caravaggio, as does the realism of his scenes.

In one of his best known painting, the *Dance Over the Eggs* (77), we are in an interior identified as a public house by the pitcher with its clutch of leaves hanging in the doorway. A young man is performing the egg-dance, a favorite peasant entertainment in the sixteenth century (when eggs were cheaper than today). An old woman and another young man watch with interest the dancer's maneuvers around the egg. No ballet-lover, a young carouser in the foreground bawls a song obviously appreciated neither by the girl crouched at his feet nor by the bagpipe player at the rear.

In its content this depiction of peasant pastimes takes something like a middle position between Bruegel's moralizing parable-like peasant pictures (93) and the ironic pothouse scenes of an Adriaen Brouwer with their exposure of human foibles and worse (138, 139). But Aertsen was a pioneer in his own right, in the still-life painting which in the next century would become so important for Netherlandish painting in general and that of Holland in particular, though he himself never painted a pure still life. The examples he did paint crop up as incidentals in such religious pictures as that of Christ in the house of Mary and Martha (79) where however they tend to take up more space than in earlier painters' works. Here, with an exuberance worthy of a Baroque still life, Aertsen spread utensils of daily life, flowers, and food across the foreground. Meanwhile what is ostensibly the main subject, Christ's discussion with Mary and Martha, is merely glimpsed through an open door in the background, almost as if by accident. Not that Aertsen is likely to have viewed the religious subject as merely a pretext to paint a still life. In this context the still life means more than itself, it has the kind of allegorical implications that would be the rule in the next century.

Like Aertsen, Jan Sanders van Hemessen (c. 1500-c.

79 Pieter Aertsen, *Christ in the House of Mary and Martha.* 1552. Oil on panel, 60 × 101.5 cm (23⅝ × 39¾ in). Vienna, Kunsthistorisches Museum

1573) delighted in everyday scenes. Born in Hemixen near Antwerp, in 1524 he was admitted as master into the Antwerp Guild of St. Luke and 1550 moved to Haarlem. Characteristic of his approach is an often exaggerated effort at three-dimensionality as well as a realism which often pushes his figures to the verge of caricature, as in the late so-called *Surgeon* where a quack performs a head operation outdoors on a city square (80). Assisted by an old woman and young girl, the self-made surgeon opens the forehead of a patient apparently strapped in a chair. An onlooker, perhaps a relative of the patient, rings his hands in horror. A scene from daily life—or is it? All the personages wear not contemporary clothes but Burgundian costume of the fifteenth century.

Such operations were know in Netherlandish as *van de kei*, removal of a stone. Popular superstition had it that stupidity and feeblemindedness were the result of a stone in the head (compare American slang: "rocks in the head"). Mountebanks made a nice profit out of a simple conjuring trick: after making a skin-deep incision into their foolish victim's forehead, they pro-

duced with a bit of legerdemain the stone that caused all his troubles and sent the poor fool home poorer and even foolisher. From quite early times the *van de kei* operations has been taken as an allegory of human stupidity, and while it seems not to have appeared in art before Bosch with that specific meaning there is no doubt that Hemessen's painting is to be read thus. This would make it not a pure genre scene but one of those moralizing depictions often inspired in the first half of the sixteenth century by the writings of Erasmus of Rotterdam. This might explain the return to the costume of the preceding century, to assure us that this is not, whatever it may seem, an ordinary scene from ordinary life.

It is really a long way from Patinir, with whom this chapter began, to Hemessen, and in summary it can be said that Netherlandish painting in the first half of the sixteenth century offered a many-sided spectrum distinguished by two chief currents: one indebted to Italy, the other more a product of local traditions, and of these the first would win out in the second half of the century.

Portraiture

82 Unidentified Artist (after a lost painting by Quentin Massys). *Portrait of Paracelsus*. Oil on panel, 72 × 55 cm (28⅜ × 21⅝ in). Paris, Musée National du Louvre

The great Netherlanders of the fifteenth century had already ventured into portraiture, and in this, as in so much else, that century took the decisive step. What Burckhardt called "the discovery of man" came about when people began to know themselves as individuals in their own right. For long the norm for depicting human features and forms was the generalized "objective" appearance at first attributed to saints and their like: the sum of numerous expressive qualities considered beautiful and beautifully formed. This meant a kind of universal abstract uniformity, and only in the course of the centuries was it accepted that what is expressive and admirable resides in the faces and figure and movements of individuals: something rather like what happened with the treatment of character when Shakespeare came on the scene.

The breakthrough to well-characterized individuality came about in Italy and the Low Countries at much the same time, in the early years of the fifteenth century. Jan van Eyck's donors on the exterior of the Ghent altarpiece of 1432, the *Man with the Red Turban* of 1433 (12), and the Arnolfini marriage picture of 1434 (11) show his gift for catching the essence of a specific personality. Rogier van der Weyden likewise, in his busts or waist-length portraits (23, 24), caught the feel of individuals, though always against a neutral background and never matching Van Eyck's amazing range of characterization. Petrus Christus, like Van Eyck, dispensed with the neutral ground (17), Memling could set a portrait fully into a landscape and do so with sheer mastery (34).

The portraits of the next major master in the line, Quinten Massys, are indebted to Memling for basic approach. Massys was much admired in his time; particularly the likenesses he did in 1517 of Erasmus of

83 Joos van Cleve,
Margaretha Boghe
(pendant to a matching
portrait of her husband
Toris W. Vezeler). c.
1520. Oil on panel, 57.1
× 39.6 cm (22½ ×
15⅝ in). Washington,
National Gallery of Art

84 Jan Vermeyen,
*Erard de la Marck,
Prince-Bishop of Liège.*
Oil on panel, 64 × 54.5
cm (25¼ × 21½ in).
Amsterdam Rijks-
museum

85 Dirck Jacobsz, *The Palatine Count Pompeius Occo (1483-1537)*. 1531. Oil on oak panel, 66 × 54 cm (26 × 21¼ in). Amsterdam, Rijksmuseum

86 Cornelis Anthonisz, *Banquet of Seventeen Members of the Civic Guard* (with the artist himself in the upper left corner holding a stylus). 1533. Oil on oak panel, 130 × 206.5 cm (51⅛ × 81¼ in). Amsterdam, Rijksmuseum

Rotterdam and Petrus Aegidius, both of them humanists and friends of his, were widely imitated. The original of the powerfully effective portrait of Doctor Paracelsus (82, a copy) is unfortunately not known now, but a century later it impressed Rubens so much that he copied it (Brussels, Museés Royaux des Beaux-Arts). In another portrait (81) the landscape background was probably done in collaboration with Joachim Patinir who, it is known from documents, took over that task for Massys on several occasions.

Both Massys and Joos van Cleve, an Antwerper much influenced by him, went beyond what Flanders itself could give them and must have been acquainted with the portrait art of Leonardo da Vinci. The quiet play of color in a face and the careful gradation of tones in something like Joos's portrait of a young woman with a carnation (83) recall the poetic lyrical mood with which the great Italian infused his *Mona Lisa* of 1503. What could be considered an artistic weakness in the two Antwerpers, that in their portraits they rely a good deal on eloquent gestures of the hands, can be justified as a deliberate secondary, or accessory, expressive means: the symbols that former-ly were richly strewn through the scenic background are now placed in the hands of the individuals portrayed. Not so, however, in Jan Vermeyen's portrait of Erard de la Marck, Prince-Bishop of Liége (84). He holds nothing but seems to be counting on his fingers, a gesture that indicates deliberation and underlines even more the striking presence of that overweening wielder of temporal power in the name of the Church. The hands are used here to bring out even more convincingly what Dostoevsky called "the moment when the model most closely resembles himself," and here everything is staked on that aim, calculated for it.

Specialization in portraiture was catching on. When an exceptionally successful expert in that domain appeared—someone like Anthonis Mor—he was literally handed from court to court. An even more daring step toward a gripping expressive force was taken by Frans Floris in his portrait of the wife of a falcon hunter (88), described by F. Winkler as, "thanks to the harsh earthiness of the sitter, the most splendid female portrait of the sixteenth century in the Netherlands, of a racy directness and strength that

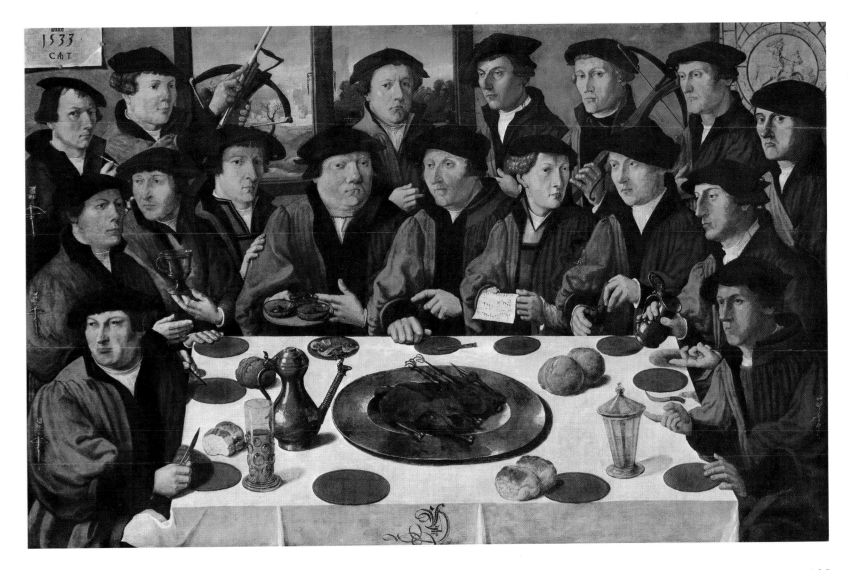

calls to mind Jordaens." But the real importance of Floris lies more in the field of narrative painting.

Dutch portrait artists were not always a match for those across the border, though the Dutch were the real pioneers in broadening the field from the individual to the family or group portrait. As in Flanders, portraits in the northern Netherlands too took their life from the new self-awareness and the greater need of the various estates and classes to show themselves at their best. The Pompeius Occo painted by Dirck Jacobsz. (85) was an Amsterdam banker and humanist, while Cornelis Anthonisz.'s rather monotonous circle around a table (86) presents the Amsterdam civic guard presumably using the name-day banquet of their patron Saint George (recognizable in the stained-glass medallion at the upper right), as the pretext for having their portraits taken. The spectrum was broad: the family portrait by Heemskerck (87) was patently done from life, and it is only in the nurseling that old conventions are followed. The way was set for the portrait art of the seventeenth century, and perhaps all that was still lacking was the deeper insight into the psychological and spiritual sides of the persons portrayed.

87 Maerten van Heemskerck, *Family Portrait*. c. 1530. Oil on panel, 118 × 140 cm (46½ × 55⅛ in). Kassel, Staatliche Kunstasammlungen

88 Frans Floris, *Portrait of an Elderly Woman*. 1558. Oil on panel, 107 × 83 cm (42⅛ × 32⅝ in). Caen, Musée des Beaux-Arts

Pieter Bruegel

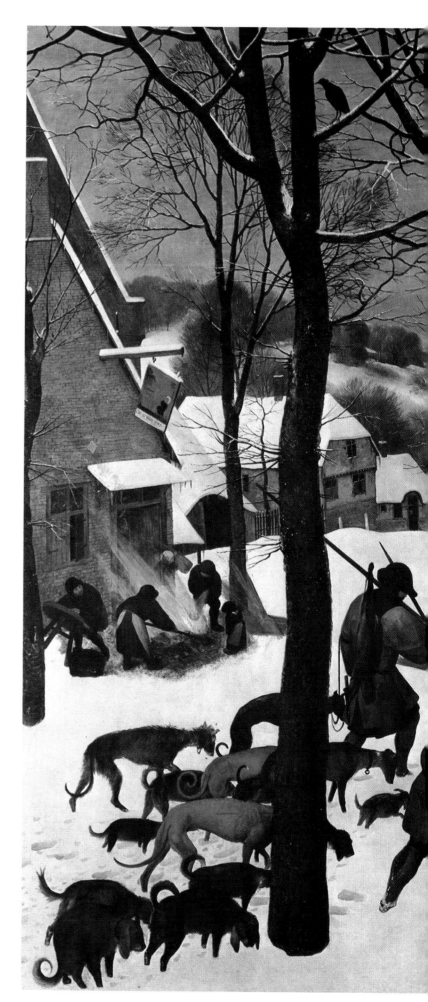

89 Pieter Bruegel the Elder, *January: The Return of the Hunters.* 1565. Oil on oak panel, 117 × 162 cm (46⅛ × 63¾ in). Vienna, Kunsthistorisches Museum

When Domenicus Lampsonius, a painter and writer on art, wished to praise Pieter Bruegel in the Netherlandish parallel to Vasari's *Lives* he published in 1572, he hailed him as the "new Hieronymus Bosch," obviously having in mind Bruegel's dreampictures of infernal happenings and creatures like his *Dulle Griet* (91). Others, like Carel van Mander, considered Bruegel more as a careful observer and depicter of reality, of village life especially (92), a notion that later earned him the byname of "Peasant Bruegel." Both writers pinpointed only particular aspects of Bruegel's work, yet, with some oversimplification, summed up the contradictory duality in his paintings and engravings alike: fantastic art and naturalism, tradition and innovation.

Pieter Bruegel, called the Elder to distinguish him from his son of the same name, was born around 1525-30, probably near Breda. Van Mander's biography of him is both the earliest and the most extensive, and speaks of study under the Antwerp Romanist Pieter Coecke van Aelst. In 1551 Bruegel became a free master in the Antwerp St. Luke's Guild, the painters' organization, and soon afterwards he left on an extended trip to Italy that we know about from numerous drawings. Back in Antwerp in 1555 at the latest, he prepared drawings for the copperplate engraver and publisher Hieronymus Cock, and began to paint a few years later. In 1563 he moved permanently to Brussels where he died in 1569. Of his marriage to Mayken Coecke three children were born, of whom Pieter the Younger (1564-1638) and Jan the Elder (1568-1625) continued in their father's profession.

These few facts are almost all we know of Bruegel's

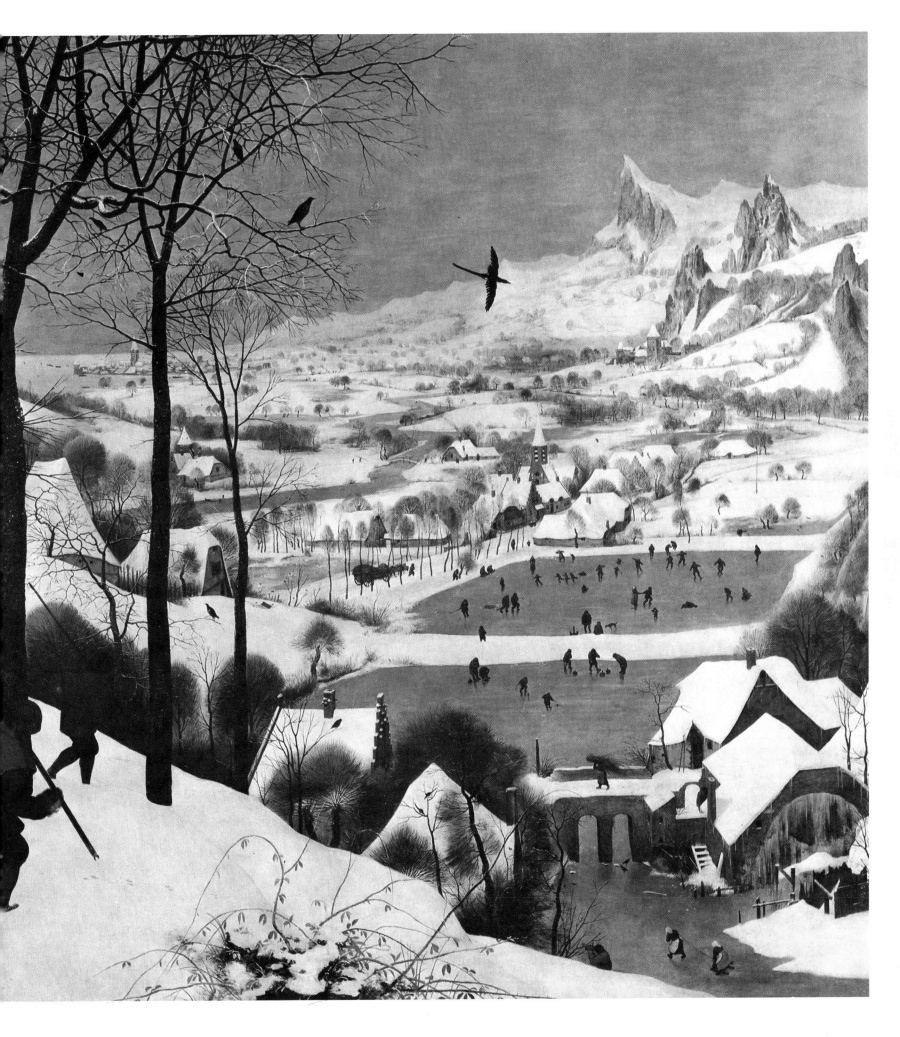

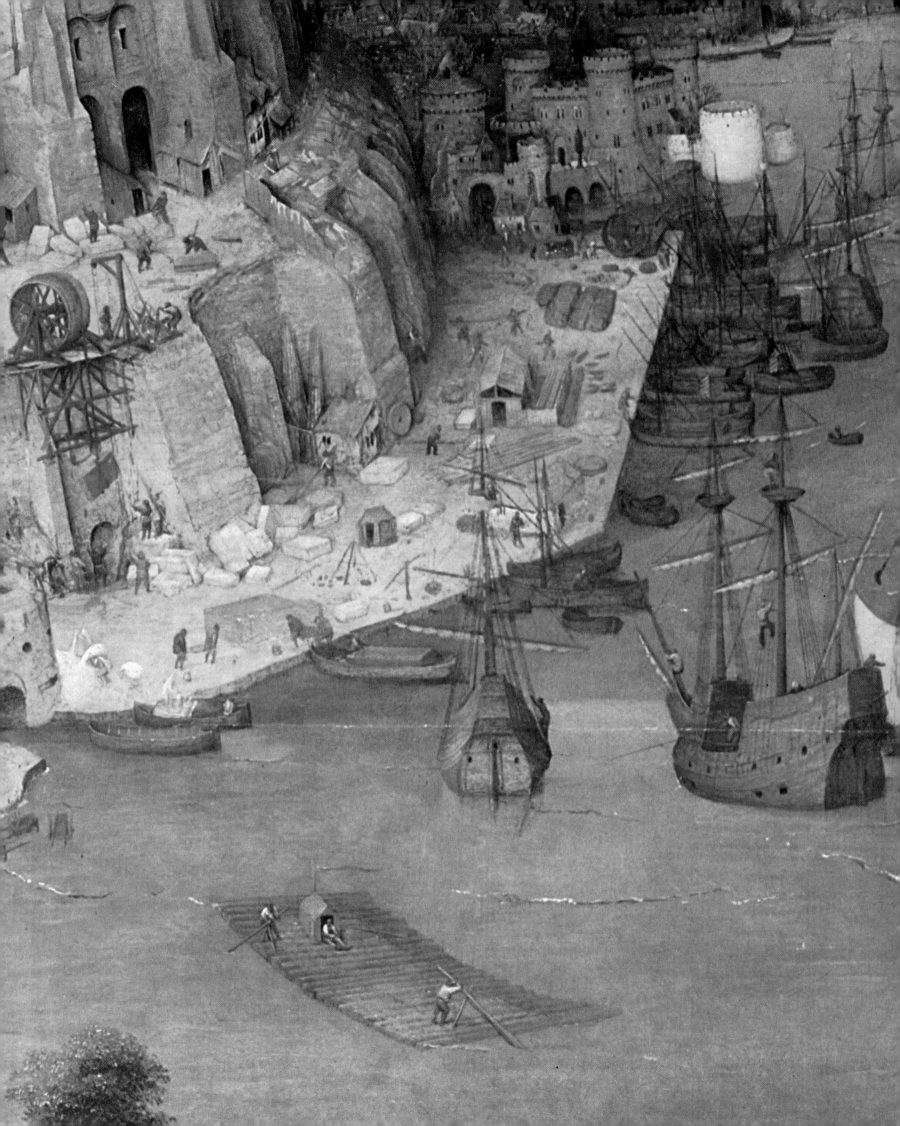

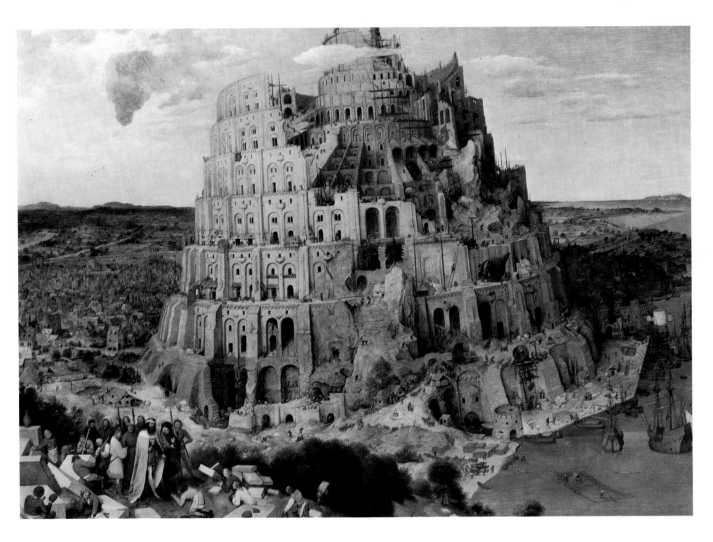

life, and they say nothing of his personality. His works, however, do occasionally fill in the gaps in the biography: his travels to and in Italy, for instance, can be reconstructed from his quite precise topographical drawings. Yet the key question remains, despite what Van Mander reports: we do not know who his teacher was. Not even his early works have anything in common with the Italianizing paintings of Pieter Coecke or any of the Antwerp Romanists.

His earliest known works are drawings, both landscape views of the Italian journey and models for Hieronymus Cock's engravings. His orientation was clearly Netherlandish. The twelve so-called *Large Landscapes* published in 1555 occasionally recall the worldlike expanses of the imaginary views by Patinir and his school, whereas in his almost thirty allegorical figure compositions one senses the influence of Bosch, particularly on the series of c. 1558 with the *Seven Deadly Sins*. Not only did Bruegel derive his demoniac motifs from inventions of the 's-Hertogenbosch master, he laid out his drawings in the Bosch manner: the high-lying horizon creates an infinitely vast landscape in which, as in Bosch's *Garden of Delights* (47-49) one can nonetheless read a swarming throng of

finely detailed motifs.

An old-fashioned approach to composition, then, was still in use in his early paintings. But Bruegel's career as a painter was extremely short, and his "early" paintings date already from the final decade of his life. Not before 1559/60 are there any paintings we can be sure are from his hand, and their subjects are drawn from children's games, Netherlandish proverbs, and the "battle" between Carnival and Lent. In these, as if on display shelves opened before our eyes, groups of small figures are scattered about seemingly arbitrarily, playing children's games, acting out proverbs, or carrying on in devilish fashion like the weird creatures accompanying Dulle Griet.

In themes as well, Bruegel's early paintings are often connected with Bosch. The latter's *Cure for Folly* (*Removing the Stone,* Prado, Madrid) is unquestionably an ancestor of Bruegel's pictures on proverbs. Both castigate human stupidity and confront us with pictures of a topsy-turvy world and our own foolishness. The most puzzling of the early paintings is the *Dulle Griet* (Mad Meg) of 1562-63 (91, 91a), whose devilish character most clearly points back to Bosch. It has been read as a political allegory attacking the

Spanish oppression of the time but also as an occult exhibition of alchemical doctrine. But the raving and even rabid madwoman wearing a kitchen apron along with armor surely embodies the power-become-flesh of woman, whom Bruegel seems to have thought of as an evil, greedy, violent-tempered creature terrifying even Hell and all its devils.

Although in his first paintings the landscape — a subject, we have seen, Bruegel had studied in and for itself in his drawings — served for little more than a background screen to tie together the various groups and the action, in the mid-1560s he took to painting large views from nature. In 1565 he produced a sequence of pictures of the months of which five have survived, among them the *January: Return of the Hunters* (89), where hunters bent with weariness and followed by their half-frozen half-lamed pack return to a typical Flemish village. The village is transplanted, however, to the foot of steep Alpine peaks, while in the left background the view dissolves into an open sea. This is

91a Pieter Bruegel the Elder, *Dulle Griet (Mad Meg)* (detail)

112

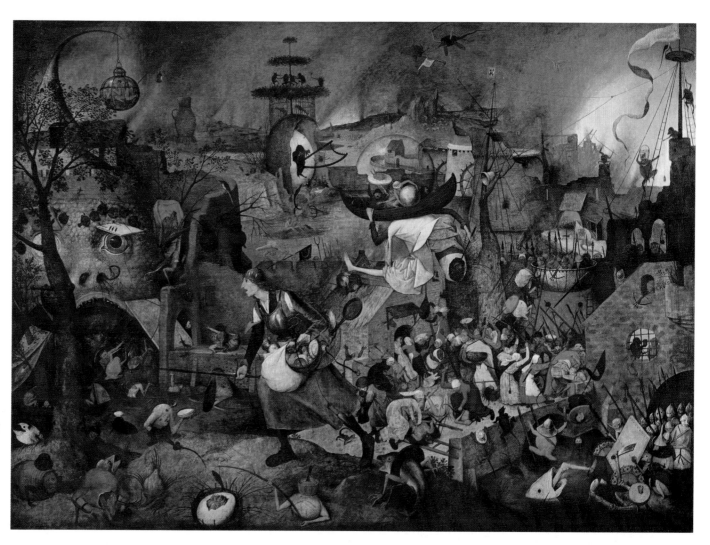

91 Pieter Bruegel the Elder, *Dulle Griet (Mad Meg).* c. 1563. Oil on oak panel, 115 × 161 cm (45¼ × 63⅜ in). Antwerp, Museum Mayer van den Bergh

certainly not a real view, a topographical *veduta*. Nor in fact is the alignment of four trees in the line of direction taken by the hunters something observed in nature. It is a deliberate artistic compositional device serving to intensify the effect of depth. Landscape phenomena of very different places are artfully combined into an imaginary panorama, and the union of so many diverse elements, the clear separation of planes from front to rear, and the high viewing point all recall Patinir's way of dealing with landscape. Likewise the idea of showing different seasonal activities—hunting, harvesting, driving the cattle down from the highlands— has its roots in earlier art, at least as far back as the calendar miniatures the Limbourg brothers painted in the early fifteenth century (2, 3). Much, however, has changed. In the early scenes it is the human activitiy that is the main point; with Bruegel it is much more the way the landscape changes in the course of the year, how light, color, air, warmth, or coldness differ in each season. So if his pictures of the months continue to be tied to the Netherlandish tradition in many respects, his attempt to render atmospheric effects and moods represents a higher phase in the history of landscape painting, one

that would have its climax in seventeenth-century Holland.

Little as Bruegel in his early pictures, with their miniature-like swarms of figures and precision of detail, limited himself to recording folkloristic doings, little as his calendar-paintings render the physiognomy of any particular landscape, so little too do his paintings on biblical themes merely illustrate the story.

In 1563 he produced a painting (90, 90a) on the Bible story [Genesis 11] of how the descendants of Noah raised a tower to reach as high as Heaven and to be a sign of their own fame, for which *hubris* the Lord destroyed their tower and "scattered them abroad from thence upon the face of the earth" and confounded their languages.

Within a spreading Gothic city laid out in a flattish seacoast landscape Bruegel depicted the unfinished Tower of Babel whose uppermost platform is higher even than the clouds and whose incredibly monumental vastness is brought out even more by the tininess of the houses around it and the builders' workshops that cling to it like swallows' nests. In the left foreground a great king, for whom it is being raised, approaches

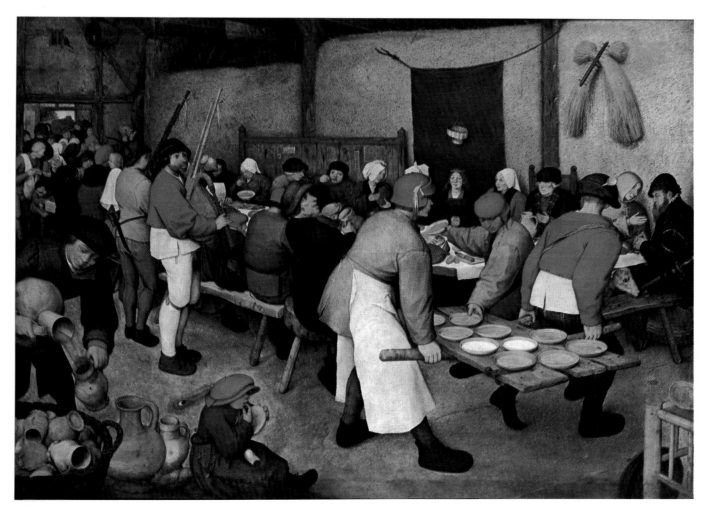

with his escort. The activities of the stonecutters and masons are depicted in ample detail. The working procedures, tools and equipment, means of transport being used to build the great construction (whose upper part is much like the Colosseum in Rome) are scrupulously portrayed. Because of this Bruegel's Tower of Babel, with its encyclopedic display of architectural knowledge, has been intepreted as a symbol of the human will to order and of human progress. Others, however, read this painted praise of architecture as a denunciation of the vanity of human efforts since, despite its wealth of invention and all the great work deployed in it, the architectural folly of the Tower of Babel will come to nought through the power of the Lord. The viewer is presumed to know the outcome of the story; this will make him take to heart its warnings against the vanity of all things earthly and the perils of pride.

To that same range of themes belongs one of Bruegel's last works, *The Blind Leading the Blind* of 1568 (93), painted in tempera on canvas and unfortunately now much rubbed off. Five blind men place their trust in a blind leader, and their diagonally laid-out procession can end in only one thing: in a ditch into which their guide himself has just fallen. The man behind him is caught, as in a snapshot, in the act of

stumbling over him, and we are left in no doubt that all the others, helpless and passively trusting, will meet the same wet end. Their unsteady steps and desperate but vain blank stares from empty eye-sockets are depicted with terrifying precision. Yet Bruegel, who often painted outsiders and outcasts, asks no pity for his blind men. He is telling a parable of an upside-down world where the blind let themselves be led by the blind. Their infirmity is to be understood figuratively, as gullibility and misplaced confidence, and in fact the copperplate engraving Bruegel brought out in the same year has an inscription admonishing all of us to go our way with forethought and to trust God alone.

The theme goes back to the New Testament [Matthew 15:14] and Jesus' dismissal of the Pharisees: "Let them alone: they be blind leaders of the blind. And if the blind lead the blind, both shall fall into the ditch," a parable signifying that those who are blind in soul and spirit can never see into the meaning of revelation. In texts of Bruegel's time that followed the only recently reformed concepts of church and faith, the biblical parable was read as a criticism of the Catholic Church, which was accused of clinging to a conservative position and of permitting its blind—that is, unknowing—priests to continue to lead equally blind

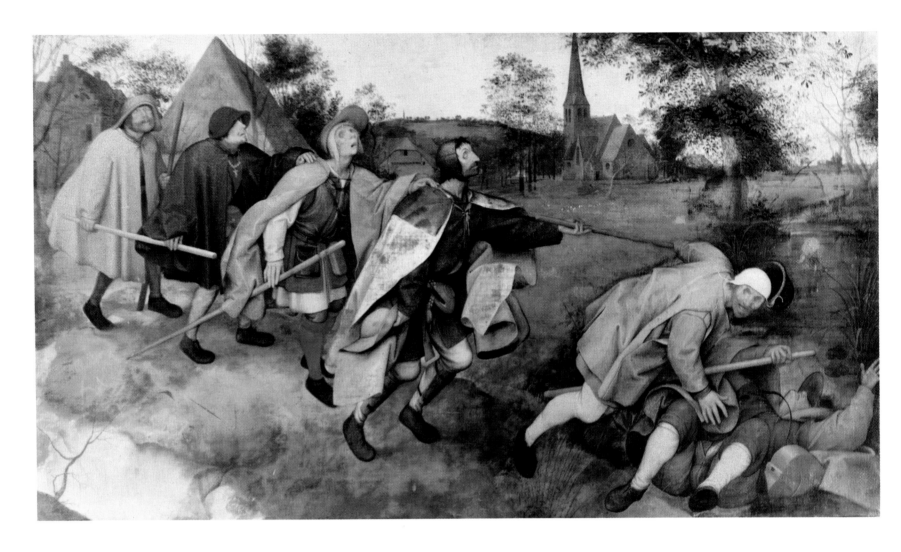

congregations. We know too little of Bruegel to say for certain if his picture expresses that sort of anti-Catholic propaganda current in his time, or even to presume him to have been a partisan of the Reformation. But neither can we ignore—be blind to—the fact that this woeful scene is played before a church in front and alongside of which stand withered trees, an old symbol of vanity and fruitlessness. Moreover, with their crosses and rosaries, staves and hats, the blind men are identified as pilgrims and therefore perhaps to be understood as Christians [Catholics] who go in mistaken ways since their eyes remain closed to the new church.

Bruegel had treated this theme earlier, in the background of the *Netherlandish Proverbs* of 1559 (94). The group of very small figures, barely visible in the remotest upper right distance, is already so much like the one in the parable-picture of 1568 as to make that picture seem almost an enlarged detail. This change reflects the general shift in Bruegel's style. After the painter moved to Brussels he took to painting monumental individuals as exponents of the action rather than a swarm of tiny figures. The *Adoration of the Magi* of 1564 (London, National Gallery) focuses entirely on the large main figures, and was followed by other pictures with that approach: a *Christ and the Woman Taken in Adultery* in 1565 (London; private collection), and the *Misanthrope* (Naples, Capodimonte Museum) and *The Proverb of the Bird's Nest* (Vienna, Kunsthistorisches Museum) in 1568. Unless we assume that the gradual stylistic change came about at the unknown behest of unknown patrons, it seems more likely that in his last years, and on his own initiative, Bruegel came to terms with Italian Renaissance and Mannerist art. What he had done in Antwerp was still largely a product of the local tradition, but in the late paintings he took over, varied, and reworked to his own purposes both compositional and figural motifs from Italian masters.

The Italian influence is reflected even in the paintings to which Bruegel owes his fame as portrayer of a racy, down-to-earth Flemish folk life. Van Mander reports that the painter often attended village festivities and took pleasure "in observing the behavior of the peasants in eating, drinking, dancing, frolicking about, wooing and other droll carryings-on, which he then was able to render very amusingly and pleasingly in paint." No picture corresponds better to the notion

93 Pieter Bruegel the Elder, *The Blind Leading the Blind*. 1568. Tempera on canvas, 86 × 154 cm (33⅞ × 60⅝ in). Naples, Museo e Gallerie Nazionali di Capodimonte

of Bruegel as naturalistic painter of peasant life than his *Peasant Wedding* of 1568 (92, 92a). In a barn, cleaned out for the occasion, the wedding guests crowd around a table which the painter views from a diagonal position. Two bagpipe players squeal away, while two helpers — sturdy men tightly packed into their clothes — serve the meal from a door pressed into service as a tray. The man at the far right end of the table, obviously a townsman, has been taken to be Bruegel himself and adduced as proof of Van Mander's account of his habits. But a closer look makes one doubt that this is a faithful picture of any real gathering. There is, for instance, the firm compositional structure made up by the vertical supports of the timberwork in combination with three marked diagonals: one made by the two servers with their door-tray, another by the table itself, the third by the tops of the caps worn by the man filling pitchers in the lower left corner and the child licking its fingers. That the disposition of figures and objects is not, as it seems, a matter of chance but of careful composition is shown by an apparently entirely unimportant motif which however is most subtly worked out: in the lower right corner a chair, cut off by the margins, repeats the main verticals and diagonals of the composition. Add to this that the general plan of the painting may go back to a *Last Supper* by Tintoretto. Altogether, we must conclude that "reality" has been structured by the artist. Yet here, as in the *Return of the Hunters*, one is aware of no artifice, no effort to make a picture for and in itself. Instead, through thoughtfully devised structures and symbols of reality as the artist beheld it, such pictures speak more convincingly of nature, of its atmosphere, of men and their actions than a naturalistic reflection, a mirror-image devoid of thought, ever could.

94 Pieter Bruegel the Elder, *Netherlandish Proverbs*. 1559. Oil on panel, 117 × 163 cm (46⅛ × 64⅛ in). Berlin-Dahlem, Gemäldegalerie

95 Jan Bruegel the Elder, *View of a Harbor City with the Continence of Scipio.* 1609. Oil on copper, 72.5 × 107 cm (28½ × 42⅛ in). Munich, Alte Pinakothek

96 Joos de Momper, *Mountainous Landscape with Bridge.* Oil on oak panel, 53 × 71.5 cm (20⅞ × 28⅛ in). Cologne, Wallraf-Richartz-Museum

Flemish Landscape Painting

The Netherlander, says the Dutch writer Anni Romeyn Verschur, is "a person who sees." Such a gift for accurate and affectionate observation is a basic trait of Netherlandish painting in general, and is of the greatest importance in landscape art. It may well have been the prime reason why, right from the early sixteenth century, Netherlandish landscape pictures became much sought after abroad: as early as 1535 the dealer Matthieu de Nasar exported more than three hundred of them to Italy.

97 Lucas van Valckenborch, *View of the Town of Huy.* 1567-70. Oil on panel, 24 × 33 cm (9½ × 13 in). Antwerp, Koninklijk Museum voor Schone Kunsten

98 Gillis Claesz. D'Hondecoeter, *Landscape*. 1613. Oil on panel, 49 × 83 cm (19¼ × 32⅝ in). Antwerp, Koninklijk Museum voor Schone Kunsten

Among the most renowned Flemish specialists in this field was Jan Bruegel the Elder (1568-1625), the first son of Pieter, and he was no less famous as a flower painter (136, 137). After an apprenticeship in Antwerp, about which little is known, he went to Italy where he found an ideal patron in Cardinal Federico Borromeo who would continue to order pictures from him even after his return to Antwerp in 1597. Bruegel's prestige in his native city is evident from the fact that he was among the close friends of Rubens and that such a great master did not disdain to paint the staffage figures in a number of Bruegel's landscapes. Although Bruegel exploited all the types of landscape developed during the sixteenth century, he still relied often on the characteristic type of vast "world-landscape" devised generations earlier by Patinir (58, 59), with its world-in-miniature combining the most diverse motifs and viewed from above as if through a peepshow-slot. What is more, Bruegel still kept to the system of coloristic and atmospheric perspective, though he was at pains to bring it into accord with the laws of linear perspective. The particular fascination of his paintings resides in their unstinting imaginativeness and a painstaking miniature-like execution (95).

Joos de Momper (1564-1635) worked along much the same lines, though his landscapes are less minutely detailed and miniature-like than those of his friend Jan Bruegel (who occasionally painted the small figures in them). Despite their numerous bizarre rock

formations, they characteristically have a strong feeling for nature that comes out especially in a naturalistic coloring (96). Further, the distant background—an essential element with Bruegel—plays a secondary role with Momper.

While the highly detailed distant-view landscapes of a Jan Bruegel or Joos de Momper were the dominant type in Antwerp, in nearby Mechelen a group of painters carried further the type practiced by Pieter Bruegel the Elder in which the scene is garnished with everyday genre details. Among them was Lucas van Valckenborch (1530/35-1597) whose life and career were much affected by the struggle for freedom in the Netherlands. As early as 1566 he had to leave his native Louvain because of his sympathy for the Reformation. After entering the service of archduke Matthias in 1577 he settled in Linz, Austria, in 1581, moving in 1597 to Frankfurt. His landscapes are more realistic (a relative term, in this context) than those of his Antwerp contemporaries, their cut and composition usually tighter, the view more close-up, the coloring less artificial. The view of Huy (97), a river landscape with swineherds on the near bank, shows his concern with recording specific sites.

Gillis van Coninxloo (1544-1607) likewise had to flee from his Antwerp home in 1587 because of his religious convictions. He made his way to refuge in Frankenthal, a Netherlandish artists' colony in Germany, and finally in 1595 in Amsterdam where he introduced the Flemish tradition. His particular achieve-

99 Gillis van Conixloo, attributed. *Landscape with Elijah Fed by a Raven*. Oil on canvas, 115 × 178 cm (45¼ × 70⅛ in). Brussels, Musées Royaux des Beaux-Arts

ment and innovation was the landscape observed closer-to (99), which meant abandoning the traditional peepshow-principle of the remote view with planes staggered one behind the other like stage-scenery flats and fading into remotest mist. Instead he gave new importance to the immediate foreground whose sole purpose, with his predecessors, had been to emphasize the depth of the pictorial space. The new prominence given to the foreground ruled out the use of all that wealth of motifs afforded by the Mannerist remote-view landscape-as-microcosm. Coninxloo, however, created a new motif, the forest landscape and its views through masses of trees with their abundant foliage and bizarrely twisted trunks, something truly novel since the forest had always been relegated to a more or less subordinate role in landscape compositions. In the painting seen here, a hilly terrain with a stand of oak trees takes up some two-thirds of the picture space, and the real subject of the picture is the trees and the way their trunks and crowns overlap and intersect. A gap in the forest affords a view down to a rivercourse which fades away in the distance between mist-bathed

hills. If this latter note is much as in the earlier world-view landscapes, it remains no less true that there is a real difference in the prominence allotted to the foreground.

New also in the landscapes of Coninxloo is the function of light and shadow. With Jan Bruegel the Elder, their chief importance was to articulate the pictorial space; with Coninxloo, it is to create and convey the mood. He was the first to recognize the picturesque effect of light slanting through trees and to make it the chief motif in innumerable forestscapes in which the human figure is no more than an accessory, literally a "walk-on." By his settling in Amsterdam, this new approach came to have more impact on Dutch than on Flemish landscape painting and favored the development of a specifically Dutch conception.

The close-viewed landscape style of Coninxloo was carried further by Gillis Claesz. d'Hondecoeter (1580-1638), another who quit Antwerp because of his religious position, settling first in Delft, then for twenty-five years in Utrecht, and in his last years in Amsterdam (98).

No less atmospheric than the landscapes of Coninxloo are those of Roelant Savery (1577-1639) of Kortrijk (Courtrai). He too emigrated for religious reasons, and his life was spent mostly in restless wandering. After a short stay in Amsterdam, he entered the service of Emperor Rudolph II and his successor Matthias II in Prague from 1604 to 1615. In 1616 he returned to Amsterdam and three years later finally settled in Utrecht. His is a kind of fairytale world, with landscapes inhabited by animals of all sorts mostly living together in a Garden-of-Eden peace. Human figures had virtually no importance for Savery. He was partial to ruins overgrown with trees and vegetation, as if built by vanished humans in vanished epochs. When on occasion these scenes of primal life include people, they are usually figures from Greek mythology such as Orpheus whose song might beguile the beasts, though not in the picture seen here (100). In this far from idyllic scene the Bacchantes in their rage dismember the sweet singer while the innocent wild animals flee in terror: man, for Savery, will always destroy the Earthly Paradise.

Although Savery's paintings are often held up as forerunners of the large-format seventeenth-century Flemish pictures of animals and the hunt, his lyrical landscapes with animals are so unlike those often gruesome hunting scenes that there can be no more than the most superficial connection.

Although a few painters gave signs of a realistic tendency, throughout the second half of the sixteenth century and the early seventeenth Flanders continued to produce artistically composed imaginary landscapes of an unreal world. The Dutch however, in the seventeenth century, would paint something very different: real meadows traversed by real canals, herds grazing, and the particular light and atmosphere of their own countryside. Nevertheless, with so many Antwerp artists choosing to live in Holland, the Flemish approach to landscape painting had an enormous influence there and became no less important in the new Dutch Republic than in the still Spanish-dominated southern Netherlands. Later, Rubens would depict the Flemish flatlands and peasantry not without a certain native idyllic cast, and to some extent he would reconcile the differences between north and south that political disunion had exacerbated.

Mannerism and Caravaggism in Haarlem and Utrecht

In the first half of the sixteenth century numerous Flemings—Quinten Massys, Jan Gossaert, Joos van Cleve, and others—and Hollanders like Jan van Scorel and Marten van Heemskerck had often quite lengthy sojourns in Italy. Their own formal vocabularies, still in some ways bound to Late-Gothic canons, became enriched with stylistic traits derived chiefly from the followers of Raphael and from Michelangelo. Still it remained for the Antwerper Frans Floris, in the paintings he did in the 1540s and 1550s on mythological and profane themes, to translate that so-called Romanist quasi-Renaissance style into more energetic and complex pictorial structures. Reworking as he did virtually all types and fields of Italian Mannerism, he became

101a Cornelis Cornelisz. van Haarlem, *The Marriage of Peleus and Thetis: The Banquet of the Gods* (detail)

101 Cornelis Cornelisz. van Haarlem, *The Marriage of Peleus and Thetis: The Banquet of the Gods*. 1593. Oil on canvas, 246 × 419 cm (8 ft 7⅛ × 13 ft 9 in). Haarlem, Frans Hals-Museum

known with some justice as "the Flemish Raphael."

Engravings after Italian Mannerist paintings became known throughout the Low Countries thanks chiefly to Floris and his workshop. From about 1550 it became the vogue to exploit their motifs and ideas in one's original works, and after 1580-90 there was even greater indebtedness to prints after Raphael, Dürer, Lucas van Leyden, and other earlier masters. The most successful agent and promoter of that somewhat indiscriminate eclecticism was the engraver Hendrik Goltzius. In 1582 he opened his own publishing workshop in Haarlem, and in the following year joined Cornelius Ketel and the painter and humanist Carel van Mander in organizing a school along the lines of the Bologna academy where painters could learn to draw from the nude, something indispensable to the new Mannerist themes and style. Besides engravings after Italian works, Goltzius also brought out compositions by Bartholomeus Spranger (1546-1611) who in consequence became the best known exponent of

the mature phase of Netherlandish Mannerism. Together with Frederik Sustris (1520-1591), Jan van der Straeten (1523-1605), and Peter de Witte (around 1548-1628) — who worked in Italy, chiefly Florence, and to such an extent that the latter two are better known as Giovanni Stradano and Pietro Candido — Spranger not only created an authentically Netherlandish Mannerism but gave it a far-reaching international character. He left his personal mark on the local aristocratic styles of Vienna, Munich, Augsburg, Prague, and the other capitals to which his fame took him.

Sustris and Spranger gave the decisive turn to the Mannerist style of the so-called Haarlem school, whose chief representatives were Carel van Mander and Cornelisz. van Haarlem, as well as to the Utrecht school headed by Abraham Bloemaert and Joachim Antonisz. Wtewael. Netherlandish Mannerism thenceforth took its cue from those two centers. In contrast to the French Fontainebleau

102 Abraham Bloemaert, *The Preaching of Saint John the Baptist.* c. 1600. Oil on canvas, 139 × 188 cm (54¾ × 74 in). Amsterdam, Rijksmuseum

103 Joachim Antonisz. Wtewael, *The Marriage of Peleus and Thetis: The Banquet of the Gods*. 1589/99. Oil on copper, 16 × 21 cm (6¼ × 8¼ in). Munich, Alte Pinakothek

school, whose masters were mostly Italian and Netherlandish, the Netherlanders took their orientation from the Florentine Giorgio Vasari and the Zuccari brothers in Rome, adding French stylistic traits such as the affected poses and extremely elegant attitudes that are explained by Spranger's sojourn in Paris in 1565 and Bloemaert's and Wtewael's early training in France.

Amalgamating this Italian-French approach with the native traditions and their Late-Gothic holdovers produced a mixture rich in citations and sometimes densely packed into unusually small formats. Cornelis van Haarlem laid out his mythological *Marriage of Peleus and Thetis* (101, 101a) on a complicated structure fraught with tensions. What appear to be casually scattered groups of nude figures do in fact fit together, though in extravagantly strained interlockings. The larger nudes in the foreground have somewhat the effect of academic models hanging on to their poses for dear life. Finally, the direct and unmediated leap in dimensions between foreground and rearground militates against an impression of overall pictorial unity.

Using a similar vocabulary of forms, the Utrechters

Bloemaert and Wtewael varied them rather more freely. If their spatial effects are still a little pedantic and contrived, in their figures the slight awkwardness of the Haarlemer Cornelius gives way to more relaxed movement. Bloemaert, in his *Preaching of Saint John the Baptist* (102), succeeds in integrating his figures into the landscape by exploiting a chiaroscuro technique and by dispersing their relatively small number into a few groups. The result, though, is that one's attention is drawn to the landscape and foreground figures before discerning, in the midground, the chief personage preaching in the shadow of a great tree.

Wtewael, for his part, makes striking use of what has been called a "doughy" style, in which the limbs of his figures seem almost as if kneaded out of clay. In his *Marriage of Peleus and Thetis* (103) there is a superabundance of extravagant movement, and the bends and angles of the elongated and tight-muscled bodies are almost absurdly exaggerated. Formally, however, the various theatres of action of the cloudy empyrean, each crammed with masses of mythological personages, are disposed as if on separate stages and

127

104 Hendrick Terbrugghen, *Saint Sebastian Tended by Irene and her Maid*. 1625. Oil on canvas, 150 × 121 cm (59 × 47⅝ in). Oberlin, Allen Memorial Art Museum

adroitly staggered to convey the effect of depth.

The Late Mannerist trends in the Netherlands went over into a kind of academic classicism with set formulas after 1600. But the first decades of the century took another turn with a wave of innovation, once again from Italy: the entirely novel way of seeing created by Caravaggio who died, still young, in 1610. This new realism, whose impact was due to an inten-

sive and dramatic use of chiaroscuro, was taken up especially in Utrecht which, after liberation from Spanish rule, chose to remain Catholic. The artists of Utrecht thus remained attached to a more traditional iconography of Italian stamp, something evident in Terbrugghen's *Saint Sebastian* (104) whose theme was among those no longer current in Holland, least of all in the special form of showing Saint Irene attempting to remove the arrows from the martyred body.

Haarlem too was open to artistic innovation, and until about 1630 its artists held the leading position in Holland. The northern provinces, and Haarlem in particular, became a kind of counterpole to Antwerp which still dominated the southern provinces, even more so since Rubens appeared on the Flemish scene with his heroic Baroque which overtly opposed Caravaggism in religious art especially. In Antwerp virtually the only Caravaggists who could hold their own between 1600 and 1625 were Abraham Janssens (c. 1575-1632) and his circle of pupils. Not so in the north. In those years, in Utrecht and Haarlem, per-

sonal tastes and a ready market for paintings meant a free exchange of ideas and images. Particularly the use of the new style in the larger formats of easel paintings assured Utrecht Caravaggism a ready audience and rapid acceptance. Its first promoters were Hendrik Terbrugghen (1588-1629), Gerard van Honthorst (1590-1656), and Dirck van Baburen (c. 1590-1624). All three probably studied in Utrecht with Bloemaert and had lengthy sojourns in Italy, though only Terbrugghen, who had been in Rome and Naples as early as 1604, could possibly have known Caravaggio in person. After their return in the 1620s their teacher himself eagerly adopted their imported chiaroscuro technique and genre approach.

Unorthodox as it was, the predilection of these artists for treating both profane and religious themes as genre pieces and their general rejection of symbolic attributes and heroic grandeur was less revolutionary than their unusual and even surprising way of depicting such subjects. Among their favorite themes there are musicians in colorful costumes, as in Terbrug-

105 Gerard van Honthorst, *Adoration of the Shepherds.* 1622. Oil on canvas, 164 × 190 cm. (64⅝ × 74¾ in). Cologne, Wallraf-Richartz-Museum

106 Hendrick
Terbrugghen,
Flute Player.
1621. Oil on can-
vas, 70 × 55 cm
(27⅝ × 21⅝ in).
Kassel, Staatliche
Kunstsammlungen

ghen's *Flute Player* (106) or Baburen's *Boy with Jew's Harp*. Viewed in extreme close-up, the often dramatically solid and three-dimensional types they painted appear almost as if caught in a rapid camera shot, and by putting them in front of monochromatic flat or shallow backgrounds the unstudied and almost accidental effect is emphasized even more. Light falls into these pictures obliquely, picking out only parts and fragments of body or clothing here and there, and it was this balanced interplay of strong light and dark zones that particularly fascinated the Utrecht painters, so much so that Honthorst, for one, used nocturnal illumination even for subjects commonly associated with daytime. Candles and torches were often used to produce a kind of lighting more natural to caves or cellars, and in Honthorst's *Adoration of the Shepherds* (105) the light radiates from the Infant Himself. Terbrugghen, however, always worked with daylight, but modeled it with gradated and muted coloring.

The systematic turn to genre and religious subjects, the detailed realism in their half-figure pictures, as well as the use of light in strong chiaroscuro assured the Utrecht painters great influence after 1620. Their decisive mark appears in the early work of such otherwise independent artists as Frans Hals, Rembrandt, and Vermeer who, in style and subject matter, prepared the way for the rapid rise and diversity of other local schools in Haarlem, Amsterdam, and The Hague.

107 Everard Quirijnsz. van der Maes, *The Ensign of the Orange Company of the Hague Militia*. 1617. Oil on canvas, 198 × 102 cm (78 × 40⅛ in). The Hague, Gemeentemuseum

131

Frans Hals

A Haarlemer born in Antwerp, though he painted nothing but portraits Frans Hals proved himself one of the most skillful colorists of a century almost over-rich in strong artistic personalities. His pronounced interest in the individual facial features and range of expression of his sitters, along with his skill in making us see them as real living presences through a highly nuanced repertory of pose and expression, for the first time raised portraiture in Holland to the rank of an independent national art.

The reports of the time portray Hals as a vital personality who enjoyed life to the full: a pleasure-loving soul according to the painter Matthias Scheits writing at the end of the century; a man who never failed to get drunk every day of his life if we are to believe Arnold Houbraken's biography published in 1718-21. Exaggerations perhaps, and they certainly do not accord with the high appreciation of his patrons, who came from not only the higher echelons of The Hague burghers and the heads of the guilds and guard companies but also the highest patrician circles; even the philosopher René Descartes sat to him.

Hals produced portraits exclusively, and there is no report of any attempt to work in other fields — his only variations were portrait-like depictions of the Evangelists or occasional less formal pictures of local inhabitants that cannot be strictly classified as portraits. Yet the whole notion of genre, so much favored in Flanders and Holland, does in a sense underlie his works and show itself in his theatrically staged portrait groups and even in portraits with one or two figures, though never overtly nor as an end in itself. Dealing chiefly with portraits with a single subject, Hals was obliged to take advantage of every possible

108 Frans Hals, *Banquet of the Officers of the Haarlem Militia Company of St. George*. 1616. Oil on canvas. 175 × 324 cm (5ft 8⅞ × 10 ft 7⅝ in). Haarlem, Frans Hals-Museum

means of variation: bust, half-length, knee-length, full-figure, and sometimes portraits of couples were done as separate matching paintings. Group portraits were of two types: many-figured display pieces with the notables dressed in accord with their social function, or intimate family pictures. In the latter, the husband and wife are seated in a landscape—a type first developed in Flanders—or in an interior where they are surrounded by their children. The outdoor family portrait was little practiced before Hals and called for particularly sensitive staging. Likeness and landscape had to be treated equally with a feeling for life that was both vital and relaxed, and the result had to be unlike the common genre theme known as "the merry company" with its suggestions of dissoluteness or worse.

Hals also specialized in the so-called genre portrait, as exemplified in the *Gypsy Girl* (111) or the *Malle Babbe* (Berlin-Dahlem, Gemäldegalerie). In these he often emphasized attributes and gestures, creating a sort of iconography though without any drop in artistic quality, Indeed, these portrait-like genre paintings offer the best evidence of Hals' special genius: with the sense-impression and physical presence of the model as point of departure, he exploited completely spontaneous brushwork and a virtuoso use of effects of color and light to bring out the true uniqueness of his sitter in what appears a natural unstudied pose. Thus Hals achieved in one painting both a remarkably individualized personality and a characteristic type. Some of these portraits, especially those dating from the 1620's, could even be interpreted along the lines of the moralizing allegories of the Five Senses or Vanities that were much sought after at the time. For instance, the *Peeckelhaering* of around 1628 (Kassel, Gemaldegalerie) may suggest taste, and the *Gypsy Girl* touch or feeling, while *Malle Babbe* may be a portrait of drunkeness which, though it is not one of the five

109 Frans Hals, *Catharina Hooft with her Nurse.* c. 1619/20. Oil on canvas, 86 × 65 cm (33⅛ × 25⅝ in). Berlin-Dahlem, Gemäldegalerie

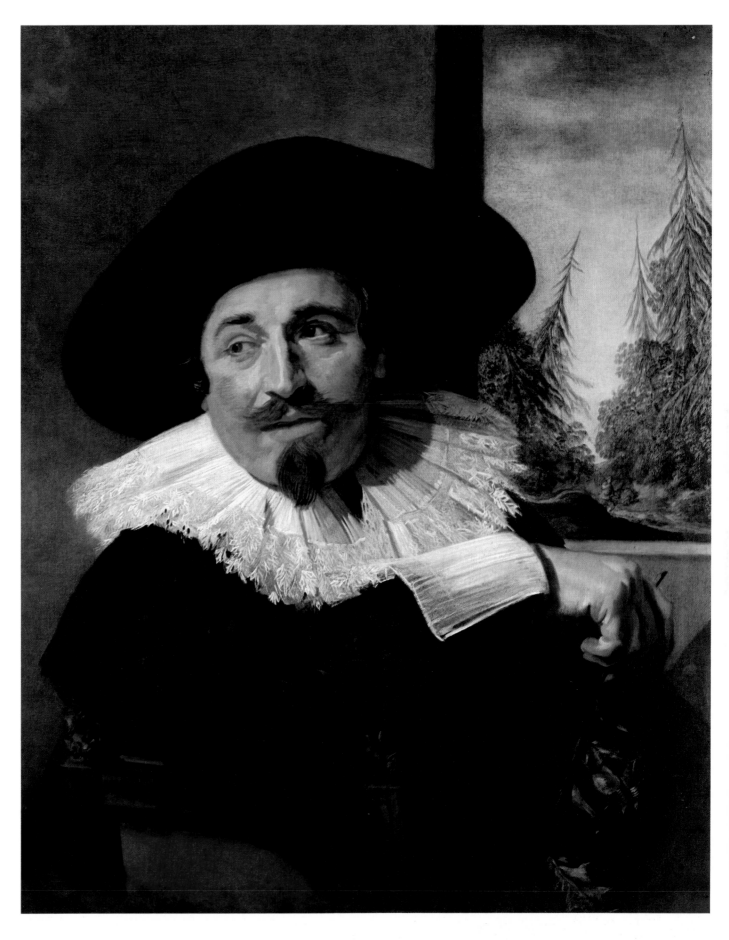

110 Frans Hals, *Isaak Abrahamsz. Massa.* 1626. Oil on canvas, 80 × 65 cm (31½ × 25⅝ in). Toronto, Art Gallery of Ontario

senses, is certainly allied with the idea of sensual indulgence.

There was a bond of sympathy between the artist and the burghers of Haarlem where he lived most of his life, and it extended to their representatives in public life, to officers of militia companies, heads of guilds, regents of hospitals and old people's homes. But he lavished the same unprejudiced, warmly living

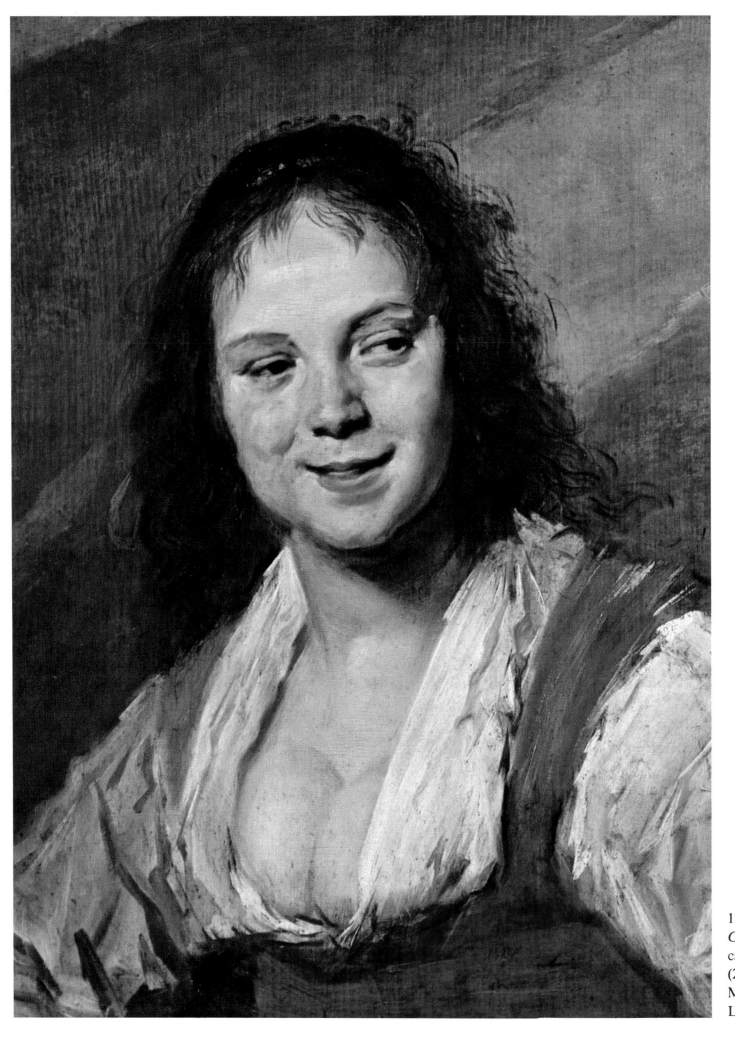

111 Frans Hals, *Gypsy Girl*. 1628/29. Oil on canvas, 57.7 × 52 cm (22¾ × 20½ in). Paris, Musée National du Louvre

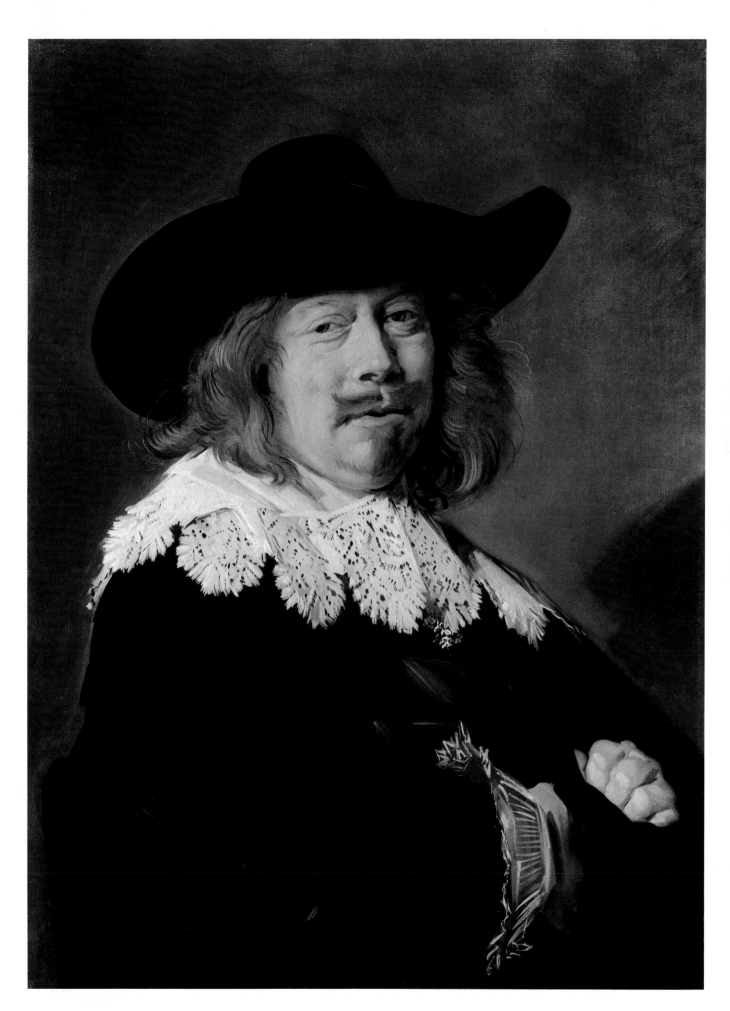

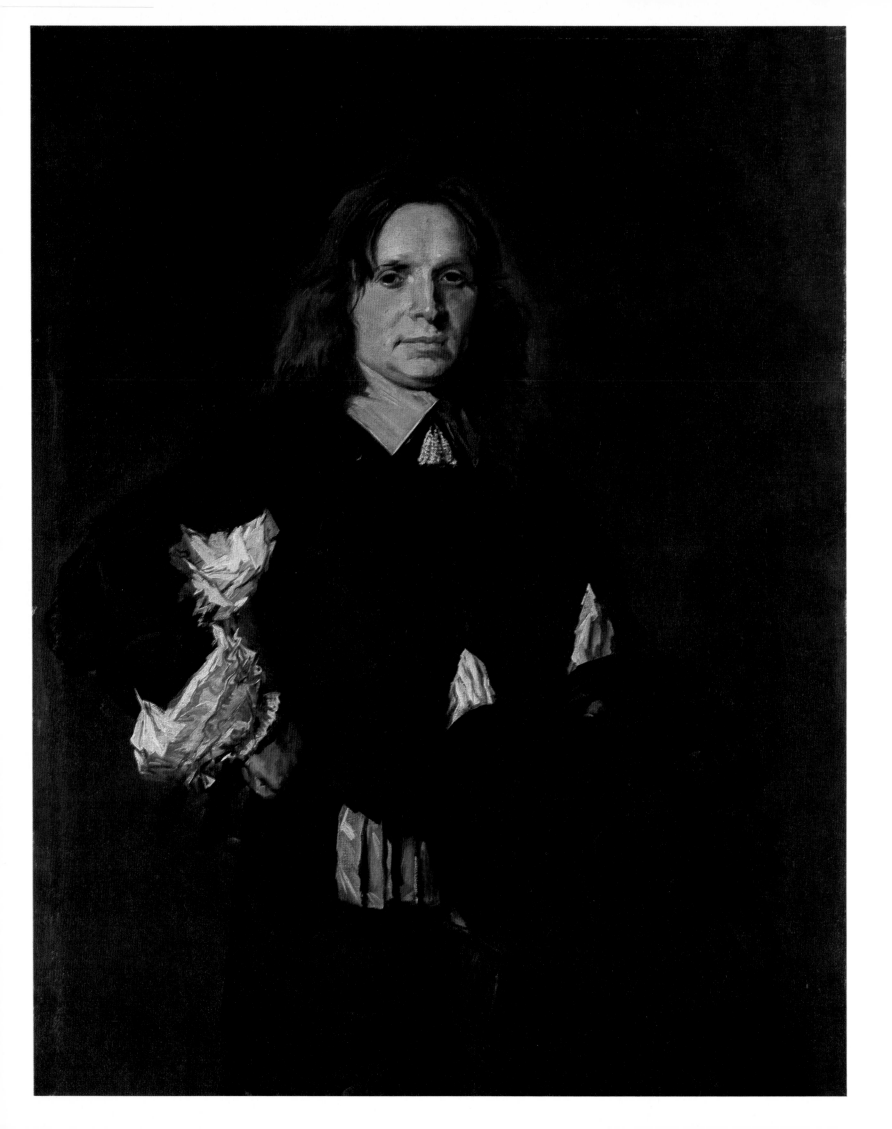

approach on his occasional pictures of groups of scholars and preachers, and of common folk — servant girls, innkeepers, loose women, fishermen — who, before him, had scarcely had such attention and appreciation.

In all these likenesses Hals used to the full conventional portrait poses, ingenious viewing angles, compositional cutting and framing, and lighting. He obtained striking effects from costumes, such as the black dresses of the regentesses with their heavy white collars (114) and from poses like that of the lifesize *Willem van Heythuyzen* of around 1625-26 with arm akimbo (Munich, Alte Pinakothek). But from his earliest works Hals' focus was on the expressiveness to be drawn from the head, eyes, nose and mouth of the sitter. Theatrical gestures and poses (in part taken, by way of Anthonis Mor, from sixteenth-century Italian portraits) and special effects in lighting and setting served primarily to attain the utmost vitality in expression and a convincingly living presence and thereby to heighten even more the contact with the viewer.

Hals' style must always be understood in terms of his personal use of paint, and it was only sporadically that there was a touch of influence from other approaches of the time such as Caravaggism or the Flemish Baroque. It was his own style, essentially determined by the exploitation and increasingly monumental rendering of the portrait types he settled on, determined too by the structural framework of his compositions. In addition, a large repertory of motifs of action and movement were utilized to ensure that neither individual nor group portraits would give any impression of stiffness, formality, or artificiality. He sought to give each picture the character of what we associate with an instantaneous snapshot, without entirely giving up a certain distance between himself and his sitter. For all that he might deliberately aim at a general type, the result was always natural: consider

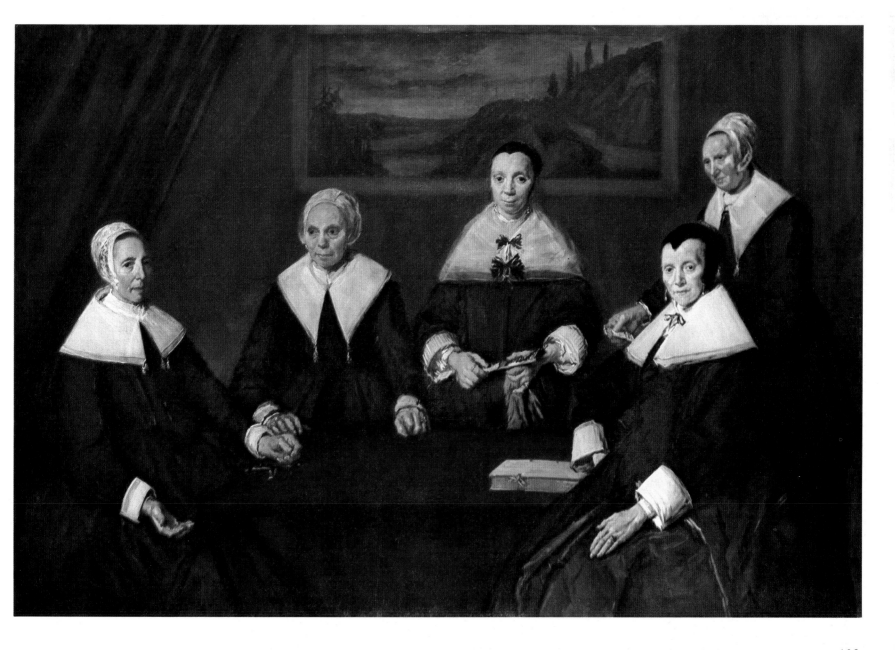

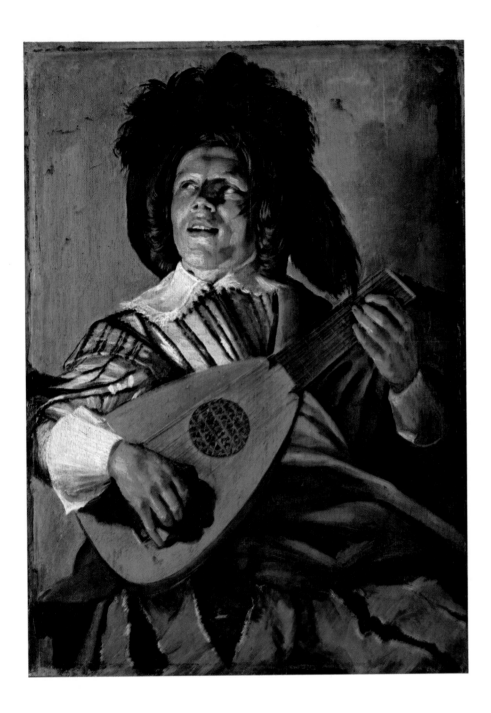

sign of the Orange Company of the Hague Militia by Everard Quirijnsz. van der Maes (107) which is certainly soberer and almost documentary. Hals's painting is directly related in theme and details to the first militia piece in Dutch painting, the portrait of the same company in 1599 (Haarlem, Frans Halsmeseum) painted by the Cornelis van Haarlem we met earlier in a different, rather less dressed, context (101).

But where the earlier painter had settled for a regular repetition of the same pose of like-uniformed militiamen, Hals avoided monotony by varying the heights of the heads, direction of gazes, gestures, and body positions to produce an energetic springing rhythm full of life and accentuated by the skillful disposition of flags, scarves, and collars, which take up the dominant colors and transmit them along the line. In his first major public commission Hals concerned himself less with turning out an official picture than with characterizing the gathering through a profusion of movements, splendid coloring, and a joyous mood. The portraits of the next phase, to about 1622, reveal a smoother and more unified application of color and a gradual reduction in three-dimensional solidity.

Following the lead of the Renaissance Venetians who used such darker grounds as a brownish red bole, Hals took to using a dark blackish brown ground, as in the *Catharina Hooft with her Nurse* for one (109), where also the fleshy modeling of the face suggests the Flemish precedents of Cornelis de Vos and Rubens, and there is an effective contrast between the nurse's plain clothing and the rich, finely-detailed decoration of the child's dress or, again, between the fruit and the golden ornate bell that the child forms.

Beginning in 1624 the picture space becomes lighter and at the same time deeper, as in the Munich *Willem van Heythuyzen,* a much more "public" image than, say, that of *Isaak Abrahamsz. Massa* (110) with its more natural pose. But the latter also combines a number of new motifs: a contrast between the alert look of the man and his relaxed arm resting on the chair; the extremely close-up view of the carved chair back; the landscape view in the background painted probably by Pieter Molyn, not Hals himself. Particularly revealing is the way solid color areas in the hat and clothing are opposed to the gradations of color in the face, collar, and green branch.

After 1626, when it is thought Hals spent some time in Utrecht, there was a clear change in themes and manner of painting. Under the influence of the Utrecht Caravaggists Hals' angularly cut-off half-figures in smoother, more uniformly laid on paint take

115 Judith Leyster, *The Serenade.* 1629. Oil on oak panel, 45.5 × 35 cm (17⅞ 13¾ in). Amsterdam, Rijksmuseum

the masterly knee-length likeness of a patrician (113) or the bust-length *Happy Drinker* of 1625/30 (Amsterdam, Rijksmuseum), two very different pictures yet both radiating self-assurance, human warmth, and brisk vitality.

The earliest portraits, such as the half-length *Jacobus Zaffius* of 1611 (Haarlem, Frans Halsmuseum), still depended stylistically on the leading portraitists of the time, Cornelis Ketel and Paulus Moreelse. But his first militia group, the *Banquet of the Officers of the Haarlem Militia Company of St. George* (108), burst upon the art of its day, as Seymour Slive has put it, like a cannon shot announcing the advent of the golden age of seventeenth-century Dutch painting. This spirited grouping of sturdy gentlemen was done at almost the same time as the *En-*

on more sculptural roundness, and there are paintings of this period that have much in common with those of Terbrugghen in both theme and treatment.

Beginning in 1627 with the genre portraits, there was increasing use of a spontaneous application of paint with heavier impasto. In obvious rapport with the contemporary farces and their stage figures (already commemorated in paint by the Caravaggists) Hals took to painting broadly laid-out half-figures marked by strong movement and abrupt turns of the head which may have some relationship with the Five Senses allegories. With a virtuoso handwriting he applied layers of still-wet paint one over the other, a method at the time unique to Dutch painting for obtaining the effect of fleet and momentary movement. Along with the smaller sketchlike genre portraits, to the end of the 1630s Hals also carried through more demanding public commissions such as the second *Banquet of the Officers of the Haarlem Militia Company of St. George* and the *Assembly of the Officers and Subalterns* of the same company painted in 1639 (both Haarlem, Frans Halsmuseum), group portraits which with their great variety of facial expressions, shimmering gleam of uniforms, and rich nuances of color in flesh and clothing, rank among the high points in Hals's work. In them he could expand the individual male portrait into elaborately staged groupings organized through contrasting systems of surface treatment and color. Likewise the occasional portrait of couples in a landscape or the many-figured family groups (for example, the ten-figure painting in the National Gallery, London) show the artist to be admirably many-sided in depicting the different ages and characters of his sitters. In his treatment of traditonal themes, whether commissioned official group portraits of the militia or more intimate and private likenesses, he achieved an artistic expression entirely new in his time.

After 1630 the dynamic disposition of the group portraits gave way to a quieter monumental pictorial organization, with color now restricted mostly to a few neutral tones, chiefly grayish black. This new and more mellow approach, reflected in both individual and group portraits, no longer strove to capture many typical qualities of the sitter and instead placed greater value on a restrained and atmospheric overall impression. The tendency became pronounced in late works like the *Regentesses of the Old Men's Home* (114) where the figures are fixed in mute isolation, staring out at us, dressed soberly and solemnly in the garb of their official position which accords with the austerity of the setting and their own dignified poses.

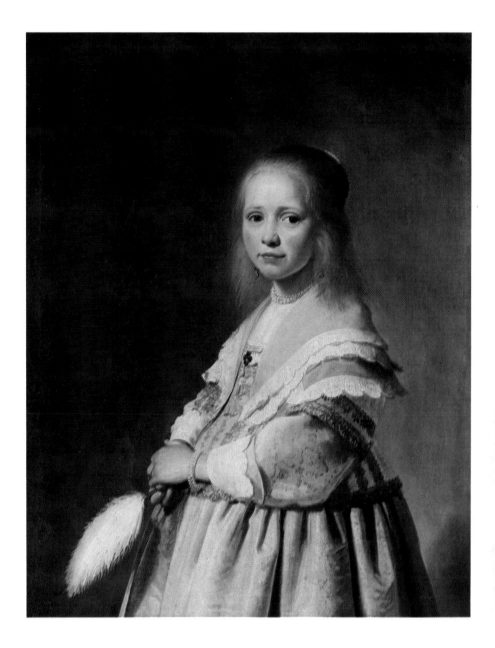

All expression is concentrated in the faces. The short choppy conduct of the heavy brushwork and the hazy, almost dissolving silhouettes before a diffuse background represent an ultimate and scarcely surpassable simplification in the treatment of figure and setting.

Once Frans Hals had handled so exhaustively all the themes and pictorial possibilities, further development in portraiture could hardly be expected in Haarlem. Judith Leyster, in something like the *Serenade* (115), virtually copied the style of the Caravaggists. Johannes Cornelisz. Verspronck, however, worked rather more independently, though his children's portraits (116) are not without their debt to Hals's richly nuanced palette. But Hals was not truly appreciated before the Impressionists whose new way of seeing and of painting was particularly influenced by his brushwork, which seems to live and act on its own, and by the expressive drama it conveys regardless of the subject.

116 Johannes Cornelisz. Versponck, *Portrait of a Girl in a Blue Dress*. 1641. Oil on canvas, 82 × 66.5 cm (32¼ × 26⅛ in). Amsterdam, Rijksmuseum

Peter Paul Rubens

The entire life and work of Frans Hals centered in Haarlem; his Flemish contemporary, the Antwerper Peter Paul Rubens, was in every sense a European. In 1977, when the world celebrated the 400th anniversary of Rubens' birth, it was again made clear that Europe entire had been the scene of his activity. His age lives on in his paintings. The key personalities of his time sat for him for their portraits, were acquaintances or more. No less famed as a diplomat, Rubens was called on to play a part in the complex negotiations for settle-

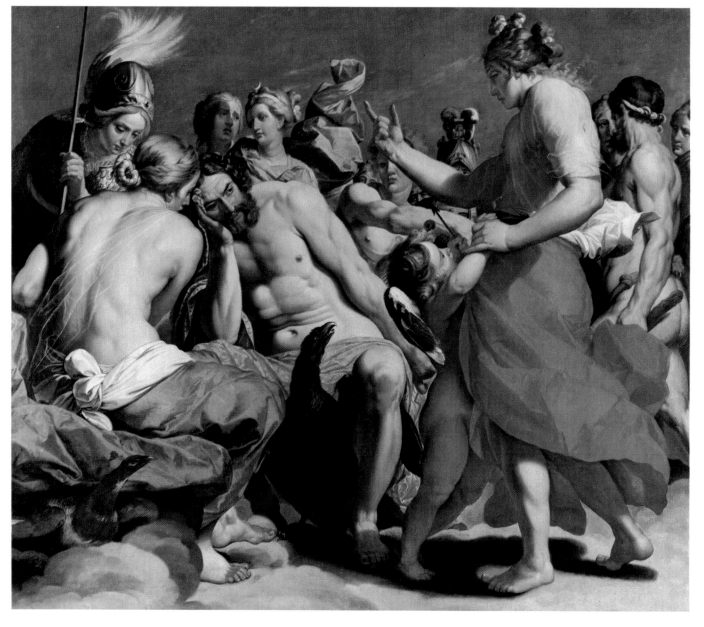

117 Abraham Janssens, *Olympus: The Council of the Gods*. c. 1615. Oil on canvas, 207 × 240 cm (6 ft 9½ × 7 ft 10½ in). Munich, Alte Pinakothek

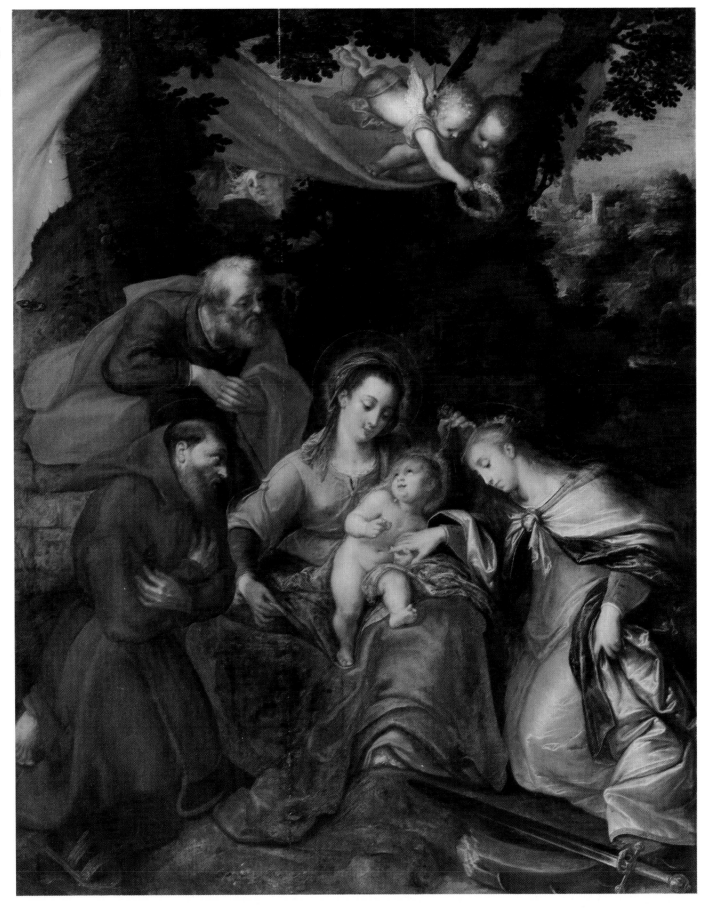

118 Otto van Veen,
The Mystic Marriage of
Saint Catherine with the
Christ Child. 1587. Oil
on panel, 183 × 146 cm
(72 × 57½ in).
Brussels, Musées
Royaux des Beaux-Arts

ment and peace during the eighty years of hostility that began in 1568. His political activity gave him occasion to sit down at the same table, more or less literally, with the rulers of Europe, and those encounters likewise led to his adding the likenesses of the great to his considerable body of portraits. Close to home there were Archduke Albert of Austria. regent over the Netherlands by the will of the Spanish crown; his wife Isabella of Spain, daughter of the all-powerful King Philip II, who assumed the regency after her husband's death and was often in contact with the painter: Archduke Ferdinand, the Cardinal-Infante, who succeeded Isabella as regent and for whose solemn entry into Antwerp in 1635 Rubens provided festal decorations. Abroad there were Spanish and English kings, French monarchs, Italian dukes, and we know them better thanks to Rubens. He portrayed some forty of such rulers, yet his lasting fame goes beyond portraiture to embrace a great gamut of religious, mythological, and historical subjects.

Rubens was born in Germany, at Siegen, during the fifteen-year exile of his Flemish parents. His father was a gifted man of law who, in happier times, would likely have become burgomaster of Antwerp but who

sympathized with the Reformation and so thought it wiser to decamp to Germany. In the same year as Peter Paul was born, the family moved to Cologne, and it was there that the boy had his first schooling. When the father died in Cologne and the family returned to Antwerp, the future painter was first educated to be a page and then, beginning around 1591-93, was trained in painting by the Antwerp artists Tobias Verhaecht, Adam van Noort, and Otto van Veen.

The young man's style was so firmly rooted in Italianate models that it is still disputed whether a number of early works should not be attributed to his teachers, especially Otto van Veen who, ten years earlier, had visited Italy and whom Rubens could thank also for an acquaintance with humanist thought such as that of Domenicus Lampsonius of Liège (1532-1599). The teacher's *Mystic Marriage of Saint Catherine with the Christ Child* (118), done for the Capuchin church in Brussels, has no end of Italian features. The theme—the dream of Saint Catherine in which the infant Jesus places a betrothal ring on her finger—was rare in the Netherlands before 1600 and, once introduced, was generally treated in the manner of Raphael and Correggio. The overall character that

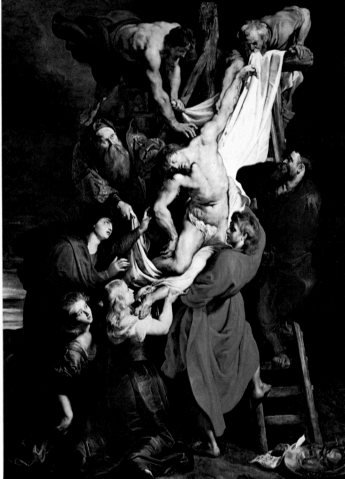

119-121 Peter Paul Rubens, *The Descent from the Cross*. 1612-14. Oil on panel, center panel 418 × 310 cm (13 ft 8⅝ in × 10 ft 2 in), each wing 418 × 149.5 cm (13 ft 8⅝ in × 4 ft 10¾ in). Antwerp, Cathedral

120a Peter Paul
Rubens, *The Descent
from the Cross,* center
panel

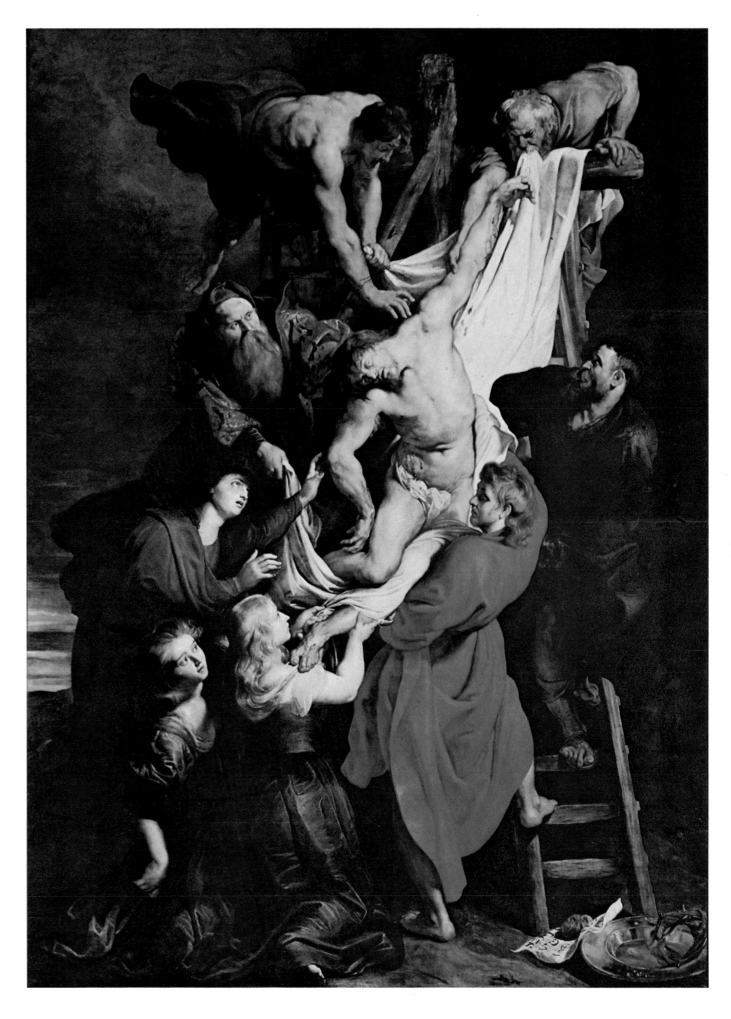

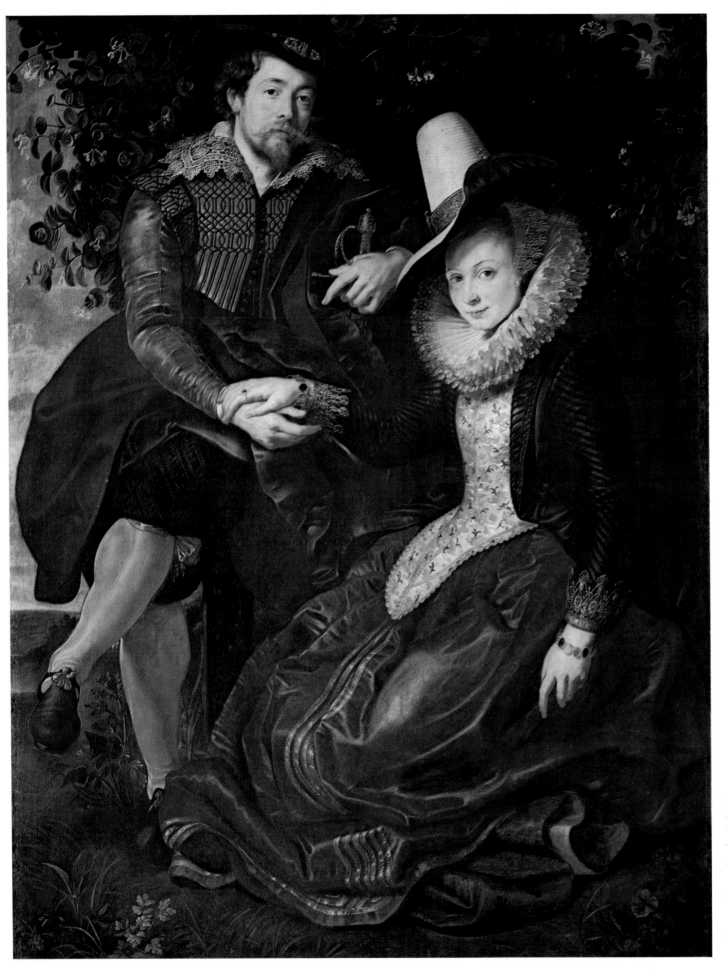

122 Peter Paul Rubens, *Rubens and Isabella Brant in a Honeysuckle Bower.* c. 1609. Oil on canvas attached to panel, 178 × 136 cm (70⅛ × 53½ in). Munich, Alte Pinakothek

Van Veen brings out was set by the Counter Reformation, and as J. Müller Hofstede remarked, it is through gestures of devotion and pious submission that the artist leads the viewer to reverent meditation.

As we have seen, a journey to Italy was a traditional part of the education of any Netherlandish painter. The influence of the South made itself felt early, most notably in artists like Quinten Massys and Joos van Cleve. In the second half of the sixteenth century it was given new impetus with the renewed enthusiasm for the so-called Romanist approach. Typical of that manner (though already well into the next century) is the *Olympus* (117) by Abraham Janssens, one of the last of the Romanists and a contemporary of Rubens in Antwerp. Here, with great Jupiter cringing at the almost violent exhortation of Venus that he come to the aid of Troy, the figures are brought close to us, and their composition appears restless because the quite different stylistic tendencies are not effectively reconciled.

Rubens too had his sojourn in Italy, lasting eight years. No sooner had he returned to Antwerp in 1608 than he was awarded two major commissions, one after the other. So brilliant were his solutions for these that with a single blow the local traditions were put well and truly out of date and Flemish painting was set on a course over which Rubens would henceforth hold a firm monopoly. The triptych he began in 1610 with the *Raising of the Cross* [after Mark 15:24] for the high altar of the Sint Walburgis church in Antwerp drew the sum of what had impressed him in Italy: the strength and weight of Michelangelo's figures, the painting technique of Titian and Veronese. The *Descent from the Cross* [after John 19:38-42 and parallel passages] (119-121), begun a year later and completed in 1614 for the altar of the Crossbowmen's Guild, went beyond that synthesis. These two major altarpieces (both now in the Antwerp cathedral) proved to his contemporaries how vast a span Rubens could encompass, and their praise of him was unstinting. The flood of written commentaries since that time attest to how stimulating those pictures have continued to be, and innumerable paintings by other artists point to them as an inexhaustible fount of inspiration.

Obviously in depicting the removal of the dead Christ from the crucifix Rubens had to use very different interpretative means than with the cruel act of the raising of the cross. The way the divine corpse is lowered with tender care into the waiting arms of His friends cannot help but stir a human sympathy: as Rubens painted it, said Jacob Burckhardt, Christ glides "into the bay of love." The faithful of the time

could not but be struck by the prodigious and almost ironic tragedy of Rubens' conception: Christ, Who carries mankind to redemption, is Himself carried by human love. The paradox that non-Christians see in the crucifixion of Christ, and that Saint Paul unraveled so impressively [I Corinthians 1:17-2:16], was given pungent formulation and form by Rubens. Rogier van der Weyden 150 years earlier had treated the same episode (18) with a pictorial language that is anything but immediate. Where Rogier channels the most earnest concentration into a meditation over meaning Rubens puts into play everything that can excite our sympathy — and in so doing forces us to admit the irrationality, the *skandalon,* of God's death on a cross.

The Fleming went about it with a painterly temperament that exploded every last familiar tradition. His powers were unlimited and fascinating: look at the way he played off the red swathe of the Saint John against the blue of Mary, at the light that pours along the sweep of the shroud, at the devotedly rapt faces in which the luminescence of the shroud and its tragic burden is reflected against the overall darkness, at the poses in which the desire to be of help is in each figure translated into a rising motion while all together testify to the bond that binds each to all.

Rubens married relatively late. It was a thirty-two-year old who led Isabella Brant to the altar of Sint Michael in Antwerp: his years at the ducal court of Mantua had ripened him into a man of experience. In his double-portrait in a honeysuckle arbor (122) he raised a monument to his wife and their union. Honeysuckle in the language of the folk translates to something like "the longer the better," and that is the meaning intended in this marriage portrait. We have seen the wonderful gesture of the superimposed hands before, in Van Eyck's marriage-portrait of the Arnolfini couple painted in 1434 (11), though nothing tells us that Rubens know that painting.

Isabella was the daughter of a much respected patrician, the city secretary Jan Brant whom Rubens also portrayed. It was apparently a case of love at first sight, since only a few months earlier Rubens had written about his brother's marriage: "I have no intention of hurrying to imitate him, since he has hit on such a good choice that her like is not to be found, and I should certainly not like it, were he to compare my young wife with his and find her an ugly creature." On the other hand, he recognized that "such a matter as this needs to be handled not in cold blood but with true fire."

In this woman, who in some pictures gives the im-

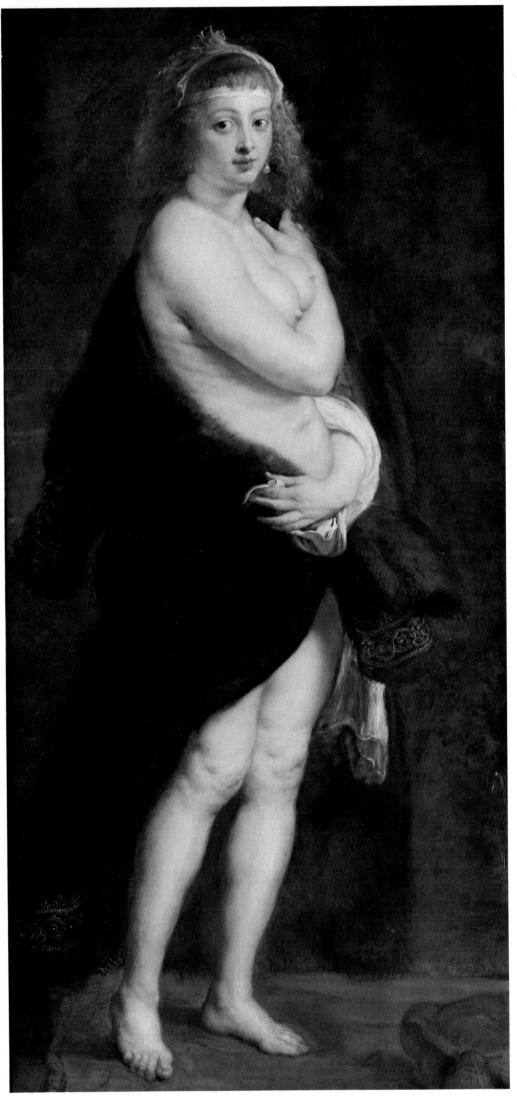

123 Peter Paul Rubens, *Helena Fourment in a Fur Wrap ("Het Pelsken")*. c. 1638. Oil on panel, 176 × 83 cm (69¼ × 32⅝ in). Vienna, Kunsthistorisches Museum

pression of a certain coolness of temperament, Rubens found great fulfillment. We know what their children looked like from sensitive drawings and portraits (one of Clara Serena, another of Nicolaes and Aelbert together, in Vaduz, Collection of the Reigning Princes of Liechtenstein). When word of Isabella's death reached Rubens in 1626 he avowed his deep grief without reserve in a letter to a friend in Paris: "I have in truth lost a good companion who could rightfully be loved, indeed had to be. . . . Such a loss seems to me to merit a great grieving, and since the only remedy for all sorrow is forgetting — the child of Time — doubtless I must hope to have my only consolation from it."

Four years later the fifty-three-year-old artist met the sixteen-year-old Helena Fourment. His life changed suddenly and entirely. The ten years that remained to him were shared with her in undisturbed delight. Over and over her features and her decidely womanly body appear in his paintings in the most varied themes and subjects. Rarely has any artist painted so many hymns to his wife. In the boldest pictures, where her nudity is covered only with a length of fur (123) or where she unpudiciously turns her fully unclothed body to our gaze as in the *Andromeda* (Berlin-Dahlem, Gemäldegalerie), her living breathing flesh is sensed and portrayed with utter devotion and such overt sensuality as scarcely another artist ever dared in rendering the female body.

Her charms lend their spice to many other paintings. In the *Rape of the Daughters of Leucippus* (124) the two nude women are caught in movements that at one and the same time tantalizingly display and conceal their seductions. An enthralling work where everything participates in a compelling movement, we find ourselves caught up in its irresistible rotary swirl, its dynamism that seizes hold of space itself, its untrammeled freedom. Anyone acquainted with the tragic character of this ancient legend [Theocritus, *Idylls* 22; Ovid, *Fasti*, V, 699; Hyginus, *Fabulae*, 80] must admire Rubens for his brilliant choice of

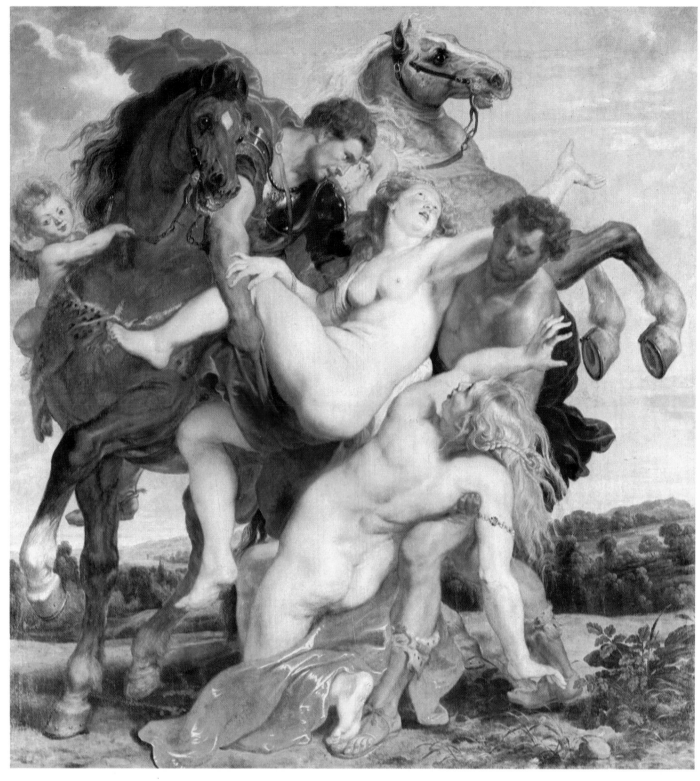

124 Peter Paul Rubens, *The Rape of the Daughters of Leucippus*. c. 1618-20. Oil on canvas, 222 × 209 cm (7 ft 3⅜ in × 6 ft 10¼ in). Munich, Alte Pinakothek

dramatic moment to picture. Castor and Pollux, the Dioscuri who were sons of Leda and Zeus, carried off the daughters of Leucippus at the very time they were celebrating their marriages to the twins Lynceus and Idas. In the pursuit, both Castor and Lynceus lost their lives. Zeus intervened, struck down Idas, and decreed that the inseparable brothers Castor and Pollux should share life and death between them, alternating their days between Hades and Olympus. Rubens disregarded the battle between the two pairs of brothers and depicted the kidnapping in a manner that suggests the sisterly pair were not all that unwilling. No convincing model is known for the way he treated the subject, but he transformed it into what Evers called "a radiant consonance that could adorn a wedding chamber." Perhaps some deeper symbolism was intended: the contact between the divine and human or the dualism of the sexes (proposed by Liess)—open questions, but not to be ignored.

The unbounded enthusiasm infusing pictures like this contrasts with the seriousness with which Rubens, as both artist and diplomat, comprehended the woes

of his time and the political strife raging in his divided homeland. When he emphasized the thought of Freedom, it was not as an empty humanistic formula but rather as something to be won with one's own active energy. Among his pictorial subjects, some have all the effect of admonitions to an age racked with disunion, of appeals to the rulers to avoid what Rubens, as a Fleming, could see as the consequences of war, which is in fact the title of a picture painted in 1638 (Florence, Galleria Palatina). When he was sent by Spain to negotiate a peace with the English king and his ministers, as gift Rubens brought—significantly—a painting titled War and Peace (London, National Gallery). In handling that ancient theme he directed the viewer's eyes to the abundance only peace can produce, praising the wealth of nature and the prosperity it can ensure as long as the god of war is banished.

Rubens was an eyewitness to military actions, and battle is often one of his cardinal themes, not only the battles of political warfare, of history, religion, and mythology, but also that of man in and against nature: man as pawn of natural forces (*Landscape with Philemon and Baucis*, Vienna, Kunsthistorisches Museum), but also as victor over wild beasts, though sometimes too as their prey, as in the *Hippopotamus Hunt* (125, 125a). Admittedly, such themes could also be set by the patron commissioning the works. This latter African scene, we know, was intended to decorate a Bavarian hunting palace along with three similar scenes. In such works, with their extraordinary living reality, Rubens' personal style is seen at its clearest. Nothing restrains his taste for the dramatic. Everything acts, is acted upon, is caught up in the stormiest movement, and at the same time there are all sorts of events and side-events which, taken on their own, are each worthy of pictorial treatment for themselves. This is something of what is meant by "Baroque," and in the face of such exuberant creations shot through with the utmost tensions, Rubens inevitably has claim to the title of the supreme Baroque master.

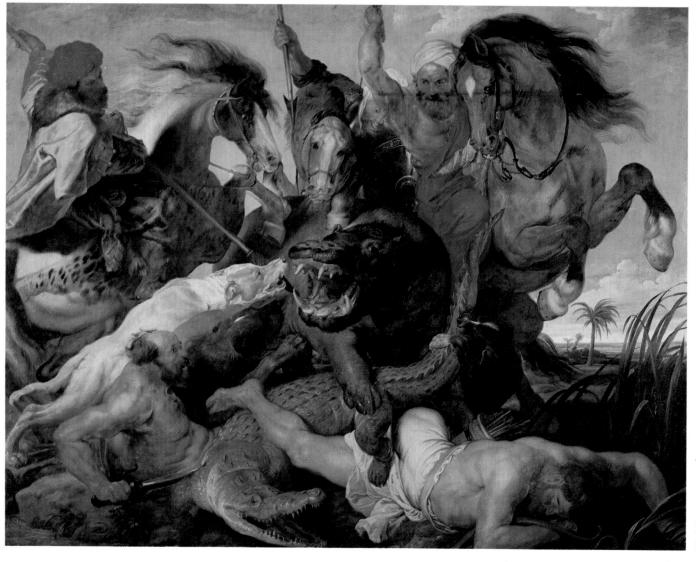

125 Peter Paul Rubens, *The Hippopotamus Hunt*. 1615-16. Oil on canvas, 248 × 321 cm (8 ft 1⅝ in × 10 ft 6⅜ in). Munich, Alte Pinakothek

125a Peter Paul
Rubens, *The Hip-
popotamus Hunt* (detail)

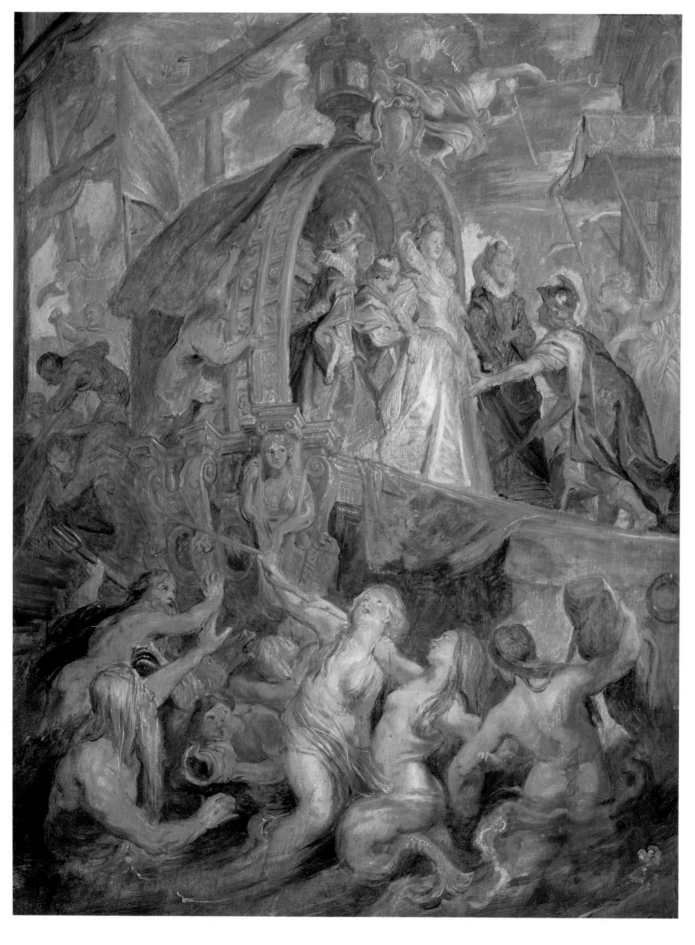

126 Peter Paul Rubens, *The Disembarkation in Marseilles of Maria de' Medici as the new Queen of France.* c. 1622. Oil sketch on oak panel, 63.7 × 50 cm (25⅛ × 19⅝ in). Munich, Alte Pinakothek

There is in fact nothing in his art which, looked at closely and compared with that of others of his time, does not deserve the epithet "sensational," and in the best sense. Three major personalities—the great aesthetician of classical art Johann Joachim Winckelmann, the painter Eugène Delacroix, and the art historian Jacob Burckhardt—placed the Flemish prince of painters alongside Homer, the greatest of poets. He was, quite simply, awesome: in range of subject matter, wealth of coloring, the sheer immensity of so many of his works, the number of paintings from his hand, but also in his theoretical writings—he wrote books on the imitation of Antiquity and on architecture—and as a diplomat and writer of letters that made him virtually one of the founders of modern news media; in every last thing he touched and in every domain he exceeded everything one might expect from a man.

A list of his known commissions and tasks would fill a chapter, and these are only the most important: from 1609 he was court painter for the regent of the Netherlands, and was initially given chiefly local assignments; around 1615-16 he produced a *Last* *Judgment* of 6 by 4.5 meters (19 feet 8 inches by 14 feet 9 inches) for the Count Palatine Wolfgang Wilhelm von Neuberg; in 1620-21 he designed thirty-nine ceiling paintings for the Jesuit church in Antwerp, most of them executed by his pupil Anthony van Dyck; in 1622 he was commissioned by the French queen Maria de' Medici to do a cycle on the history of her life with twenty-four paintings each thirteen feet high, sixteen of them almost ten feet wide, two no less than twenty-three feet wide, and most of them prepared by oil sketches (126); at the same time her son, Louis XIII, ordered twelve tapestry designs with the deeds of Constantine the Great; around 1627-28 there was an extensive sequence on the *Apotheosis of the Eucharist* for the regent Isabella; in 1636, for the Torre de la Parada, the hunting lodge of the Spanish king Philip IV, he produced the grand total of 130 paintings.

All this, of course, required a large workshop to carry through. Rubens himself was always harassed by lack of time: "To tell the truth, I am so overburdened with public and private tasks, and already committed for the future, that for the next few years I cannot

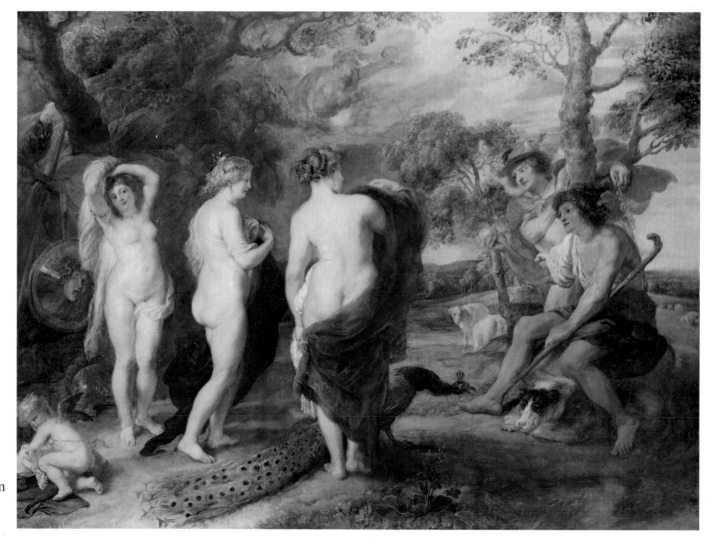

127 Peter Paul Rubens, *The Judgment of Paris.* 1632-35. Oil on panel, 144 × 194 cm (57 × 76¼ in). London, National Gallery

even be master of my own person," as he wrote in a letter in 1618.

Despite everything, and lamed with gout, the master took himself off to the country and in the quiet of his new surroundings began to fill out one last dimension of his art: landscape painting. By no means really aging, he withdrew with his young wife to Het Steen, the castle he bought near Mechelen, and lived in relative retirement, devoting himself to studying and painting nature in views such as the one seen here, with its glimpse of his own castle shining through the trees (128). With their beautifully calculated harmony, his landscapes are among the gems of all his great production, the work of a happy man.

As Evers tells it, "a few days before his death Rubens summoned his people to his bedside, and with solemn speech and debate he proposed that if his widow, his grown sons, and the guardians of his still underage children were of the opinion that he deserved such a memorial, they should have a chapel built in the parish church of Sint Jacob as tomb for himself and his descendants and as a place of commemoration for him. And in that case they should use as altarpiece a painting of Our Lady with the Child in her arms and with various saints, as well as a statue of the Madonna in marble."

His wish was fulfilled, even to the painting (129) in the center of which an old man is shown kissing the hand of the Christ Child, an image that has been interpreted as expression of Rubens' own faith and hope and which in this late painting, although without an explicit reference to the biblical episode, would appear to relate to the aged Simeon who, when he saw the child Jesus, said, "Lord, now lettest Thou Thy servant depart in peace . . . for mine eyes have seen Thy salvation" (Luke 2:24-35).

128 Peter Paul Rubens, *An Autumn Landscape with a View of Het Steen in the Early Morning.* c. 1635. Oil on panel, 131 × 229 cm (4ft 3⅝ in × 7 ft 6⅛ in). London, National Gallery

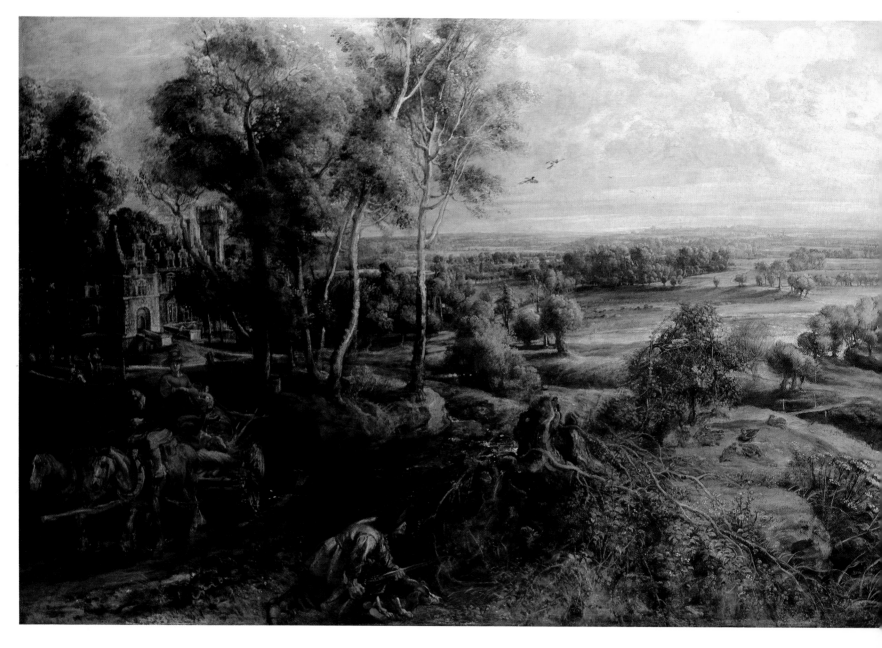

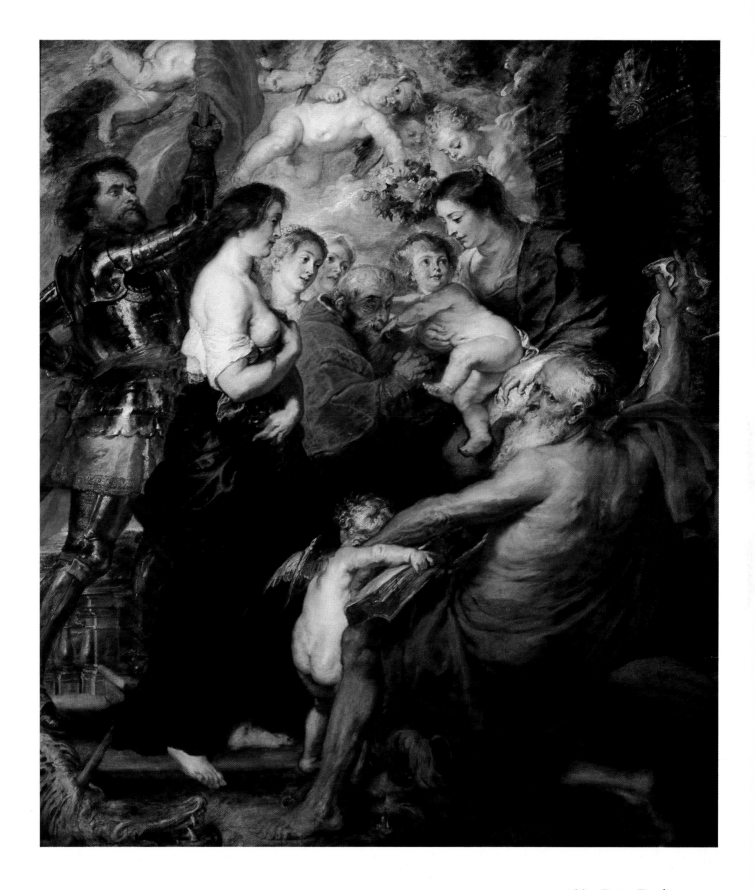

129 Peter Paul
Rubens, *Virgin and
Child with Saints.* c.
1638/40. Oil on panel,
211 × 195 cm (6ft 11 in
× 6 ft 4¾ in). An-
twerp, Jacobskerk

130 Anthony van Dyck, *Portrait of a Patrician Lady and her Daughter*. 1627-32. Oil on canvas, 204 × 135 cm (80¼ × 53⅛ in). Paris, Musée National du Louvre

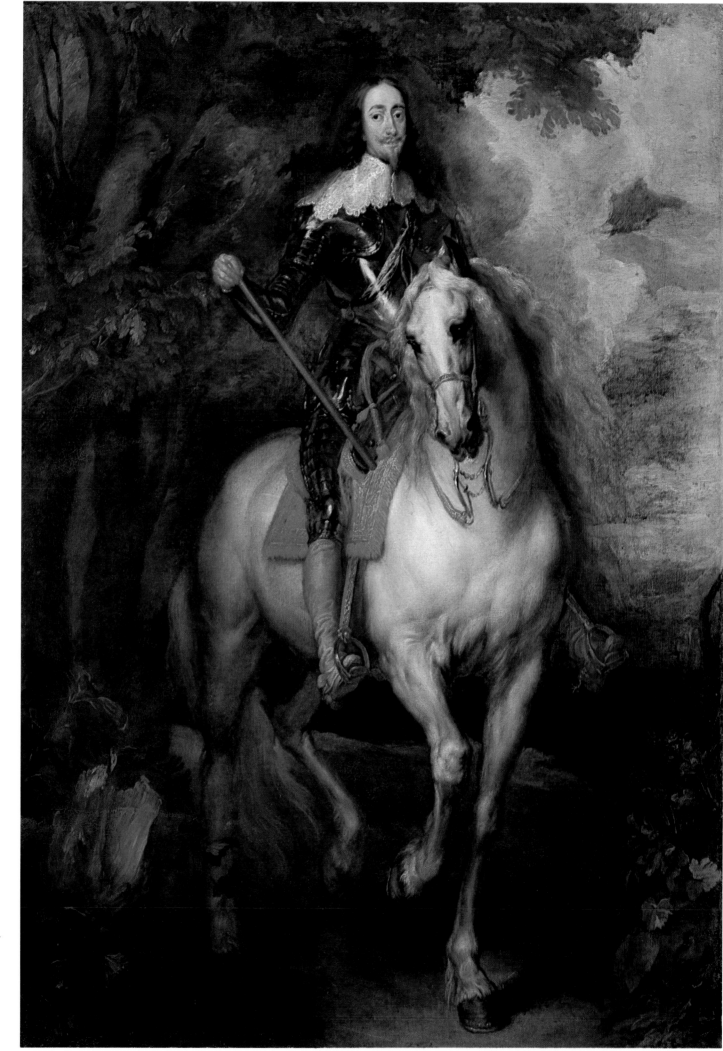

131 Anthony van Dyck, *King Charles I of England*. c. 1635-40. Oil on canvas, 123 × 85 cm (48⅜ × 33½ in). Madrid, Museo del Prado

Flemish Masters Around Rubens

The effect of a single powerful artistic personality is like that of a magnet that draws everything into its field. So true was this of Rubens that today we risk dealing unjustly with his contemporaries. The fact is, all Flemish painters of the first half of the seventeenth century stood in a more or less clear relationship to Rubens. Yet, not least because of the inspiring power of their model, many of them arrived at astounding achievements in their own right, as independent great masters.

But artist like Anthony van Dyck, Cornelis de Vos, Jan Bruegel the Elder, Frans Snyders, David Teniers the Younger, and Adriaen Brouwer were not Rubens' pupils. Before coming into contact with him and, in some cases, becoming his collaborators, they had had their training from other Flemings or Hollanders and

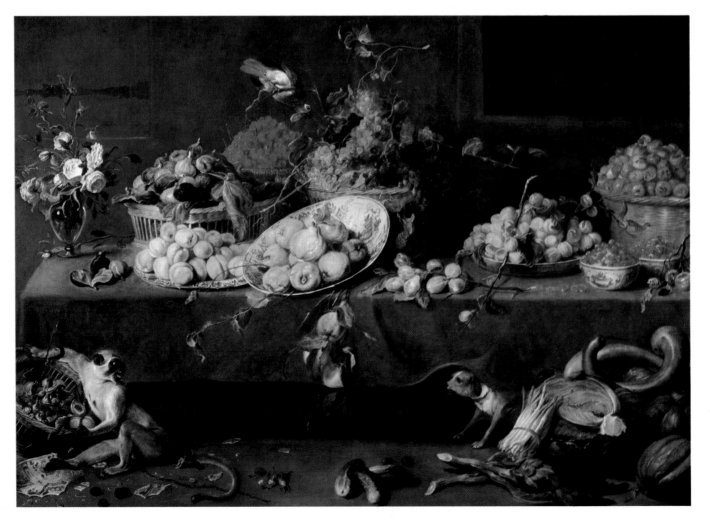

132 Frans Synders, *Still Life with Fruit and Flowers.* Oil on canvas, 165 × 233 cm (5 ft 5 in × 7 ft 7¾ in). Antwerp, Koninklijk Museum voor Schone Kunsten

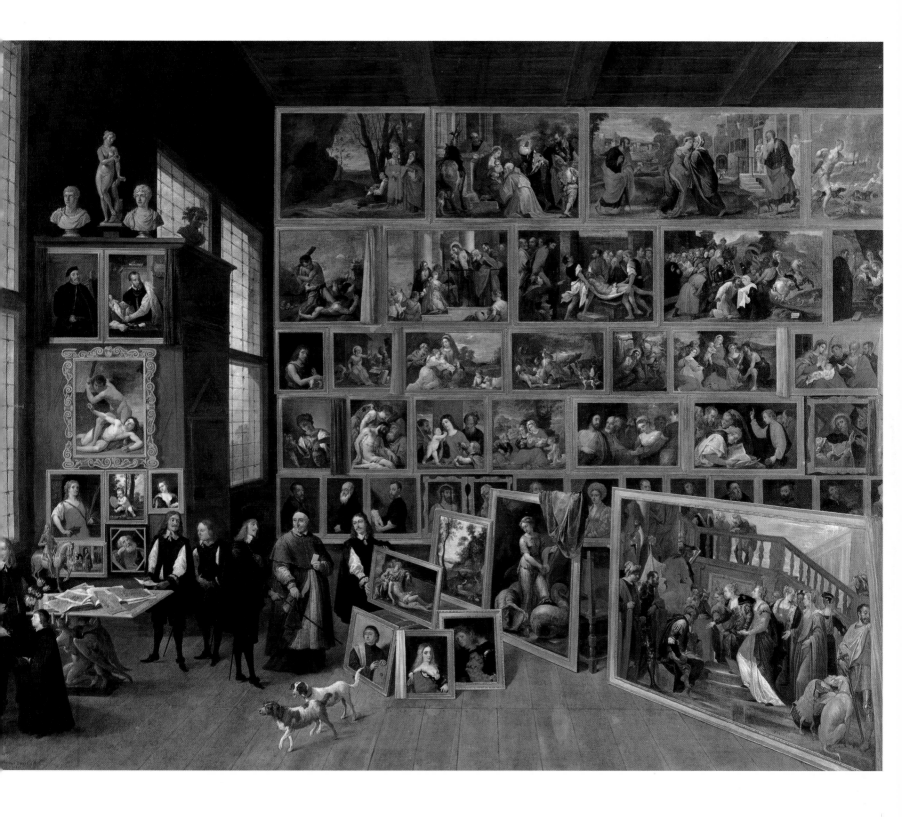

133 David Teniers the Younger, *The Art Gallery of Archduke Leopold Wilhelm.* 1651. Oil on canvas, 127 × 162.6 cm (50 × 63 in). Petworth House, Sussex, The National Trust

most of them had already been enrolled as masters in the Antwerp artists' guild. Jan Bruegel, Van Dyck, and Snyders became close friends of Rubens, and some of them were related to each other by one bond or another: Snyders married the sister of De Vos, Jordaens the daughter of his teacher Adam van Noort (who taught Rubens also), Teniers the daughter of Jan Bruegel.

Teniers in his own time was an exceptionally successful painter of landscape, genre scenes, and portraits, with a total of close to two thousand pictures.

Among his other specialties were "portraits" of private galleries of art (133), a type of picture to which we owe a good deal of our knowledge of the taste of the time and of the existence of works that have since then disappeared. In these one gets too an idea of the greater awareness of the dignity and importance, in this Baroque era, of the artist and collector who are often portrayed explaining their treasures.

Adriaen Brouwer was a rather special case. Though he died young, he had a working career on both sides of the border of the politically divided Low Countries,

receptive to influences from Frans Hals in Haarlem, concerned with somewhat the same subjects as Pieter Bruegel, visibly inspired by Rubens' dynamic approach. He fused these diverse approaches into works of uncommon power. Our own time has, characteristically, judged him positively for the social criticism apparently implied in his scenes of pothouse carousing (138, 139), and our respect has been increased by knowing that Rubens and Rembrandt prized him highly and collected his paintings.

The most important of the artists close to Rubens was Anthony van Dyck. His career touched many of the same places and phases, and brought him equally brilliant acquaintances. In 1630 he became court painter to the Netherlands regent in Brussels, the Archduchess Isabella; two years later he won the same official post with Charles I of England (131). Lengthy travels in Italy and, later, France interrupted his sojourns in England and his Netherlandish homeland. Among his many honors, he too, like Rubens, received English knighthood. He could and did lead a life of luxury and extravagance.

Van Dyck's art has often suffered by comparison with Rubens' but is impressive for its happy blend of

134 Jacob Jordaens, *Hunter with his Dogs*. 1635. Oil on canvas, 80 × 121 cm (31½ × 47⅝ in). Lille, Musée des Beaux-Arts

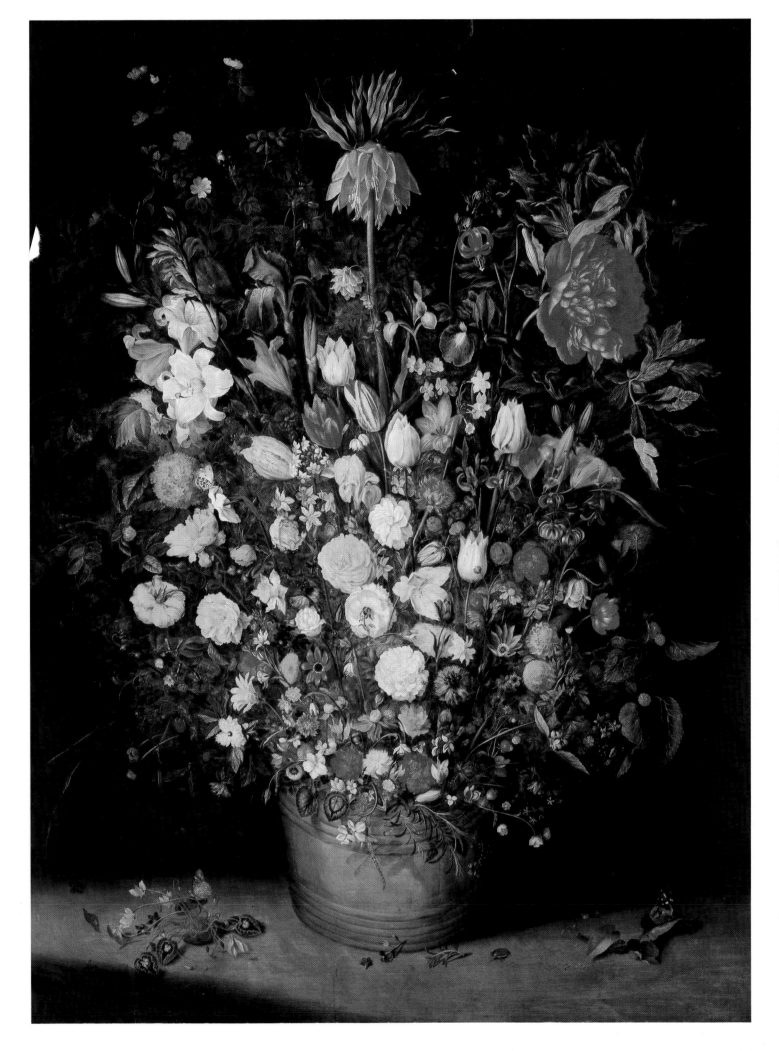

twerp of the Cardinal Infante Archduke Ferdinand in 1635. Jordaens and Rubens also worked together on the elaborate decoration of the Spanish royal hunting lodge, the Torre de la Parada. Jordaens' Baroque vitality (134), bacchanalian excesses, folklike realism, use of subjects often drawn from proverbs and folk sayings (like Pieter Bruegel's), and religious partisanship (in 1645 he converted to Calvinism) led to a highly varied and relatively ununified oeuvre that perhaps no longer enjoys the same enthusiastic approval as in the past.

Not so with Jan Bruegel the Elder, whom we have already met in connection with Flemish landscape painting. His minutely detailed flower pictures (137)

are of a captivating scrupulous exactitude and can truly be said to glow with the feel of real flowers — they make the prize displays of the finest hothouses look shabby! — and are still sought after by collectors today.

Working in almost miniature-like format, the flowers (which Bruegel insisted he studied from nature) are arranged so as to bring out all their diversity and full splendor. Toward the end of the sixteenth century, discoveries in the horticultural domain reached the Netherlandish artists also, acquainting them with foreign and exotic plants, such as the tulip from Turkey, which were then domesticated in the new

138 Adriaen Brouwer, *Peasants in a Pothouse.* c. 1630. Oil on panel, 47.9 × 75.9 cm (18⅞ × 29⅞ in). London, National Gallery

139 Adriaen Brouwer, *The Sense of Touch (A Village Doctor Bandages a Peasant's Wounded Arm)*. Oil on panel, 23 × 20 cm (9 × 7⅞ in). Munich, Alte Pinakothek

botanical gardens being laid out in those years. But the deeper interest of Bruegel's flowers and those of the specialists following him lies beyond their novelty and the beauty of their execution: there is always too the moral of the fleetingness of the blossom's magic, with the passing of such beauty understood as a metaphor for the briefness of man's life on earth. Yet there is no tragic tone, because our eyes take in the rich abundance of the flowers with all they tell us of the manifold wealth of Creation. Highly allusive symbols, already familiar from medieval and late-medieval literature and art, expand their meaning here: each of the flowers that is specially emphasized in the wreath around the Madonna (137) carries a metaphoric message. One is struck too by the skillful use of color. The basic white, yellow, red, and blue are conspicuously set against each other with mixed tones making transitions between the islands of pure color.

Rembrandt and His Influence

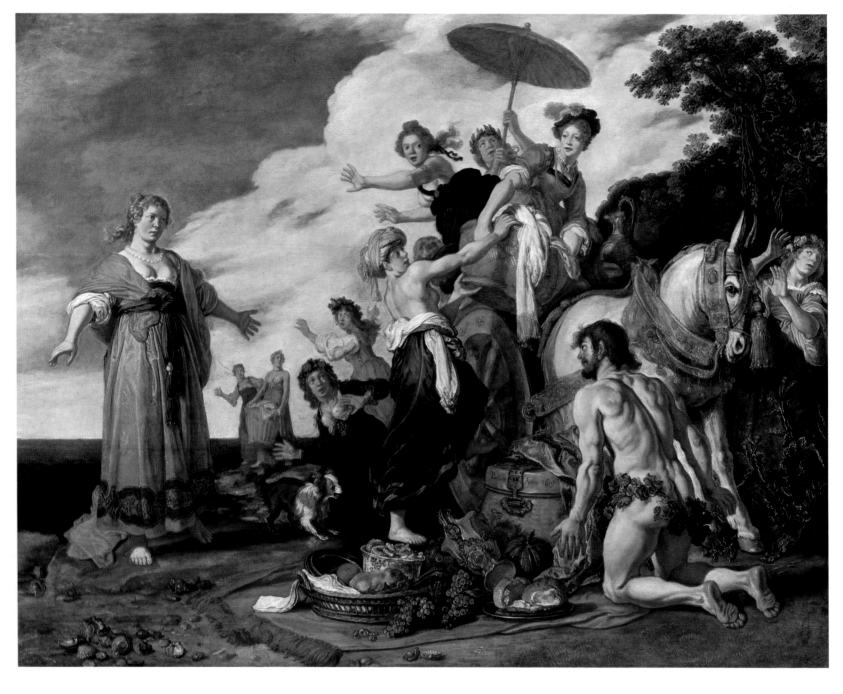

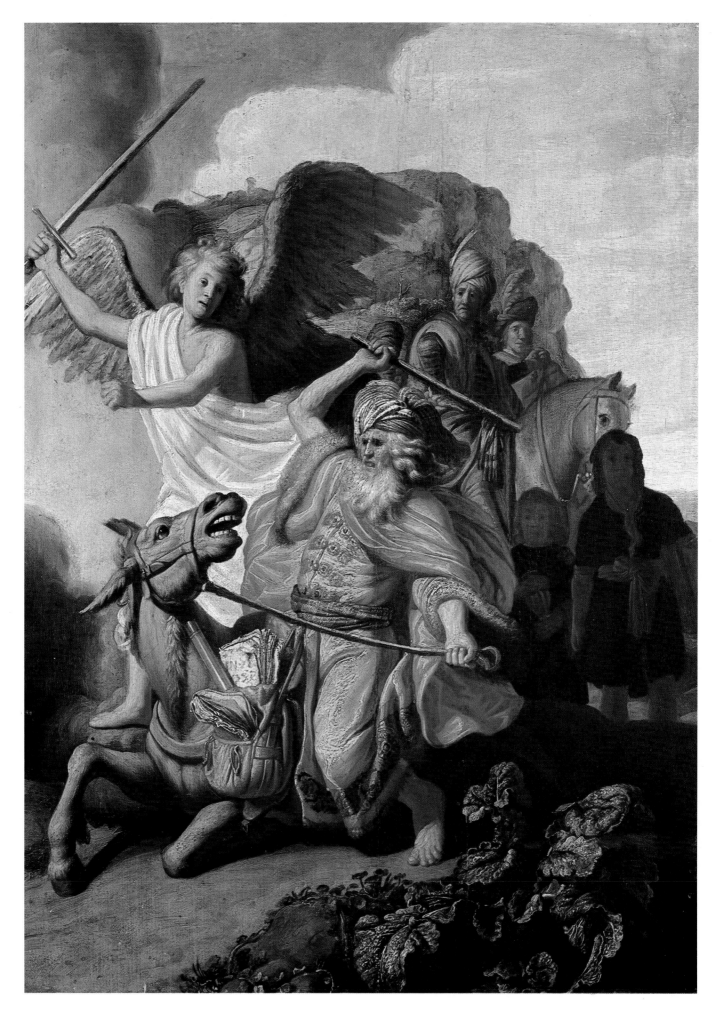

141 Rembrandt, *The Angel and the Prophet Balaam*. 1626. Oil on panel, 65 × 47 cm (25⅝ × 18½ in). Paris, Musée Cognacq-Jay

140 Pieter Lastman, *Odysseus Discovered by Nausicaa*. 1619. Oil on panel, 92 × 117.3 cm (36¼ × 46⅛ in). Munich, Alte Pinakothek

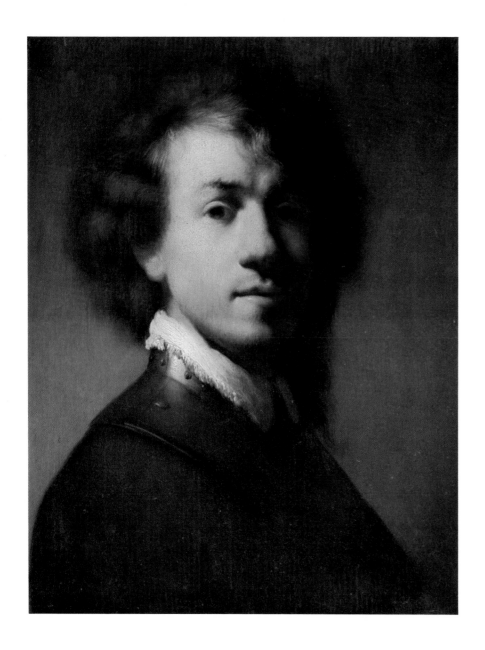

142 Rembrandt, *Self-Portrait at about Twenty-Three with Ruff and Armor.* c. 1629. Oil on panel, 37.5 × 29 cm (14¾ × 11⅜ in). The Hague, Mauritshuis

Two peaks in the art of painting: Rubens in Flanders, Rembrandt in Holland; and the cities where they worked principally, Antwerp and Amsterdam, are not far apart. They could have met—but did not—in Delft, Amsterdam or Utrecht during Rubens' visit in July, 1627, or in The Hague in December four years later. Anyone who admires both of them is impelled to weigh one against the other. With Rubens and Rembrandt, his junior by a generation, much as been made of the contrasts: Flemish versus Dutch, Catholic versus Protestant, rich versus poor; and they have been thought of as paired opposites, like Byron and Keats or Mozart and Beethoven. These comparisons are overstated, and fatally exaggerated by giving too much weight to their political, religious, and social differences.

A good part of the blame goes to the romantically colored notion of Rembrandt that still circulates in our time when we should and do know better: Rembrandt the misunderstood genius with no luck in selling his pictures, dragging out his life in poverty and isolation—whence the dark brown tones of his painting, and the subjects wrested from the gloomiest side of life. His tireless work—a production of about 500 paintings, 300 etchings, 1500 drawings—thus represents his noble struggle to overcome the grimness and tragedy of his life. His art is said to be, for these reasons, that much more impressive and moving as a human expression. Time and scholarship have cleared away a lot of these notions, husked the legend away from the core of reality: right to the end Rembrandt was a successful and highly regarded artist, in the 1630s he was apparently the best known and most sought after painter in Holland, and he had no occasion to bemoan any lack of interesting and important commissions. Which puts a rather different face on any comparison with the Flemish Prince of Painters.

If all these fanciful tales have grown up around his life, it is in part because we know so much less about him than about Rubens. The only authentic first-hand documents are seven letters and a few signatures on paintings. From the first, then, scholars had to stum-

143 Rembrandt, *Self-Portrait at Twenty-Three with Tousled Hair.* 1629. Oil on panel, 15.6 × 12.7 cm (6⅛ × 5 in). Munich, Alte Pinakothek

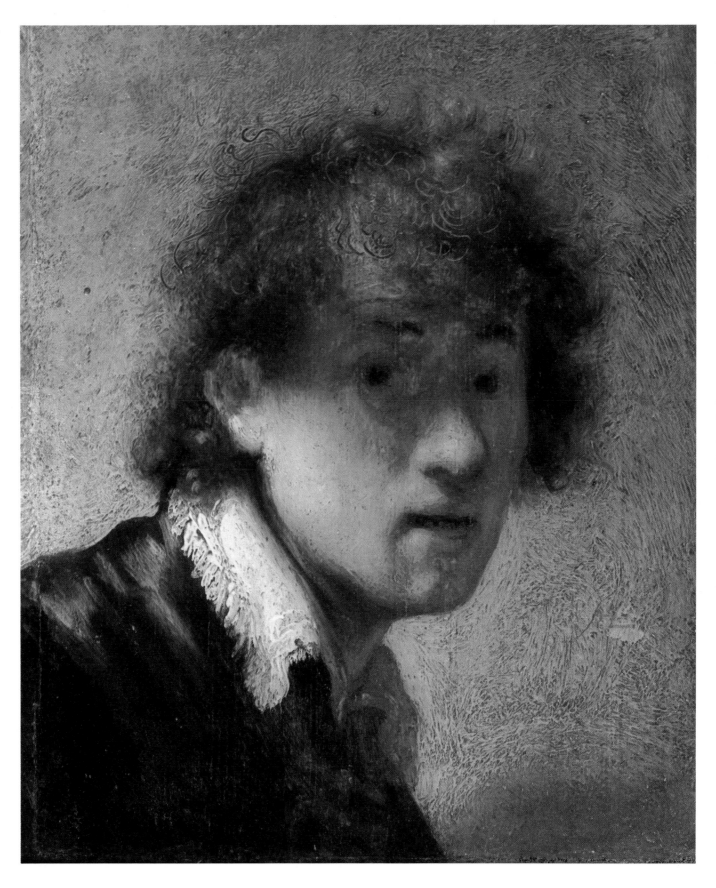

ble about in byways, making much of every chance morsel of indirect evidence—of which there is a considerable mass. Evaluating that sort of information—things like casual mentions by contemporaries or the inventories of his possessions made on the occasion of his insolvency in 1656 or again after his death—inevit-ably gives rise to hypotheses, not all of them valid. Even the unique situation that some hundred self-portraits exist which show him almost year for year throughout his life, and which invite us not only to study his changing appearance but also to read into it what we wish, only fosters further suppositions about

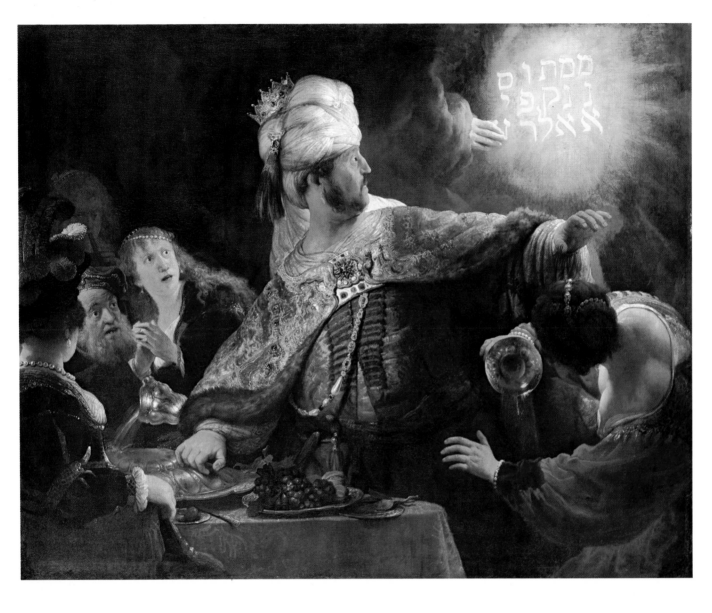

מנא
מנא תקל
ופרסין

144 Rembrandt, *Belshazzar Sees the Handwriting on the Wall.* Oil on canvas, 167.5 × 209 cm (66 × 82¼ in). London, National Gallery

the person behind the picture (142, 143, 152, 153).

Rembrandt was one of nine children of well-to-do parents who in the course of time converted from Catholicism to Calvinism. His father owned half of a mill, his mother's father was a baker. In Leyden he attended the Latin school and was to have gone on to higher education, but shortly after enrolling at the age of fourteen in the famous university of that city his interest changed to painting and he was put to study with Isaac van Swanenburgh, a narrative painter resident in Leyden who had lived for some time in Italy.

Leyden was one of the more ambitious cities in a Holland freed from the Spanish yoke. It had its own traditions in economic life as in art. In the fifteenth century the local cloth industry already enjoyed good repute. After declining under the Spanish occupation of the second half of the sixteenth century, it began to thrive again in 1609, with the start of the twelve-year truce with Spain, and the city became a major center of the textile industry. The university, founded in 1575, attracted serious intellecturals in numbers. The progressive interest in research and the new methods set into motion by the Reformation acquired such prestige there that outstanding theologians, classical scholars, and humanists came from all over.

Yet, before Rembrandt, there was no great activity in the visual arts. True, there had been a few great names in the past, like Cornelis Englebrechtsz. and Lucas van Leyden (66-70), whose works, spared by the Iconoclasts, still hung in the town hall and elsewhere, but since then it had been a dull history. No wonder, then, that Rembrandt and his gifted friend and fellow-townsman Jan Lievens had to go to Amsterdam, to Pieter Lastman, for a final polish to their artistic training before opening their own workshop in their home town around 1625, when neither had yet reached twenty.

Lastman was a narrative painter like Swanenburgh, but much more influential. Narrative art enjoyed a rich tradition and was still the most respected, though the new specialties of portraiture, landscape, and

145 Rembrandt, *Saskia as Flora*. 1634. Oil on canvas, 125 × 101 cm (49¼ × 39¾ in). Leningrad, The Hermitage

genre painting were already claiming places alongside it. Lastman headed a group of painters in Amsterdam who had remained Catholic (it included among others Jan Pynas and Jan Tengnagel) and who had all been in Italy where each to one degree or another was smitten with the same artistic approaches: a Caravaggism of the type practiced by the German painter Elsheimer, and the Mannerist formal vocabulary we have already noted among the Utrecht artists. Their biblical, mythological, and historical subjects in relatively small picture formats set out an abundance of narrative details with a bright diversity of coloring. Lastman's *Odysseus Discovered by Nausicaa* (140) depicts the moment in the sixth book of Homer's *Odyssey* when the princess comes across the shipwrecked hero. At the sight of the naked warrior each of the attendants expresses her fright in her own manner. A multitude of details—still lifes of baskets of food, shells washed ashore, a variety of headdresses, billowing garments—are all rendered with the same ex-

actness, and the total effect is somewhat overloaded and even cloying.

In the version of the same scene that Lastman painted ten years earlier (Braunschweig, Herzog-Anton-Ulrich-Museum), the figures are differently disposed and form other relationships. He treated certain themes a number of times with different solutions that mostly gain added interest through swiveling the stage around, so to speak, and thereby regrouping the figures. He also liked to intensify the drama through the use of a very low horizon, which makes the principal figures—as Nausicaa here—stand out powerfully against the sky, especially if the painting is placed high on the wall and viewed from below.

To judge by his early works, at the start of his career Rembrandt must have been much impressed by Lastman's compositional principles, though he used them later too—it suffices to compare just how he varied his treatment of various versions of such themes as the *Baptism of the Chamberlain, Simeon and Anna Prais-*

146 Hercules Seghers, *Mountain Landscape with Vista.* c. 1633. Oil on panel, 55 × 100 cm (21⅝ × 39⅜ in). Florence, Galleria degli Uffizi

147 Rembrandt, *Land-scape with a Stone Bridge.* c. 1638. Oil on panel, 29.5 × 42.5 cm (11⅝ × 16¾ in). Amsterdam, Rijks-museum

ing the Christ Child (The Presentation in the Temple), the Raising of Lazarus, the *Supper at Emmaus,* the *Prodigal Son,* and so on. Perhaps Rembrandt's "restagings" were influenced by what he could have seen in the theater; both he and Lastman proceed very much like a stage director, testing the effect made on the viewer of moving a main character in a scene from one side to the opposite. Attempts have been made, though on quite different bases (by Van Regteren Altena, for one), to reconstruct Rembrandt's contacts with theatrical life, and they may be pertinent to this aspect as well.

Rembrandt's *Angel and the Prophet Balaam* [Numbers 22:21-35] (141) is an early work indebted to Lastman's version of the subject done a few years earlier (England, The Palmer Collection) which was in turn based on an earlier example. By shifting the format from horizontal to vertical, and by displacing to the side and rear the angel barring the path to Balaam's ass so that the prophet cannot see the heavenly messenger, Rembrandt improved the composition in form and expressive content alike, so that one more readily believes in the vividly portrayed rage of the stubborn prophet who fails to recognize God's hid-den purpose and opens his eyes to it only after having beaten the innocent ass three times.

Rembrandt's first success came in 1629 with strik-ing renderings of two New Testament scenes, *Judas Returning the Thirty Pieces of Silver* and the *Raising of Lazarus.* Fame came to him immediately. Con-stantijn Huygens, secretary to the stadholder of the Netherlands and himself a true connoisseur whose own appearance we know from a portrait by Thomas de Keyser (158), was at that time penning his auto-biography and made room in it for effusive praise of the young painter.

Yet the somewhat low-spirited note struck in one of Rembrandt's self-portraits of the time (143) scarcely seems to go with such success. Eyes shadowed over, hair in disorder, lips slightly parted: so the twenty-three-year-old saw himself, yet he was already paint-ing with staggering technical perfection and with a full charge of temperament. Using the wooden tip of the brush, a few hairs are incised into the still wet paint with great effect. Was the young artist really so im-mersed in his work, as contemporary accounts say, that he scarcely left his house, and did he really strike people around him as sickly?

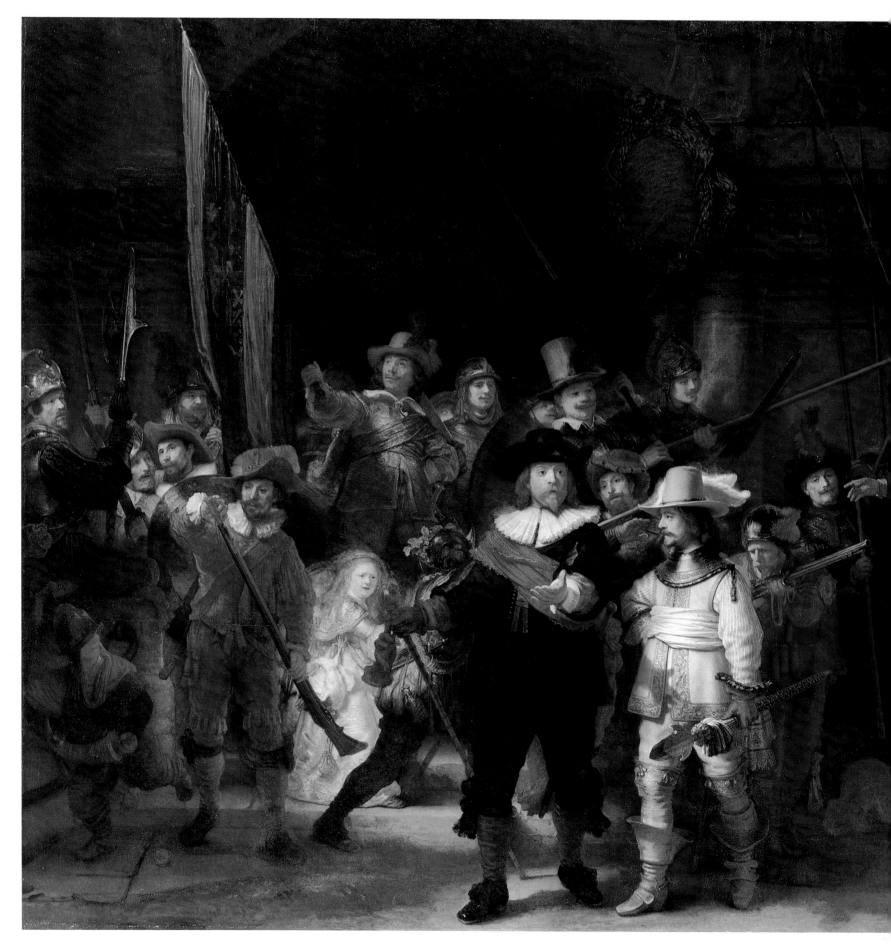

148 Rembrandt, *The Company of Captain Frans Banning
Cocq and Lieutenant Willem van Rutenburch ("The Night
Watch")*. 1642.Oil on canvas, 359 × 438 cm (11 ft 9⅜ in ×
14 ft 4½ in). Amsterdam, Rijksmuseum

Soon he moved to Amsterdam where he would remain the rest of his life. The first decade there was his most successful time as an artist and happiest as a man. His precipitous rise corresponded to the rapid growth in importance of Amsterdam. In less than fifty years it had made itself a veritable metropolis, growing from a population of 30,000 in 1585 to 115,000 by 1631. It became the new intellectual as well as economic center of Europe. Goods from all over the world changed hands there; Antwerp, Genoa, and the Hanseatic cities lost their pre-eminence to the Dutch port-city. The idea of tolerance no longer was merely part of "the bold wishful-thinking vision of a new state," as Schiller expressed it; it had materialized into an inalienable human right. Streams of refugees, both Christian and Jewish, would thenceforth swell the population.

Rembrandt was and still is the living evidence of those unexampled changes which, more than anything, were to bring about a change in the way men thought about themselves. The kind of people who commissioned paintings—merchants, craftsmen, men of the cloth, Jewish scholars—now wanted to have themselves commemorated in portraits. After earning his first laurels in Leyden as narrative painter, Rembrandt very quickly adjusted to the new situation and won as much success through portraits: in his first two years in Amsterdam there were no fewer than twenty-eight. He continued, though, to paint such narrative scenes as *Belshazzar Sees the Handwriting on the Wall* (144), in which the dramatic tension is pushed to the utmost. Here, in depicting the scene which has stirred imaginations through the ages [Daniel 5:24-28] Rembrandt showed the king still drunken with vanity and power in the precise moment when he reads his death sentence in the words, MENE, MENE, TEKEL, UPHARSIN — thou art weighed in the balance and found wanting—written by a mysterious hand on the wall, thus the instant of the sharpest contrast. What intrigued the painter here and afterwards was the abrupt dramatic change, and he would work for years at the problem of how to capture in a painting the effect of a diversity of emotions all flaming forth in the same moment. Tenaciously he practiced ways of representing unbounded movements, lurid relations of light, contrasting colors, striking facial expressions. An entire series of such impulsive and forceful works arose in this period that can be called his storm and stress phase.

Yet in the same breath he was also conjuring up restrained and delicate likenesses of his wife in which he gave great attention to every decorative detail and embellishment, as in the *Saskia as Flora* (145) painted in 1634, the year he married Saskia van Uylenburch, the daughter of a burgomaster. In three paintings he tricked her out with the trappings and attributes of the goddess Flora: Saskia, for her husand, was clearly associated with springtime, blossoming flowers, fruitfulness. The blissful marriage would end with her early death after only eight years, but many of his paintings speak of it. The popular double portrait (Dresden, Gemäldegalerie) where in rollicking mood he holds her on his lap and raises his champagne glass to us—a picture immortalized on candy boxes and telegrams of congratulation—nonetheless carries a note of sadness, reminding us of the precariousness and fleetingness of all happiness.

Rembrandt's great gifts soon extended to all realms and techniques of painting. Beginning in 1636 there were landscapes, at first simply poetic reworkings of impressions of nature. If the *Landscape with a Stone Bridge* (147) has a savor of possible reality, still it is the unreal and fantasticating element that predominates in it. The sun breaking through the heavy mass of clouds in one place pours a livid gleam on a patch of the midground where it grazes a huge mighty tree. The two men busy with a boat in the foreground look so much the smaller in this setting. The color scale is reduced to brown, ocher, and olive-green tones. It was not before the 1640s that Rembrandt took to depicting his surroundings in lifelike manner and with a more controlled simplicity, and it may be that he was inspired to such bold and affect-laden visions by Hercules Seghers, the fascinating but little esteemed Haarlem painter who died before 1638. Rembrandt owned eight of his paintings and reworked certain of his copperplates into compositions of his own. Seghers had recognized what was undefinable in the breadth of the Dutch landscape and, in a personal manner, added to it mountain gorges with half-dead vegetation and jagged rock cliffs. The *Mountain Landscape with Vista* seen here (146) may have been owned by Rembrandt who may in fact even have painted over part of it.

It was in the year of Saskia's death that Rembrandt painted his most famous and most controversial work, the so-called *Night Watch* (148). The title is false, and was pinned on it during the years when the canvas, uncleaned and unrestored, had darkened considerably. The true subject is the falling-in of the milita company of Captain Frans Banning Cocq by daylight. The captain is shown ordering his lieutenant

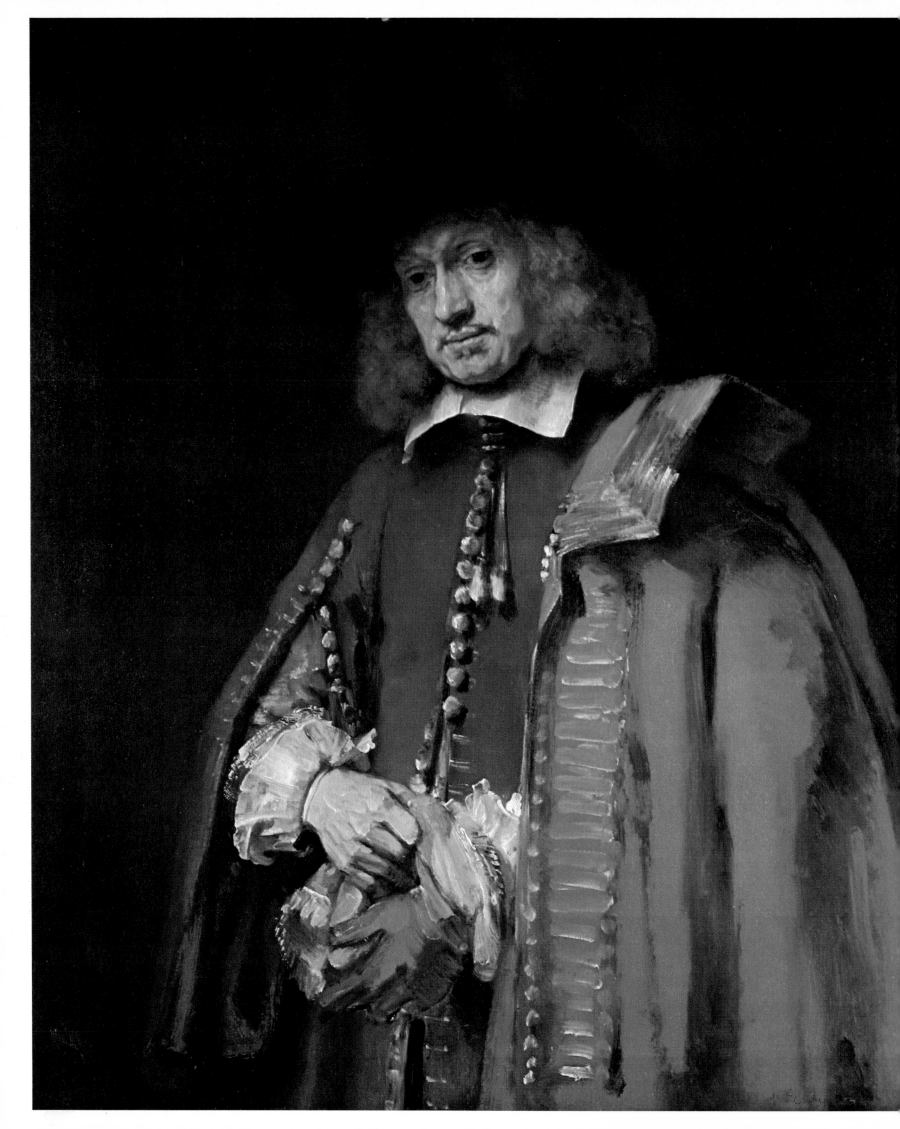

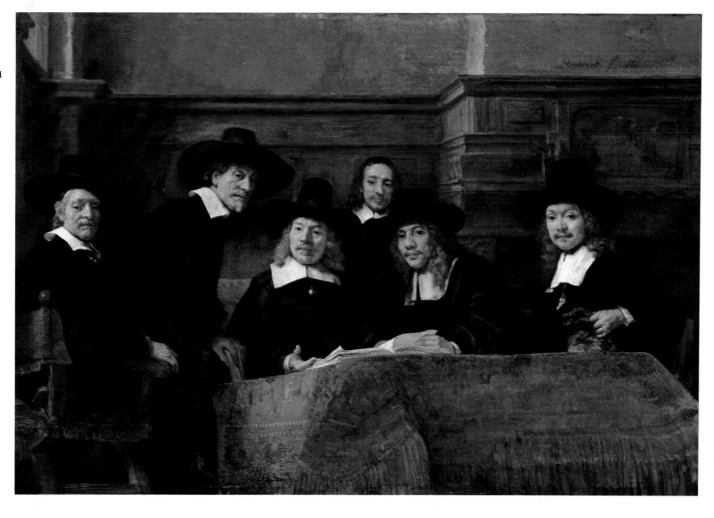

Willem van Ruytenburch to have the men assemble, and Rembrandt has caught the precise moment when the company has not yet formed its ranks, so that each member is seen preparing whatever his assigned task may be. One loads his matchlock gun, another fires a trial shot, a third blows the powder, a fourth is just about to play his drum. In their midst sits a market woman who is there to supply their provisions. By catching just the moment before the troop falls in, and by utilizing particular painterly means such as marked contrast in lighting, Rembrandt infused the scene with a feeling of animation and even excitement. The details, such as the historically important insignia of the *Kloveniersdoelen,* the arquebusier company,(found regularly as emblem in the didactic books of the time), or the claws of the chicken at the market woman's waist are shown in such a way that they are integrated into the action rather than brandished before us as accessory symbols.

Rembrandt broke with the tradition of civic guard company portraits by having all the members involved in a common action. Previous group portraits had lined up all the guardsmen in approximately regular rows as the "fairest" was to satisfy everyone paying a share of the artist's fee (86). A difficult problem for any artist who had to content the lot of them! No wonder that—with the exception of those by Frans Hals (108)—the results were mostly stiff and boring, and that is the way the other six guards' company portraits came out that were executed for the same Hall of the Arquebusier Companies completed in 1638. They were no match for the canvas Rembrandt hung alongside them. On the other hand, his compositional innovation was not hailed enthusiastically by those members of the militia who found themselves half-concealed by others or, worse, scarcely recognizable in the background. For such reasons, and because Rembrandt produced less in the years after 1642, the legend grew up that he came to grief with the so-called *Night Watch* and that thenceforth he worked only in deepest conflict with his time. The facts belie this. From the accounts of other artists and of biographers writing in those years it appears that, for all its daring and decidedly unusual conception, the work was received with understanding and, by some, with real enthusiasm.

In retrospect it becomes clear that, in this exceptional painting, Rembrandt was making perfectly

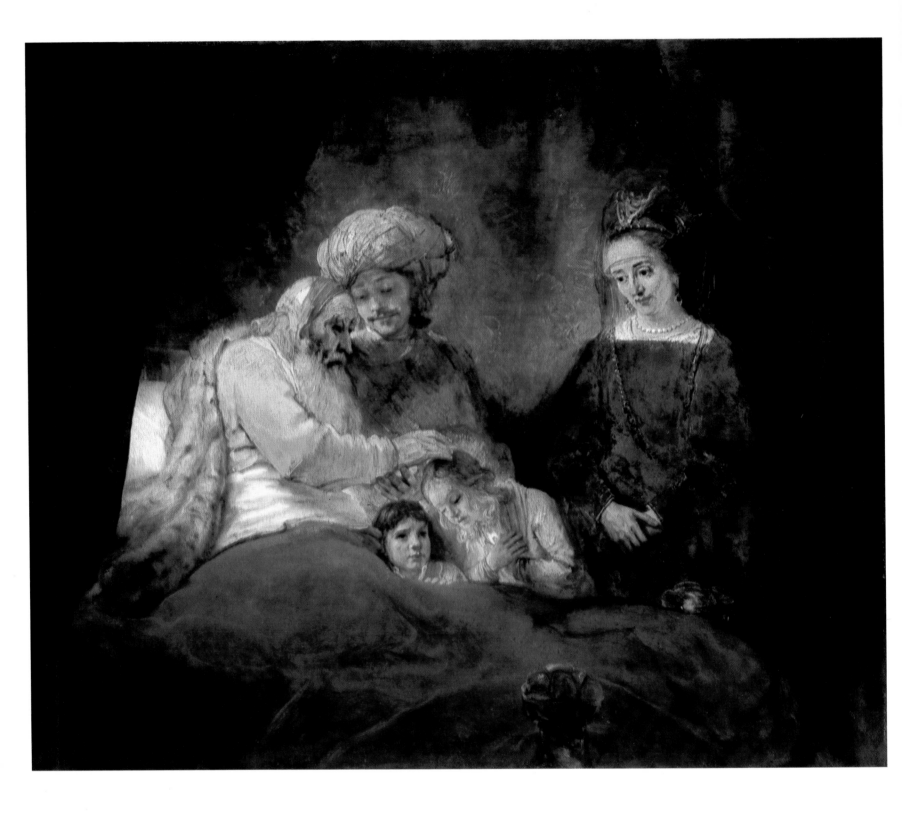

logical use of his earlier experiments. His Amsterdam years had begun with another famous group portrait, the *Anatomy Lesson of Dr. Tulp* of 1632 (The Hague, Mauritshuis), in which he already dispensed with a schematically lined-up row of portraits in favor of a concrete scene caught at the specific moment when Dr. Tulp is demonstrating the arm musculature of the cadaver and the members of the surgeons' guild are giving him full attention.

Likewise in his last major group portrait, the *Syndics of the Drapers Guild* of 1662 (150), he attempted to introduce a tension that seems to permeate each of the figures, though what the cause of that tension might be, and why all six men are subject to it despite their rather different reactions, has never been ascertained. Yet if one feels impelled to guess at it, it is because of another aspect of Rembrandt's art, the particular style of his late years which became ever more enthralling and evocative the more it took shape.

In the 1640s his style changed. Dramatic compositions of Baroque character, exciting in their grandiloquence and extreme outward intensification, gave way

151 Rembrandt, *Jacob Blessing the Sons of Joseph.* 1656. Oil on canvas, 174 × 209 cm (68½ × 82¼ in). Kassel, Staatliche Kunstsammlungen

to a more pacific pictorial construction. Now the human element began to come to the fore more markedly, and inward qualities were laid bare with intense sympathy (as in the etched self-portrait of 1648). The artist had passed through personal upheavals that left him perforce changed. Of the four children Saskia bore him, only Titus survived, and he was only nine months old when his mother died. As nurse Rembrandt took into the house Geertghe Dircx, a widow from North Holland, with whom he soon became involved though later he stood his distance from her and turned her out. He replaced her with Hendrickje Stoffels, the daughter of an army sergeant from Bredevoort, who remained his faithful companion to her death in 1663. She bore Cornelia, the only one of his children to outlive him.

Rembrandt was anything but competent in running his affairs and his house. After having acquired considerable wealth in the 1630s, with a house in the best neighborhood of Amsterdam, and having built up exceptional collections of all sorts and gone in for speculating in what we call securities, he appears to have so far exceeded his possibilities that he fell increasingly into debt. By 1657 he was insolvent and had to see all of his possessions auctioned away. However he did manage to avoid bankruptcy and was permitted to earn his living without attachment of income, having secured the judicial conveyance of inheritance rights conceded only to citizens of irreproachable reputation.

The change in his art to a quieter, more humanly introspective approach fell in a time of general cultural change. Since mid-century Dutch taste had been shifting to a more academic, classicistic style with lighter colors smoothly laid on. Newly rich burghers insisted on being portrayed in poses that gave them an elegance they still lacked. A good many artists, even some of Rembrandt's own pupils, quickly adjusted to the new fashion, for example Bartholomeus van der Helst (159). Rembrandt, though, clung to his own very different way, although it did not isolate him as much as is sometimes claimed. Not only in Holland but even abroad he still had highly placed patrons, like the Sicilian nobleman Don Antonio Ruffo who in the 1650s rounded out his important collection with canvases by Rembrandt. Another patron was Jan Six, joint owner of his grandfather's cloth and silk factory in Amsterdam, later burgomaster of the city, who in 1647 had himself portrayed in drawings and an etching by Rembrandt, and in 1654 in a painted portrait (149), one of the most brilliant creations in that domain,

which it has remained in the Amsterdam house of the sitter's heirs. The likeness of the thirty-six-year-old industrialist and humanist is almost sketched in, with a flowing technique, vehement brushwork, and economy of color. The thoughtful face is carefully characterized—one cannot help wondering what he is thinking about—in contrast to the spontaneous rendering of the gesture of pulling on a glove. As for the color, "white highlighting sits on the most glowing golden glazed tone, which is varied from golden ocher to deep transparent brown" (M. Doerner).

The works of Rembrandt's last decades have ensured his worldwide fame: etchings like the *Three Trees* of 1643, the so-called *Hundred Guilder Print (Christ Healing the Sick)* from around 1642/49, the *Doctor Faustus* of around 1652-53, the *Three Crosses* of 1653; such paintings as the *Mars after Laying Down His Arms* of around 1650 (Berlin-Dahlem, Gemäldegalerie) better known under its old title of *The Man with the Golden Helmet,* the *Aristotle Before the Bust of Homer* of 1653 (New York, Metropolitan Museum of Art), *Jacob Blessing the Sons of Joseph* (151), *Saul and David* of around 1658 (The Hague, Mauritshuis), the *Isaac and Rebekah* of around 1665 traditionally called *The Jewish Bride* (Amsterdam, Rijksmuseum), and *The Return of the Prodigal Son* of around 1668-69 (Leningrad, The Hermitage).

In the painting in which the aged and blind Jacob blesses his grandsons Manasseh and Ephraim in the presence of their parents Joseph and Asenath [after Genesis 48:14-22] (151), the artist caught the moment when the patriarch favored Ephraim, the younger brother, with his first blessing, following the promptings of God rather than the law. As the Bible has it, Joseph sought to hinder him and direct his hand to the head of the first-born but his father refused. Yet as Rembrandt painted it, Joseph seems not to object but indeed to consent to the act. Further, the gesture of blessing is rendered in a manner that does not suggest any typological parallel with the sign of the Cross as was so frequent in earlier such depictions. In addition, the mother is given a dominant place though her presence is not mentioned in the biblical account and so is very rare in the pictorial tradition.

While we do not know for whom Rembrandt did this painting, it seems likely that the divergencies from biblical and pictorial tradition would have been at the wish of a patron, perhaps himself a Jew as R. Haussherr has suggested. Rembrandt is known to have had contact with representatives of various faiths, including Jews, and the Hebrew letters in the mysterious

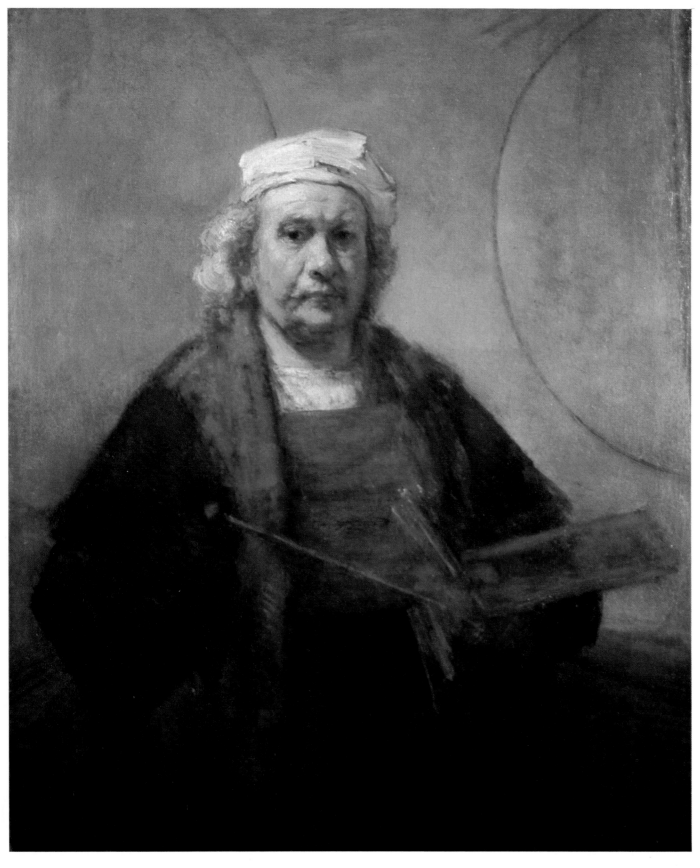

152 Rembrandt, *Self-Portrait in his Fifties*. c. 1659-60. Oil on canvas, 114.5 × 94 cm (45⅛ × 37 in). London, Kenwood House, The Iveagh Bequest

153 Rembrandt, *Self-Portrait as the Apostle Paul*. 1661. Oil on canvas, 91 × 76 cm (35⅞ × 29⅞ in). Amsterdam, Rijksmuseum

inscription of his *Belshazzar Sees the Handwriting on the Wall* (144) might have been shown to him by Rabbi Menasseh ben Israel. Then too, in the scene of blessing the presence of the mother may lack biblical sanction but conforms to the Jewish conceptions of Rembrandt's time. Still, her figure does fill a gap in the composition and makes an impressive counterweight to the group around the patriarch. Perhaps too, by introducing a woman the painter may have wished to complete the symbol of humanity entire. This was not the only time he so enriched a scene: Rachel appears in the etching of *Joseph Relating His Dreams* of 1638

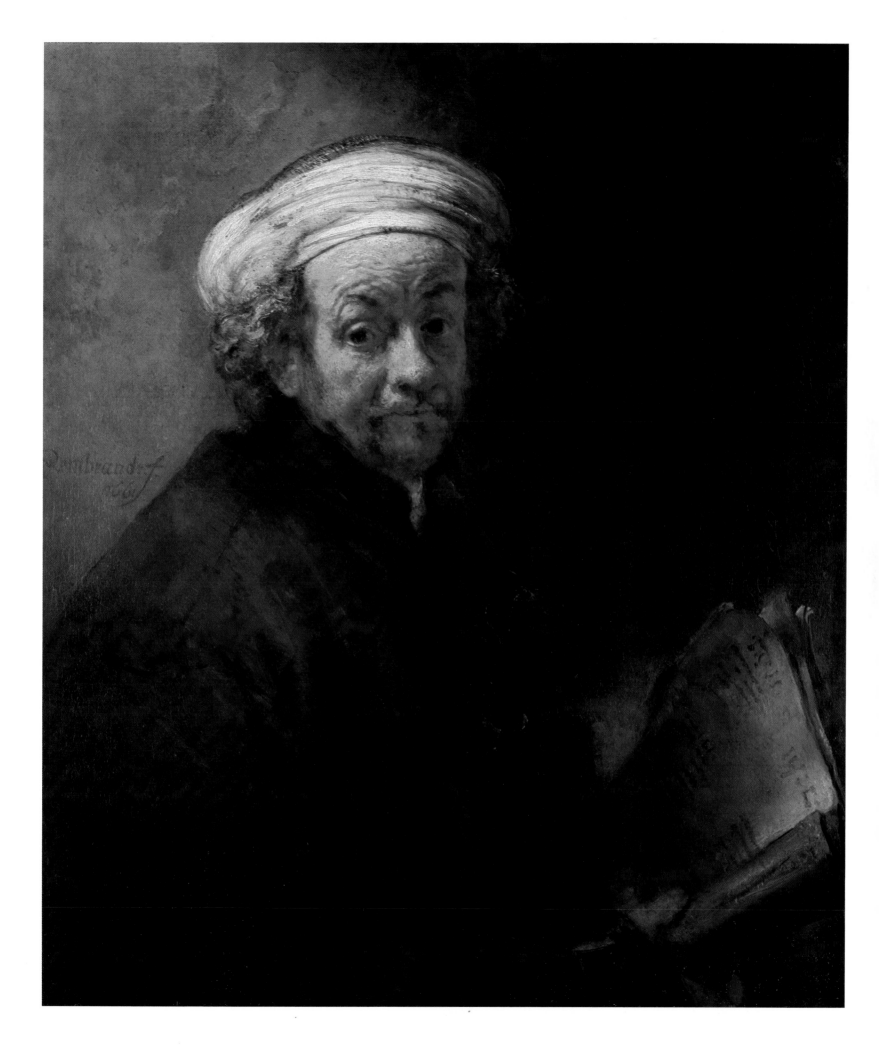

and Ishmael in that of *Abraham Entertaining the Three Angels* of 1656, though in these there are pictorial precedents (none, however, very typical). Whether or not Rembrandt knew precedents for the figure of Asenath in this painting, he could have introduced it for any of the reasons we have suggested. Yet nothing tells us just why, and this is a good example of how mistaken it can be to rely on a single explanation for a picture, no matter how plausible it may seem. The real artistic motivation may be very different indeed.

If discussions still go on concerning this picture, it is because of its unusually strong and compelling impact. Nor is it the only work in which Rembrandt ignored a textual or pictorial tradition. Finally, precisely its remoteness from a tradition is a sign of the artist's rich inventiveness. Interest in this particular picture was renewed in 1977 when it underwent a complicated restoration. Cleaning confirmed its high quality, and the occasion was used also to investigate it by modern technical means. X-ray analysis showed that Rembrandt did not immediately arrive at the present posi-

tions of the figures, the Joseph in particular. Similar hesitations have been ascertained in other paintings, in the *Syndics of the Drapers Guild* for instance (150), and such observations do cast light on the creative process, often giving us new and unexpected insights and information.

Rembrandt's genius and fame attracted young painters from as far away as Germany to his studios. He taught as early as his Leyden years, and one of his pupils there, Gerard Dou, adopted his more detailed approach of that time, combined it with a smooth treatment of paint, and rose to quick fame with works rich in still-life and genre motifs that already in the seventeenth century commanded the highest prices (194). Not all of the thirty known pupils of Rembrandt were that successful, but most were better than the average and some—Jacob Backer, Govaert Flinck, and Ferdinand Bol, for instance—count among the most sought-after Dutch narrative painters of the time.

Rembrandt's teaching was not at all like Rubens'.

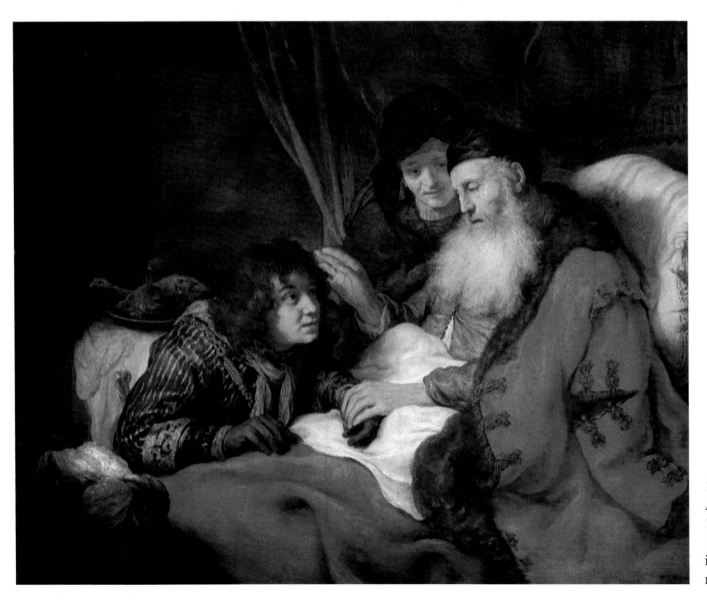

154 Govaert Flinck, *Isaac Blessing Jacob.* 1639. Oil on canvas, 117 × 141 cm (46⅛ × 55½ in). Amsterdam, Rijksmuseum

155 Carel Fabritius,
Self- Portrait. c. 1654.
Oil on panel, 65 × 49
cm (25⅝ × 19¼ in).
Rotterdam, Museum
Boymans-van Beuningen

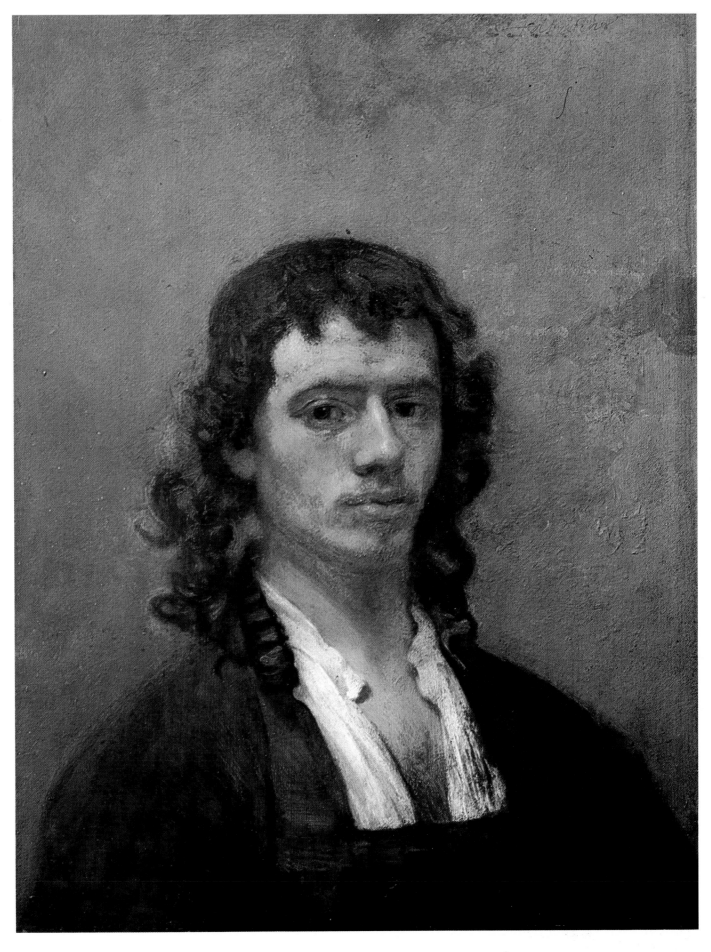

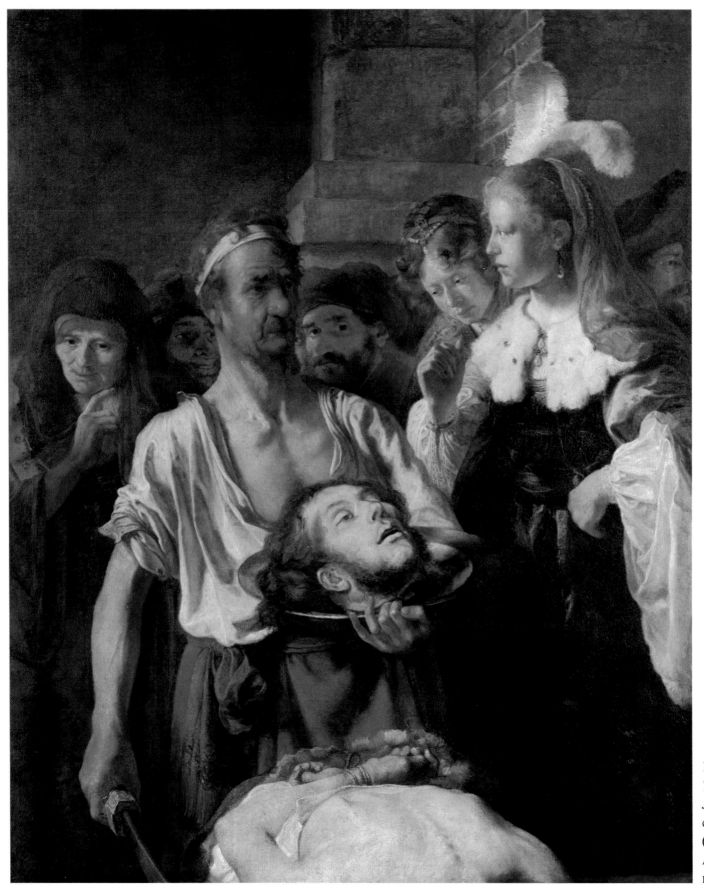

156 Carel Fabritius, *The Beheading of Saint John the Baptist*. Oil on canvas, 149 × 121 cm (58⅝ × 47⅝ in). Amsterdam, Rijksmuseum

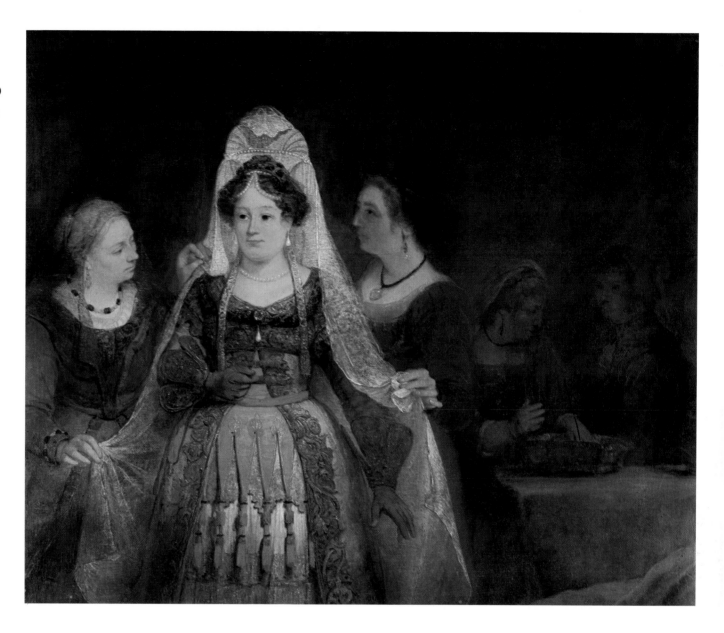

He did not use his pupils as helpers in his own work, as Rubens did in his huge workshop, but encouraged them in their individual gifts and tendencies. He had them draw from the model, chose some of his own pictures (mostly earlier ones) as examples for them, and divided the atelier with partitions so that each student had his own small studio where he could work undisturbed. Drawings survive which show what the master corrected and improved and how he advised bringing out the chief aspects of a composition. As long as these young artists remained with him—the by no means modest tuition covered food and lodging as well—each in his own way came so much under the master's sway that their works of that period are often hard to tell from his. When they left him, either they continued to practice a style that he himself sooner or later left behind or they took up newer and more fashionable trends.

Govaert Flinck, Rembrandt's pupil in the 1630s, is said to have been able to counterfeit his style to perfec-

tion. His *Isaac Blessing Jacob* [after Genesis 27:18-29] of 1639 (154) may be based on a drawing by the master, if the drawing (Benesch catalog number 509) in fact preceded it, but in any case unquestionably bears the mark of Rembrandt's influence. The pupil who showed himself most congenial to that influence, and who truly absorbed and made it his own, was Carel Fabritius whose uncommonly promising career was cut short at the early age of thirty-two when he was killed in the powder magazine explosion in Delft in 1654. His early *Raising of Lazarus* (Warsaw, Muzeum Narodowe), done under the direct influence of Rembrandt, shows him already boldly grasping all the possibilities implicit in his teacher's work, and his self-portraits too are related to Rembrandt's powers of psychological penetration (155). There are daring foreshortenings and a mettlesome realism in the *Beheading of Saint John the Baptist* ascribed to him [after Matthew 14:1-12] (156), and in a *Soldier of the Guard* (Schwerin, Staatliches Museum) there is a sovereign

158 Thomas de Keyser, *Constantijn Huygens and his Clerk*. 1627. Oil on panel, 92.4 × 69.3 cm (36⅜ × 27¼ in). London, National Gallery

mastery that makes it very likely that Fabritius was a major influence on Vermeer who worked in Delft after him.

Only Aert de Gelder perpetuated Rembrandt's late style, though in more superficial fashion, simply applying the master's last manner of painting to the same sort of subjects (157). In a few of his paintings, though, one does sense something of his teacher's inner tension and must conclude that he had at least some awareness of Rembrandt's true greatness.

A number of Dutch painters somewhat older than Rembrandt had found their own idiom before he appeared on the scene and, like Thomas de Keyser, already showed themselves promising talents. His portraits of Huygens receiving a letter (158) may have stimulated Rembrandt to similar motifs. In the course of time, however, the relationship changed, and it was Rembrandt who had a beneficial effect on his older contemporaries. But it was mostly younger painters who were attracted by his art, men like Bartholomeus van der Helst, but then only to turn away from him and adopt the new aristocratic modish style. Helst's portrait of the son of the Amsterdam burgomaster (159) falls perfectly in line with the new demand for a "pretty picture" with the fanciest of finery — here one is tempted to speak of the subject as "all dolled up" — that made headway after mid-century in Holland. Even Rembrandt pupils like Flinck and Ferdinand Bol (193) took up this new superficial taste which — it is too readily forgotten — went along with really astounding skill in painting. Helst's portrait of the fat youth, like it or not, is a technically brilliant, splendid feast for the eyes.

But wherever one looks in this golden century of Dutch painting at its peak, it is Rembrandt who appears at the very heart of it as an ardent, all-pervading force. Few artists have dug so deeply and directly into the core of their own being as he did in his self-portraits (142, 143, 152, 153). Most have fallen prey to the temptation to show themselves at their best, as they would like to look. But in Rembrandt's many self-portraits there was also a certain play-acting in which he assumed various roles, and they ranged from beggar to the Apostle Paul (153), from a youth on a ladder helping to take down the dead Christ to the laughing philosopher Democritus, from solider to lover.

There is a paradox implicit in this play-acting: the artist takes on a role in order to play himself. Yet he comes before us in so utterly honest and disarming a manner that we cannot mistake the mask for the man. We see into Rembrandt's soul and it is as if time has stopped for an infinite instant. Did he think of this, even count on it, when he portrayed himself like a patriarch in front of two enigmatic circles (152)? Or did he turn his back on all such external purposes so that he could concentrate the forces that speak so compellingly from those pictures of himself?

159 Bartholomeus van der Helst, *Gerard Andriesz. Bicker as a Youth*. Oil on panel, 94 × 70.5 cm (37 × 27¾ in). Amsterdam, Rijksmusem

Dutch Landscape Painting

Little in Dutch art surpassed the landscape painting it produced so bountifully in the seventeenth century. Here the decisive step was taken to a "pure" landscape with no need or use for mythological or other figures and with no concern for academic composition formulas. Where Mannerism and the classical Baroque had relied on generalized motifs forced into artificial categories, now there were precise views of specific places. Yet for all the interest in the here-and-now there was nothing trivial about it but instead an impressive picture of reality with certain of its aspects intensified. Goethe summed it up in 1813 when he wrote about Jacob van Ruisdael: "The artist grasped with admirable ingenuity the point where the power to produce comes together with pure understanding and thus transmits to the viewer a work of art which, pleasing to the eye in and for itself, evokes an inner meaning, stimulates us to think about it, and finally conveys a concept without losing its identity or the warmth of its inspiration."

The turn to "inner meaning" took many different paths, and the break with current conventions was as varied and individual as the artists involved. The differences between Rembrandt and Asselijn, Cuyp and Ruisdael, Post and Pynacker—to name at random landscape painters of the same generation—seem to run deeper than their differences from artists of other parts of Europe. Considering their originality of conception and highly accomplished technique, it is startling to realize that many of them were not even full-time artists. Van Goyen, Aert van der Neer, and Jan Wynants were innkeepers, Hobbema from his thirtieth year was wine-gauger for the city of Amsterdam, Breenbergh was a merchant, Koninck lived on the income from his shipping line between Amsterdam and Rotterdam, Jan van de Capelle owned a dyeworks, Jan van der Heyden was connected with the Amsterdam fire department and instituted the first system of public street lighting.

The power and diversity of the various individual approaches owed much to new conceptions of what the artist did and for whom. For the first time pictures

160 Adriaen van de Venne, *Allegory of the Truce of 1609 between the Southern and Northern Netherlands.* 1616. Oil on canvas, 62 × 112 cm (24⅜ × 44⅛ in). Paris, Musée National du Louvre

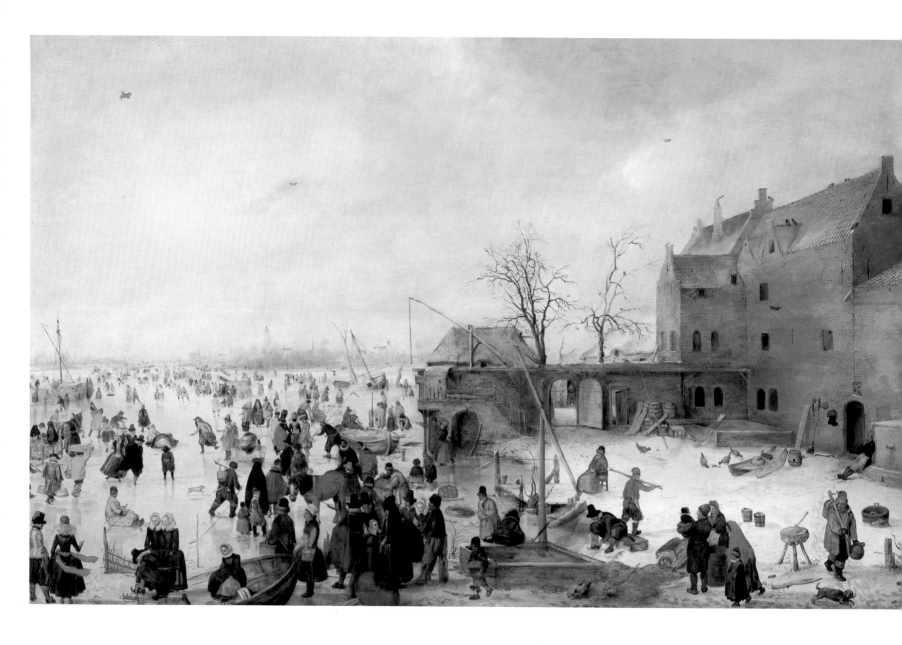

were painted to be hung in the houses of a broad stratum of prosperous city burghers. Moveover, such pictures were usually not commissioned but were already being turned out for an anonymous market subject to the ever-changing whims of taste. In Holland, where the tone was set by Calvinism, men trusted to the evidence of their senses when it came to understanding reality, and this had its effect also on what they expected from pictures. In Catholic countries, well up to the end of the eighteenth century the language of analogy and metaphor continued, as was long traditonal, to have a full measure of supernatural content. As Max Weber has put it, in the Puritan and Protestant search after the way to God man hoped "to track down His purpose for the world through the exact natural sciences. . . where His works could be grasped physically," and thus, by means of "the empirical comprehension of the divine laws in nature, to

be able to rise to knowledge of the 'meaning' of the world." Thus, what man could grasp of the essence of the world and the things it holds was to be discovered only in the things themselves: it lay *in* them, not beyond or above them.

The individual human being, the society that had grown up through history in each local community, and the site of everyday human activities—house, marketplace, the country roads and lanes—were now in a real sense *real*, and they were to be taken seriously as stations on the way to salvation. Then too, the Dutch saw in the landscape what was known in the time about the nature of nature: the landscape was where the elements came together, where the cosmic forces operated that held the world in thrall—light especially, and light ever since early medieval times had been regarded as a divine force.

It is often said that the Dutch discovered nature as

161 Hendrick Avercamp, *A Scene on the Ice near a Town (Winter Sports)*. c. 1615-20. Oil on panel, 58 × 89.8 cm (22⅞ × 35⅜ in). London, National Gallery

mirror of subjective moods and feelings. Not so. In the landscape around them they saw, instead, the expression of objective natural forces which, like their own history, embodied a part of the social and personal challenge posed by the world as a whole. The general tendency of their creative thinking was "realistic" in that they proceeded from immediate and momentary impressions and then singled out those natural forces amenable to artistic expression. This inner dynamic was understood very subjectively, and there was no convention for its function or description.

Early in the seventeenth century Dutch landscape pictures still followed the Flemish, and it was Flemish artists who had settled in Amsterdam and Utrecht — Gillis van Coninxloo, Roelant Savery, Gillis de Hondecoeter, David Vinckbooms, Alexander Keirinck — who were responsible for the rise of an independent landscape art in Holland. There were Flemish prototypes also for the work of the Dutch painter, illustrator, and poet Adriaen van de Venne (1589-1662) who had a particular stylistic debt to Jan Bruegel as one sees in the *Allegory of the Truce of 1609* he painted in 1616 (160).

162 Esaias van de Velde, *A Winter Landscape*. 1623. Oil on panel, 25.9 × 30.4 cm (10¼ × 12 in). London, National Gallery

163 Aert van der Neer, *Frost Scene with Skaters and Townspeople.* Oil on canvas, 55.5 × 64 cm (21⅞ × 25¼ in). Amsterdam, Rijksmuseum

There one sees what looks like a wedding procession: a Flemish nobleman and a Dutch lady come forward hand in hand, in harmonious union, behind Cupid and a dove of peace. Behind them a great multitude is lead by the Brussels regents Albert and Isabella of Austria along with the princes Maurice and Frederick Henry of Orange. At the right, court musicians play, and choice food is spread out in front of them. At the left lies a heap of now discarded weapons, drums, and a flag; in the lower left foreground personifications of Envy and Discord try vainly to hide in a pit in the woods. In the center background, as if in an open grove, is the castle of Tervuren near Brussels. The theme, then, is symbolic: the reconciliation of the warring Netherlands provinces, south and north, and the consequent return of tranquility and the pleasures of peace. A number of fur-

ther allusions are woven into the scene, and a poetic message is ingeniously conveyed even in such apparently unimportant details as the painted lid of the spinet with its Arcadian picture of Latona with the Lycian peasants she has metamorphosed into frogs as punishment for their obduracy.

The unity of the whole is, in the final analysis, intellectual. Yet rather than a mere alignment of intellectual allusions, the idea is presented in the guise of a theatrical pageant with portrait-like personifications and specific actions to testify to the coming of peace. Instead of a symbolic transposition, in the center of the picture at any rate, there is a feigned assembly of historical persons. Everything is as direct as a reportage of some court festivity in which the guests witness a symbolic spectacle to the music of the court consort and the commentaries of court fools and dwarfs. Thus

an idea is presented as a real event in an apparently real-life setting. Serving as the stage is the landscape, articulated into a number of sections and viewed from a high place with a wide angle of vision. In the diversity of perspectives, in the use of staffage (the small figures normally merely accessories in landscape painting), and in the gradated staggering of spatial coloring (foreground brown, midground green, rearground blue and yellow), this landscape painting—but not its figurative content—remains within the limits of Flemish tradition.

From around the same time as Van de Venne's allegory, the *A Scene on the Ice near a Town (Winter Sports)* (161) by Hendrik Avercamp (1585-1634) of Amsterdam and Kampen represents another type of picture exploited earlier by Flemings like Pieter Bruegel, Momper, and Valckenborch, but already much favored in the calendar miniatures of early Netherlandish illustrated manuscripts. In its origins the theme was cosmological: winter and its natural forces and the phenomenon of water freezing into snow and ice. Pieter Bruegel had treated a number of its aspects and shown how they affect all sorts of human activities. Avercamp, however, concentrates on rendering the scene rather than illustrating a theme. Though a wide-angled view, it is organized now with a single perspective, which governs also the buildings at the side. Where Bruegel chose to depict various characteristic activities in different zones of his pictorial stage, Avercamp gives us a more or less concentrated slice of things observed, specifically the city dwellers disporting themselves on their frozen river. Instead of nature and a generalized mankind, what the artist places under observation here is the human being in a real society. Cut out as if by scissors, representatives of all estates and classes, sexes and ages, are shown as isolated figures in an endless variety of poses and movements. The landscape itself makes a flat stage platform, and its lack of any color of its own causes all the figures to stand out so much the more.

This stylistic relationship is reversed in the slightly later *Winter Landscape* (162) signed in 1623 by Esaias van de Velde (around 1590-1630) in which figures, houses, trees, and road are fused into a tonally muted unity. The most forceful shapes are those of the trees and house. No attempt is made to embrace a wide range of human types and activities nor to endow them with any special distinction or dignity. The somewhat phlegmatic figures blending into the landscape echo the dullness and frozen immobility of nature itself. Brushwork is limited to sketchy contouring. What matters, and what is observed with utter consistency, is the *oneness* of an atmosphere in which shapes and local colors more and more blur and dissolve in the distance. Winter itself becomes a form and concept compounded of refracted light and of life lived at

164 Arent Arentsz., called Cabel, *Fishermen and Peasants.* Oil on panel, 27 × 52 cm (10⅝ × 20½ in). Amsterdam, Rijksmuseum

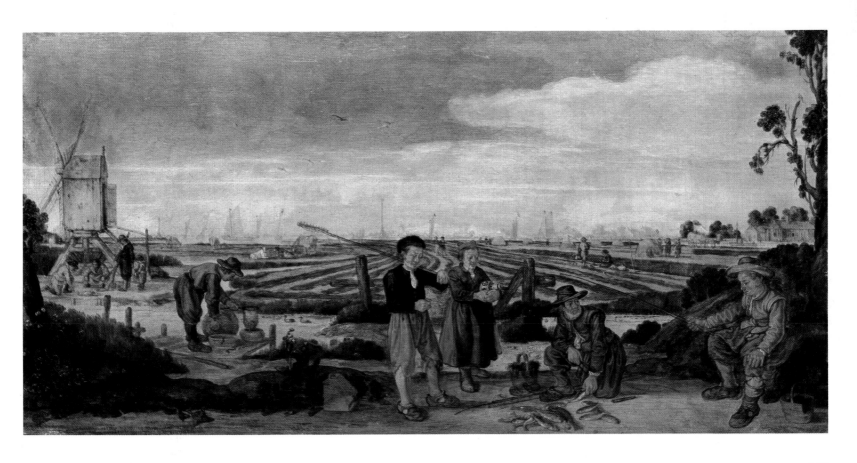

muted pitch. The psychology made visible here can be read too in the hemmed-in, relatively natural angle of vision, and in the visual distancing of the foreground figures. The muted temper of the general approach enhances our illusion that we are ourselves caught up in the chill scene. In its tonal treatment of color the picture is Dutch, and likewise in the way it is framed and laid out before a low horizon. Yet the emphasis on natural textures and the over-characterization of the twisted knotty trees are more typical of Flemish painting, and so too is the virtuoso brushwork.

That the Dutch approach was becoming increasingly clear and unified is evident in a winter scene from a subsequent stylistic phase, this one painted in mid-century by the Amsterdamer Aert van der Neer (1603/04-1677) (163). The action—both social and sociable as it is—and the treatment of the setting like a piece of stage scenery have something in common with Avercamp's scene on the ice. But the narrower angle of vision goes along with an unconstrained direct head-on view in which the eye is not distracted to details in the bright and busy arena of action but is led irresistibly into the distance. The horizon is low, the vanishing point not far above the heads of the figures. The outlines and disposition of the trees are already less decorative than Avercamp's and more realistic. Similarly, the loss in color and animated shapes in the figure groups is compensated by a more convincing psychology in the way they are put together. But it is in the zone of sky—which takes up two and a half times as much space as the landscape itself—that the expressiveness of the picture really resides. Here light, refracted by clouds and the wintry atmosphere, comes into its own in its low-keyed coloring: it transforms the land. The real subject of the picture is not so much the characterization of the season and its mood, as with Esaias van de Velde, but the refraction of light and the magic of its effects. The proof is in the fact that, with Van der Neer, most of his pictures concentrate on particular situations of light: sunset and twilight, moonlight, and no end of winter scenes, often with refracted light in a most varicolored rendering.

The path the development took can be seen in another type of subject. The *Fishermen and Peasants* (164) by Arent Arentsz., called Cabel (1585/86-1636), a minor painter indebted to the later style of Avercamp, presents scenes from everyday life with lapidary conciseness. Before the lowish horizon of a broad polder landscape, robust fishermen and peasants occupy the foreground. In the midground other small groups illustrate the peasants' work, in the background boats do the same for fisherfolk. As for the figures at the foot of a mill in the left midground who examine a hunter's kill, they are probably meant to allude to the power of fire, just as the mill itself suggests air. Thus this ensemble of the four elements can be read as praise of man's intimate, dependent relationship with the forces of nature.

Such everyday scenes with built-in moralizing messages were carried further in the later peasant genre pictures whose chief masters included Adriaen van Ostade (1610-1685) and his brother Isaak (1621-1649). The precocious younger Ostade specialized in genre scenes set in open country, on a village road, or in front of isolated peasant farms. His *Winter Scene with an Inn by a Frozen Stream* (165) has people at rest, work, and play, some just arriving, others leaving. But the emphasis is not on work as such but rather on the colorful anecdotal quality of what people do. True, in Avercamp's bright scenes on ice there are amusing incidental notes: skaters take a tumble, go through the ice, or even lose their clothing. But with Ostade the accent is not so much on individual types or happenings as on the way the daily things of life intersect: work and rest, busy motion and repose. Nor, as with Arent Arentsz., are the folk figures set squarely in the foreground but, instead they are shown turning away, or foreshortened, or moving about with no concern for the viewer. Psychologically everything is unified, tuned to a single instant observed both close-to and in deep distance. While the figures and constructions in the foreground are given due prominence, in the background they are all absorbed into the overall unity of the atmosphere. But the ice and the white horse's coat reflect the diffuse silvery light. As with Van der Neer, the local colors retreat with respect to the gradient between the close-up darkness and the distant and disembodied mists of light. In front of this almost mystical backdrop the silhouettes of the busy foreground figures take on a certain harsh weightiness. If, as is likely, there was once some symbolism attached to this picture, we no longer can guess it, though it may have been something like that of the picture of Arent Arentsz.

In such paintings, instantaneous glimpses of a believable action—they have their most important parallels with Frans Hals, the teacher of Adriaen van Ostade, Isaak's older brother and teacher—were carried to the furthest point a static picture can tolerate. Those scenes served in a didactic moralizing view of man and nature. However, as time went on the directness and earnestness of such observation of ordinary life more and more gave way to entertaining and even amusing story-telling. That change is obvious in a work by the extremely successful Haarlemer Philips Wouwerman (1619-1668), one of the most imitated

165 Isaak van Ostade, *A Winter Scene with an Inn by a Frozen Stream.* c. 1645. Oil on panel, 48.8 × 40 cm (19¼ × 15¾ in). London, National Gallery

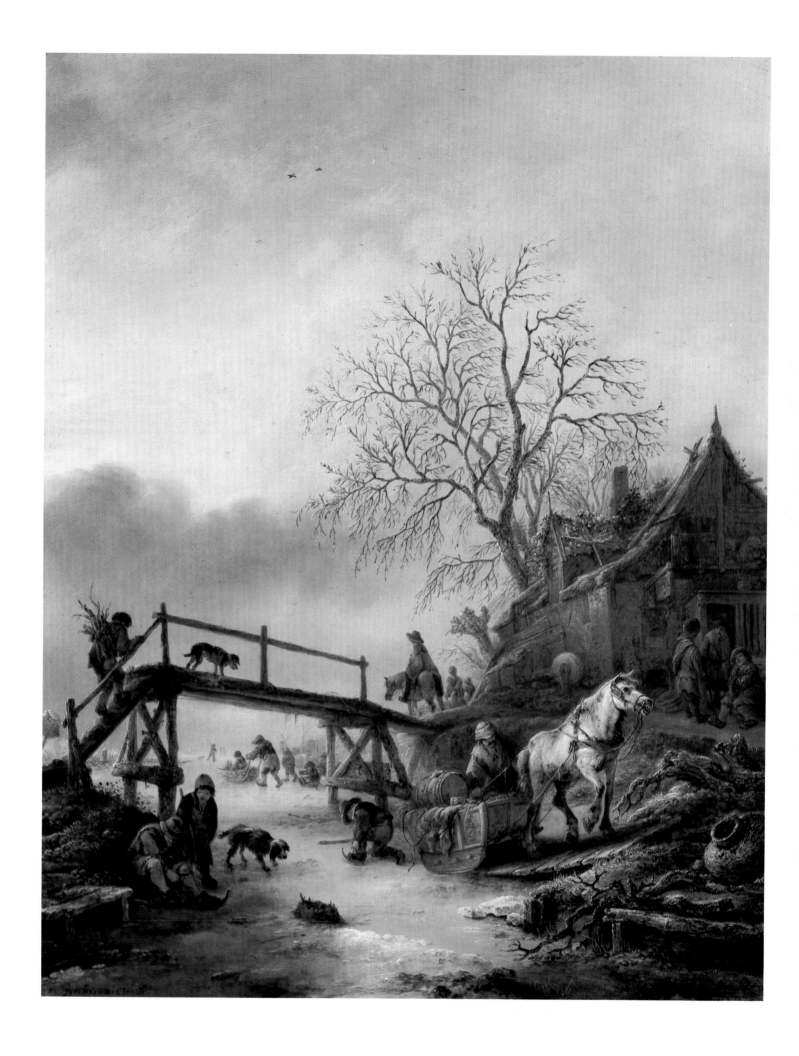

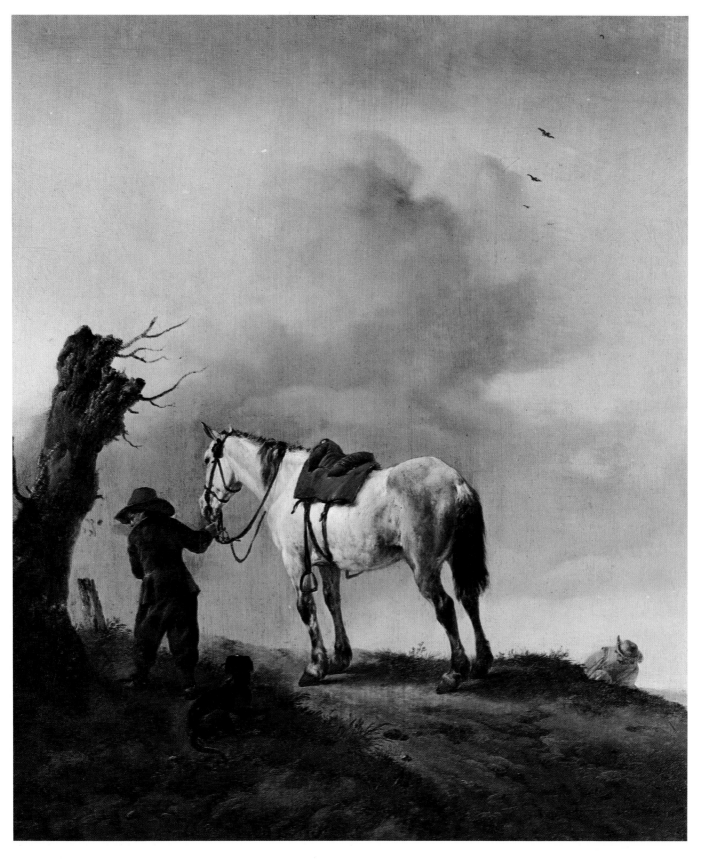

166 Philips Wouwerman, *The White Horse.* c. 1640-45. Oil on panel, 43.5 × 38 cm (17⅛ × 15 in). Amsterdam, Rijksmuseum

and most often engraved artists up to the end of the eighteenth century. Called today *The White Horse* (166), the picture was certainly not meant for an animal portrait but as illustration of the instinctive character of all creatures. Like the tree trunk at the left, bare of branches and foliage, the riderless white horse stands out starkly against a cloudy sky. A boy holds the bridle, light gleams on the empty saddle — we are intrigued to look for the proud rider, and we find him, half hidden behind a hillock, attending to his natural needs. What in earlier folk pictures was a crude marginal note is here transformed into an artistically arranged narrative motif. But in contrast to the picture by Isaak Ostade, this demonstration of the

natural earthiness of life no longer possesses an element of universality, and it has lost a meaningful relationship with the light and atmosphere. Parables of life, that had possessed their own immediate realness, are now simply sources for conventional narrative motifs to be depicted with due elegance. As in the still lifes, genre pictures, and portraits of the same time, there is a change in mood and purpose: pictures become enteraining and showy, and instead of parable-like glimpses of reality they offer no more than a spectacle for cultivated society. Even the highly accomplished painterly technique, developed out of observation of the refractions of light, became a superficial art of delicately shimmering refinement. The use of elegant and restrained motifs of horses and riders, and the anecdotal distance from the real life of the folk, explain why the European upper classes so passionately collected Wouwerman's pictures.

In the second third of the century painters achieved a technical bravura and at the same time settled on certain groups of motifs as marketable conventions, and all this went along with a certain superficiality that few of them escaped. Look at the *Landscape with Cattle and Bathers* (167) by Paulus Potter (1625-1654), a major specialist in both landscape and animal painting. In front of a farmhouse bathers and domestic animals bask in a sunny arcadian idyll. Yet between the very Dutch simple farmstead, the strikingly realistic trees, the rather un-idealized bathers looking more naked than nude, and the arcadian mood, there is something incompatible. Distance lends enchantment to the background scene, but the objects in the foreground, treated with loving preciseness, tend to look prettified. Yet in this particular picture the loss in spiritual depth is compensated by a certain innocent delight in incident.

Similarly perfect, though with limited artistic pretensions, are the works of Frans Post (1612-1680)

167 Paulus Potter, *Landscape with Cattle and Bathers ("The Cow Reflected in the Water")*. 1648. Oil on panel, 43.4 × 61.3 cm (17⅛ × 24 in). The Hague, Mauritshuis

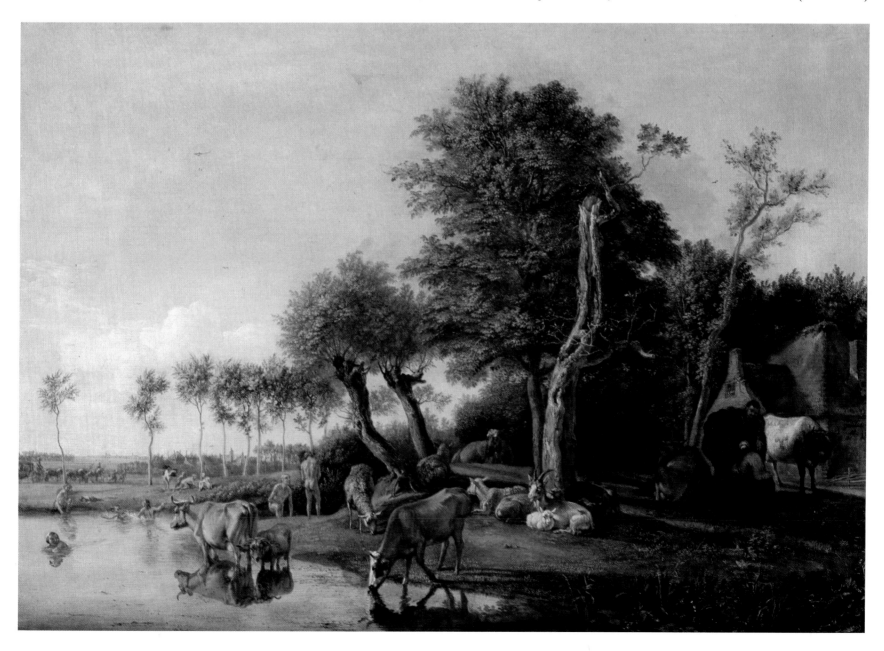

168 Frans Post, *Brazilian Landscape*. 1638. Oil on canvas, 62 × 95 cm (24⅜ × 37⅜ in). Paris, Musée National du Louvre

which have rather come back into fashion in our time. Just as Potter did not go beyond a portrait-like approach to landscape and animals for Post the entire sense and purpose of painting came down to a careful rendering of the natural formations, houses, and creatures of the exotic lands where he worked—which he transcribed in the mood and character of his native Dutch landscape. His *Brazilian Landscape* (168) is one of the innumerable views (much appreciated by his contemporaries) that Post painted between 1637 and 1644 while he was overseas in the retinue of Prince Johan Morits, who had been sent by the Dutch West India Company to colonize northeastern Brazil. Post's task was to illustrate a documentary book on Brazil, which appeared in 1647, and his painstaking combination of the individual exotic motifs gives his pictorial reportage a charmingly naive flavor.

Yet some artists, Philips Koninck (1619-1688) for one, could still paint realistic landscapes based on accurate topography and typically Dutch in character but which also held a charge of dramatic expressiveness. Though appreciated in his time more as portrait and genre painter, Koninck produced a number of very large landscape panoramas indebted in style to Hercules Seghers and Rembrandt. His *Landscape with*

Houses along a Roadside (169) is dated 1655 and exemplifies a style that had its impressive precedent in Seghers' panoramas glowing with light, shadowed with smoky haze, and seemingly formed of lava masses which stretch from mountain cliffs across misty forelands (146). With Koninck, however, the vast view is topographically precise. A virtually endless broadly sweeping vista begins at foreground hills seen as broad surfaces, like rocky debris, with indistinctly textured groups of trees and houses, and then embraces cities, rivercourses, and chains of hills which emerge here and there out of the spatial depth through stretches of light and cloud-shadows. Long-ranging cloud masses that hang slantwise across the picture surface correspond in rhythm to the stratified earth formations. The marked zones of darkness and bursts of light in the atmosphere are repeated, intensified, in the land areas whose edge is finally lost in the haze of the remotest distance.

The tiny figures in the foreground as well as the different sizes of the houses mark out the distance encompassed in the foreground with all its details and which is quite apart from the great stretch of space. The real theme of the picture is immense spatial distance, and it is the tension between light and

darkness that binds it all into an experience of the atmosphere with sunlight breaking through clouds.

The painting of a few masters who followed in the wake of Esaias van de Velde (162) is unencumbered by any burden of realism. That master's deft drawing and his way of composing with transparent silhouette motifs were carried further by Jan van Goyen (1596-1656) and Salomon van Ruysdael (around 1600-1670). Despite their use of a low horizon and broad visual field, with both artists the almost playful brushwork and the alternation of dark and light coulisses preserve

a flatness of surface that recalls watercolor and thin India ink drawing. Light and dark zones are bound together through an underlying ocher ground. Van Goyen in particular made use of a subdued palette of ocher, greenish gray, russet, and yellow tones to capture the effect of a honeyed, sun-drenched atmosphere. Shaded parts appear flatter when filtered through a scrim of warmly shimmering light. The *View of the Town of Arnhem* he painted in 1646 (171) shows how he unified deeper zones that finally fade off into shallow silhouettes. The kind of brushwork

169 Philips Koninck, *Landscape with Houses along a Roadside.* 1655. Oil on canvas, 133 × 167.5 cm (52⅜ × 65⅞ in). Amsterdam, Rijksmuseum

used in this almost casually assembled, serene everyday view across fields, roads, river and dunes can be found in purest form already in the many preparatory sketches Van Goyen made while traveling about in Holland.

As his *Travelers Halting at an Inn* (170) shows, Salomon van Ruysdael's landscape vistas depend less on a smooth progression into depth and distance than on principal motifs in a fairly close midground. Filigree-like delicate tree foliage, animals, the shapes in a counterlight. In place of continuous transitions in a warm overall tone, here we have the contrast of these a warm overall tone, here we have the contrast of these delicately articulated motifs against a cool light sky. Dreamily, pensively, the artist's eye looks from a low viewing point into a distance of layered clouds and sky. Light enters from the left and rear of the painting

into the midground, producing an interesting combination of back and side-lighting. The foreground is left in shade and bright highlights are used to bring out the shadowy figures. The yellowish, bluish, silvery atmosphere is of a transparent, diffuse brightness and not a succession of bright and dark parts such as one finds with Van Goyen, who often makes his skies match the articulation of his landscapes.

There is a very different poetry in the coastland scenes of an artist of a younger generation, Adriaen van de Velde (1632-1672). His *Beach at Scheveningen* of 1658 (172) shows how light wanders across the flat shore. A few clouds have blown into the clear blue sky that fills three-quarters of the picture, and their shadowy undersides are mirror-matched by fleeting strips of shadow gliding away across pools left on the shore by the tide. Similarly the crests of the waves of

170 Salomon van Ruysdael, *Travelers Halting at an Inn*. 1648. Oil on panel, 70 × 92 cm (27⅝ × 36¼ in). Enschede, private collection

the surf coming in from the right take up the direction of a bright edge of cloud above them. The figures take their place, some as dark silhouettes, others as small bright shapes of light, between a sky where the edges of the clouds slope gently upward and the shore and sea with their mirror-like falling rhythms. The human beings, though rendered with a fine eye for anecdote, are really no more than points of interruption in the broad, surging panorama.

A harsher feeling informs the landscapes which Allaert van Everdingen (1621-1675) painted in cold green and broken-up earth colors. Most of his works show features of the Nordic landscape: mountain rises and gorges, waterfalls, dark forests topped by tall firs, an occasional isolated house. These are motifs and types of mood the painter discovered on his travels in Sweden and probably Norway around 1640 and which he — and other artists friendly with him, such as Jacob van Ruisdael — subsequently made much of. In his *Mountain Landscape with Castle* (173), it is the earth formations that reflect their textures on the clouds — the opposite to what we saw in Adriaen van

de Velde's beach scene. Earth colors, contrasting with the green on the grass, moss, and trees, set the basic tone for the cloud shadows. The colors of sky and water are only brighter interruptions between the towering rock formations and trees, and the very tiny men and animals make us sense how huge and bizarrely overwhelming these landscape configurations are.

With the most dramatic landscape artist of the age, Jacob van Ruisdael (1628/29-1682), all the various approaches to an intensified representation of nature were brought together. Landscape motifs sketched on his travels were—literally—staged to convey impressions of monumentality, and this is evident already in early works as in his more than ten different versions of the *View of Bentheim Castle* (174). In 1650 while traveling from Haarlem to Cleve and along the German border, Ruisdael and his friend Nicolaes Berchem both did studies of this castle which they used later for

paintings. While Berchem, characteristically, used the motif to decorate a lovely Italianate arcadian landscape, Ruisdael made it into a fortress topping a rocky height approached by a steeply rising terrain.

Thanks to his signed works, Ruisdael's activity can be followed from 1646 on. The early works were influenced by his uncle Salomon and the Haarlem landscapist Cornelis Vroom. What he learned from them about depicting trees and foliage was then put to use in ever more animated fantasy compositions. As regards the articulation of motifs and the juxtaposition of disproportionately huge trees and exaggeratedly small human figures, the stimulus came from the Italianizing Jan Both and Jan Asselijn. Ruisdael, however, refused to idealize his motifs or make them fit neatly together in harmonious compositions. Everything he did was gauged to make dramatized individual features stand out in vivid contrast. As in the picture

172 Adriaen van de Velde, *The Beach at Scheveningen.* 1658. Oil on canvas, 50 × 74 cm (19⅝ × 29⅛ in). Kassel, Staatliche Kunstsammlungen

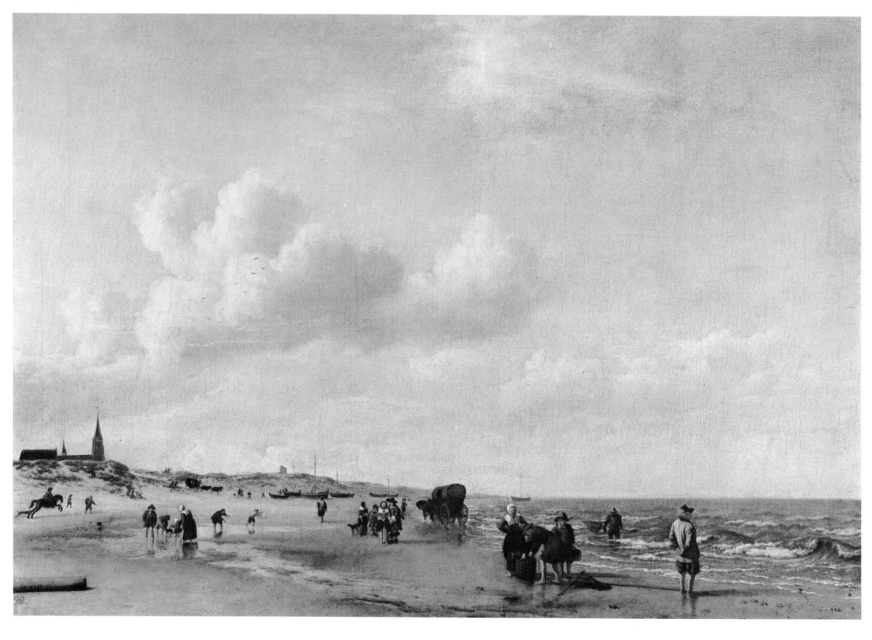

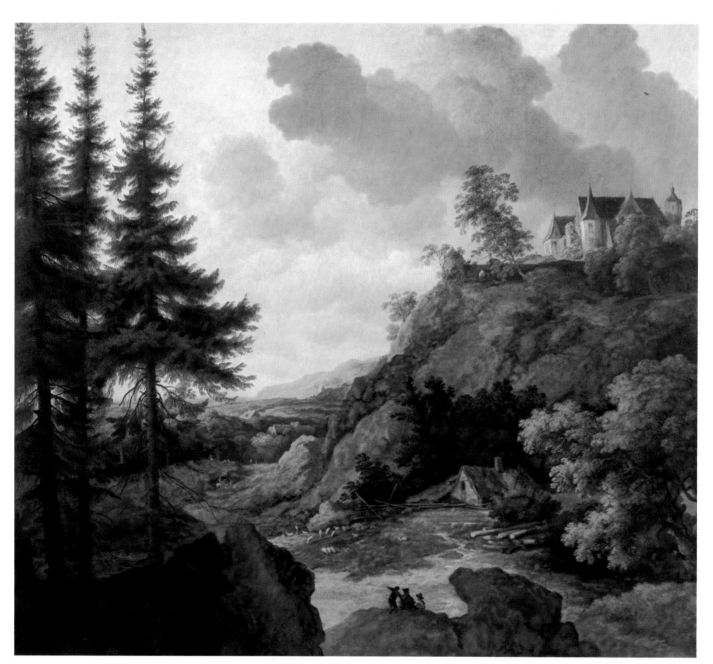

173 Allaert van Everdingen, *Mountain Landscape with Castle.* c. 1650. Oil on canvas, 140.5 × 157.5 cm (55⅜ × 61⅞ in). Stuttgart, Staatsgalerie

with Bentheim Castle, in other early landscapes the emphasis is on the dynamic profile of the natural terrain and on powerfully modeled tree trunks. An even light falls from one side and helps to turn winding country roads, bare hill slopes, and fallen or diagonally propped-up tree trunks into rising or falling compositional accents. A deep vanishing point lends additional force to these rolling, rearing landscapes.

Ruisdael's exploration of the dynamic properties inherent in all things earthly retreats in the later works. In the *Jewish Cemetery* of around 1660 (175) the land formation with the natural or man-made shapes of church ruins, tombs, and trees is now only a passive witness to the elements, to storm and flood, violent winds, sudden bursts of sunlight.

The picture itself goes back to studies Ruisdael

made in the Jewish cemetery at Oudekerk near Amsterdam, but it is not so much the subject as the total pictorial impression that matters. This results directly from lighting effects which, in a realistic picture, are explainable only as peculiar phenonema of the atmosphere, the way the light is dispersed to accent certain elements and lend them a special character. There is a considerable literature about the meaning of this *Jewish Cemetery* (which exists in two versions, in Detroit and Dresden). One can understand what led the early Romantics to rediscover it: graves, ruins, weather-racked and shattered oak trees, storm clouds—precisely their vocabulary for speaking of how man and his works are forever threatened by the grim hostility of the forces of nature. Yet, with Ruisdael, the drama of nature is less tragic, has less of

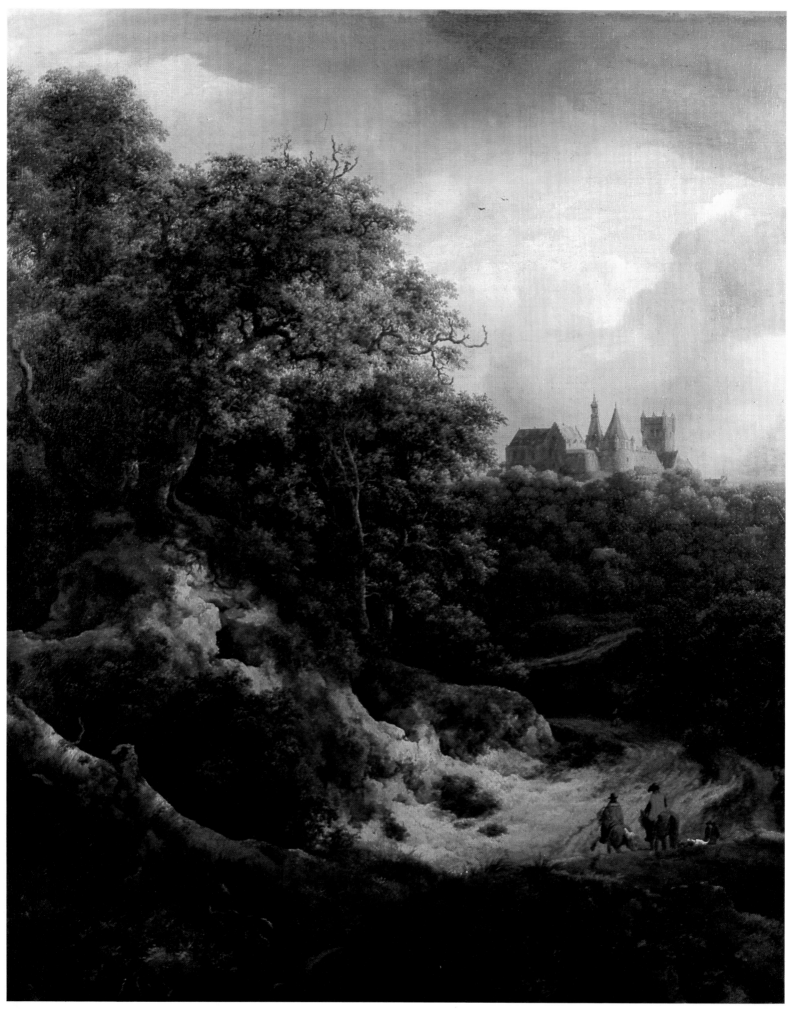

174 Jacob van Ruis-
dael, *View of Bentheim
Castle*. 1651. Oil on
canvas, 97.7 × 81.3 cm
(38½ × 32 in). Private
collection

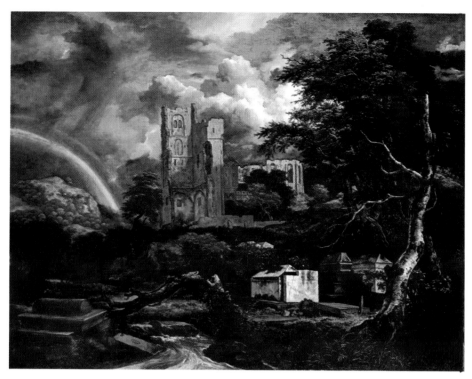

175 Jacob van Ruis-
dael, *The Jewish Ceme-
tery*. c. 1660. Oil on
canvas, 135 × 172.5 cm
(53⅛ × 67⅞ in).
Detroit, Institute of Arts

the chill and remoteness from life, than with Caspar David Friedrich a century and a half later. Beyond question, here the theme is death, decay, the ravages visited on what once had life, on what men had built. But along with the black storm a certain subdued light breaks through, gleams on the open terrain, plays across the shattered gravestones. The ruined tower and the swift-racked clouds assume shapes of rather similar form and texture. Transitoriness and decay have their part in a changeful movement of the elements: water has disappeared from the withered trees, yet bursts forth elsewhere as a sudden torrent. The rainbow in the background speaks of Resurrection: it is not by chance that it rises alongside the ruined church walls.

The use of cloud formations as unifying compositional device, frequent in Dutch painting in particular, was exploited by Ruisdael as early as the 1640s in his marine views. Cloud shadows and stretches of light alternately divide the surface of the water. Later—probably stimulated by the panoramic landscapes of Koninck—he made use of that principle for broader views across land, as in his beach scenes and various views of Haarlem. But instead of composi-

tions whose structure derives chiefly from correspondences between the directional lines, Ruisdael concerned himself also with spatial relationships. No one before him had so closely attended to the solid bulk of cloud-shapes and their spatial rapport with the surface of the earth below: look at his vast landscape with a ruined castle and a village church (176). In the same way as its roads and hillcrests lead diagonally into the depth, the cloud masses and strips hanging low over the countryside are pursued into the remote distance. The diagonal cloud strips that flatten out and fade off at the horizon are to some extent brought into spatial symmetry with tongues of land and combs of hills. Numerous directional correspondences strengthen the impression that somewhere beyond the horizon earth and clouds come close, even touch. The eye glides from the lower corners of the picture into the pale depth, only to be turned back again just as clearly. The pervasive, incessantly repeated compositional form is a broad *X*. In the foreground its arms are spread so widely as almost to become flattened, then just before reaching the edge of the picture they suddenly curve upward. As if from a distant pressure point, both above and below the horizon the forma-

tions appear to hasten apart while, in the foreground, they become increasingly voluminous and dark-toned. Conversely, the clouds themselves become darkest towards the left corner of the canvas. The farther they soar away from the vanishing point, the steeper the ascent of their directional lines, and when they curve upward in the upper half of the picture they lead our eye in their wake. The panoramic conception of the cloudscape determines the whole: not only the distribution of light across the land appears to be pre-structured in the cloud masses, but also even the stretches of what, for present purposes, we can call the earthscape.

A similar general scheme is applied in a late picture, The *Mill at Wijk* (177), to a particular site still recognizable today. The only deviation from reality is the dramatic main motif of the proportionately over-large windmill with its sail shooting up in the directions of the cloud masses that seem to be rising before our eyes. The fact that the concentration and dispersion of the clouds is again the central event here is brought out by the way they are linked in composition with the land configuration, by the reflection of their color in the water, and, equally, by the direct connection between the gleam of light on the mill tower and the gap in the dark clouds opposite it.

Ruisdael's pupil and onetime assistant Meindert Hobbema (1638-1709) was the most independent among his many imitators and followers. An exclusive specialist in landscape, especially the sort with forest roadways, millstreams, and quiet weirs, his work was

176 Jacob van Ruisdael, *An Extensive Landscape with a Ruined Castle and a Village Church*. 1665-70. Oil on canvas, 109 × 146 cm (43 × 57½ in). London, National Gallery

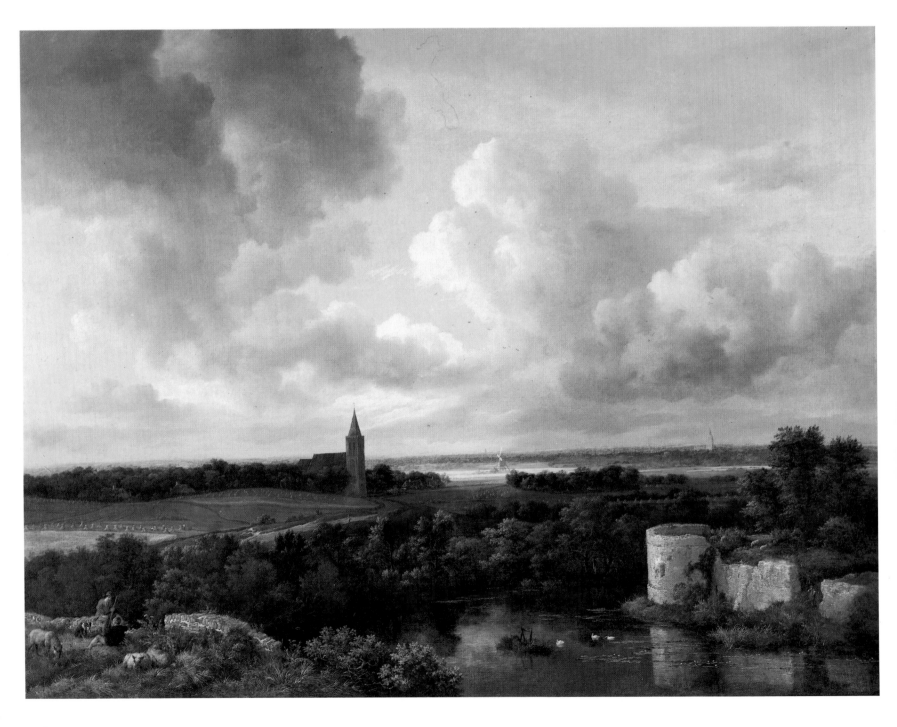

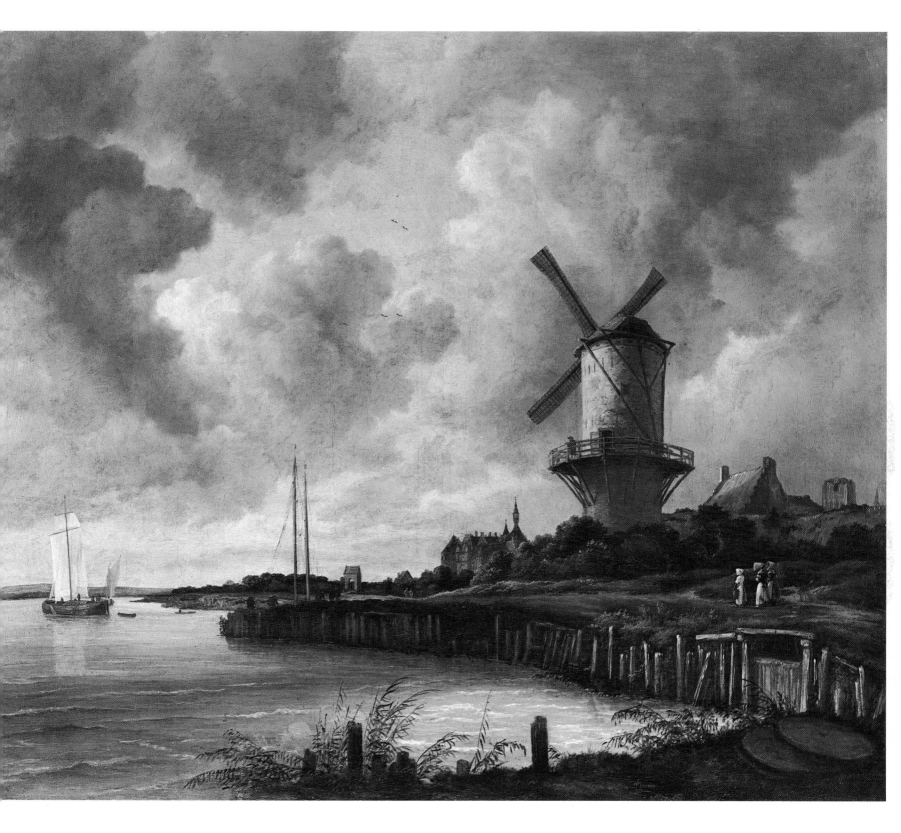

177 Jacob van Ruis-
dael, *The Mill at Wijk*.
c. 1670. Oil on canvas,
83 × 101 cm (32⅝ ×
39¾ in). Amsterdam,
Rijksmuseum

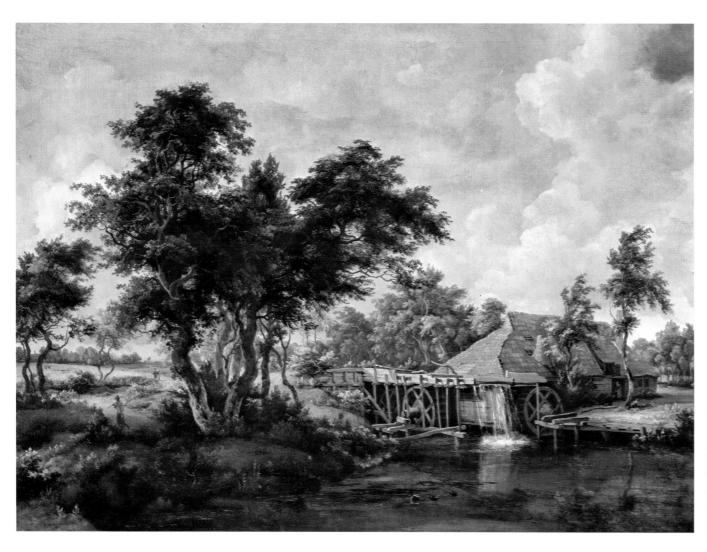

178 Meindert Hobbema, *The Watermill with the Great Red Roof.* c. 1664. Oil on canvas, 81.3 × 109.6 cm (32 × 43⅛ in). Chicago, The Art Institute

done chiefly between 1663 and 1668, after which date his position as Amsterdam city wine-gauger left him less time to paint. His pictures became the special model for English landscape painting in the eighteenth and nineteenth centuries, and most of his important works quickly made their way to England and only later became gradually dispersed abroad, many of the finest to American museums.

Although Hobbema borrowed many individual motifs from his teacher, and even complete compositions such as Ruisdael's etching of a forest lake, he radically transformed their mood and feeling. As his *Watermill with the Great Red Roof* (178) shows, he no longer telescoped the main motifs into potentially expressive formation but grouped them freely. The few trees in front of a light background still suggest something of the power and somber forcefulness of Ruisdael, but now they are characterized like isolated figures, almost like personages in a play. Bizarre in silhouette, they are intended to contrast with the lighter and more distant clumps of trees and the meadow as well as with the bright red roof of the mill and the light-colored wooden tank over the mill wheel.

Each of these motifs gets a special accent as a typical specimen of the "picturesque." The composition is loosely organized through diagonal articulation and a series of sloping contours staggered one behind the other. The significant motifs are lined up across the midground like episodes in a story. There too is gathered everything in the way of color accents, while the foreground—as in so many of Hobbema's pictures—remains relatively unarticulated and dark. Is there some special meaning behind the natural and man-made things displayed here, or any reference to an elemental natural force? Rather more obviously the overall creative unity results from presenting all at once, in a single picture, motifs that are romantically heroizing and idylically pastoral, so that nature itself takes on a poetic cast.

In much the same way, the foreground in the *Road Along the Dyke* (179) is darkened by the shadow of clouds though illuminated at the right to draw attention to a striking staffage group. As in many Dutch landscapes, here too a specialist painter was called on for animals and human figures: the picturesque cows and the three figures chatting were painted by Adriaen

van de Velde, author also of of staffage elements in Ruisdael's *Extensive Landscape with a Ruined Castle and a Village Church* (176); in both paintings those elements are clearly of higher quality than in Hobbema's *Watermill*.

Here too we have the same device as in the *Watermill:* a transition to the midground is carried through by a massive clump of trees looming dark and heavy against the light vista beyond them. Growths of trees spread in a broad arch from the right foreground into the distance. The free view into the center distance is blocked by the great trees which so dominate the scene

that the reed-thatched houses in the midground are scarcely more than hinted at, though, glimpsed through and beyond the mass of foliage, they add a note of shelter, domesticity, peace. The contours of the compositional focus constituted by the central group of trees seem merely natural in form, yet their gentle transitions over and again continue or parallel directional lines in the landscape, and the overall impression is of an evenly rolling gentle wave. The edges of the tree foliage and the slope of the dyke are caught by the light and seem to rise steeply, while the tree trunks and branches, the path and road set up a coun-

179 Meindert Hobbema, with figures and animals by Adriaen van de Velde, *The Road along the Dyke.* 1663. Oil on canvas, 108 × 128.3 cm (42½ × 50½ in). Ireland, Beit Collection

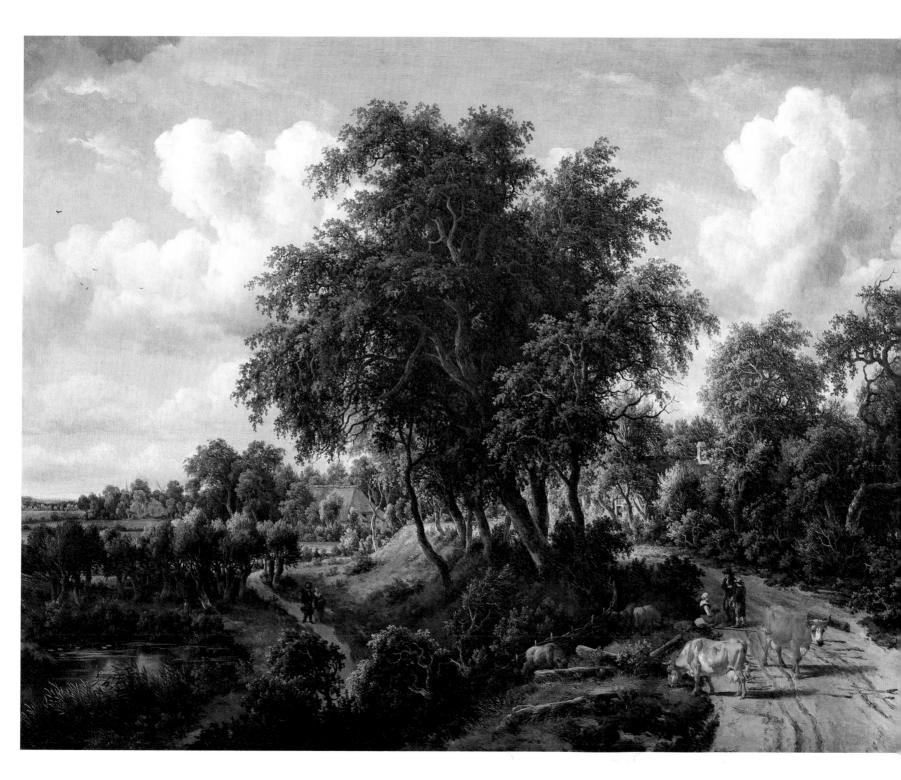

ter-direction, and these rhythmic vectors have their echo in the cloud masses.

If Ruisdael's dynamic and dramatic approach to nature anticipated the Romantic vision, Hobbema was a pioneer after his own fashion. The philosophical concept of nature as theater of contrasting temperaments was given concrete form in his works, and Hobbema's special vision gave rise to the theatrical types of landscape in the eighteenth century but also, and as much, to the atmospheric painting of the 1800s.

Among the greatest achievements of Dutch art was marine painting, meaning specifically the sea piece rather than the river or shore landscape with a glimpse of watercourse or surf, a distinction that has its justification in the large number of Dutch artists who specialized in the seascape proper.

As in many other types of painting, here again the sixteenth-century Flemish prepared the way. The major themes—the storm at sea as battle of the elements,

the ship "portrait," the fleet in an open harbor—had already been set fully by Pieter Bruegel. The finely detailed, subtle art of Bruegel's son Jan set the key for the early ventures into marine landscapes that were made in Holland, most notably by Hendrik Vroom, Cornelis van Wieringen, Aert Antum, Cornelis Verbeek, Hans Savery, Adam Willaerts, and Adriaen van de Venne. An innovatory Dutch approach came only with Jan Porcellis (around 1584-1632) with his gray-toned depictions of the atmospheric phenomena of storms and rough seas.

Just as landscape paintings show the human environment as a matter of specific situations made intelligible through roads and houses, people and animals, so the seascape conveys the sea's moods as they affect ships and the people in them. But the ship on a stormy sea is more than a demonstration of the forces of nature: it is the symbol of the perils of human existence, of the buffets a true faith must withstand.

180 Jan van de Cappelle, *The State Barge Saluted by the Home Fleet.* 1650. Oil on panel, 64 × 92.5 cm (25¼ × 36⅜ in). Amsterdam, Rijksmuseum

181 Aelbert Cuyp, *View of Dordrecht.* c. 1655. Oil on canvas, 98 × 138 cm (38⅝ × 54⅝ in). London, Kenwood House, The Iveagh Bequest

The change from depicting the elements in dynamic action to intensive observation of the atmosphere came with a younger generation of painters like Jan van Goyen, Salomon van Ruysdael, and Simon de Vlieger (1600/01-1653). The latter became a master in observing the refraction of light and its reflection on water, and the poetic way all details are lost in distant haze. He gave rise to a school, and his mood-laden art of viewing ships in counterlight and against a mirror-smooth sea was taken up by Jan van de Cappelle (1626-1679) whose *State Barge Saluted by the Home Fleet* (180) is a political picture, doubtless done on

commission and signifying a homage to the state authorities, but is also a sensitive picture of nature.

The scene is dominated visually by the reddish brown shapes of the sails in an atmosphere of clouds and haze that seems to press in from all sides. Sea and sky are one in intensity of light and in color. At both sides of the picture cannon smoke blurs the line of the horizon. The more distant boats and sails increasingly lose all color contrast in the misty atmosphere. The dark shapes of ships and boats in the foreground, viewed from a close and low perspective point, take on a certain drama against the far distance where colors

and forms merge in mist. Light pouring through gaps makes one aware even more of the smoky dampness of the clouds densely packed immediately behind and over the ships.

The marine paintings of Aelbert Cuyp (1620-1691) are more restrained in their treatment of clouds and mist and so give a more unified impression of the changing mood of light in the course of a day. His *View of Dordrecht* (181) has a cool morning light coming in obliquely. The surface of the water is almost

182 Ludolf Back-huysen, *The River Ij before Amsterdam.* 1673. Oil on canvas, 81 × 67 cm (31⅛ × 26⅜ in). Amsterdam, Rijks-museum

183 Willem van de Velde the Younger, *The Harbor of Amsterdam with the Flagship "De Gouden Leeuw."* 1686. Oil on canvas, 179.5 × 316 cm (5 ft 10¾ in × 10 ft 4⅜ in). Amsterdam, Rijksmuseum

without motion. In gentle counterlighting the individual motifs are carefully set against each other to make a compositional balance. Only exceptionally are Cuyp's pictures as symmetrically laid out as here, though all of them are very consciously composed. Here there is none of Van de Cappelle's throng of sailboats, human figures, and cloud masses, but instead perfect clarity in the spatial and aerial perspective. The characteristic individual shapes and forms are carefully set apart on his broad stage bathed in light.

The high point of Dutch marine painting was reached in the works of Willem van de Velde the Younger (1633-1707). Born in Leyden and brought up in Amsterdam, Van de Velde studied with his father, himself a marine painter, and later with Simon de Vlieger. Father and son emigrated in 1672 to England where, as painters to the court of Charles II, they were paid a hundred pounds yearly to produce pictures, mostly of naval battles.

During a brief visit home in 1686 Van de Velde was commissioned by the Amsterdam harbor commission to paint a very large canvas for their meeting hall (183). The city itself can be made out at the right, half-hidden behind a forest of masts. At the left, a salute to an on-coming vessel, "De Gouden Leeuw" the splendid former flagship of Admiral Cornelis Tromp. The

white cannon smoke and bright sails contrast with the darkened surfaces of sea and clouds. The ships and harbor are punctiliously portrayed, but by ingeniously arranging the effects and moods of the light the overall composition is given painterly articulation. The dramatic cloud-shapes, the coloristic treatment of water, and the sails billowing between them—devices developed in earlier paintings—recur here. Now however it is not their function to create a unified picture of the elements, but instead—as was consistent with the stylistic approach of Hobbema and others in that younger generation—to savor to the full the choicest and most picturesque (and most painterly) atmospheric effects. In addition, no painter surpassed Van de Velde in knowledge of how ships were built—countless drawings show how thoroughly he studied them—and could unite it with such a sure feeling for vividly expressive shapes.

If the accent in Van de Velde's marine painting was on ships themselves and all their various profiles, with his contemporary Ludolf Backhuysen (1631-1708) it shifted to an even more marked chiaroscuro treatment of figures standing out with dramatic sharpness against ships and sails on wharves, shores, and sea. In *The River Ij before Amsterdam* (182) his docks, masts, and sails make a uniquely fascinating geometrical pattern. For ornament there is chiefly the virtually

213

abstract system of verticals, horizontals, and a few shallow obliques and curves, and these are broken up in the dark foreground by groups of figures, in the limpid background by sky and clouds and their reflections. Emphasized here are not so much the topographical and individual features of harbor and ships, nor the juxtaposition of the ingenious works of man and the forces of nature, as the oddness of the shapes in themselves. This hint of something almost uncanny in Backhuysen's peaceful harborscapes is found too in his pictures of storms at sea. In both types of subject, zones of light and darkness overlie everything, natural or not, and introduce something of the strangeness—

alienation, if you will—that would later mark Romantic painting, and it is not irrelevant that, for his gloomy storm pictures in particular, Backhuysen became one of the most highly appreciated and best paid artists of his time and was much imitated well into the nineteenth century.

One of the special branches of landscape was the city view. Here again there were Flemish forerunners: Hendrik van Steenwijk the Elder and Bartholomeus van Bassen, for instance, who were early masters of a sort of architectural scenery painting. In the late sixteenth century depictions of a Renaissance humanistic fantasy-architecture made way for topographically ac-

184 Jan van der Heyden, *View of Veere*. c. 1660-65. Oil on panel, 45.7 × 55.9 cm (18 × 22 in). London, The Collection of Her Majesty the Queen

185 Pieter Saenredam, *Utrecht, the Mariakerk and Square from the West.* 1663. Oil on panel, 110.5 × 139 cm (43½ × 54¾ in). Rotterdam, Museum Boymans-van Beuningen

curate scenic backgrounds. From these, along with the engraved topographical views of streets, markets, and towns, there developed a special category of picture increasingly sensitive to the expressive aspect and deliberately making the most of the means of perspective. In the same way as in countless engraved views of cities, foreshortening was ingeniously exploited for panoramic views which, thanks to such tricks of projection, were made to look broader and more imposing than the original: witness the minutely detailed town views and architectural paintings, with every roof tile and paving stone given its due or more, by Pieter Saenredam (1597-1665) and Jan van der Heyden (1637-1712). The latter's *View of Veere* (184) seen from the southwest city gate, is one of innumberable pictorial compositions after topographical drawings. Probably done in the 1660s, like the views of the time it is true "selectively": the major church buildings and their spatial relations are accurate enough, but otherwise there is a good measure of license in such details as the town hall and the non-religious buildings at the right which are simp-

ly arbitrary insertions.

With Saenredam, interior and exterior architecture is presented as if in rigorously designed and constructed stage scenery. Whether viewing churches from outside or inside, his pictures are always controlled by a consistent central perspective with a low vanishing point that makes the scene appear deeper than it is. The prominent church buildings of his Utrecht scene of 1663 (185) also exploit a symbolic perspective since their vanishing point is the tower of the cathedral. The people on the square are drastically reduced in size so that, as in other pictures by Saenredam, the architectural masses are made to seem literally overpowering. Saenredam's approach appears very restrained, closer to the carefully measured and calculated copperplate views than to the richly detailed, colorfully composed, and atmospherically rendered scenes of the much younger Van der Heyden. The draftsmanlike constructional element with Saenredam is not only a matter of biography—he was son of an outstanding copperplate engraver and fellow pupil and friend of the painter and architect Jacob van

186 Pieter Saenredam, *The Old Town Hall of Amsterdam*. 1657. Oil on panel, 64.5 × 83 cm (25⅜ × 32⅝ in). Amsterdam, Rijksmuseum

Campen—it is also a feature of this type of picture, that was originally merely documentary and only later became recognized as a freer and more "artistic" category.

Saenredam's working method tells something of the old-fashioned links still in force in his métier: using sketches made directly on the spot, he proceeded to work out a full-size measured drawing with fully constructed perspective which he then traced onto canvas and painted. This geometrically idealized organization neatly evaded the distortions inevitable when relying on the eye and provided a precise basis which the artist could then color and model in paint. But the system of surface reconstruction through central perspective likewise could be used to produce distortions as can be seen in *The Old Town Hall of Amsterdam* (186) painted in 1657 after a drawing of 1641, a gap of sixteen years during which the building itself had burned down. The fascinating, almost starchy effect results from rendering the facades strictly parallel to the picture plane without taking account of the oblique viewing angle, so that the buildings look not rectangular but rhomboid in ground plan.

Where Saenredam seems almost to be merely coloring a picture, not working with paint, the younger painters of townscapes and architectural interiors—Gerrit and Job Berckheyde, Gerrit Houckgeest, Hendrik van Vliet, Emanuel de Witte—are remarkable for their secure treatment of light and atmosphere. They founded a special marginal category of architectural painting, the church interior—depicted as a public place where people come together for any and every reason, and not only to hear sermons on Sundays. In combining an interior full of mood and atmosphere with figural groups, these pictures take a place between the architectural views of, say, marketplaces, and the genre scenes in domestic interiors. One such painting by Emanuel de Witte of Alkmaar (187) shows an interior where the gravedigger has just finished his work—Netherlandish churches at the time provided burial space for members of the congregation—and he chats with a woman just come from the market. A group conversation and a man followed by his dog mark this as an everyday scene. The vast interior is

216

187 Emanuel de Witte, *Interior of a Church*. 1668. Oil on canvas, 98.5 × 111.5 cm (38¾ × 43⅞ in). Rotterdam, Museum Boymans-van Beuningen

broken up by numerous streams of light, by greater or lesser brightness, by changing depths of shadow, and together these create uncommon visual articulations. The zones of brightest light are made strikingly prominent and draw our eyes as we look deeper into the interior. Light is both an everyday fact, like death, and a radiant transcendant force. The interior itself is a composite of St. Bavo in Haarlem and the Oude Kerk in Amsterdam, thus not an architectural "portrait" but a union of history and actuality, past and present, transformed through a fleeting and at the same time otherworldly light.

A special post within Dutch landscape painting is held by the so-called Italianate artists who differ from others not only in what they paint but how they paint it, in their composition and use of color. The landscape formations and the people and animals in them are no longer merely typical of the Dutch environment with some element intensified and stressed. Instead they bear the mark of southern Europe, Italy mostly, of a world drenched in beneficent sunlight and less real than everyday. By means of disproportionately huge crags and boulders, trees and ancient ruins, those distant places are given a rather special emotional feeling, a tinge of the historical, arcadian, or heroically mythological. In Italy, and especially in the idealizing landscape painting being practised in Rome, the Netherlands' artists found inspiration for a poetically

188 Pieter van Laer ("Il Bamboccio"), *Herdsman and Washerwomen at a Stream*. Oil on copper, 29 × 43 cm (11⅜ × 16⅞ in). Amsterdam, Rijksmuseum

transfigured conception of art. The approach to landscape as a harmonious unity of contrasting formations and significances that was developed by the Carracci, Domenichino, and the Northerners Bril and Elsheimer was taken up first by Cornelis van Poelenburgh (1586-1667) and Bartholomeus Breenbergh (1598/ 1600-1657), then by a second generation who worked in Rome in the 1630s. In those years among the members of the Bent, the association of Dutch artists living in Rome, were Pieter van Laer (1599-after 1642), Herman van Swanevelt (1600-1655), Jan Asselijn (1615-1652), and Jan Both (1618-1652). During their Italian sojourns they filled sketchbooks with drawings of architectural and landscape motifs which, most often only after their return to Holland, they reworked in paint, frequently trading sketches among themselves to be used as models.

Yet, for all the influence from the Roman tradition and most likely Claude Lorrain, who had long been an established part of the Roman art world, it was not all one-way. Realistic Netherlandish motifs found their way into the work of the native Italian artists. This is clearest in the down-to-earth depictions of the commonfolk introduced by Pieter van Laer. His own

humpbacked stunted appearance (the Italians referred to him as a *bamboccio,* a rag doll or stumpy child) gave the name to a new genre depicting market people, peasants, and beggars, the *bambocciate.* The southern landscape lent such depictions of ordinary people a certain carefree flavor, so the effect is not moralizing but simply picturesque (188).

Without ever setting foot in Italy, a number of Dutch painters depicted the bright skies and shepherd scenes of the Campagna, with compositions ingeniously put together out of impressive rock formations and architecture. Even one of the most Italiante among them, the Haarlemer Nicolaes Berchem (1620-1683), may never have gone to Italy and only have taken ideas and images from Asselijn, Both, and his cousin Jan Baptist Weenix. In one of his typically Italian pictures (189) painted around 1658 in Holland, a composition simple as a stage set and the fresh and relaxed painting technique, as well as the arcadian subject all anticipate key traits of eighteenth-century paintings. In fact Berchem's work remained well known, through engravings, in France especially.

The same highly effective articulation of surfaces

189 Nicholaes Berchem, *Peasants with Four Oxen and a Goat at a Ford by a Ruined Aqueduct.* c. 1658. Oil on panel, 47.1 × 38.7 cm (18½ × 15¼ in). London, National Gallery

was used most liberally by Adam Pynacker (1622-1673). As with Aelbert Cuyp, clearly contoured foreground motifs are set in a mild counterlight before a misty light-suffused background, with the emphatic shapes of foreground and background brought into a rhythmic relationship (190).

Genre Painting

Along with the art of landscape, genre painting has always been considered a unique achievement and expression of Netherlandish art. Among its remote roots can be reckoned the *Annunciation* of the Ghent altarpiece by the Van Eyck brothers, the younger Van Eyck's Arnolfini marriage portrait (11), the picture by Petrus Christus of Saint Eligius as goldsmith (17), and the elder Pieter Bruegel's peasant scenes (92-94). In the seventeenth century innumerable artists contributed to its further development Yet, taken literally, the term applied to this kind of art showing everyday life implies something rather negative. What academic art theory, after neatly pigeonholing the categories of history, landscape, and still-life painting, had no place

190 Adam Pynacker, *The Shore of an Italian Lake*. Oil on panel, 97.5 × 85.5 cm (38⅜ × 33⅝ in). Amsterdam, Rijksmuseum

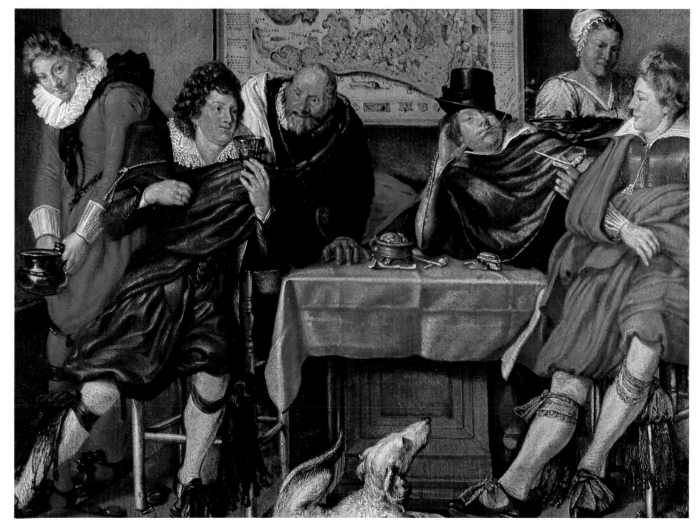

191 Willem Pietersz. Buytewech, *Merry Company*. Between 1617 and 1620. Oil on canvas, 49.3 × 68 cm (19⅜ × 26¾ in). Rotterdam, Museum Boymans-van Beuningen

for, it relegated to a special and lowest branch to which it gave the name of *genre,* a general abstract term signifying no more than "kind, sort, species, category." But because it depicts the ordinary doings of ordinary people, this purportedly low branch of painting is of utmost moment for the cultural historian. By dispensing with everything elevated, idealized, and instructive in favor of an everyday reality, painting can hand on the image of an historical epoch and of a society and its relationships This, for many writers, distinguishes the Netherlandish genre art as progressive and, indeed, modern.

A certain caution is not amiss, however, when it comes to such latter-day biases. Compared with Sweerts's picture of students in a drawing class (192) or Bols's portrait of a youngster in fancy togs (193),

Buytewech's *Merry Company* (191), a popular theme of the time, turns out to be something more than meets the eye. Attended by a serving maid, its five gentlemen sprawl around a table in rather affected idleness and bombastically stilted poses. Food, wine, and tobacco are in evidence, yet there is no particular sense of conviviality nor do the gentlemen look to be sitting for a group portrait: for either a banquet scene or portrait the somewhat Mannerist elongated and decoratively posed figures are much too self-conscious. However, when one learns that they wear the costumes sported by English actors guesting in Dutch playhouses, the whole look of the men takes on a tinge of willful irony. Although we do not know the piece or their roles, obviously the five actors are playing some sort of scene, and the picture could be considered a theatrical scene

192 Michiel Sweerts, *Drawing Class.* c. 1660. Oil on canvas, 76.5 × 109.9 cm (30⅛ × 43¼ in). Haarlem, Frans Hals-Museum

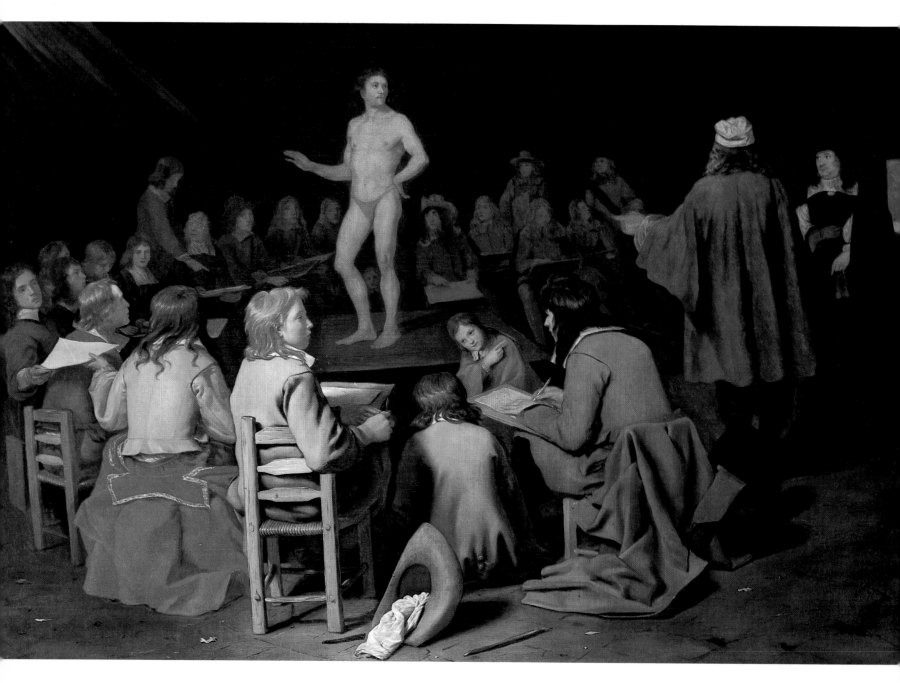

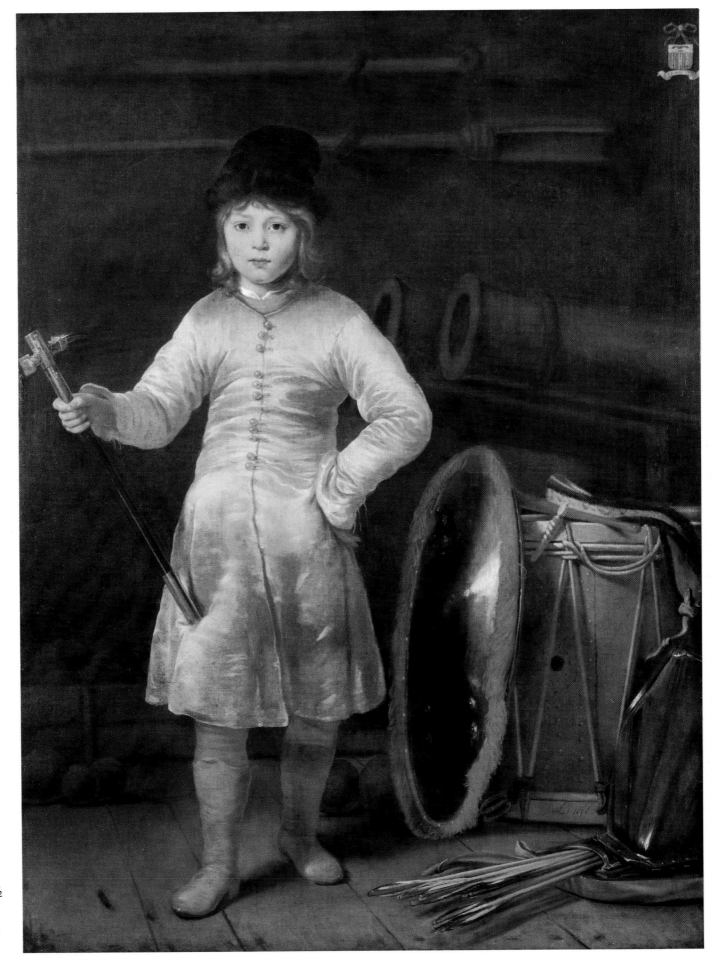

193 Ferdinand Bol, *Portrait of a Boy in Polish Costume*. 1656. Oil on canvas, 158 × 120.5 cm (62¼ × 47½ in). Rotterdam, Museum Boymans-van Beuningen

223

rather than just another "merry company".

This type of painting was obviously not intended for display in churches or places of public assembly. Why then, and for whom were they painted? Up until this time, private ownership of works of art had been mainly the privilege of the nobility and the very

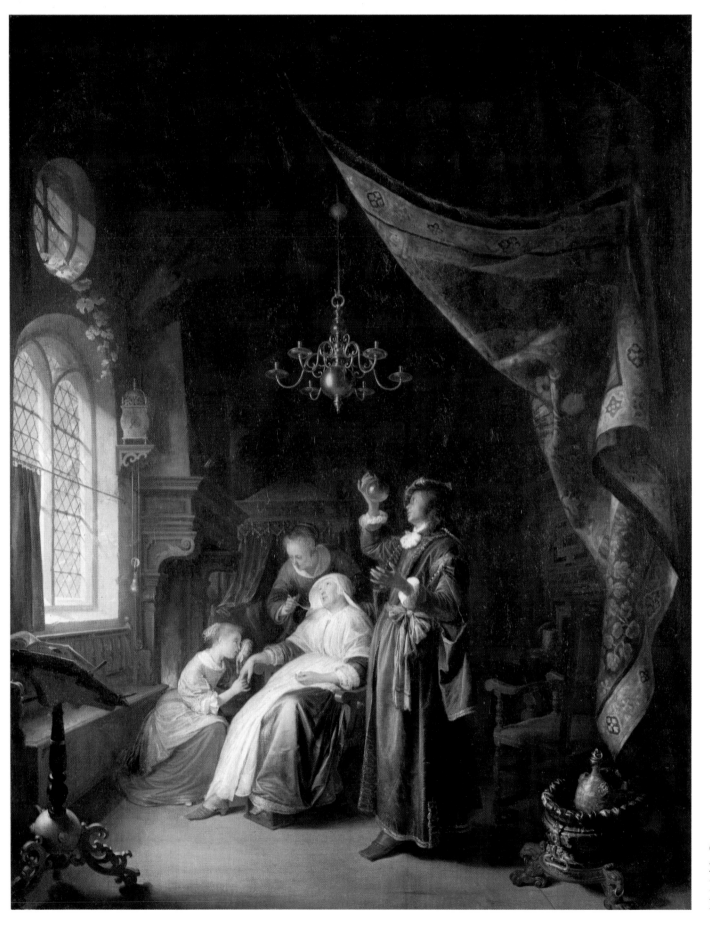

194 Gerard Dou, *The Woman with Dropsy*. 1653. Oil on panel, 83 × 67 cm (32⅜ × 26⅜ in). Paris, Musée National du Louvre

195 Caspar Netscher, *The Lace Maker*. 1664. Oil on canvas, 33 × 26.6 cm (13 × 10½ in). London, Wallace Collection

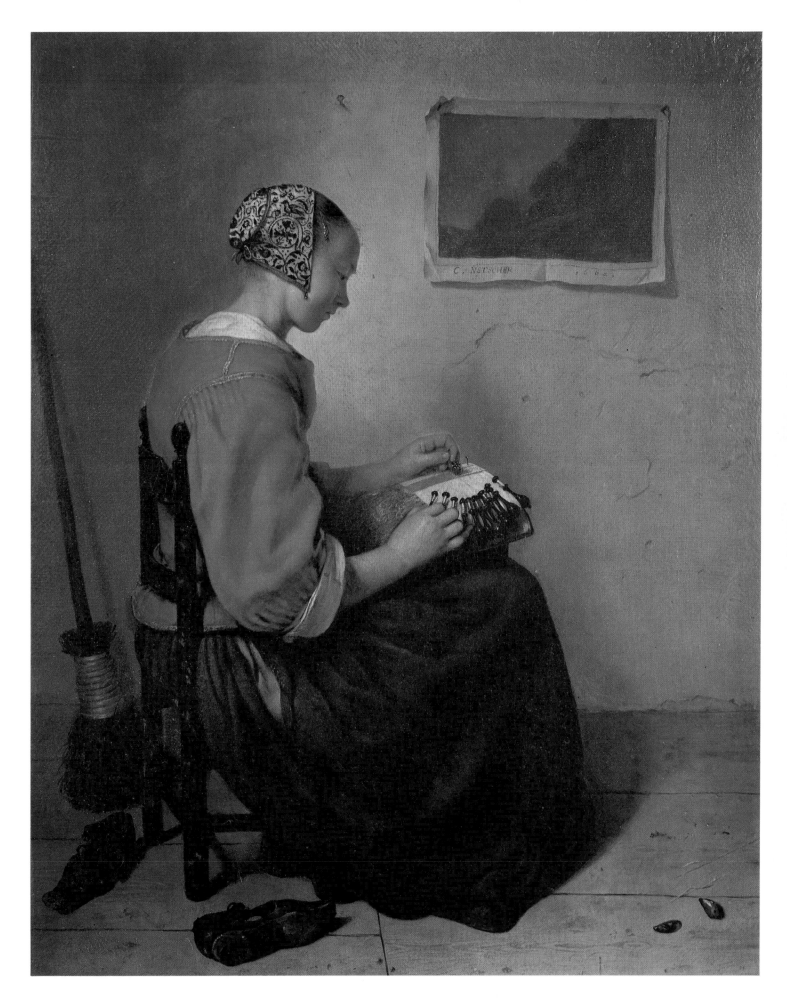

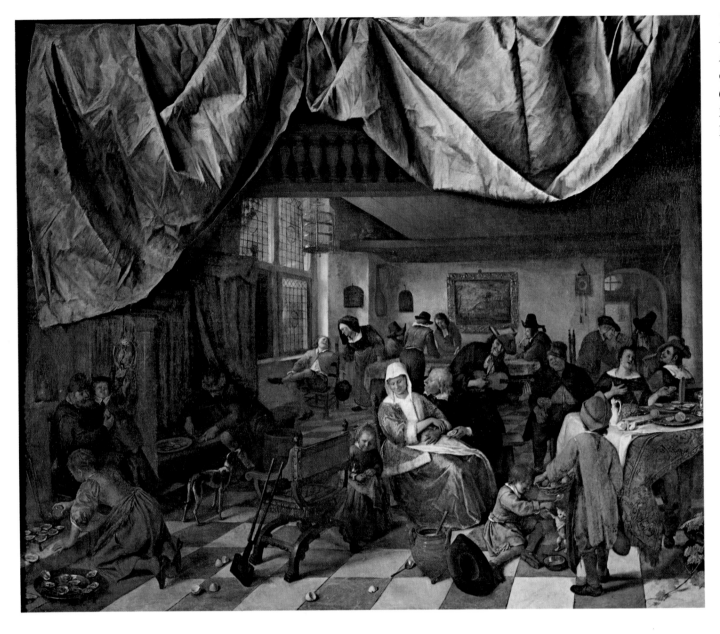

196 Jan Steen, *The Life of Man (The Brewery of Jan Steen)*. c. 1674. Oil on canvas, 68.2 × 82 cm (26⅞ × 32¼ in). The Hague, Mauritshuis

wealthy. Portraits and allegorical or mythological pictures, which served as a glorification of power and family, and devotional images for private ceremonies, had been proudly owned and displayed. These new genre paintings were much more modest both in size and subject matter. They were just right, however, for hanging in a middle-class parlor, easily put up and taken down and essentially decorative. With the loss of the monumental context and no need for commemoration of anyone or any event, pictures did in fact change in purpose, in meaning, and in the manner of painting.

The historical and social situation of the time should be kept in mind. With the liberation of the northern provinces from Spanish rule and with the economic upswing that ensued, with the spread of a comfortable well-being within the framework of new civic, guild, and economic freedoms, a previously unknown feeling of solidarity and national awareness grew up. To en-

sure domestic and foreign peace for the Union which was still under threat, the Dutch citizenry under the influence of Calvin and Erasmus came to prize simplicity, sobriety, steadfastness, human dignity, and masterly skill as fundamental virtues which, subsumed under the untranslatable term of *deftigheydt* (something in the order of the republican Roman *gravitas* of Cicero), came to mark private and social life.

In the arts, this implied a high level of skill in painting, something of the sort seen in, say, a Gerard Dou with his industrious rendering of every last detail, of every aspect of every material, of the way light catches them or they retreat into shade, all integrated into carefully illuminated or shadowed interiors (194). Likewise the taste for domestic themes, as in Netscher's *Lace Maker* (195), reflects those virtues and the value attached to the contentment that comes from quiet and humble work and domesticity. But then we

197 Jan Steen, *The Morning Toilette*. 1663. Oil on panel, 64.5 × 52.7 cm (25⅜ × 20¾ in). London, The Collection of Her Majesty the Queen

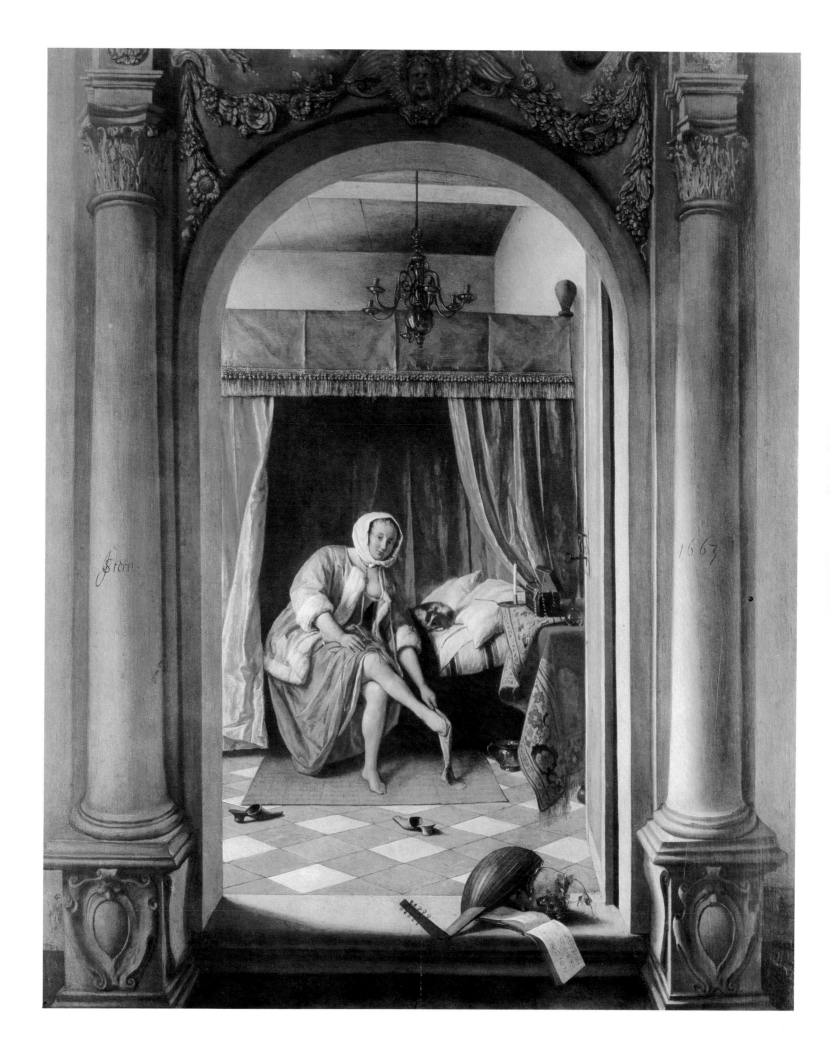

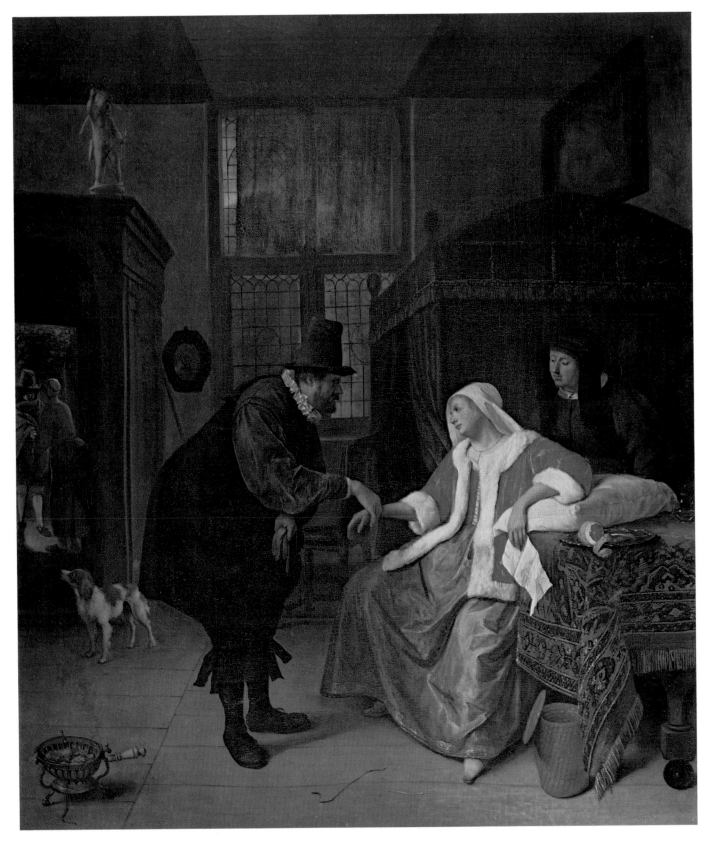

198 Jan Steen, *The Lovesick Girl*. 1660-62. Oil on canvas, 61.5 × 52.1 cm (24¼ × 20½ in). Munich, Alte Pinakothek

must question what really brings about the feeling of peaceful contemplation we get from a little picture like this, so intimate and inward as to seem scarcely concerned with making an effect on any viewer. Certainly there are differences. In his *Woman with Dropsy* (194) Gerrit Dou lavished Rembrandt's painterly means on a modest subject, yet without any grasp of his teacher's

way of linking atmosphere and human drama. But faced with such well calibrated, clearly set forth middle-class genre pictures, one cannot but wonder if there may not be some elusive hidden significance and, if so, how it is conveyed.

To begin with, a "parlor picture" on the wall of a bourgeois interior, not fixed into any set architecture,

is something like an opening or window through whose dark and usually deep-carved frame something outside the particular room is brought indoors to trick and divert the eye. Pictures with alcoves or windows having half-figures or scenes in or behind them (something especially frequent with Dou) testify to that function, as do also painted architectural settings or curtains drawn back. But those *trompe-l'ceil* elements may also conceal meanings we are only now really deciphering and which call for the most careful observation.

In Jan Steen's *Morning Toilette* (197) on the doorsill of a columned portal lies a still life of a lute, music book, and death's head, a clear admonition of the impermanence of all things earthly. Yet beyond it, through the open door we look into a bedroom where a young woman is dressing. There is room for a partner in her bed (note the two pillows), and that gives us the clue to reading the picture as illustration of the proverb, "Music-making, stocking, and jug make

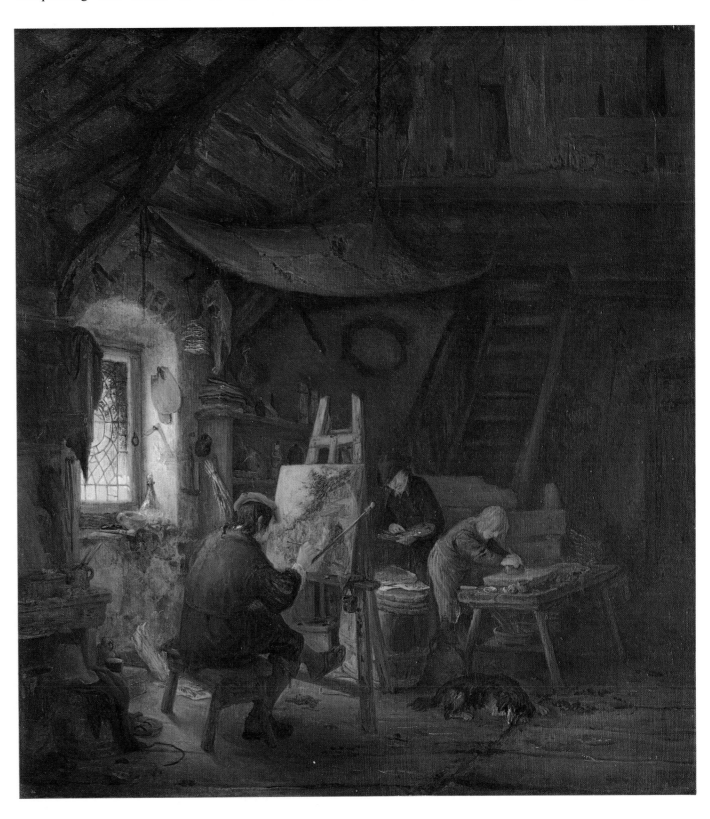

199 Adriaen van Ostade, *A Painter's Studio*. Oil on panel, 36 × 35 cm (14⅛ × 13¾ in). Amsterdam, Rijksmuseum

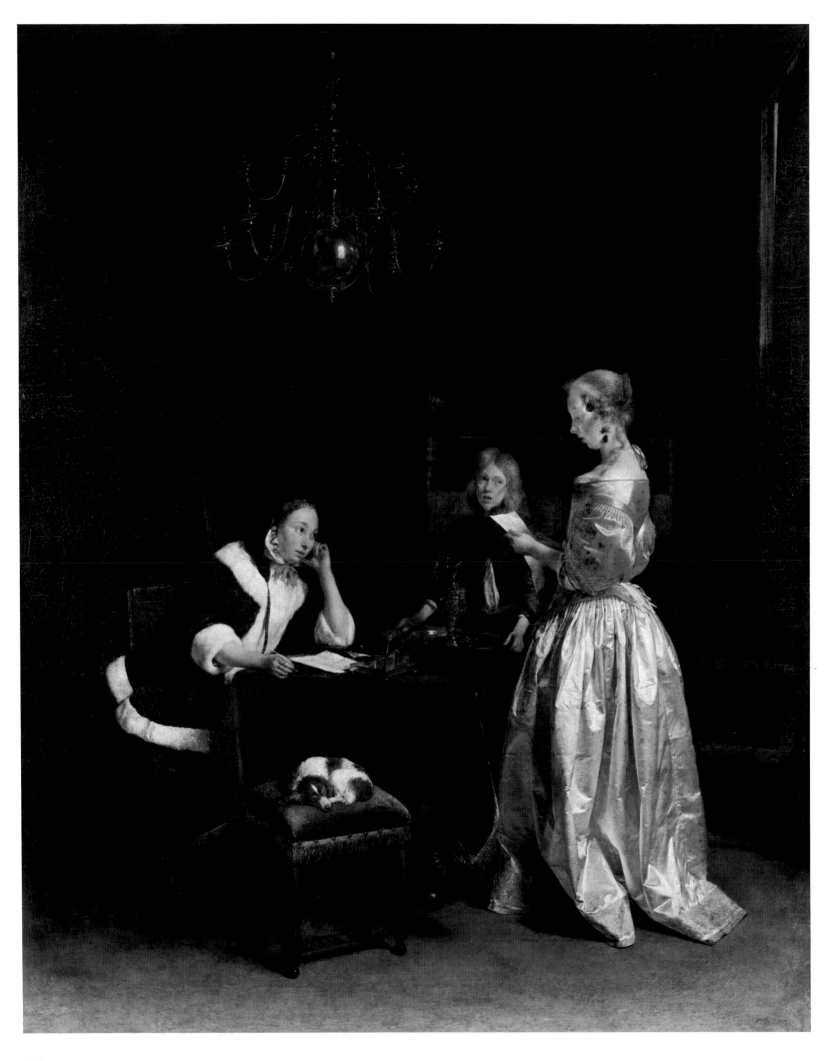

many a man poor," since in Dutch the word for stocking (*kous*) has the secondary meaning of the female sex organ. In the same artist's *The Life of Man* (196) a close look discloses a veritable anthology of illustrations of the pleasures of the senses, to be read from the relations between the groups and the actions, poses, and physiognomies of the denizens of this alehouse (the picture is often called *The Brewery of Jan Steen*, the painter having doubled as tavern keeper). Everything, down to the tiniest detail, speaks of how vain and passing are all things human: the boy in the loft who lies on his belly alongside a skull and blows soap bubbles down into the room sets the key for the Human Comedy, the Great World Theatre, the picture

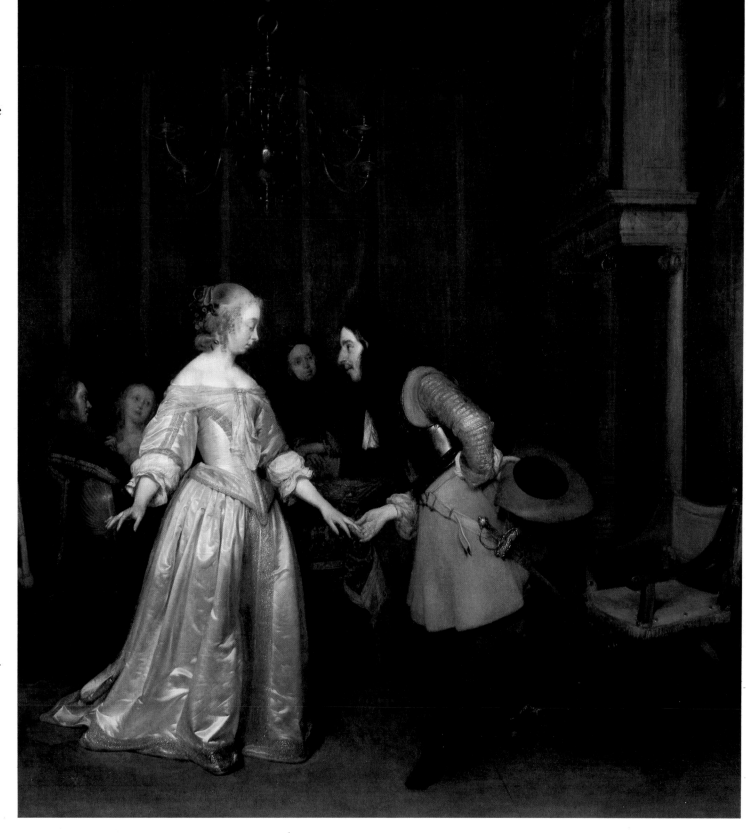

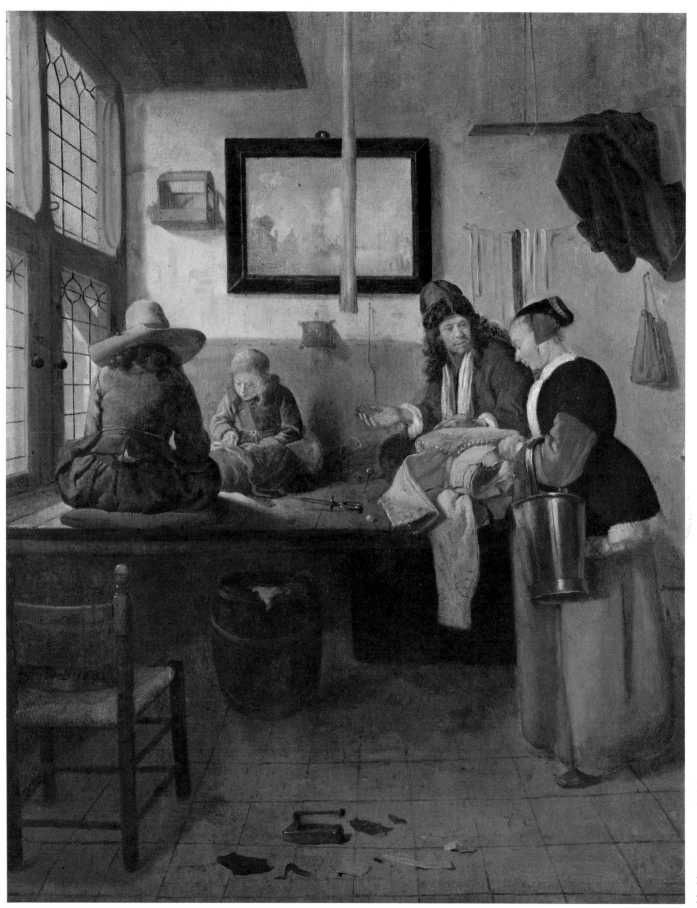

202 Quiringh Gerritsz.
van Brekelenkam, *The
Tailor's Workshop*.
1661. Oil on canvas, 66
× 53 cm (26 × 20⅞
in). Amsterdam, Rijks-
museum

represents. Yet delight in seeing, a general cheeriness, wit, and irony preserve the picture from schoolmasterly preaching. Likewise in Steen's *Lovesick Girl* (198) where the costume of the doctor borrowed from the Italian *commedia dell'arte*, the cupid over the vestibule, the letter being delivered at the front door, and finally the text on the paper the patient holds all give the message, the old saw that *daar laat geen medesyn want het is minnepyn* (what good is a doctor when the trouble is love?). Yet there is more to such pictures than a mere anecdote, more in genre paintings than the amusing double-meaning we recognize with a smile.

Just as the religious image of past centuries conveyed its truth through its content, another type of image conveyed messages on the lay level though these have largely been forgotten. The humanistic emblem served to express and explain the single, double, or multiple meaning of a depicted object. The painted representation thereby took on a universal significance which was the reason for its existence. For example, Buytewech's *Merry Company*, a picture of a convivial gathering or a theatrical scene, could also be read as a demonstration of the Five Senses. And over and beyond the story it tells, Steen's *Lovesick Girl* speaks of Melancholy, of the "humor" revealed in the patient's pulse beat. Those connections were part of what everyone knew, and passed directly into every painter's observation and description of the world around him, exactly as was called for in the art theory of the time.

To fulfill that task, to give visible form to universal human meanings, was the painter's mission, and it is brought out in the theme of the "studio." It is safe to presume that even when Adriaen van Ostade treats that subject (199) it is not by chance that people and place alike are depicted as utterly unassuming, even humble. And this is because visual perception itself is conditioned: man can choose between sight and insight, blindness and illumination, the evidence of the eyes or of revelation.

As one would expect from Gerard Terborch's more cosmopolitan orientation—he visited Italy, Spain, France, and England—his themes are more "gallant," his personages of higher class and more fasionably dressed. Yet even they, as in his *An Interior with a Dancing Couple* (201), are vehicles of very different feelings when it comes to the attraction and repulsion between the sexes. They too suffer through the contradictions and inconstancy of human behavior, have to steer a course between seduction and steadfastness. These groups of figures picked out by the light shelter unobstrusively within the refuge of the dark room, and they make clear how the artist contrives to bring

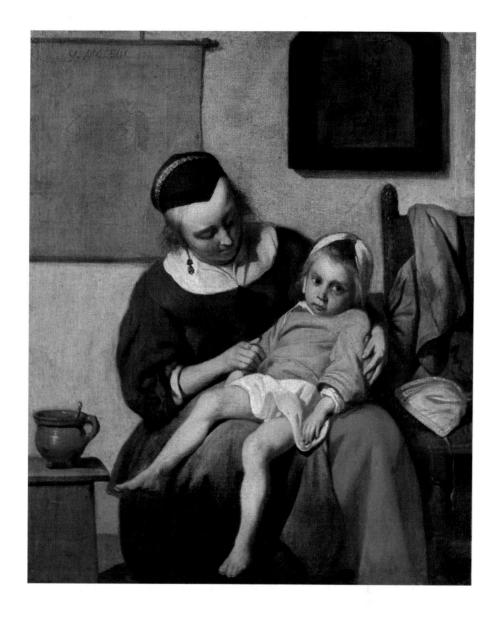

out the rather subtler sentiments at play here—amorous sentiments, it so happens, as in his *The Letter* also (200). His aim is achieved by making us share in the experience of these persons, and by a painterly compression and linkage of individuals and the room they are in—and of light and air as well—into a situation pregnant with meaning which, in the interplay of inward experience and spatial environment, makes it impossible to distinguish one from the other. These persons have their life within *this* room: room and atmosphere combine to explain them. One sees this also in Metsu's *The Sick Child* (203) whose quiet closed forms in front of a picture of the Crucifixion on the more brightly lighted rear wall let one read it as a transformation of the *Caritas* allegory—Charity with her children—into a genre scene.

Just as the two dogs in the brothel scene by Frans van Mieris (204) alert us to the real point of that picture, in almost every genre picture one or more details give the clue to whatever is behind a seemingly banal

203 Gabriel Metsu, *The Sick Child.* c. 1660. Oil on canvas, 33.2 × 27.2 cm (13⅛ × 10¾ in). Amsterdam, Rijksmuseum

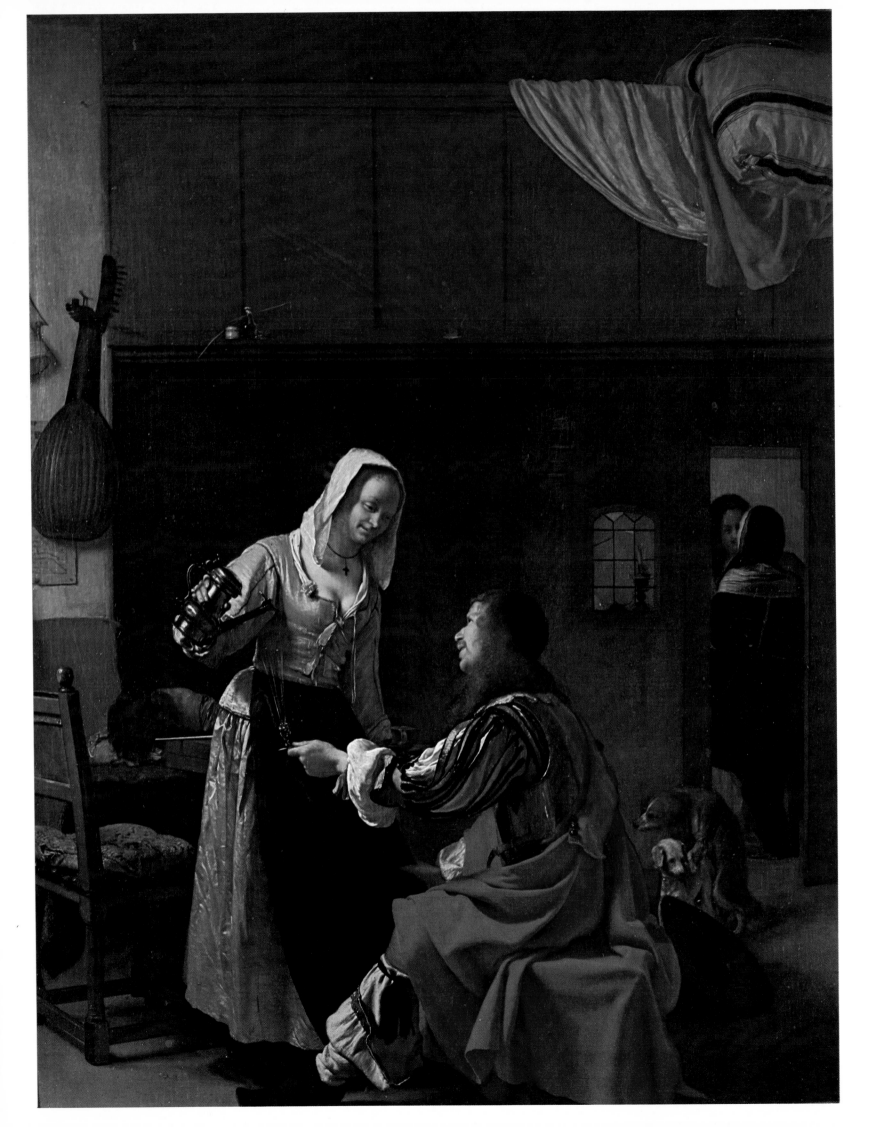

204 Frans van Mieris the Elder, *Brothel Scene*. 1658. Oil on panel, 43 × 33 cm (16⅞ × 13 in). The Hague, Mauritshuis

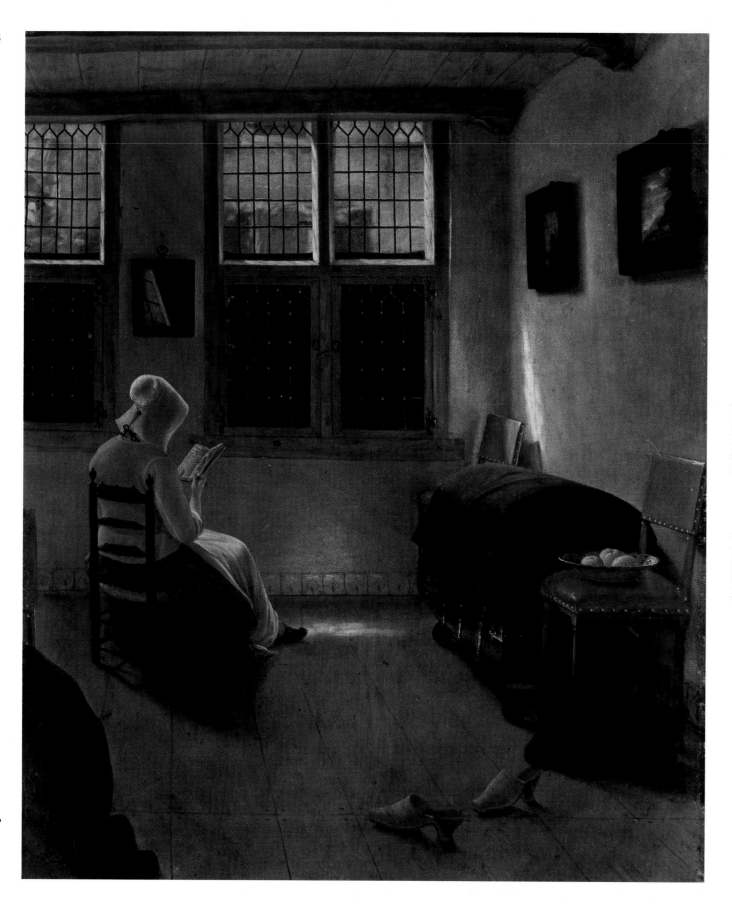

205 Pieter Janssens, *Woman Reading*. c. 1660-70. Oil on canvas, 75 × 62 cm (29½ × 24⅜ in). Munich, Alte Pinakothek

slice of daily life. Idyll, anecdote, and symbol simply carry further or delimit something already set out clearly in the picture.

The seventeenth-century Dutch poet and art theorist Jacob Cats gave for each of his emblems an amorous, social, and religious explanation, yet art, he maintained in accord with Horace's old but perennial precept, was chiefly meant to entertain and please. In the same way, whatever its symbolic meaning the genre picture had to prove its quality through the sheer

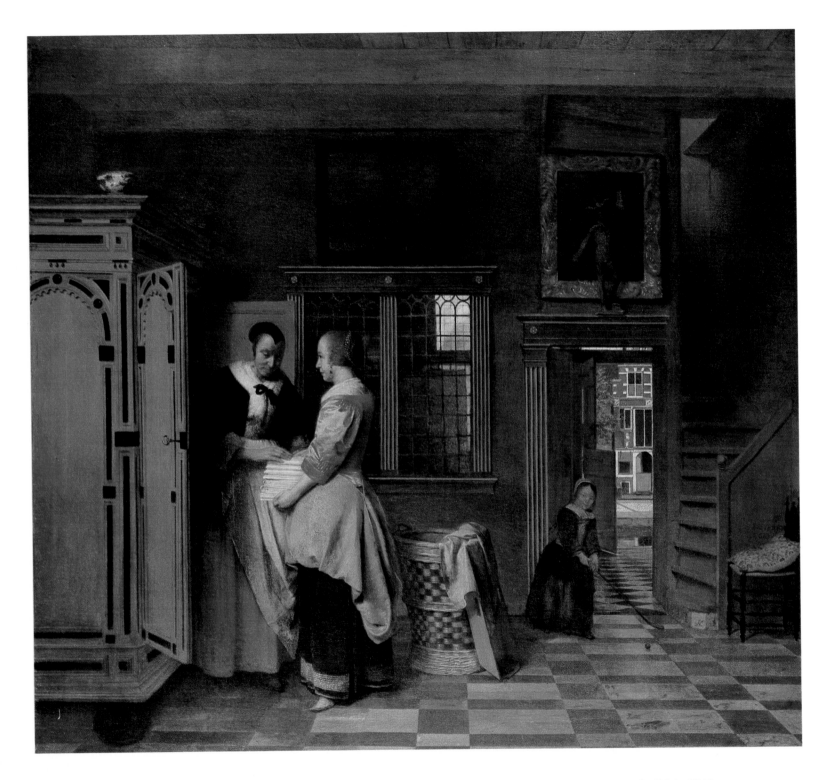

mastery of its painting. The pleasure taken in its perfection, in the observation and rendering of the appearances of materials and surfaces under different atmospheric conditions of light and air, is therefore every bit as important as the equivocal meanings to be extracted from its content. Genre painting appealed to a great number of artists and so offers no end of personal solutions and expressions from which each viewer can select what he appreciates most.

The domestic scenes of Pieter de Hooch (206, 207) communicate the atmosphere of comfortable orderliness so characteristic of Dutch households and towns. These are perhaps the "purest" of genre pictures, simple everyday scenes rendered with great skill and sensitivity. There is no reason to read any symbolism into them. They are complete in themselves, small worlds of glistening light and a quiet mood of well-being.

206 Pieter de Hooch, *At the Linen Closet.* 1663. Oil on canvas, 72 × 77.5 cm (28⅜ × 30½ in). Amsterdam, Rijksmuseum

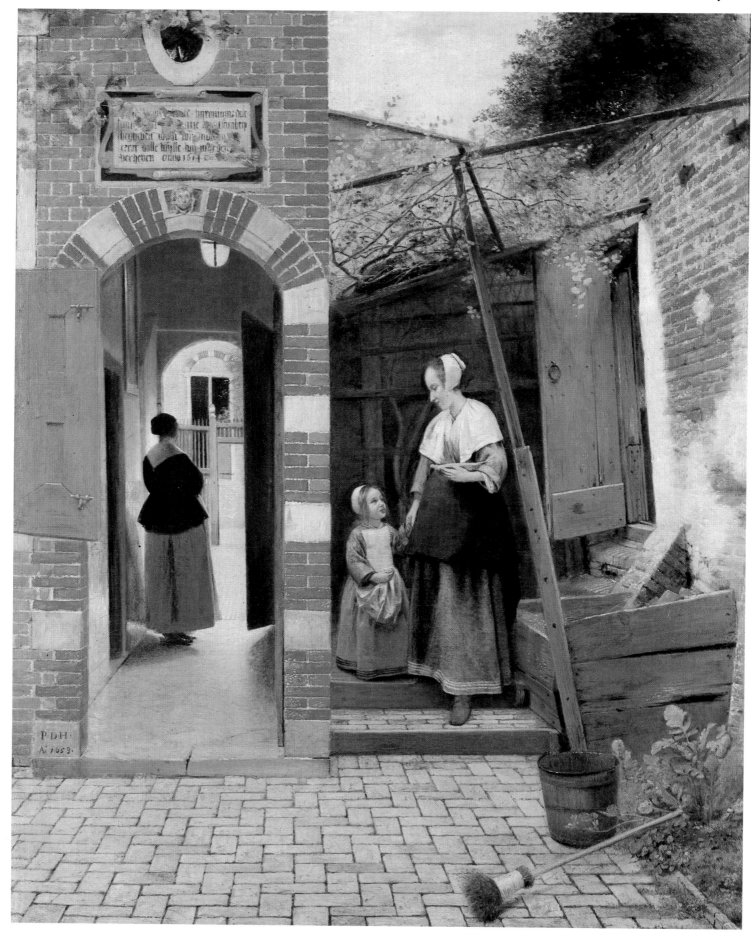

Jan Vermeer of Delft

The enthusiasm for capturing in paint the precise look and feel of the physical world and all it contains, which was the main effort of Netherlandish painting around and after the middle of the seventeenth cen- tury, had its chief productive centers in Haarlem, Amsterdam, Utrecht, and Leyden. Delft, the home of Vermeer, played only a relatively modest, though very important role, and this chiefly through the presence

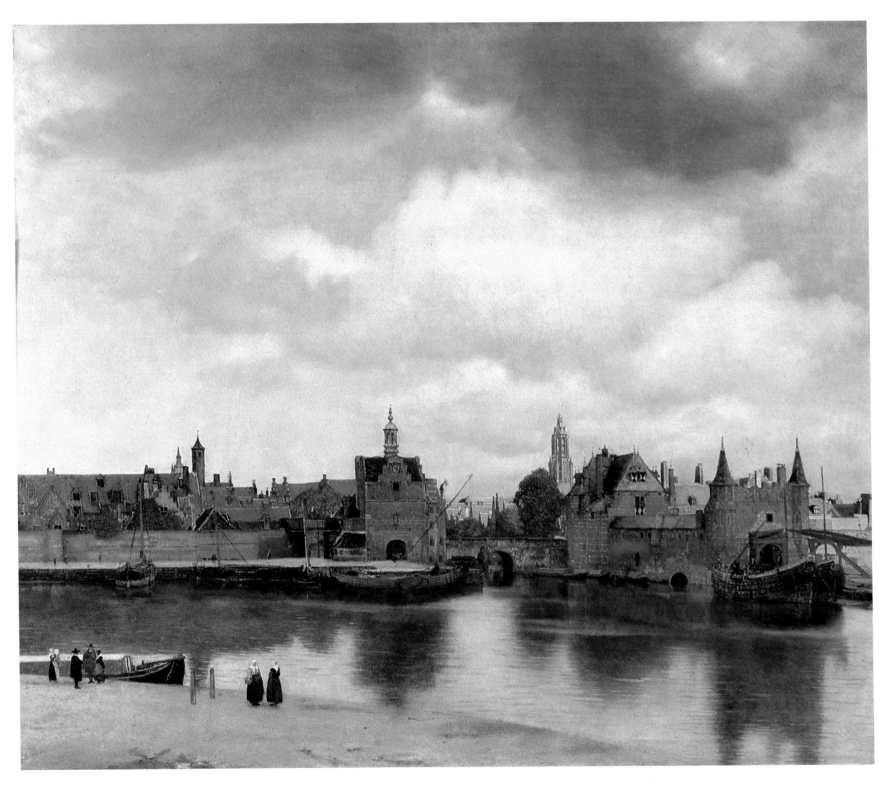

208 Jan Vermeer, *View of Delft, taken from the Rotterdam Canal.* c. 1661. Oil on canvas, 98.5 × 117.5 cm (38¾ × 46⅜ in). The Hague, Mauritshuis

209 Jan Vermeer, *The Little Street.* c. 1658. Oil on canvas, 54.3 × 44 cm (21⅜ × 17⅜ in). Amsterdam, Rijksmuseum

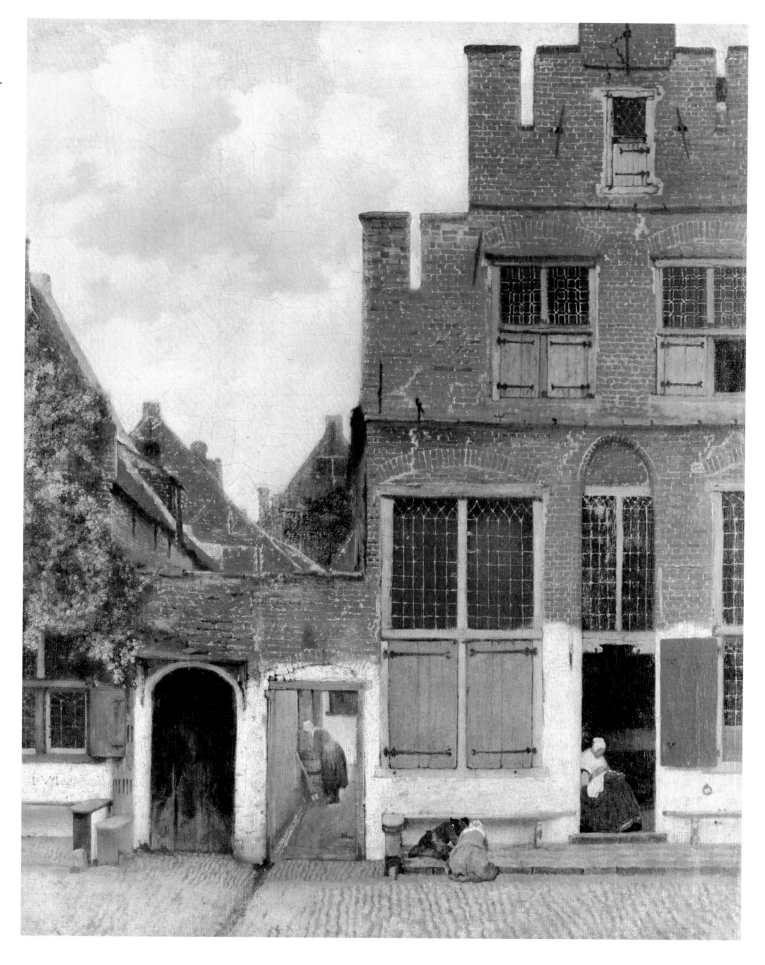

there of Carel Fabritius between 1650 and his tragic death four years later. With the lessons of Rembrandt as point of departure, Fabritius' concern with the means and principles by which painters apprehend and depict nature—perspective, trompe-l'oeil, close and far vision, and the like—had a decisive influence on his local colleagues Pieter de Hooch, whose art reached a veritable climax between 1655 and 1662 when he lived in Delft, and Jan Vermeer. The scrupulous mastery of perspective to be seen the way both Vermeer and De Hooch painted rooms and the rooms beyond rooms was surely not uninfluenced by Fabritius. Then too, De Hooch brought the outdoors—courtyard, garden, and street—into relationship with his very human and intimate domesticity, and though different in pictorial aim, this has been seen as a step

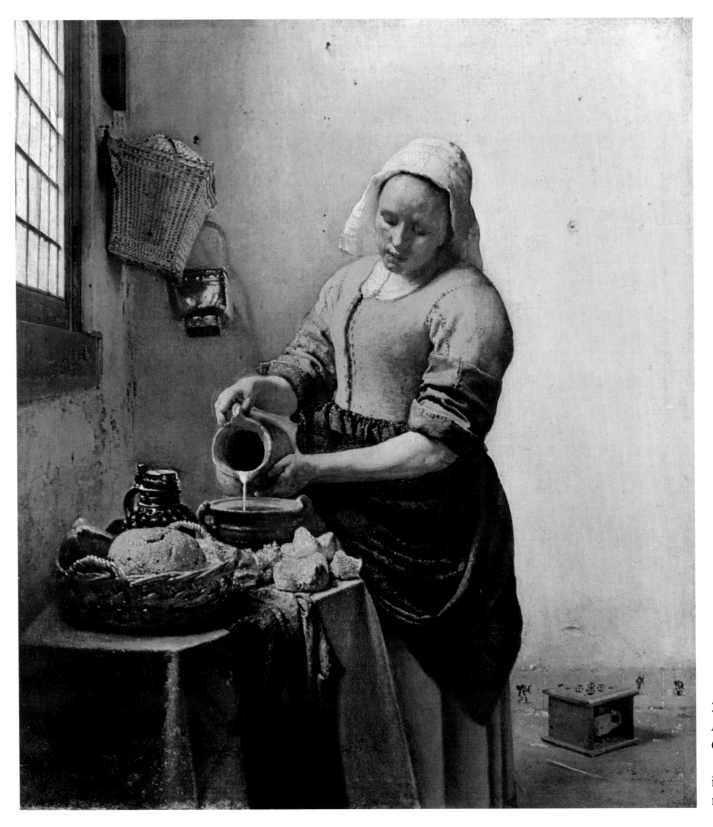

210 Jan Vermeer, *The Kitchen Maid*. c. 1658-60. Oil on canvas, 45.5 × 41 cm (17⅞ × 16⅛ in). Amsterdam, Rijksmuseum

toward Vermeer's *The Little Street* (209). Though both artists practiced a clear tectonic approach to composition, with Vermeer there is a more evident reduction in coloristic richness and the exploitation of painterly means, a reduction whose sober simplicity tells us how much he strove for controlled observation and a carefully weighed equilibrium between all the creative means he brought into play. De Hooch's colors are stronger and range over the entire scale, whereas Vermeer limits himself to a generally prevailing color and color harmony. Instead of lighting from multiple sources, with Vermeer there is a uniform effusion of brightness. And this particular use of both color and light are essential factors in his meticulous rendering of the interplay between materials, color, and atmosphere. His view of a humble city lane takes much of its character from an expanse of clouded sky which has its counterplay in the specific look and feel of bricks, mortared joints, wooden window frames and shutters, glass panes, plastered walls, paving stones.

Such scientific precision in observation of real things, and such subtle reworking of reality toward aesthetic ends, found their grandiose fulfillment in Vermeer's *View of Delft* (208). One can still sense the cool freshness of the early hours in the reflections of light on the roofs and walls of the houses that rise beyond the stretch of water. It is the fleeting, glancing rays of light breaking through which, in the contrast of bright and shaded areas, lend depth to the space, life to every thing seen, and a precise physiognomy and lucidly defined typology to the entire scene. In the sparkling light reflected in bright points on the bow of the ship still lying mostly in a nocturnal shadow there are painterly qualities that would not be rediscovered and carried further before the open-air painting of the nineteenth century. What one sees—facts and phenomena—is affected by the tension between material nature and atmospheric conditions and yet is fully rooted in the values of luminosity and color. To understand how Vermeer could pin down in paint such sensitive observations one needs to keep in mind that outdoor scenes were painted indoors, in the case of this townscape and street scene looking through windows of houses still identifiable, and what we see is an aesthetic transformation of real views.

While these two outdoor paintings are unique among Vermeer's work, his broader grasp of an open-air atmosphere carried over into his interiors as well. The restriction to an unpretentious motif, a narrowly delimited corner of space, a simple unequivocal lighting, a pithy and yet utterly delicate color harmony punctiliously modified according to degrees of brightness, may at first strike one as somewhat rigorous in

The Kitchen Maid (210). But the real theme is the gradations in light and the way it touches the familiar objects. At its most brilliant on the basket, bread, and glazed pottery, the light shatters into glittering refractions that almost break up the shapes; on the maid's headkerchief it brings out a glow of radiant whiteness; in its middle values it makes possible the strongest coloring; in its dusky shadows it still holds pure color never broken down into black; its richest play is in the colored iridescence of the large expanse of wall. Behind a dark foreground, with the rich-colored figure set against a bright ground it is light that creates space, that gives all forms their solidity, that compels the colors to unceasing change, that lends the figure and objects in the room the unity and completeness of an atmosphere. This is a very different conception of light from that of Rembrandt: it no longer brings dramatic significance to some personal action in immeasurable deep-shadowed space; instead it has become the medium for opening up —disclosing— space, objects, the overall mood.

With this pellucid simplicity Vermeer was as representative of his generation as Frans Hals was for his; only Rembrandt in the great Dutch triumvirate developed in ways that were his alone. If the optimism of the first decades of the century found expression in Hals's pictures, the serene view of life of the later decades' middle classes can be read in Vermeer's. The town of Delft, with a population of 25,000, had been superseded by Rotterdam as an important commercial center, but still enjoyed a comfortable bourgeois prosperity, in which Vermeer did not share. Constantly distracted by financial problems, he could scarcely turn out more than three or four pictures a year, and in fact, a mere thirty-six have been identified. As for his teachers and predecessors, historical research gives almost as little information as the pictures themselves, in which virtually nothing of the man's biography can be deciphered. Other than to note his supreme mastery of his craft, the art historians can produce only a handful of general conclusions: in the close-up treatment of space he was preceded by Gerrit Houckgeest; for his highly atmospheric characterization of interiors through light and air there was a precedent in the pictures of church interiors by Emanuel de Witte who worked in Delft between 1641 and 1651 and who was himself indebted to the light-drenched architectural paintings of Hendrick Cornelisz. van Vliet.

Vermeer's paintings themselves speak only of his essential aim: an aesthetically serene clarity as value in itself and from which all dross has been distilled away.

In the room darkened by a red curtain in the *Woman Weighing Pearls (or Gold)* (211) we see how

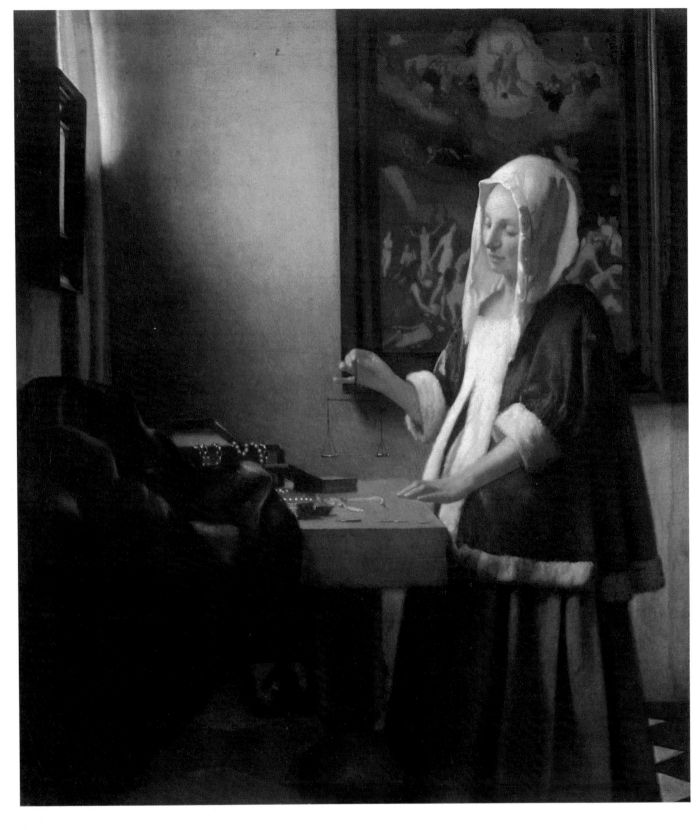

211 Jan Vermeer, *Woman Weighing Pearls (or Gold?)*. 1662-65. Oil on canvas, 42.5 × 38 cm (16¾ × 15 in). Washington, National Gallery of Art, Widener Collection

Vermeer studied the refraction and gradation of local colors in the fabrics, the picture on the wall, the reflection on objects, the gradual change of color on the wall. In this aura of color, the act the woman performs is transformed into a meaningful content paralleling the weighing of the souls in the picture of the Last Judgment on the wall behind her. In the *Young Woman Standing at a Virginal* (214), whose porcelain-like brilliance of color marks it as from a later phase, a picture within the picture likewise holds the key to the subject. Insofar as they have an implicit further meaning these pictures are closer to genre, with its symbolic intent, than to something like the *Kitchen Maid* (210) whose point is made without anecdote, as pure image. Such a picture is more like a still life, with a human figure drawn into its dreamlike timeless spatiality. The

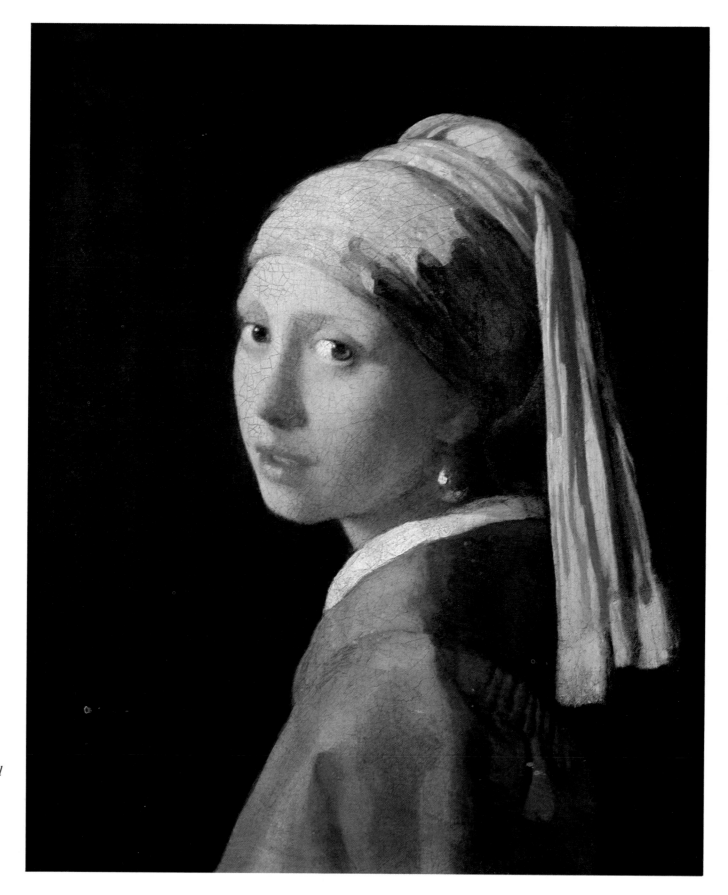

212 Jan Vermeer, *Girl with Pearl Earring*. c. 1665. Oil on canvas, 46.5 × 40 cm (18¼ × 15¾ in). The Hague, Mauritshuis

maid's activity is caught up wholly in the mood of the humble interior: we feel ourselves intruders. Yet no illustrative purpose, no great display, no moral lesson or pressing message lies behind the picture.

Such a conception—a matter of pure principle—is not jeopardized even when, in another picture (212), a pearl-earringed girl looks out at us with an open, vul-nerable, but entirely unfrivolous or over-familiar gaze. Close-up as the figure is and utterly charming, it holds us at a distance. That effect, due somewhat to the shoulder turned sharply toward us, is matched in other pictures, not least in the *Artist in His Studio: Allegory of the Art of Painting* (213), by a complexity of composition. From a narrow foreground room, a

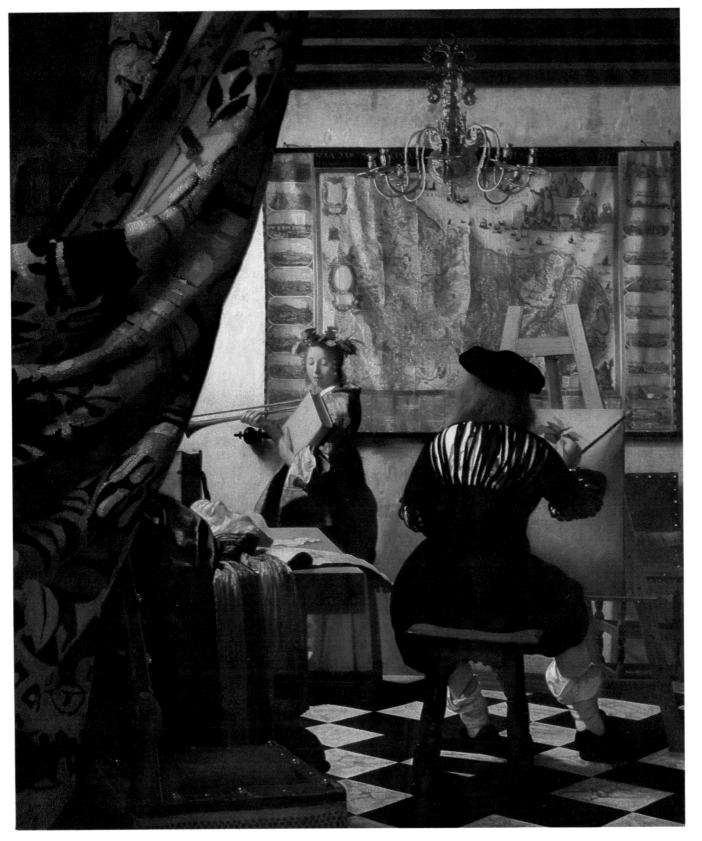

213 Jan Vermeer, *The Artist in his Studio: Allegory of the Art of Painting.* c. 1665. Oil on canvas, 120 × 100 cm (47¼ × 39⅜ in). Vienna, Kunsthistorisches Museum

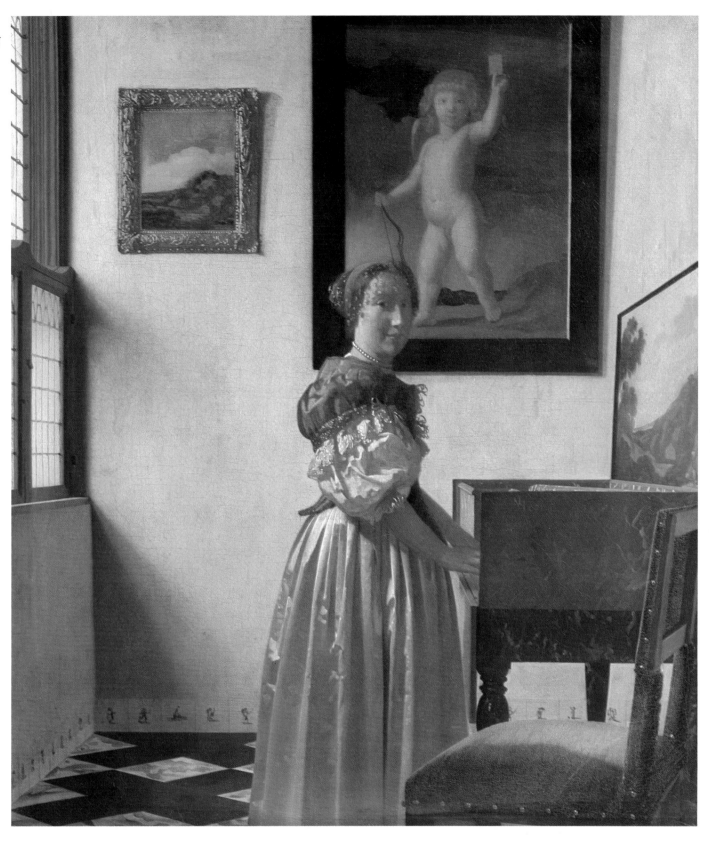

drawn-back curtain lets us look into an artist's studio. Wearing a fanciful costume of an earlier era the artist sits at the easel, his eyes fastened on a model in bright light who poses as Clio, personification of History, Fame, and Contemplation. In this secularized form of the iconography of Saint Luke painting the Madonna, the picture represents Vermeer's own conception of his art and the high mission the artist is called on to fulfill.

Still Life

In the seventeenth and early eighteenth centuries a few hundred still-life painters were at work in the Netherlands. Not perhaps a great number among all the thousands of Flemish and Dutch artists of the time, but nonetheless surprising in view of such a relatively restricted subject matter: flowers, fruit, animals, utensils of all sorts, with only rarely a living intruder. Mostly, and literally, things that are motionless, still. And though they may look like everyday things haphazardly come upon, we know the artist

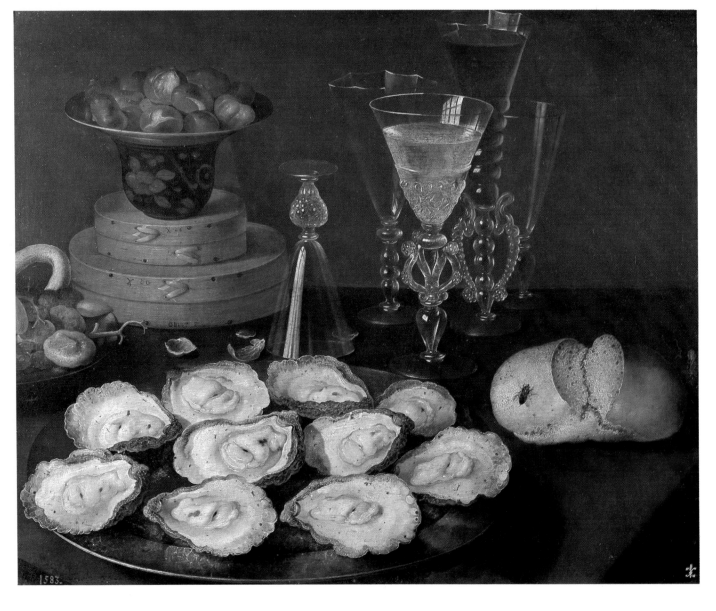

215 Osias Beert, *Breakfast with Oysters and Wine*. Oil on panel, 43 × 54 cm (16⅞ × 21¼ in). Madrid, Museo del Prado

216 Ambrosius
Bosschaert, *Bouquet of
Flowers with Shells and
Insects in a Window
Niche Giving on a
Landscape.* c. 1619. Oil
on panel, 63.5 × 46 cm
(25 × 18⅛ in). The
Hague, Mauritshuis

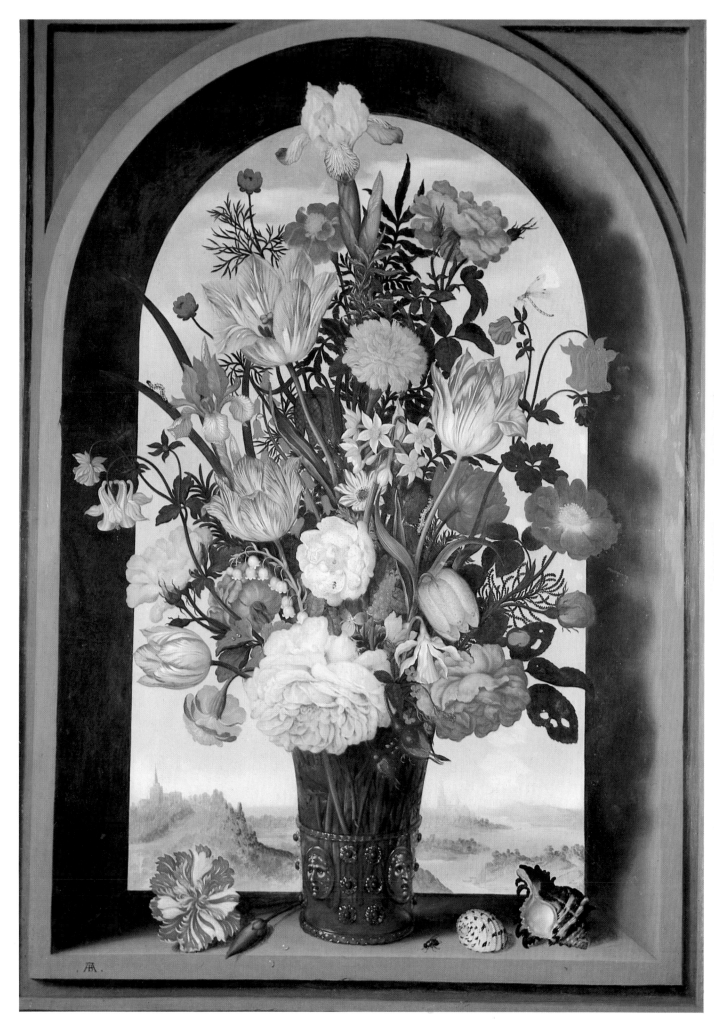

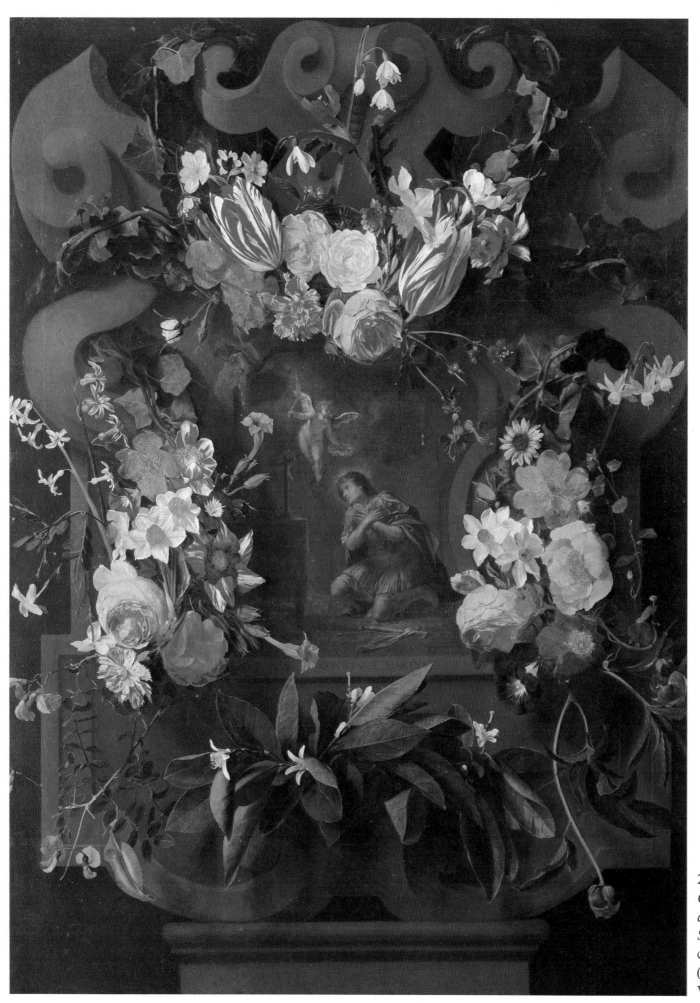

217 Daniel Seghers, *Cartouche with Flowers around an Image of Saint Goswin.* Oil on canvas, 95 × 68 cm (37⅜ × 26¾ in). The Vatican, Picture Gallery

took no end of thought and trouble to contrive a beautiful arrangement. Unpretentious objects on tables or in niches become touched with magic through the painter's treatment and devoted attention. A caterpillar can be painted with passion, a drop of water with the most scrupulous exactitude, a fallen leaf with sensitive delicacy. And in examples from the final stage of development of this special art (224, 225) one finds a technical perfection and virtuosity that could have gone no further. Jan Huysum typifies that end point, working with a hand lens and exploiting every possibility of oil painting with utmost refinement: Nature is imitated to perfection — and beyond. It is not unusual to hear someone ask, in a museum, if the insects on the leaves or the drops of water are real or "only" painted.

But why did artists lavish such zeal and effort on still lifes in particular? Out of pleasure in the tiny things of life? Because of the newly discovered plants, stones, and shells from exotic places? Because deeply meaningful allusions could be concealed in images that to the eye seem insignificant? Out of nostalgia and decadence? In each of those questions lies a bit of an answer, yet there can be no single explanation for any or all of it.

One can detect quite early beginnings for the still life. We have seen that the origins of other types of painting such as genre and landscape could be traced back to the early fifteenth century, and for the still life too we can look to Jan van Eyck, Rogier van der Weyden, Petrus Christus, and the others. In his Arnolfini marriage portrait (11) Van Eyck obviously took special delight in details already much like still lifes, and we have seen that, with masters of his time,

218 Jan Jansz. van de Velde, *Unfinished Breakfast with Oysters and Pipes*. 1651. Oil on canvas, 69 × 89.5 cm (27⅛ × 35¼ in). Amsterdam, Rijksmuseum

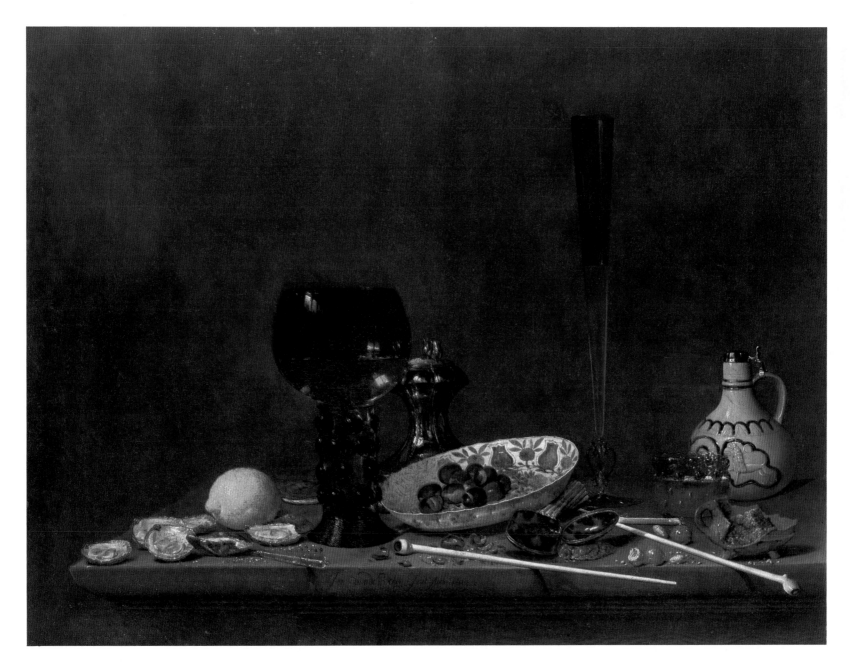

there is nothing casual about the objects selected, that they are rich in ingenious allusions. In his Ghent altarpiece (7) the carefully placed plants have been interpreted (by Behling) as referring to both health and salvation. Without wishing to claim that a development involves merely exploitation of something already existing, or that the origins of still life followed a single narrow path (there were inspirations from abroad we cannot go into here), in this field connections certainly existed between the fifteenth and seventeenth centuries. One of those, in the sixteenth century, was provided by Pieter Aertsen. In a religious picture painted in 1552 (79) he reversed the traditional hierarchy: the biblical scene with Christ in the house of Mary and Martha takes up only part of the background, while the entire foreground is dominated by a compact still life. But any facile conclusion that with Aertsen the profane still life has pushed aside the theme of Christian salvation is simply unjustified. If nothing else, the inscription over the fireplace — "Mary hath chosen that good part" — transforms the realistically depicted everyday objects into part of the Christian message and therefore no mere superficial embellishment. What is more, the objects themselves have double meanings that point beyond their factual reality to assert both the value of human life and the vanity of all things earthly.

But what matters in our context is that the picture is undeniably a step toward the still life in and for itself which began to be practiced toward the close of the sixteenth century in Antwerp by such Flemish artists associated with Rubens as Frans Snyders and Jan Bruegel the Elder (132, 136, 137) as well as Osias Beert, Ambrosius Bosschaert, and Daniel Seghers (215-217). But those were men of the seventeenth century, and by their time the Dutch too were taking to

219 Willem Claesz. Heda, *Unfinished Breakfast with Blackberry Pie*. 1633. Oil on panel, 58.5 × 79 cm (23 × 31⅛ in). Haarlem, Frans Hals-Museum

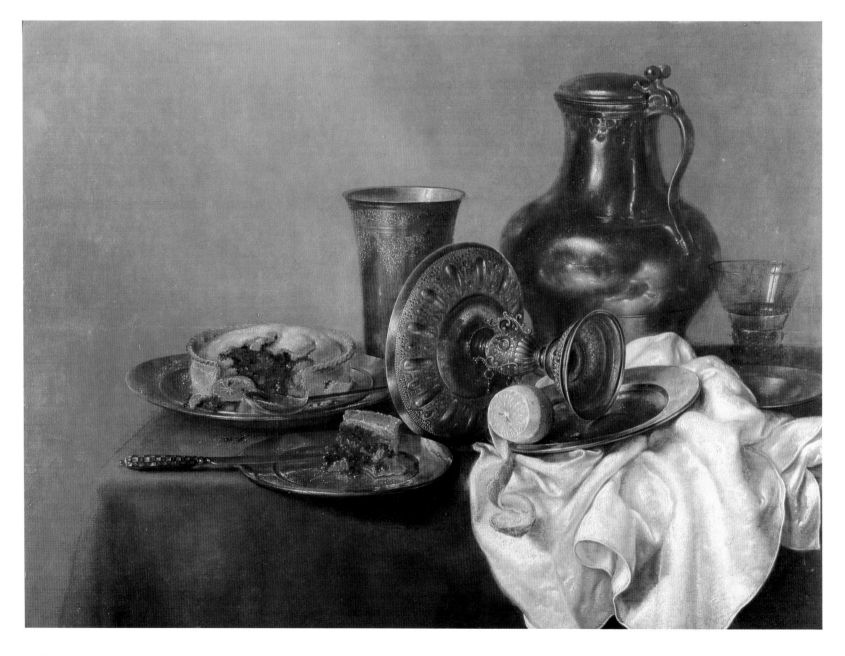

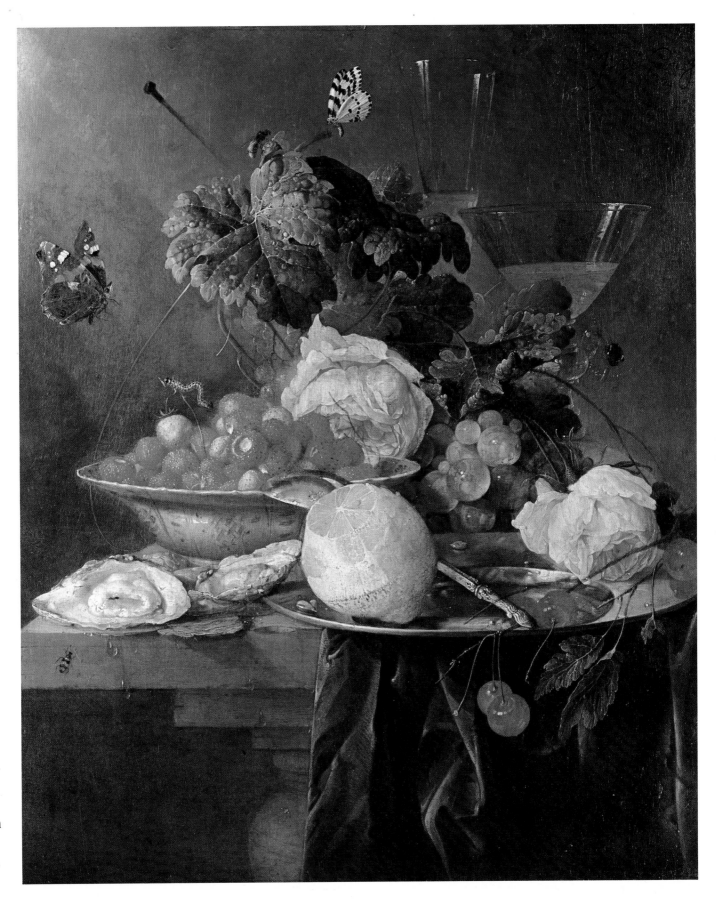

220 Jan de Heem, *Unfinished Breakfast with Oysters, Roses, and Butterflies*. 1652. Oil on panel, 41.6 × 35.6 cm (16⅜ × 14 in). Prague, Národní Galerie

still life, often under Flemish influence. Bosschaert for one had quit Antwerp for Middelburg for religious reasons by the age of twenty and would leave his mark on Dutch painting. In his case one may well doubt that his flower still life in a window niche with a landscape vista (216) was painted only out of botanical interest and with no symbolic intent. True, the sudden appearance and importation of new flowers like the crown imperial (fritillary) from Afghanistan, the tulip from Turkey, and the nasturtium from Peru, along with the

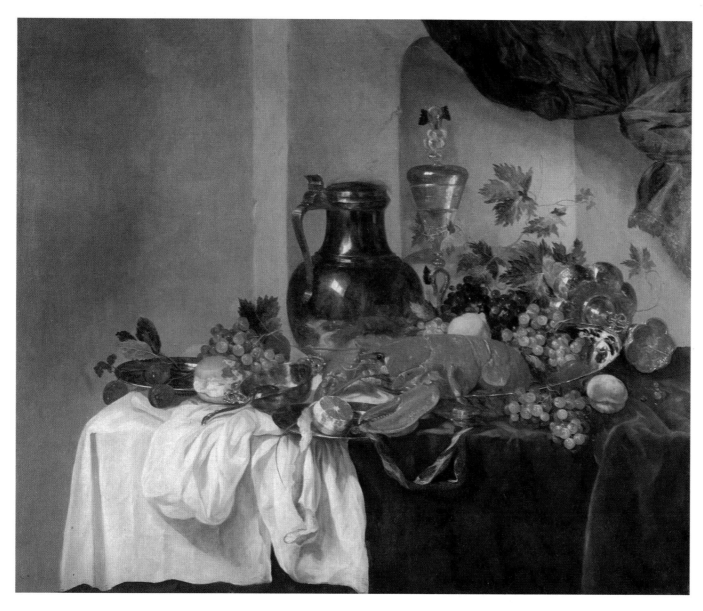

221 Abraham van Beyeren, *Banquet Still Life with Lobster, Fruit, and Wine.* 105 × 130 cm (41⅜ × 51⅛ in). Zurich, Kunsthaus, Ruzicka-Stiftung gift

cultivation, crossbreeding, and improvement of rare plants, did give a spur to collectors and to botanical studies as well. But this did not mean that the long-traditional symbolic associations attached to familiar flowers and accessory motifs were put out of mind. The carnation blossom on the windowsill in Bosschaert's painting reminds us that Christ took on human flesh (*carnatio*), while the empty shells and the fly maintaining a prudent distance speak of the transient beauties of this world. On the band around the vase two masks stare out at these thought-provoking signs.

It is hard to say to what extent if any Flemish and Dutch still life painters differed on religious grounds in their use of symbols. The religious dualism that went along with the political partitioning of the Netherlands led to no marked difference in Christian imagery. Yet, when one compares the breakfast, flower, and showpiece still lifes of Dutch painters like Willem Heda, Jan van de Velde, Jan de Heem, Abraham van Beyeren, and Willem Kalf (218-222) with those of the Flemish, it does seem advisable to interpret the underlying allusions on the basis of different intellectual and religious positions. But there was so much give-and-take across the border that the problem is far from simple. We have mentioned Bosschaert's move to Holland, but in another case, that of De Heem who was one of the finest Dutch masters in this specialty (220), the move took the opposite direction, from Leyden to Antwerp. Such cross-currents kept the traditional associations alive: the lily that refers to Mary or Christ, cherries that recall Paradise, walnuts whose interiors take the form of Christ's cross, caterpillars as metaphor for the soul because they give birth to butterflies, bread and wine in gleaming bowls and splendid goblets that bring to mind the sacrament of mass, and finally the four elements of fire, water, air, and earth as represented by a fuse, wine, pipe (or a

cloth drying in the air), and strawberries (in Germanic languages, "earth-berries"). Not that this very far from complete catalogue of symbolic meanings was—or is—meant to be applied, point for point, to every picture, but there is no doubt that such elaborate plays of image and thought took an important part.

In the course of the seventeenth century those significances nonetheless tended to become hackneyed and outmoded. Productions in series, patrons who wanted only "something splendid," and a new, more aristocratic taste for the sumptuous inevitably led to a more superficial art. The hunt still life was particularly apt for that changed world and the new tastes, and it developed into a much sought-after specialty (223).

Still lifes changed from sober arrangements to luxuriously bedecked tables offering a feast for palate and eye, from simple clear compositions to artfully complicated structures, from unobtrusive coloring to a sparkling, gleaming sumptuousness. One thing however remained more or less the same: the dogged, patient, all-consuming work involved—obsessional, surely—and the blazing enthusiasm that must have guided the artists' hand in "portraying" what were, after all, decorations. And when creative artists observed, rethought, and observed again, and with utter devotion and intensity, small wonder that they should penetrate ever more deeply into the look and nature of those everyday objects and bring out hidden qualities, small wonder too that they should light upon unsuspected aspects in the things observed and win to new inspirations. As for us, the viewers, the more we live with still life painting the more it reveals.

222 Willem Kalf, *Still Life with Nautilus Goblet and Chinese Porcelain Bowl*. 1660. Oil on canvas, 79 × 67 cm (31⅛ × 26⅜ in). Castagnola, Villa Favorita, Thyssen-Bornemisza Collection

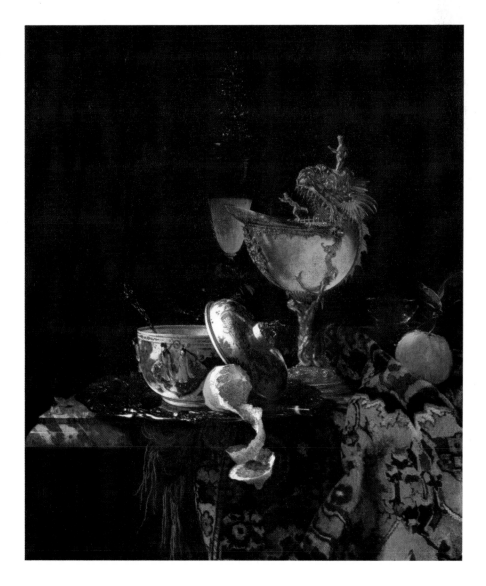

223 Jan Weenix, *Dead Game with Hunting Gear.* 1697. Oil on canvas, 114.5 × 69 cm (45⅛ × 27⅛ in). Amsterdam, Rijksmuseum

224 Jan van Huysum, *Flowers in a Vase.* 1726. Oil on panel, 80 × 60 cm (31½ × 23⅝ in). London, Wallace Collection

225 Jan van Huysum, *Hollyhocks and other Flowers in a Vase.* c. 1710. Oil on canvas, 62.1 × 52.3 cm (24½ × 20½ in). London, National Gallery

Brief Lives of the Most Eminent Netherlandish Painters

These condensed biographies are intended only to provide the reader with the main facts of the artists' lives. That task is more difficult than might appear. Sources differ, sometimes more even than interpretations. If there are discrepancies between this appendix and the main body of this book, it is because the compilers of this section have worked from other sources and in some instances have interpreted the information differently. For this English-language edition a number of the biographies have been extensively revised by Ronald Forsyth Millen.

Aertsen, Pieter, born c. 1508/09 in Amsterdam, buried there 3 June 1575. Very little is known of Aertsen's life, but is is likely that he studied with Allaert Claesz. In 1535 he was admitted into the Antwerp painters' guild. Although prosperous and successful in Antwerp, in 1555/56 he returned to Amsterdam and applied for reinstatement as citizen. In Flanders he had produced large altarpieces in a heroic style rivaling that of the Romanist Frans Floris, but few of these survived destruction by the Reformist iconoclasts. Some writers have suggested that their loss may explain Aertsen's turn to peasant genre scenes and especially kitchen or market pictures that, not infrequently, have the foreground filled with heaps of food and other objects while some biblical episode, of the greatest gravity, is tucked away inconspicuously in the background, so that still life and narration complement each other and bring to the picture a special, usually moral significance. Aertsen's subtle skill in infusing everyday things and scenes with deeper meaning was given a somewhat coarser turn in the paintings of his pupil and nephew by marriage, Joachim Beuckelaer (c. 1530-c. 1573), but Aertsen himself can be credited with setting the way for the seventeenth- century approach to genre and still life which would rarely be without some moralizing implication. Plates 77, 78, 79.

Anthonisz., Cornelis, born c. 1499 in Amsterdam, died there in 1556. A painter, woodcarver, engraver, and map maker, his fame rests chiefly on a group portrait of the civic guard he painted in 1533, one of the first such pictures in Holland with middle-class sitters. Important also are his city views using a bird's eye perspective. In the service of Charles V as cartographer, he went with the imperial armies to Algiers in 1541 and also took part in 1553 in their siege of Thérouanne in northwestern France. In that capacity he also mapped the North Sea and the Baltic with all their coastal regions. Plate 86.

Arentsz., Arent, called Cabel, born 1585/6 in Amsterdam, died there in 1635. Arentsz. painted genre pictures, winter landscapes with skaters and sleigh riders, and hunting and fishing scenes. Plate 164.

Avercamp, Hendrick, born 27 January 1585 in Amsterdam, died 15 May 1634 in Kampen. A deaf mute (often called "the Mute of Kampen"), Avercamp was somewhat influenced by Jan Bruegel the Elder but soon came to stand on his own. Painting chiefly winter landscapes, his stylistic orientation unlike that of the Flemish tradition was quite realistic, depicting familiar surroundings (though freely varied) rather than the traditional type of vast world-landscape. He also did marine views. Arent Arentsz. was influenced by Avercamp who, for all his Flemish prototypes, is nonetheless in the mainstream of Dutch painting. Plate 161.

Backhuysen, Ludolf (also Bakhuysen, Bakhuizen), born 18 December 1631 in Emden, died 17 November 1708 in Amsterdam. He came to Amsterdam as a merchant's clerk (with, it seems, an after-hours sideline of teaching fine penmanship). He went on to study painting and drawing with Allaert van Everdingen and Hendrik Dubbels (1621?-1676?) and soon won fame for his marine pictures. When the prime masters in that specialty, the Van de Veldes father and son, moved to England, Backhuysen succeeded to their fame and clientele. He painted mainly stormy or choppy seas in a denser color, tone, and brushwork than used by the

young Van de Velde, but also produced harbor scenes and winter landscapes dramatically exploiting silhouette and light. Like most marine painters, he allowed more importance to topographical accuracy than did the contemporary *terra firma* painters in their landscapes and city views. Plate 182.

Beert, Osias, born c. 1580 in Antwerp, died there in or before 1624. He entered the Antwerp guild in 1602 after a six-year apprenticeship. Along with the Antwerpers Clara Peeters (c. 1595-after 1657) and Jacob van Es (c. 1596-1666) and the Haarlemer Joris van Schooten (c. 1590-c. 1655), Beert belonged to the first generation of Netherlandish still-life painters who specialized in sumptuous displays of rare fruits, fancy biscuits, and wine in Oriental porcelain dishes, embossed gold goblets, and delicate glassware, laid out not with the highly contrived seeming disorder characteristic of later still lifes but in stately rows on white or damask cloths against plain dark backgrounds. Plate 215.

Berchem, Nicolaes (Claes) Pietersz., baptized 1 October 1620 in Haarlem, died 18 February 1683 in Amsterdam. His father, the still life painter Pieter Claesz., trained him; in 1642 he was admitted to the Haarlem guild; in the same year he may have gone to Italy with his cousin Jan Baptist Weenix, but if he did, he was back in Haarlem by 1646. More inconclusive are reports of subsequent visits to Italy in 1653 and 1656. Whatever the case, many motifs in his scenes of the Roman Campagna could have been borrowed from sketches by his cousin and others who are known to have made the Italian journey. And whether or not he saw that land with his own eyes, he has his firm place among the second generation of Italianizing Dutch landscapists, alongside J. B. Weenix, Jan Both (c. 1613-1652), Jan Asselijn (1610-1652), and Karel Dujardin (1622-1678). Of special note with Berchem is the dramatic flair and brilliant clarity of light and tone that he brought to views of Roman ruins or striking rock formations towering above picturesque and somewhat arcadian peasants and their herds. He produced also a few religious and mythological pictures in a rather more classicizing manner. Plate 189.

Beyeren, Abraham Hendricksz. van, born c. 1620/21 in The Hague, died in 1690 in Overschie. In 1639 he was living in Leyden, but in the following year he joined the guild in The Hague. Through his second marriage he became the brother-in-law of the fish painter Pieter de Putter, apparently also his teacher. Still in The Hague in 1656, the next year he enrolled in the guild in Delft; 1663 found him back in The Hague, 1671 in Amsterdam, 1674 in Alkmaar; 1678 in Overschie. He specialized in still lifes of fish and crustaceans as well as banquet displays with ornately arranged seafood, flowers, and fruit set among rich draperies, fine glassware, and costly tableware, painted freely but finely and sometimes in rich colors but more often in pallid off-tones of clashing hues. In addition, around a dozen sea pieces by him are known. Plate 221.

Bloemaert, Abraham, born 25 December 1564 in Gorinchem, died 27 January 1651 in Utrecht. Son of the sculptor and later Amsterdam city architect Cornelis Bloemaert, this painter and engraver learned the rudiments of drawing from his father and later studied with Joos de Beer in Utrecht. Around 1580 he was in Paris studying with Jean Bassot and the Fleming Hieronymus Francken. The style of his religious and mythological narrative pictures was further indebted to Anthonie Blocklandt as well as Frans Floris. It is a style distinguished by glowing, gleaming coloring and broadly drawn and unusually elegant figures. Together with, and before, Joachim Wtewael, he was the chief exponent of the so-called Utrecht school of Late Mannerism. He played a key role in founding the Utrecht St. Luke's Guild whose head he became. Among his pupils were Jan Both, Jacob Cuyp, and Jan Weenix. His subjects were mostly drawn from biblical sources and mythology. From 1620, he assimilated influences of the Utrecht Caravaggists (his former pupils) but later developed a bucolic style that has been called pre-Rococo. Plate 102.

Bol, Ferdinand, baptized 24 June 1616 in Dordrecht, died 24 July 1680 in Amsterdam. This painter, etcher, and draftsman was greatly influenced by his teacher Rembrandt. In 1652 Bol acquired burghership in Amsterdam, where he had been living since the 1630s, and he married there the following year. He became a much respected and well paid painter, particularly in demand for portraits. However, he also produced a number of subject pictures on religious and historical themes. His best work was done between 1650 and 1660. After 1669 and his second marriage, this time to a wealthy widow, he seems to have painted little. Plate 193.

Bosch, Hieronymus, born around 1450 in 's Hertogenbosch, buried there 9 August 1516. Born Jeroen van Aken, he was son and grandson of local painters. The earliest document mentioning him, from 1480 or 1481, refers to him as painter, and he is likely to have held

master's status for some time by then. The first reference to his marriage likewise comes from those years. The son of artisans, Bosch married a woman of some wealth, the daughter of a minor nobleman. His social position in the town improved, and in 1486 he could join the lay Confraternity of Our Lady attached to the cathedral and would soon accede to the status of a "notable" among its members. The brotherhood, a charity organization, was also responsible for arranging processions and performances of mystery plays and its members must have been pleased to have in their ranks such an inventive talent, and by all evidence his art was not unaffected by those theatrical experiences. Whether, as has been argued, Bosch was also associated with the pious mystical Brethren and Sisters of the Free Spirit must remain moot. If he did, and there is no concrete evidence for it, the art historian's task would be infinitely easier, since the unorthodox ideas and ideals preached and practiced by those coteries would do much to explain the hopelessly unorthodox imagery in the pictures by this solid, respectable, highly respected citizen of a provincial Netherlandish town. The rest of his history is uneventful. It consists of little more than records of donations to the cathedral or confraternity, expert opinions on church decorations, and an occasional commission from such high authorities as Duke Philip the Fair of Burgundy and the Netherlandish regent Margaret of Austria. And if there had been so much as a smell of heresy, the Confraternity of Our Lady would not have held a solemn burial sevice in their chapel in the cathedral for "our late brother Jeroen van Aken, known as Bosch, the illustrious painter."

Interpretations of Bosch's paintings exclusively in terms of an heretical sect would not, in any case, really cover all their intellectual content. His central theme was, in the deepest sense, religious: hell on earth. Many of his pictures show a demoniac world in which the abnormal has become the norm. In extraordinary interlinkages the things of this world grow into each other, pupate in hollow bleached-out forms, give birth to chimaeric creatures, are forever in metamorphosis.

The esoteric intentions in Bosch's works will doubtless never all be decoded. Recently scholars have proposed yet another source in literary works of the time (some by coincidence directly connected with 's Hertogenbosch as the place of their printing) and there are also sermons of certain fire-breathing Dominicans that are full of just such ghastly images. It was a time of world unrest and change when men knew that witches and – even worse – Reformist heretics walked the earth. Alchemists were speaking and writing with images startlingly like certain of Bosch's inventions, and this was the age of the great magi, the philosopher-magician-physicians who were spreading scientific knowledge in a hermetic language – the only safe one – which was clear to initiates only. But whatever the source of Bosch's thoroughly believable incredible monsters, as pure painting his art left a lasting impact on both landscape and caricature for centuries, certainly well into ours: the Surrealists hailed him as their great predecessor in doing away with all and every rational connection between effect and cause. Plates 47-49, 50, 50a, 51, 52-54, 55, 56, 57.

Bosschaert the Elder, Ambrosius, baptized 18 November 1573 in Antwerp, died 1621 in The Hague. As a boy he moved with his family to Middelburg, then a city second in importance only to Amsterdam. He joined the guild there in 1593, having probably learned his art from his father. Restless and somewhat inclined to start or invite quarrels with clients or guilds, he lived at one time or another in Bergen-op-Zoom, Utrecht, and Breda. He died in The Hague, en route to deliver to the wine steward of Prince Maurits of Nassau a flower piece for which he was demanding the royal sum of 1,000 florins. Bosschaert was one of the first to specialize in painting flowers and fruit and, himself a member of a dynasty of painters, he was followed by sons and grandsons and many others, most notably his brother-in-law Balthasar van der Ast (1593/94-1657), who perpetuated his decorative approach. His small flower pieces, often on copper, are composed symmetrically. Almost every blossom is complete and fully visible, and the bouquet is set against an open sky and is usually surmounted by a single rare or often symbolic bloom, a device much used also by such contemporaries as Jan Bruegel, Roelant Savery, and Jacques Gheyn (1565-1629) who likewise put together flowers that could not, even under artificial conditions, blossom at the same time. In this, Bosschaert and his generation set the pattern for all future Dutch practitioners of a specialty whose works have more to do with artifice than nature, with ingenious allegory rather than unstudied naturalness. Plate 216.

Bouts, Dirk, born between 1410 and 1420 in Haarlem, died on 6 May 1475 in Louvain, where he had lived from at least 1457. Continuing the art of the Van Eyck brothers and Rogier van der Weyden, his closest stylistic relationship was however with Petrus Christus, to whom, in fact, his works were long attributed and whose pupil he may have been. In the course of his development, he nonetheless moved more and more into the world of Van den Weyden. Characteristic of

his historical stylistic position and artistic individuality is a portrait of a young man dated 1462 (London, National Gallery) which already has a good measure of mood and feeling. While all the half-length Madonnas of Bouts and his school derive from prototypes by Rogier, in their rich depictions of interiors and landscape vistas works like his *Virgin and Child* (London, National Gallery) show the new feeling for atmospheric mood. The chief traits and real individuality of his style are evident in the major works of his maturity such as the *Martyrdom of Saint Erasmus* from around 1468 or the large polyptych of the *Last Supper* of 1464-67 (both Louvain, Sint Pieter). Serenity and the absence of all drama characterize his figurative world, nowhere more so than in the late panels on the theme of Justice commissioned by the city of Louvain in 1468 and completed some two years later (Brussels, Musées Royaux des Beaux-Arts). Plates 28, 29.

Broederlam, Melchior, documented between 1381 and 1409 in Ypres, West Flanders. Active in the earliest years of the so-called International Gothic Style of around 1400, Broederlam worked at the court of Philip the Good of Burgundy. The only surviving work known to be from his hand and firmly authenticated comprises two wings of an altarpiece he painted in Ypres between 1394 and 1399 for the Carthusian monastery church of Champmol near Dijon, where it was installed the latter year. Related in composition and iconography to contemporary manuscript miniatures, and to some extent still indebted to the Sienese painters of the Trecento, certain aspects of Broederlam's work nonetheless prepared the way for Jan van Eyck. In these panels, a landscape that so fills the surface as to compress the gold background to a narrow strip is combined with a baldaquin-like architecture in such a way as to create some indication of space and depth. Plate 1.

Brouwer, Adriaen, born around 1605/06 in Oudenaarde, Flanders, buried 1 February 1638 in Antwerp. Brouwer's unstable life early gave rise to more or less unreliable biographical accounts and anecdotes. His first teacher was probably his father, who did designs for the local tapestry manufactory, but his real training must have come from some Flemish master, and even before moving to Amsterdam. At sixteen, after his father's death, he went to Holland, though just where is not known. In 1625-26 he was in Haarlem and Amsterdam and appears to have met Frans Hals, though that encounter does not seem to have been decisive, as is sometimes said, since his early works remained distinctly Flemish and by no means in the Hals manner. His first known paintings, presumably produced in Holland, were naturalistic peasant scenes in an almost wild manner and with an overtly provocative crudeness. Around 1631 he returned to Flanders, to Antwerp where he was admitted to the guild with master's status and where, apparently, he settled down to work seriously, even acquiring a pupil and helper, Jean Baptiste d'Andois. So much for good intentions: in 1633, despite his growing reputation, his finances were so bad that one of his debtors foreclosed and he was taken off to prison in the citadel. There he whiled away his time by giving lessons to a baker who was to become the noted genre painter Joos van Craesbeeck (1605-1654/61). In debt all of his life, Brouwer was the very model of the bohemian artist. He received poor returns for his work, squandered whatever he earned, was often compelled to sell pictures by weight in order to get ready cash. He lived miserably, died young and a pauper, was buried in a common grave. Sandrart, however, reports that his remains were eventually given decent burial by a group of gentlemen-connoisseurs who appreciated his work posthumously. For all his disorderly life, Brouwer was nonetheless a man of culture, as attested by his membership in the literary academies of both Haarlem and Antwerp.

Given the biographical record of a dissolute life, with Brouwer it is difficult to distinguish the man from the subjects he painted. Yet the way he painted them gets closer to the truth. There is a sensitive variety in his use of paint, a haunting play of gradations within an overall ocher or grayish- brown tonality, a delicate, diffuse light that picks out unexpected patches of the picture to give them a life of their own, and an underlying beautifully constructed geometrical composition that brings balance and artistic control to what, viewed only as subject matter, looks riotous and crude. Toward the end of his brief life there were a few portraits but also landscapes that, in their very personal dreamlike poetry and sensitive execution, are virtually unique in Flemish art and a match for the finest in Holland.

There is evidence of Brouwer's influence, direct or indirect, in the work of Adriaen van Ostade, David Teniers, Craesbeeck, Jan Lievens, and Jan Miense Molenaer. Rubens and Rembrandt admired and collected his pictures. Significantly, with the advent of Impressionism in the latter nineteenth century the work of this highly refined painter of unrefined subjects came to be viewed with new respect. Plates 138, 139.

Bruegel the Elder, Jan (also Brueghel; called "Velvet"

or "Flower" Bruegel), born 1568 in Brussels, died 12 January 1625 in Antwerp. The second son of Pieter Bruegel the Elder, orphaned in the first year of his life, had his first lessons in painting from his grandmother, who was a miniaturist, and his later teachers are thought to have been Pieter Goetkind and Gillis van Coninxloo. The crucial years in his development, however, were 1590 to 1569 when he lived in Italy, came to know the art of the Renaissance and Mannerist artists, became acquainted with ecclesiastical and aristocratic society and was friend and companion of Cardinal Federico Borromeo. After returning to Antwerp, he joined the guild there in 1597, and in 1609 was named court painter to Archduke Albert of Austria, regent of the Netherlands in Brussels. He died of cholera in 1625.

Bruegel's art was drawn essentially from two sources. To his training in miniature painting he owed his skill in the new genre of minutely and splendidly executed flower still lifes, but he also took up many themes used by his father, notably landscapes with historical and biblical episodes or peasant scenes in country settings. The latter notwithstanding, nothing of the father's moralizing approach carried over to the son's works, which were fully in accord with the aesthetic requirements of his princely and wealthy bourgeois clients.

The flower pieces he painted in his last two decades are distinguished by great clarity and precision, and he served other painters by doing garlands, animals, and even entire landscapes for their pictures, so that a work like the *Paradise* (The Hague, Mauritshuis) was truly a collaboration between Bruegel and his close friend Rubens. From his two marriages came sons, Jan the Younger and Ambrosius, who followed his trade without however attaining his excellence. Plates 95, 136, 137.

Bruegel the Elder, Pieter (also Brueghel; called "Peasant Bruegel"), born between 1525 and 1530 in the village of Brueghel near Breda, died 5 September 1569 in Brussels. Although his numerous signed and dated works give us a good idea of the development of his art, which comprised a large body of not only paintings but also drawings and engravings after his drawings, as concerns his life we have only a few documents and contemporary sources to go on. Even the year of his birth is merely deduced from that of his entry into the Antwerp guild (1551). As a fully trained master he visited Italy during a year or two beginning in 1552, an experience that left its mark on his work. After returning north he was employed by Hieronymus Cock to supply him, Philips Galle, and Pieter van der Heyden

with drawings for their engravings. It was then that he came into contact with the humanistic circles of Antwerp, but not before 1558 did he become really active as a painter on his own. In 1563 he married the daughter of the Romanist painter Pieter Coecke van Aelst (1502-1550) and settled in Brussels, where he found an excellent clientele among merchants, humanists, and even such a potentate as Antoine Perrenot, Cardinal Granvelle, minister of state to Charles V. He died early, leaving two sons, Pieter the Younger (1564-1638), who spent his entire life imitating or copying the works of a father he knew only until the age of five, and Jan, who was an infant in 1569.

Bruegel's career began in 1555 with the publication of Cock's engraving series, the *Large Landscapes,* after drawings Bruegel had made in the Alps on his road to Italy. With two other series of engravings, the *Seven Virtues* of around 1557 and the *Seven Deadly Sins* of around 1558, his art expanded to include an iconography largely associated with Hieronymus Bosch and which still enjoyed some favor forty-odd years after that master's death. Thus it was with landscape and genre-like grotesqueries, two major aspects of the art of the time in the Low Countries, that Bruegel launched the process that was to occupy the rest of his career: the synthesis of traditional Netherlandish motifs from the popular iconography, naturalistic observation of peasant life, carefully observed and yet creatively reworked landscape, inventions of a fantasy rivaling that of Bosch, and an exceptional skill in conveying through images a moralizing and often deep-cutting satirical content as commentary on the happenings and attitudes of the world around him.

His works were already prized during his lifetime and attracted purchasers from abroad. In their message and the way it was conveyed, they were quite outside the mainstream of sixteenth-century art, in the Netherlands as elsewhere. Strikingly unusual means and devices were resorted to in order to stimulate the viewer's response to the intellectual, moral, or social content. The *Tower of Babel* represents perhaps the real keynote of his art: in this warning against human foolishness and vain pretensions, he set the theme for so much of the art that would follow in the Low Countries which over and over, whether through parable as in the case of Bruegel or through the less obvious associations in still lifes or genre scenes, would preach – in the earthiest and most physically concrete manner – the vanity of all things earthly.

In both the religious and profane fields Bruegel's art had a vast influence in Flanders and a wealth of followers. The peasant picture, which grew into an in-

dependent genre in the next century, can be considered his personal creation. And content aside, his independent and intrepid exploitation of the painter's means had a new appeal in our century, especially among the Expressionists. Plates 89, 90, 90a, 91, 92, 92a, 93, 94.

Buytewech, Willem Pietersz., born 1585 or 1591/92 in Rotterdam, died there on 23 September 1624. Little is known of the life of this painter, draftsman, and etcher, In 1612-13 he was living in Haarlem but by 1617 had returned to Rotterdam. He appears to have known Frans Hals and been much influenced by that artist's hearty approach to life and art and is himself often credited, along with Hals's younger brother Dirck, with initiating the special genre known as the "merry company," polite or riotous scenes of conviviality among the young gallants of the middle and officer classes and their ladies of the same, or no, class. Seemingly realistic, such pictures often have an allegorical or moralistic implication not too difficult to unravel. Numerous drawings from Buytewech's hand are known, as well as etchings. Plate 191.

Campin, Robert (identical with the Master of Flémalle, author of the Mérode altarpiece and that on the Betrothal of the Virgin), born around 1375 in Tournai (?), died there 26 April 1444. After a childhood and apprenticeship for which no documents survive, Campin is found in Tournai, where he is mentioned as master from 1406 forward. He became a burgher of that city in 1410 and remained there all his life, though he seems also to have worked for the court of Savoy. To judge by the works commissioned from him, he must have headed a large workshop, and his pupils included Jacques Daret and Rogier van der Weyden, the latter after 1427.

His major works include a *Nativity* from around 1425, which rounded off his early period (Dijon, Musée des Beaux-Arts), a triptych on the Burial of Christ from around 1425/30 identified only in 1942 (London, Collection Count Anton Seilern), and a fragment of an altarpiece from around 1430/32 with the *Bad Thief Gesinas on the Cross* (Frankfurt, Städelsches Kunstinstitut) of which an early copy reproduces the entire altarpiece (Liverpool, Walker Art Gallery). Three panels with *The Virgin and Child, Saint Veronica,* and *Holy Trinity* (all Frankfurt, Städelsches Kunstinstitut) belong to an altarpiece considered to come from the abbey at Flémalle near Liège. Campin painted portraits also, notably one of a stout man now identified as Robert de Masmines (Berlin-Dahlem, Gemäldegalerie). Influenced by both French and Netherlandish art, and in his late works by his two younger contemporaries Rogier van der Weyden and Jan van Eyck, Campin is considered one of the cofounders of early Nehterlandish painting. His paintings are distinguished above all for their marked plastic qualities, realism in details, and expansion of spatial depth, and can be interpreted as a new and more secular approach to Christian subject matter. Plates 15, 16.

Cappelle, Jan van de, born 25 January 1626 in Amsterdam, died there 26 December 1679. If not a pupil of Simon de Vlieger, Van de Cappelle was at least spurred to his own style through study of that marine painter's drawings of which he owned a good 1300 in the vast collection his wealth as head of a dye works permitted him to acquire. One of the chief masters of Dutch marine painting, he confined himself mostly to pictures of calm seas in morning or evening light, in which a cloud-swollen sky finds echo in a hazy sea filled with masts and sails casting translucent shadows. He also painted beach scenes and winter landscapes. Plate 180.

Christus, Petrus, born between 1415 and 1420 in Baerle (Brabant), died 1472/73 in Bruges. The most important painter in the wake of Jan van Eyck, he combined that artist's approach with stimuli from Rogier van der Weyden and Robert Campin. Surviving documents mention Christus as burgher of Bruges on 6 July 1444, with the qualification of master.

Christus simplified compositional schemes taken over from Van Eyck and clarified their spatial relationships. Among his major works are a portrait of a young woman (Berlin-Dahlen, Gemäldegalerie) and one from 1446 of Sir Edward Grymestone (London, National Gallery, on loan from the Earl of Verulam), and there are portraitlike features in another masterwork, the panel with Saint Eligius as goldsmith done in 1449 for the goldsmiths' guild. Plate 17.

Cleve, Joost van, born 1485 (?) in Cleves, Germany, or Antwerp, died in Antwerp in 1540/41. Made master in 1511 in Antwerp, he would seem to have been active also at one time in Bruges, to judge by the influence of Memling and David on his work. From 1530 to 1535 he was court painter in France where he was much affected by the ideas implanted there by Leonardo da Vinci and the early Florentine Mannerists. Subsequently he appears to have gone also to England where he portrayed Henry VIII. What is remarkable is his ability to graft such very different influences to a native stock comprising the lessons of the Bruges

painters of earlier generations, the Antwerp Mannerists of the start of the century with their odd Neo-Gothic ornateness, and the landscape art of Patinir. It is now fairly certain that he is the artist known as the Master of the Death of the Virgin (works in Cologne and Munich), whose art aroused such enthusiasm among the German Romantics of the early nineteenth century. Plate 83.

Coninxloo, Gillis van, born 24 January 1544 in Antwerp, buried 4 January 1607 in Amsterdam. From one history book and encyclopedia to another he is invariably proclaimed a pupil of Pieter Coecke van Aelst, but it seems to us that he would have had to be terrifyingly precocious to profit from the teaching of that master who died in 1550 and in Brussels, not Antwerp, where the painting dynasty of the Coninxloos was long established. Whoever taught him, he does seem to have made his way to France in 1565 and perhaps even to Italy. It was only in 1570 that he joined the Antwerp guild. Seventeen years later, because of religious persecution, he fled to Frankenthal in the Palatinate where there was already a colony of émigré Flemings whose artists, along with local Germans, constituted a school of landscape painting. Not until 1595 did he return to the Low Countries, to Protestant Amsterdam, where he exerted great influence on the subsequent development of the Dutch landscape art. Whether or not he did go to Italy, he seems to have had some acquaintance with the works or at any rate approach of certain Flemings established in the Veneto (Pauwel Franck known as Paolo Fiammingo and Lodewijck Toeput called Pozzoserrato) and of the Venetian Muziano, especially as regards the idealized landscape. Be that as it may, what he developed was something new, the forestscape composed of great wide-branching trees heavy with foliage making a screen pierced by tunnel-like openings that lead into the distant depths of space and the picture, toward a lighter and more open world. Besides these innovatory landscapes he produced at least one still life, probably after 1600, which ranks among the earliest examples of Netherlandish flower painting (Arnhem, Gemeentemuseum). Coninxloo's influence extended to Jan Bruegel the Elder, Roelant Savery, Gillis d'Hondecoeter, David Vinckbooms (1576-c. 1632), Kerstiaen de Keuninck (c. 1560-1623/25), and Alexander Keirinck (1600-1652). Plate 99.

Cornelisz., Cornelis ("Cornelis van Haarlem"), born 1562 in Haarlem, died there 11 November 1638. Pupil in Haarlem of Pieter Aertsen's son Pieter Pietersz. (1543-1603) and, in Antwerp, of Gillis Coignet

(c. 1538-1599), he also learned much from a visit to France as a youth of seventeen, at a time when the Mannerist art originating in Fontainebleau was full-blown. Under such influence, and that of Bartholomeus Spranger (1546-1611), the prime exponent of International Mannerism at the imperial courts of Vienna and Prague, he and Hendrik Goltzius (1558-1617) developed a local Haarlem Mannerist style characterized by large canvases on mythological or biblical themes which were used primarily as pretext for pictures bursting with muscular nudes of heroic proportions and with erotic connotations and an undercurrent of potential violence (a strangely pagan art for Calvinist Haarlem!). His later works were purified into a more luministic and harmonious classicism in line with the trend of those years in the Netherlands. Plates 101, 101a.

Cornelisz. van Oostsanen, Jacob (also Jacob Cornelisz. van Amsterdam), born before 1470 in Oostzaan near Amsterdam, died before 18 October 1533 in Amsterdam. He was probably trained in Haarlem, in the circle of Geertgen tot Sint Jans, and appears in Amsterdam after 1500 as an independent master. Characteristic of his portraits, votive panels, and altarpieces is the realistic rendering of an almost excessive number of details, the decorative sumptuousness of the heavy garments (as in the *Noli me tangere* of 1507 and the *All Saints* altarpiece of 1523, both in Kassel, Gemäldegalerie). Besides panel paintings, he did a great number of sketches for woodcuts. Plate 63.

Cuyp, Aelbert, born in October 1620 in Dordrecht, buried there 15 November 1691. A landscape, animal, and portrait painter as well as engraver, this most important member of a Dordrecht family of artists owed his training and earliest style to his father, the portraitist Jacob Gerritsz. (1594-1651/52), with whom he soon collaborated. His landscape style first came under the influence of Jan van Goyen, then changed radically under that of the first and second generations of Italianizing Utrechters, especially after Jan Both returned from Italy and introduced the idea of an all-permeating golden sunlight. Equeally at home with small and large formats, he favored scenes along the great rivers of southern Holland with their busy traffic. However, he also painted pasturelands with cattle and sheep silhouetted against the light, roadways with horsemen, and views of towns, particularly his native Dordrecht and the broad stretch of the Maas on which it lies. Grown wealthy and famous, he took an active part in public life as elder of the Calvinist church and

member of the high court of southern Holland, and after marrying a wealthy woman in 1658, he painted less. Cuyp's pictures were particularly influential during the next two centuries in England where they were used as models for painters like Richard Wilson, John Crome, and J.M.W. Turner. Plate 181.

David, Gerard, born c. 1460 in Oudewater near Gouda, died 13 August 1523 in Bruges where, in the wake of Memling, he had become the leading painter around the turn of the century and whence, through his pupils Joos van Cleve and Joachim Patinir, he exerted his influence on Antwerp as well. He must have settled in Bruges around 1484, the year in which he enrolled in the painters' guild there, which means his training would have been acquired in Holland.

Documentary sources show that between 1487 and 1498 he painted several panels for the Hall of the Magistrates in the Bruges Town Hall. The two that survive (in the museum there) are distinguished by a plastic treatment of solid figures modeled by light and shadow within a correctly constructed spatial perspective. Such scenes with numerous figures and clearly laid-out actions must have set new standards for realistic depiction in Bruges. The third picture to be uncontestably from David's hand is a *Madonna with Angels and Saints,* done in 1509 for the Carmelite nunnery of Sion in Bruges, whose sculptural, weighty figures cover the surface, right to the margins.

It is presumed that between 1511 and 1515 David visited Italy. His late style, from around 1515, the year of his admission into the Antwerp St. Luke's Guild, is characterized by lighter and more velvety colors, a softer treatment of drapery folds, and reduction of the composition to a dominant group of figures whose gestures already suggest something of Mannerist ostentation. Plate 45, 46.

Dou, Gerard (Gerrit), born 7 April 1613 in Leyden, buried there on 9 February 1675. He learned his art first from his father, a glass painter, then in 1628 began three years of study with Rembrandt. Beginning in 1632 he worked on his own in Leyden, and in 1648 became one of the first members of the painters' guild organized there. Although he never left his native town, he won considerable fame as both painter and teacher. At the outset his choice of subjects and his manner of painting were much indebted to Rembrandt, but around 1640 he took to doing masterly small genre scenes using fine brushes and often aiding himself with a hand glass. His influences on this sort of finely detailed painting continued in Leyden well into the eighteenth century. Plate 194.

Dyck, Anthonis van (Sir Anthony), born 22 March 1599 in Antwerp, died 9 December 1641 at Blackfriars, London. Van Dyck began his studies at the age of ten or eleven with Hendrik van Balen and remained with him at least four years. At sixteen he already had his own studio and even had pupils, and in another three years he could enroll in the St. Luke's Guild with master's rank. Sometime between 1616 and 1618 he joined the studio of Rubens. Less pupil than collaborator, the young man proved an invaluable aid in all sorts of tasks, even engraving his works for publication. Often Rubens had him paint the heads in his pictures, sometimes full figures, and Van Dyck was one of the team who worked at the decoration of the Antwerp church of Saint Charles Borromeo. So closely did master and assistant collaborate that the controversy still rages among scholars as to which, the mature artist or the precocious youth, deserves credit for the series of oil sketches done in 1618 and intended for tapestries on the history of the Roman consul Decius Mus, the first major effort in the Baroque to recreate the look of ancient Rome with archaeological exactness (Vaduz, Collection of the Reigning Prince of Liechtenstein). Foreign connoisseurs became interested in this bright new star, in 1620 he was invited to the court of James I and awarded an annual salary. Whatever the reason for curtailing his stay, he was back in Antwerp early in 1621.

By autumn of 1621 Van Dyck was ready to leave for Italy, to acquaint himself with the art of Genoa, Turin, Mantua, Padua, Venice, Bologna, Florence, Rome, and Palermo and, where possible, to make a name for himself. Requests for portraits were plentiful, but not for grander enterprises except for a single great altarpiece (Palermo, Congregazione della Madonna del Rosario). But young as he was, Van Dyck gave Italy as much as he took, perhaps even single-handedly setting the style of the Baroque portrait. There are questions, though. Why, at this crucial point in his career, having only just turned twenty, did the talented youth quit a prosperous center like Antwerp and look abroad for opportunities, first to England, then Italy? Mere restlessness? Or the realization that Rubens held Flanders in his grip and no young artist, whatever his genius, would be able to assert himself with a style of his own? The answer is uncertain, but he did choose to return home in 1627 only shortly before Rubens left for Spain. Now commissions poured in. In Italy Van Dyck had sloughed off the vestiges of Rubens' Baroque Classicism to arrive at something softer, richer, more painterly, which proved attractive to a patrician public. Three years later he was honored with the title of court painter to

another sovereign, Archduchess Isabella, the Spanish regent in Brussels, though he chose to remain in Antwerp, where he could work also for the court of Orange in Holland.

By 1632, however, Van Dyck again found himself under the shadow of Rubens. He decamped to England, where he was knighted and made painter-in-ordinary to Charles I. Initially he was limited almost entirely to portraying the royal family and household, but later became the virtual overlord of art in Britain (though scarcely with the dictatorial powers that were Rubens' wherever he held sway). Small satisfaction, though, to paint portrait after portrait, even if he did infuse them with all the talent he would have liked to deploy in grander works: every aristocratic capital in Europe was offering great projects to be done, and Van Dyck's former teacher was getting most of them. There was another try at a permanent position in his homeland. In 1634 he recrossed the Channel to portray the new regent, Archduke Ferdinand. Again there were commissions, from the nobility, churchmen, even wealthy burghers; even an occasion or so to do something grander and more challenging than those eternal likenesses. Antwerp lavished public honors on him, put him on a par with the great Rubens, even. And he could avail himself of the highly skilled Antwerp engravers and printers to bring out his *Iconography,* a portfolio of engravings by himself and others after his portraits of the most famous personalities of the time in government, learning, and the arts. But there was always the competition of Rubens, and Rubens had even latterly invaded Van Dyck's English fief to paint the ceiling of the royal banqueting hall in Whitehall. It was time to return. Waiting for him was a grandiose project to design tapestries on the history of the Order of the Garter to be hung on the walls of that same royal reception hall, an ensemble that would have got as much attention, more even, as the abstruse allegory Rubens painted on the ceiling. Nothing came of it. The expense would have been too great for even the King of England.

Van Dyck was to return to Flanders just once more, in 1640, after Rubens died. The British exchequer was in a bad way, even the King was having to cut back on his extravagances, civil war loomed. But Flanders had little for him, even Paris was reluctant to award him the task of decorating the grand gallery of the Louvre, and the man who had begun his career so brilliantly as virtually an infant prodigy was old and ill at forty. He returned to London despite the troubles and was buried there, the next year, in Old St. Paul's.

The mere facts of biography may make it appear that everything Van Dyck did was in reaction to Rubens as father figure, teacher, collaborator, rival. No so. From the start Van Dyck had his own idiom and an innate sensitivity that shrank from Rubens' virile excesses. The Italian years taught him a painterly *morbidezza* derived from what he saw of Correggio, the Baroque-Classical Bolognese Carracci and Guido Reni, the opulent Grand-Style Venetians like Titian and Veronese. His mature language is distinguished above all by a very fluid treatment of paint, a nervous brushwork, a highly painterly chiaroscuro. His figures, though satisfyingly three-dimensional, are classically idealized. His compositions, no matter what the format, are always large in conception and monumental. At the same time there is always a refinement that, with or without reason, we associate with the notion of "aristocratic," a refusal of the aggressively masculine thrust and slash and full-bodiedness of Rubens. This meant, in his religious paintings, a morbid sensitivity very unlike the writhing fleshy martyrdoms of a Rubens or a Jordaens; in his portraits, a respect for the sitters – even a certain disengagement – which makes them the veritable embodiment of distinction, elegance, and the aloofness appropriate to their high estate or income. There is also, it must be conceded, a certain lack of vitality. His religious paintings are contemplative, lyrical rather than dramatic. His mythological and literary pictures are sumptuous and yet somehow intimate. Though he may have aimed at something higher, his enduring influence was in the aristocratic portrait. What he did set the types and forms and painterly tone for subsequent portraiture in the Netherlands, Italy, France, and above all England from Sir Peter Lely (himself a transplanted Hollander) to the eighteenth-century constellation of Gainsborough, Reynolds, Raeburn, and Lawrence and, for better or worse, to the official royal portraits in Victoria's time and still in ours. Plates 130, 131.

Engebrechtsz. Cornelis (Engelbertsz., Engelbrechtsen, etc.), born 1468 in Leyden, died there in 1533. After an apprenticeship with Colijn de Coter in Brussels, this major representative of Netherlandish painting between the Late Gothic and the Renaissance founded a workshop in his native town, where he taught Aert Claesz. and Lucas van Leyden among others. His few surviving altarpieces reveal an increasing tendency to shake off the tradition of the waning Gothic and profit from newer Italian models. Particularly notable are two major triptychs, one from 1508 with donors and angels framing a Descent from the Cross, the other from around 1512 with a Crucifixion as main panel (both Leyden, Stedelijk Museum "De Lakenhal").

A few portraits also survive. His importance lies chiefly in the way he went beyond the Gothic rigidity of forms, in his more relaxed and at the same time more realistic conception of traditional pictorial themes, and in his creation of a new atmospheric feeling in background landscapes. In a sense it was his work that gave the incentive to a school of Leyden landscape painters. Plate 66.

Everdingen, Allaert Pietersz. van, baptized 18 June 1621 in Alkmaar, buried 8 November 1675 in Amsterdam. Everdingen was a landscape painter and engraver who studied with Roelant Savery and Pieter de Molijn. He joined the St. Luke's Guild in Haarlem in 1645, and from 1657 enjoyed citizen's rights in Amsterdam. In 1644 his travels through Sweden and Norway resulted in numerous drawings and paintings which introduced into Dutch painting for the first time such gloomy Nordic mountain motifs. Although he produced a few seascapes in the manner of the early gray-toned period, the main emphasis in his work is on landscapes with a dynamic conception of nature and the typical Dutch treatment of light with strong reflections, and one understands why Jacob van Ruisdael was much influenced by them. Everdingen also won fame as etcher of a series of 103 landscapes as well as illustrations to the *Reynard the Fox* by Hinrik van Alkmar (Paris, Musée du Louvre, Cabinet des Estampes). Plate 173.

Eyck, Hubert van, born around 1370 in Maaseyck near Maastricht (?), died on 18 September 1426 in Ghent. Because of the lack of documentary evidence, and because whatever Hubert may have painted was done in common with Jan van Eyck, it is virtually impossible to distinguish him from his more famous brother. An inscription on the Ghent altarpiece – practically our only source of information about Hubert – identifies it as the work of both of them, but since we know no single authenticated work by Hubert his share in that task can scarcely be determined. What seems most likely is that in 1420 he was awarded the commission for the polyptych and that after his death Jan, who does seem to have studied with him, completed the work.

Two isolated panel paintings have been attributed to Hubert – *The Three Marys at the Empty Grave of Christ* supposed to be from around 1420 (Rotterdam, Museum Boymans-van Beuningen) and an *Annunciation* of perhaps two years later (New York, Metropolitan Museum of Art, formerly Friedsam collection) – but the first of these was probably liberally reworked by Jan and the second is more often given to Jan himself or, by many scholars, to Petrus Christus. Plates 4, 8 (?).

Eyck, Jan van, born around 1390 in Maaseyck near Maastricht, buried 9 July 1441 in Bruges. Van Eyck probably began his career as a miniature painter, and the very beautiful Turin Book of Hours, of which a large part was tragically lost in a fire, is thought to show his hand. As early as 1415-17 he may have been in the service of Willem IV, Count of Holland, Zeeland, and Hainaut, and he is known to have served from 1422 to 1424 Willem's brother Johannes III, Duke of Lower Bavaria and Straubing and Count of Holland, whose residence in The Hague he decorated. A year later he joined Duke Philip the Good of Burgundy in Lille. Though officially the Duke's "painter and *valet de chambre*," Van Eyck had a second function (one which, curiously, other Netherlandish artists in the course of history would exercise, Rubens above all), that of royal emissary. On one of such missions, in Tournai in 1427, he may have had the opportunity to serve his own purposes and meet Robert Campin, Jacques Daret, and even the young Rogier van der Weyden. The next year he was attached to the embassy sent to Spain and Portugal, with at least one specific task, to portray the Portuguese king's daughter whom Philip was wooing. At that time Van Eyck traveled extensively in Spain, from Santiago de Compostela as far south as Moorish Granada, and he seems to have painted in Spain the *Stigmata of Saint Francis* (Philadelphia, Museum of Art, Johnson Collection) and perhaps even the original version of the *Fountain of Life* (Madrid, The Prado). One is tempted to speculate about what, and how much, the Flemish artist gleaned from th majestic Romanesque and Gothic art of the Iberian Peninsula.

In 1430 Van Eyck settled in Bruges, in 1432 bought a house there, though without severing his ties with the Burgundian court. What tempted him to leave active royal service was surely one of the largest commissions ever awarded in the Netherlands, the great polyptych of the *Adoration of the Mystic Lamb* for the cathedral in Ghent. No doubt the facts will never be known, but the altarpiece would appear to have been begun by Jan's semi-legendary brother and taken over by him when Hubert died in 1426, which means that the six years preceding its inauguration on 6 May 1432 were often interrupted by other tasks and travels. Secure in his career among the burghers of the Flemish cities as well as the aristocrats of the Burgundian court, Jan took a wife and in 1434 a first child was born and received the royal gift of six silver cups from its god-

father, Duke Philip. This was the year also of the marriage portrait for the Italian merchant Arnolfini.

The following year there was a crisis. Duke Philip wished to raise his painter's salary more than three and one-half times. The ducal treasurers rejected the order, the Duke personally pleaded with them, insisting that the painter's services were indispensable and that he had "great works" in mind for him to undertake. Meanwhile the city fathers of Bruges were having their distinguished fellow citizen apply polychrome decoration to statues by other artists. The next year Jan was off again on a secret mission to an unidentified "distant" place, but in that same year King René d'Anjou was Philip's prisoner in Lille, and it has been supposed that the painter-king, creator of a book of exquisite miniatures, the *Livre du Coeur d'Amour Epris,* may have learned from the painter in person the secrets of the new method of painting with oils. The painter's busy life ended in Bruges.

Although Giorgio Vasari, writing in the latter sixteenth century, ascribed the invention of oil painting to Jan van Eyck, Jan was certainly not the first to use an oil base with pigments. This had been done occasionally in the fourteenth century, but what Jan (or his contemporaries) devised was a new mixture of pigments with linseed, walnut, or other oils, probably a kind of oil tempera involving mixing water-diluted egg yolk with drying oil, thereby giving the opaque tempera colors a strong glow and a wealth of nuances.

Even if he had no immediate followers, Jan van Eyck ranks among the most important painters of all time. With him began a new way of seeing which, even very much later, would have momentous consequences, an approach not inferior in originality to that of the Italian Early Renaissance but only different, with its won values which are not to be judged by those of Italy. He went far beyond the practice of his time not only in the use of materials and mediums but in an unprecedented precision in rendering objects according to their real nature. His entire approach, aesthetic as wel as technical, was of an extraordinary modernity, and it extended also to a masterly further development of the possibilities of perspective and spatial treatment, again in a manner all his own which was a valid alternative to that being explored in Italy in his years. However great the merit of Robert Campin, there is a certain sense in the common notion of Jan van Eyck as founding father of Netherlandish painting. Plates 4, 5, 6, 7, 8, 9, 10, 11, 12.

Fabritius, Carel, baptized 27 February 1622 in Midden-Beemster, died 12 October 1654 in Delft. Fabritius and his brother Barent, his junior by two years, were first trained by their father, but at nineteen Fabritius went to Amsterdam, where until 1643 he remained an active member of Rembrandt's workshop and one of his most talented disciples. For long he kept to the way shown him by his teacher, though with enough originiality to develop a style of his own, differing from Rembrandt not only in subject matter but also in technique. His overall tone became lighter, his colors clearer, and where the teacher placed brightly illuminated figures against a dark background the pupil reversed that device. In the first half of 1650 Fabritius became a citizen of Delft and in October 1652 a member of its painters' guild. In 1654 he lost his life when the city powder magazine exploded. Three of his most important pictures date from the last year of his life: *The Linnet* (The Hague, Mauritshuis), *The Soldier of the Guard* (Schwerin, Staatliches Museum), and a *Self Portrait* (London, National Gallery). Among Delft painters it was Vermeer who reponded most to the influence of Fabritius. Plates 155, 156.

Flinck, Govaert, born 25 January 1615 in Cleves, died 2 February 1660 in Amsterdam. This Dutch history and portrait painter in the succession of Rembrandt had his first lessons in 1629 from Lambert Jacobsz. in Leeuwarden. By 1632 he was in Amsterdam where he began a three-year study period with Rembrandt, whose style he closely imitated in his early paintings. Later however he came much more under the influence of the Amsterdamer Bartholomeus van der Helst. Evidence of independent activity begins only with 1636 but then continues without interruption until 1659. In Amsterdam he was numbered among the most respected painters and produced a great many portraits of influential personalities of the city as well as three group portraits fo militia cmpanies. Plate 154.

Floris, Frans (Frans de Vriendt), born 1516/20 in Antwerp, died there 1 October 1570. Initially Floris worked with his brother, the architect Cornelis de Vriendt who later built the town hall in Antwerp, which set the style for Netherlandish architecture for decades to come. Then, from 1538 to 1540, he studied in Liège with Lambert Lombard, arch-Romanist and enthusiast for Raphael who had just returned from Italy. Floris became master in 1540 and about a year later went off to Rome, arriving in time for the unveiling of Michelangelo's Last Judgment in the Sistine Chapel, an event and revelation that, along with the discovery of Giulio Romano and, later, of Tintoretto, was to leave a permanent mark on his art. Returning to Antwerp in 1547, he promptly organized what was to become the most important local workshop.

The principal representative of the "grand style" in the Low Countries, Floris fused his electric Italianism, an awareness of Antiquity, and the Flemish popular tradition in pictures on historical, mythological, or biblical subjects painted predominantly in tones of grayish reds or cold greens. But there was another side to him, and he became a fine portraitist, working directly from life and with vivid realism. Floris had a lasting impact on many artists, most notably on the narrative painters Maerten de Vos (1532-1603), Hieronymus Francken (1540-1610, member of a major dynasty of Flemish artists), and Frans Pourbus the Elder (c. 1540-1581), whose skill in portraiture was capped by his like-named son (1569-1622), painter to the courts of Mantua and France. Plate 88.

Geertgen tot Sint Jans (Gerrit or Geertgen van Haarlem), born around 1460/65 in Leyden (?), died before 1495 in Haarlem. Through Geertgen, painting in the northern Netherlands first achieved equal rank with that of Flanders. He was a pupil of the Haarlem painter Aelbert van Ouwater, and during the most fruitful years of his activity as painter, up to his very premature death, he was a lay brother in the Johannite monastery in Haarlem.

Geertgen neither signed nor dated any picture. His earliest work is thought to be a *Madonna and Child* (Milan, Biblioteca Ambrosiana), a very small picture which obviously first served as book illustration but is important evidence of his artistic origins. It shows, and archive documents bear this out, that his first training was in Bruges, the center of Flemish manuscript illumination in his time, which explains also why his work shows influences from Jan van Eyck, Rogier van der Weyden, and Hugo van der Goes. What is held to be his earliest surviving panel painting, a *Holy Kinship in a Church,* must date from around 1480, and the strongest influence in it is from his Haarlem teacher. Though the use of color is more diversified, there is a Flemish attention to fine detail.

But Geertgen's real significance was first revealed in two panels from the former high altar in the Haarlem Johannite monastery, the *History of the Relics of Saint John the Baptist* and a *Lamentation over the Dead Christ* (both Vienna, Kunsthistorisches Museum). In these each group of figures is associated with a portion of landscape of appropriate shape and extent. Coloring is restricted to local colors, each closely tied to a particular figure or object, and this is so in the quite detailed landscape backgrounds as well. If the inner logic of Geertgen's development seems easy to follow up to these two panels, his late and last works bear the mark of something entirely exceptional

and difficult to account for. In the *John the Baptist in the Wilderness* the entire approach to depicting landscape follows a new law. Space is treated as a continuum in both form and color, and the muted tones and gentle curves of the hilly country with its blue distances harmonize in mood and feeling with the contemplative expression of the saint lost in thought.

In his *Nativity* (London, National Gallery) Geertgen created around 1490 one of the first true night pieces and the only one among his identifiable works. Unlike earlier attempts at the nocturnal, with Geertgen light and dark became at the same time key factors in his conception. For the first time in Western painting the Christ Child was portrayed in a symbolic transposition as Light of the World and therefore the source of light for the painting.

Reviewing the broad spectrum of expressive means exploited by Geertgen, as common traits there remain a new and intense observation of nature, a new close link between a traditional type of figure and a virtually homogeneous spatial landscape, and the first signs of a psychological approach to expression and to capturing mood and atmosphere.

As prototypes for Geertgen one can name his teacher Aelbert van Ouwater (himself of Flemish schooling), Jan van Eyck, Rogier van der Weyden, Petrus Christus, Dirk Bouts, and especially Hugo van der Goes. His works had their influence on Jan Mostaert and Jacob Cornelisz. van Oostsanen but on Albrecht Dürer as well. Art historians consider Geertgen a forerunner of the Netherlandish landscape art that would come to full flower in the seventeenth century. Plates 30, 31, 32.

Gelder, Aert (Arent) de, born 26 October 1645 in Dordrecht, buried there 28 August 1727. After initial training from Samuel van Hoogstraten, in 1661 De Gelder became a pupil of Rembrandt in Amsterdam and remained there to around 1667, when he returned to his native Dordrecht. Despite the predominant classicistic trend of the time, he remained faithful to Rembrandt's style even into the eighteenth century. Along with biblical scenes and a large series of episodes from the Passion, he produced a few portraits in a spontaneous technique that proved very effective in pinning down the chief traits of his sitters. Plate 157.

Goes, Hugo van der, born around 1440 in Ghent, died in 1482 in the Rode Klooster near Brussels. Along with the Van Eyck brothers, Robert Campin, and Rogier van der Weyden, one of the most important masters of Netherlandish painting in the fifteenth century.

Despite the high repute of Van der Goes in his time, the documentary sources for his biography are as meager as for other artists in that period. There is written evidence for something as spectacular as his last illness but almost nothing about his dates, birth, learning years, and major works. An approximate year of birth has been deduced from an entry of 5 May 1467 in the lists of the Ghent painters' guild. In a mere fifteen years – from 1466/67 to 1481/82 – he established his fame and produced a number of important works, though in 1475 he withdrew from the world and, as a *conversus* (a lay brother privileged with special liberties), entered the Rode Klooster, a monastery in the forest of Soignies near Brussels.

During his remaining years he showed a tendency to psychological depressions. One of the monks in his monastery made a written record of the course of his mental decline, from which it appears that it resulted not from any specific form of derangement but from an obsessional religious mania arising from anxiety over his spiritual salvation, something not too rare in the years before the Reformation.

None of his works are dated or signed, though thanks to the sources we know approximately the year of his major work, the Portinari altarpiece. As for influences on his early works, those from before 1475, the attempt has been made to decipher them through comparison with Van Eyck's Ghent altarpiece and the works of Rogier van der Weyden. To his early period has been assigned a diptych (Vienna, Kunsthistorisches Museum) in which the choice of themes – *The Fall of Man* and the *Lamentation over the Dead Christ* – brings original sin and redemption into iconological relationship. The effort to depict Adam and Eve true to life, with natural three-dimensionality and exact rendering of the nude, shows what an impression Van Eyck's Ghent altarpiece made on Hugo. To this same early phase belongs a triptych from the monastery of Monforte de Lemos in northern Spain whose central panel with the *Adoration of the Magi* survives (Berlin-Dahlem, Gemäldegalerie) but whose wings with a *Nativity* and a *Circumcision* are lost. Here for the first time one sees traits of the painter's mature style, with strongly individualized principal figures. While certain aspects of the Portinari altarpiece clearly point to a Renaissance approach, in both structure and content it remains essentially Late-Gothic. Traditional contrasting local coloring is still relied on to make the main figures stand out more prominently in both effect and importance, yet the introduction of intermediate and transitional tones such as brown and olive do lead to a new unity of mood and

expressiveness in the picture, and this was Hugo van der Goes's particular achievement.

His last phase appears in an *Adoration of the Shepherds* (Berlin-Dahlem, Gemäldegalerie) and a *Dormition of the Virgin* (Bruges, Groeningemuseum). These are considered as expressions of an irrationality doubtless rooted in the painter's depressive illness and thought to manifest itself in the dissonant coloring of the *Dormition* and the intense contrasts in light and shade of the *Adoration*, but above all in the ambiguity of treatment of space. In any event, the expressiveness of the figures too is much heightened.

However, studies of facial and physical types in Hugo's work have thrown into question all the traditional chronology: on this basis the paintings presumed to be among his last works must have been produced before the Portinari altarpiece, and many inconsistencies in the existing chronology (for example, the return to "normal" figures in the Bruges *Dormition*) could be cleared up – but only if one denies that his illness beginning around 1480 had any effect whatsoever on his work.

Hugo van der Goes utilized to the utmost the possibilities in style and content open to Netherlandish painters in the fifteenth century, and pushed that style to its farthest limits. His most significant and most personal means for setting before us episodes from the Christian epic consisted of transforming the Late-Gothic draped figures into personages involved in an action and much more vividly true to nature, or else into monumental images of sanctity. His influence was great and widespread: in the Netherlands on Geertgen tot Sint Jans, in Germany on Martin Schongauer and Albrecht Dürer, in Italy on Domenico Ghirlandaio. Plates 38, 39, 40, 41.

Gossaert, Jan (called Mabuse), born between 1478 and 1488 in Maubeuge, died 1532 in Breda. Gossaert was the first of the sixteenth-century Netherlandish Romanists whose art would prepare the way significantly for what would be done in Flemish painting in the next century. Nothing is known of his learning years, but he joined the St. Luke's Guild in Antwerp as a master in 1503. Five years later he journeyed to Italy in the retinue of Philip of Burgundy, Bishop of Utrecht, to draw for him the ancient monuments of Rome. After returning north he remained in Philip's service. After the death of his ecclesiastical patron, he worked for Adolph of Burgundy, Lord of Zeeland, in his castle at Middelburg beginning in 1525, and in his last year he served the Marchioness Mencia de Mendoza in Breda. Although Gossaert had been in Rome

as early as 1508, his early works are still very much in the fifteenth-century Netherlandish tradition.

In his *Saint Luke Painting the Madonna* of around 1515 (Prague, Národní Galerie) there is a spacious architectural setting of Northern Italian Renaissance type. From around that time this element, as well as mythological themes, began to play a more important role in his work. Certainly the aristocratic environment in which he lived and worked had much to do with his expressive means, which often tended to a certain modishness. His preference – or that of his patrons – went to a classicistic fully modeled treatment of the nude, though portraiture was not neglected. His influence persisted for long in the Netherlands, and Barend van Orley and Jan van Scorel, who were major representatives of the Romanists, can be considered his followers. Plates 71, 72.

Goyen, Jan van, born 13 January 1596 in Leyden, died 27 April 1656 in The Hague. His first training was at the age of ten, and his teachers were one after the other Coenraet Adriansz. van Schilperoort, Isaack Nicolai Swanenburgh, Jan Arentsz. de Man, and Willem Gerritsz. Around 1615 he undertook a study trip to France, and upon his return in 1616 he had some additional study with the landscape painter Esaias van de Velde in Haarlem. Two years later he was admitted into the Leyden guild as master. From 1631 he lived in The Hague but was constantly traveling about Holland, seeing to his usually disastrously unsuccessful business ventures. The genre painter Jan Steen was his pupil and son-in-law.

Van Goyen concentrated almost exclusively on landscape painting. Although his initial style was not unconnected with earlier Flemish traditions, he was at the same time under the influence of Esaias van de Velde, whence his partiality to an excess of colorful staffage figures. Gradually he developed a unifying tonal approach using brown, green, or gray with bleached-out local colors, less emphasis on the subject itself, and fewer figures. The atmospheric quality came to dominate over anything topographical in his landscapes, and from the 1630s the river landscape became one of his favorite themes. In his late works, he carried his unifying approach even further and again took to introducing accents of color.

In his own time Van Goyen's work was not much esteemed though it exerted much influence on other painters, but with the advent of Impressionism in the nineteenth century he was hailed as one of the most important Dutch landscape artists. Plate 171.

Hals, Frans, born between 1580 and 1585 probably in Antwerp, buried 1 September 1666 in Haarlem. Hals's farther was a cloth worker from Mechelen, and by the time the younger son Dirck was born in 1591 the family had settled in Haarlem, perhaps having quit Antwerp after the Spanish seized the sity in 1585. Frans studied only briefly with Carel van Mander (1548-1606), the Late Mannerist painter and Netherlandish pioneer in art-historical writing, likewise a Fleming settled in Holland. Those lessons ended in 1603 at the latest, and in 1610 Hals was admitted as an independent master into the Haarlem guild. His earliest dated painting – significantley, a portrait – is of the following year. In the year he achieved mastership he would seem to have married, but his young wife died in 1615 leaving two very young children. As an indication of the painter's success or lack of it at the time, it should be noted that she had to be given a pauper's burial. The next year the tide turned somewhat for Hals with the commission for the first of his group portraits of banqueting militia officers. He could even afford a few months in Antwerp, perhaps to scout out new opportunities. (It was the only time he would ever leave Haarlem.) In this same year he was accepted for membership in the Haarlem society of rhetoricians.

But there was also the first of innumerable legal squabbles over unpaid debts (this one for payment of pictures he had purchased that he obviously could not afford) and, more humiliating, a court action by the nurse of his two motherless children for back pay owed her. A few weeks later, one of the children died. Then another court case for support of the remaining child, and his own mother had to agree to take over the expense. In 1617 Hals married again, this time to an illiterate shrew who was forever brawling and who presented him, in time, with nine additional mouths to feed, four of whom would become painters of no particular note but, perhaps, helping hands for their harrassed father, another of whom was mentally retarded and had to be confined as a public peril, and at least one daugther who increased the burden with a fatherless child for her father support. That things could not have been hopeless appears from his joining the St. George Civic Militia in 1622, though not as an officer (officers had to have elegant uniforms and there were banquets to pay for and artists to be paid to paint them). Occasional major commissions came in for group portraits, for the St. Hadrian's Militia in 1626-27 and again in 1633, two more for the St. George's company in 1627 and 1639. There was even a commission from Amsterdam in 1633, to portray a local militia company for a fee not too much less than Rembrandt, at the height of his fame, would get for his famous example of that typically Dutch genre. Hals

began it, dawdled, and in 1636 was served with a court order to come immediately to Amsterdam and finish the work. In bed at the time with an inflamed leg, he had the effrontery to say that not only was he unwell but it would be too expensive for him to go to Amsterdam and portray each member separately and that, if they really wanted their painting, they could jolly well each of them come in person to Haarlem. The painting had to be finished in 1637 by Pieter Codde (Amsterdam, Rijksmuseum). Such public squabbles seemingly did not do too much harm to his local reputation. In 1641 the five worthy governors of St. Elizabeth's Hospital had him paint a group portrait, and there were still such celebrated applicants for solo likeness as the philosopher René Descartes. Still, in 1654 a baker could seize his household property, bed and all, and five paintings (among them a Carel van Mander and a Heemskerck) for non-payment of his bread bill (a debt amounting to 200 florins, and Hals was happy to make 66 for a group portrait). In his last years he was literally destitute and had to be given an annual subsidy of 200 florins plus three loads of peat. But he could keep his liberty and stay out of the old men's almshouse, which meant that he could paint his two final masterworks, the portraits of the gentlemen and the lady governors of that same institution. A troublesome citizen, but still respected enough to be given burial in the choir of the Grote Kerk, the principal church of Haarlem.

One of the most perceptive and insightful portraitists of all time, adept in catching both the inner spirit and outward appearance of fools and leading citizen alike, of gypsy girls and philosophers, of law-breakers and civic guardsmen, Hals's enduring merit lies in his extraordinary virtuosity in the use of paint, in a brilliance and vitality and immediacy of brushwork that was always first-hand, spontaneous, hot with enthusiasm. It was this that won him a new and more understanding appreciation in the nineteenth century when the Impressionists, Manet most of all, recognized in his paintings and their technique the clue to the directness of communication between eye and hand that they aimed at. Plates 108, 109, 110, 111, 112, 113, 114.

Heda, Willem Claesz., born 1593/94, probably in Haarlem, died 1680/82, probably in the same city. With Pieter Claesz., Heda is the best known representative of the Haarlem school specializing in still life and working in a manner that paralleled the contemporary development in landscape art as regards the restrained use of color and a fluid use of paint. Like Claesz., Heda was a master of the so-called breakfast still life. In his early works this was limited to a simple meal of bread and cheese set out on plain pewter with a glass of beer or wine and a crumpled napkin on a bare table, with the objects grouped along a diagonal axis with strong contrasts of light and dark in a sensitive monochromatic harmony. In time, however, his still lifes became richer, more monumental and decorative, and generally called for a vertical format. In both manners there is an illusionistic rendering that makes more pungent the message of the fragility of human existence which these still lifes embody, the notion of the *vanitas* of all things earthly which can be read in the broken or overturned vessels, half-emptied rummers, half-eaten pastries, half-peeled lemons, shelled nuts that seem – but only seem – to be scattered about without compositional reason. In the 1650s the richness of Heda's compositional means was further enhanced by a brighter coloring. His last pictures date from 1664/65, though he lived on for many years. Plate 219.

Heem, Jan Davidsz. de, born around 1606 in Utrecht, died 1683/84 in Antwerp. De Heem specialized in flower still lifes, garlands of fruit and richly adorned tables, all given sumptuous painterly treatment. As a young man, however, while working in Leyden with Balthasar van der Ast between 1626 and 1631, he had also practiced the local type of *vanitas* still life, with old books piled up every which way glimpsed by the light of guttering candles and painted almost monochromatically, a subject speaking of the vanity of learning particularly appreciated in that university town. After a brief return to Utrecht De Heem moved to Antwerp in 1636. There, his early biographer Sandrart explains, he could have at hand year-round a supply of rare and exotic fruits he could paint from life. There too, thirty-three years later, his successful career was interrupted by the devastating invasion of Flanders led by Louis XIV. But the lure of Antwerp was great, and in 1672 De Heem returned from Utrecht to spend his remaining years in the great port city. If his early works still favored the sobriety of Haarlemers like Heda or Pieter Claesz., his mature style was of an opulence befitting the metropolis he chose to live in. His paintings were much imitated and often directly copied, especially by his son Cornelis. Plate 220.

Heemskerck, Maerten van, born 1498 in Heemskerck near Alkmaar, died 1 October 1574 in Haarlem. He studied with Cornelis Willemsz.. in Haarlem and Jan Lucasz. in Delft, but the decisive stylistic influence came from Jan van Scorel, in whose Haarlem atelier he worked from 1527 to 1529 and who opened his eyes to

Antiquity and to the Italian art of the time. In 1532 he himself went to Italy and after returning from Rome, some time before 1538, he settled in Haarlem, where in 1540 he was elected dean of the St. Luke's Guild.

His early works done before the journey to Italy, thus roughly between 1527 and 1532, are indebted to Jan van Scorel in treatment of both figures and landscape. Characteristically there is a clear, sharp light which makes his pictorial world often appear atmosphereless and glassy. After the Rome experience he produced on of his major works, the altarpiece with the *Passion of Christ and Scenes from the Life of Saint Lawrence* (Alkmaar, Laurentiuskerk, now Linköping, Sweden, cathedral), where the Italian influences are plain to see. The figures are slenderer, more plastically modeled and infused with movement, and this is true also of the altarpiece he painted in 1546 for the Ghent cathedral. Later works show a simplification in pictorial structure, with figures filling the space and brought into the foreground. Besides numerous altarpieces Heemskerck produced also mythological and allegorical pictures and portraits of unusual perceptiveness. His Roman sketchbook and the paintings done from motifs recorded in it opened Northern eyes to the ancient ruins, and countless engravings were produced on the superbly dramatic, often overtly violent or erotic models he supplied to the finest printers. Plate 87.

Helst, Bartholomeus van der, born probably 1613 in Haarlem, buried 16 December 1670 in Amsterdam. Trained in the latter city by the fashionable portrait painter Nicolaes Eliasz., called Pickenoy (1591-1654/56), he remained there till his death. The earliest documentary mention of him was in 1636, a betrothal document from which the date of his birth has been deduced. A militia company group portrait he completed around 1643 (Amsterdam, Rijksmuseum), the year after Rembrandt's renowned essay in that genre, brought him a fame that would soon eclipse that of the older master among the wealthy political and military classes. In part at least this was certainly due to his willingness to respect the traditional neat alignment in group portraits which ensured every contributor to the final bill his due place in the sun. His portrait manner was finely detailed, perfectley clear, brilliant, and elegant, particularly in likeness of married couples depicted out-of-doors in relaxed natural poses or actions and sometimes, though not always, with an allegorical overtone. At first traditionally monochromatic, his color became increasingly varied and light in the 1650s, and it was at that high point in his career that his more extrovert approach was adopted by such Rembrandt pupils as Govaert Flinck and Ferdinand Bol who had grown restive with the master's very personal art. Plate 159.

Hemessen, Jan Sanders van, born around 1500 in Hemessen near Antwerp, died after 1575 in Haarlem (?). Free master from 1524, he married a wealthy woman by whom in 1528 he had a daughter Catharina who herself became a noted painter. Around 1550 he settled permanently in Haarlem, a move difficult to explain since he was apparently enjoying the highest success in Antwerp. Some forty pictures have been attributed to him, and perhaps also those by an artist indentified only as the Master of Braunschweig. Always challengingly original, provocatively realistic yet monumental, he exploited the most audacious expressive means to ridicule human foibles in genre-like scenes with vehemently agitated figures that often strike bizarre foreshortened poses and, quite unlike the quainter style of a Pieter Bruegel, always seem about to explode into violence. The figures are large-scale, monumental even in the bawdiest scenes, and make an immediate impact on the viewer. Hemessen's religious paintings are replete with the same genre traits and are complex in composition, highly detailed in treatment, and done with rich paint and saturated tone. There are portraits as well, works of a much calmer feeling, but the authorship of many of them is questioned and some at least may be by his very talented daughter. Plate 80.

Henri met de Bles, born around 1500 in Bouvignes near Dinant, died 1550/60 in Antwerp (?) or Ferrara (?). Almost nothing is known of the life of this major southern Netherlandish pioneer in landscape painting, but his pictures, all of them unsigned and undated, are thought to have been done between 1530 and 1550. Probably he is identical with the nephew of Joachim Patinir named Herri de Patenier who in 1535 became free master in Antwerp. While his style is connected with the school of Patinir, Hieronymus Bosch was also his model. His past views are painted with minute exactness, and it is of note that besides employing the usual picturesque staffage motifs – religious or mythological personages or the occasional stray peasant – Herri did at least four pictures (Florence, Vaduz, Graz, Prague) in which the relation between landscape and staffage is not casual since they show, with detailed realism and accuracy, all the operations involved in mining, smelting, and casting metals right at the mines in high mountain places. Although documentary evidence is scant, he seems to have worked a good deal of his life in Italy, but it is difficult

to detect any influence on him or from him. In Italy he was called "Civetta," from the tiny owl he often inserted in odd places in his pictures. Plate 60.

Heyden, Jan van der, born 5 March 1637 in Gorinchem, died 28 March 1712 in Amsterdam. In his precisely detailed views Van der Heyden did for Amsterdam what Canaletto did for Venice. Besides which he was a graphic artist, painted landscapes, views of castles and country houses, and still lifes, and to cap it all was a pioneering civil engineer of considerable importance. To capture the exact perspective in his topographical views he like so many artists of the time made use of an optical device like the *camera obscura*. Fine brushwork and masterly use of lighting are typical of his style, and the figures and animals in his landscapes were often painted by Adriaen van de Velde. Van der Heyden had no small influence on Dutch *veduta* painters, Jan Ekels above all. Plate 184.

Hobbema, Meindert, baptized 31 October 1638 in Amsterdam, died there 7 December 1709. This major Dutch landscape painter of the last third of the seventeenth century was for a time, around 1655-57, pupil of Jacob van Ruisdael, with whom he continued to be friendly through the years. From about 1657/58 Hobbema was active on his own in Amsterdam, and he paid visits also to Haarlem, Deventer, Middelharnis, and eastern Holland. In 1668 he married a kitchen maid in the household of the Amsterdam burgomaster. The following year, probably through his wife's intervention, her former employer awarded him the position of city winegauger, and only a few works verifiably from his hand can be dated after 1670, none after 1689.

Hobbema confined his art to landscape painting; his specialties were wooded dunelands (by no means a typical Dutch theme) and water mills, plus an occasional very rare ruin or city view. Unlike the common practice of his time when a picture might demand the services of a number of specialized artists, Hobbema almost always painted his own staffage figures. However very few drawings from his hand are known. Since his pictures were almost all painted in a time when Dutch landscape painting had passed its peak, their high quality is especially notable.

His early work was influenced by Jacob van Ruisdael but also by Anthonie van Borssom and Cornelis Hendriksz. Vroom. During his main period of creative activity, before 1670, he increasingly developed a clear, almost silhouette-like juxtaposition of pictorial elements, whereas his late pictures joined the general trend to a more schematic and less baroque style with simpler overall conception. To this late development belong works from 1671 like the *View of Deventer* (Mertoun House, Berwickshire, Collection the Earl of Ellesmere) and the *Ruins of Brederode Castle* or of 1689 like *The Avenue, Middelharnis* (the latter two, London, National Gallery). While Hobbema resembles Ruisdael in technique, he differs in his more full-bodied colors, more carefully worked details, an overall decorative effect, and a less dramatic but stronger contrast between bright and dark colors and light and shaded areas.

Hobbema represents the Dutch pictorial approach at its most characteristic, applying it to the particular everyday domestic Dutch landscape. If his masterwork, *The Avenue, Middelharnis,* is clearly rooted in the traditional Dutch pictorial conception, it shows tendencies that already suggest the eighteenth century, notably in a more arbitrary construction with various viewing angles and perspectives, in the way the pictorial center and main theme coincide, in the lack of a common scale of size in separate parts of the picture, in the importance attributed to the viewer, and in introducing bizarre pictorial elements. Hobbema's fame has paled today in favor of Ruisdael, but in the eighteenth and nineteenth centuries his paintings had decisive influence, and nowhere more so than among the English landscape painters. Plates 178, 179.

Hondecoeter, Gillis Claesz. d', born 1575-1580 in Antwerp, buried 17 October 1638 in Amsterdam. This landscape painter much influenced by Gillis van Coninxloo occasionally enlivened his forest and mountain landscapes with animal scenes in the manner of Roelant Savery. Though Flemish in origin, he is documented in Utrecht from 1602 to 1627. Plate 98.

Honthorst, Gerrit van ("Gherardo della Notte"), born 4 November 1590 in Utrecht, died there 27 April 1656. After training from Abraham Bloemaert, in 1610 he went to Rome, where he remained for ten years and came under the sway of Caravaggio's naturalism and powerfully plastic approach, though at the same time developing an entirely personal note. The frequently harsh effects of the Italian innovator were moderated by Honthorst through recourse to gentler light sources, often a torch or candle, and a painstaking treatment of surfaces. Returning to Utrecht in 1622, he entered the guild there and subsequently became its dean four times. Around 1625 he freed himself of his somewhat external imitation of Caravaggio and took to doing mythological and arcadian scenes in a classicizing manner. In 1628 he was invited to England by Charles I but was not asked to remain, in 1635 he

began to work for the King of Denmark, in 1637 and to shortly before his death he was court painter for the stadholder in The Hague, decorating castles in the vicinity of the capital and painting a great number of portraits of members of the House of Orange. Honthorst's importance lies chiefly in his having introduced the Caravaggio approach into the Netherlands and then, at a later date, helping to spread classicistic forms and ideals. Plate 105.

Hooch, Pieter de, baptized 20 December 1629 in Rotterdam, died after 1684 in Amsterdam (?). Around 1645 De Hooch was a pupil of the landscape painter Nicolaes Berchem in Haarlem, and in 1653 Justus de la Grange, a cloth merchant, engaged him as both servant and painter. Two years later, after his marriage and move to Delft, he was enrolled as a "foreigner" in the Delft painters' guild. In the mid-1660s he settled in Amsterdam, where however there is only circumstantial evidence as to his presence after 1670.

At the start De Hooch painted the much favored soldier and tavern scenes, and in a style influenced by his teacher. His main production can be ascribed to his years in Delft and Amsterdam when he painted almost exclusively domestic interiors. For this the most decisive influences came from Jan Vermeer and the Rembrandt pupil Carel Fabritius, the latter especially for use of color and light sources. With a thin, often transculent application of paint, his colors became increasingly bright and strong. Objective observation and repose came to characterize his pictures of rooms opening onto rooms with different lighting. His late work, however, leaves behind those middle-class Delft interiors and depicts the more elegant world of Amsterdam.

De Hooch's interiors are among the most distinctive achievements of Dutch art. For long preferred to Vermeer, he differs from the artist especially in his more naive and genre-like motifs and a somewhat more realistic approach. Plates 206, 207.

Huysum, Jan van, born 15 April 1692 in Amsterdam, died there 8 February 1749. Along with the remarkable woman painter Rachel Ruysch (1664-1750) – an artist of such rare distinction as to enjoy an exclusive contract with that arch-connoisseur, the Elector Palatine Johann Wilhelm, – Jan van Huysum was one of the last important Dutch painters to specialize in flower and fruit still lifes. Though his pictures commanded high prices, artistically they are not up to those of the preceding period. He learned to paint from his father Justus van Huysum the Elder (1659-1716) and around 1706 began his independent career with Italianizing

heroic landscapes. In time, however, he concentrated on still lifes, usually with a bouquet of flowers of all seasons set on a marble ledge or the like. By Huysum's time any trace of moralistic or symbolic intent in such flower pictures had become the merest convention in works that were well and truly "decorator's pieces" and often ordered and designed to fit over doors or between windows in elegantly furnished rooms. Plates 224, 255.

Jacobsz., Dirk, born c. 1497 in Amsterdam, buried there 9 September 1567. Pupil of his father Jacob Cornelisz. van Oostsanen, beginning in 1529 he painted individual and group portraits of wealthy Amsterdam burghers in a style indebted to Jan van Scorel. For all its over-simple alignment of figures, the three-part portrait of a militia company he painted in 1529 is one of the earliest examples of that typically Netherlandish genre. Plate 85.

Janssens, Abraham (also, Janssens van Nuyssen), born before 1575 in Antwerp, buried there 25 January 1632. One of the last of the Netherlandish Romanists, he was also one of the first to disseminate the new style of Caravaggio in the North. In 1584/85 he studied with Jan Snellinck, in 1601 became master, and in 1606 dean of the Antwerp St. Luke's Guild. The decisive influence on his painting came with his sojourn in Italy from around 1598 to 1601. An artist who began with Netherlandish Mannerism, he became a Caravaggist ten years before the Utrechters, and by 1609 had already opted for a full-bodied academic classicism in which he worked with clearly defined and strongly modeled forms and large-scale figures that made a lasting impression on his fellow townsman Rubens. Plate 117.

Janssens, Pieter (Pieter Janssens Elinga), active around 1650-70 in Amsterdam. His interiors and still lifes are rather like those of Pieter de Hooch, and the interiors characteristically show quiet rooms with little furniture, often with female figures seen from the rear, and illuminated by streams of bright light. Plate 205.

Jordaens, Jacob, baptized 20 May 1593 in Antwerp, died there 18 October 1678. One of the triumvirate of leaders of the Flemish Baroque together with Rubens and Van Dyck, Jordaens came from a well-of burgher family (his father was a linen draper). This did not prevent his being apprenticed at the age of fourteen to the classicist painter Adam van Noort (1562-1641) who had also taught Rubens for a time. At

twenty-two Jordaens was admitted to the guild, and the following year he married his teacher's daughter. Commissions were not slow in coming in, he could afford to buy property as investments, began to have his own pupils, and in 1621 was elected dean of the guild. From that time dates his friendship and close collaboration with Rubens, which regularly became closer whenever the gifted Van Dyck was out of the country. In 1634 the two worked together on the decorations for the imperial entry into Antwerp of the Cardinal Infante Ferdinand, in 1637 on the huge task of decorating the Spanish royal hunting lodge, the Torre de la Parada outside Madrid, an undertaking left to Jordaens to complete after Rubens' death in 1640. Beginning in 1639 there was a major project to be done, a cycle on the story of Psyche and Amor for the Queen's House in Greenwich (Rubens was already too ill for such work), though it was never completed and led to one of those court cases that dogged the lives of seventeenth-century painters in the Low Countries. Among Jordaens' patrons was Queen Christina of Sweden, who bought a number of his pictures for her castles. Then, in 1649, there was the most prestigious undertaking, the decoration of the Huis ten Bosch, the Dutch royal palace outside The Hague.

Yet underneath all this prosperity and the many altarpieces done for major Catholic churches ran a surprising secret current. As early as 1651 Jordaens was fined for "blasphemous writings," and when his wife died in 1659 had her buried in a Calvinist churchyard just across the Dutch border. The next year, called to testify in a lawsuit over the authenticity of some Van Dyck paintings, he took the oath with the name of God alone, not invoking the saints. More and more there were commissions from Holland, and the Amsterdam city fathers, for whose new town hall he supplied paintings, showed themselves eager to woo him into their fold. In 1671 he came out openly and attended Calvinist holy communion in Antwerp, and three years later had it celebrated regularly in his own house. There was a visit in June of 1677 from no less than the Prince of Orange and his secretary Constantijn Huyghens, but by then the painter was confined to a chair and not coherent in speech. The following year he died in the same night as his oldest child Elizabeth, and they were buried in the Calvinist churchyard across the border, alongside their wife and mother.

Jordaens' earliest paintings were still much indebted to the sixteenth century, with large figures pushed into the foreground, large Mannerist forms crowding the surface, and everything trapped in irrational light-relationships. Yet already there was a healthy dose of realism and solidity that no one could mistake for Mannerist. Around 1617, when he began to look to the styles of the Caravaggists and Rubens, his handling of light became more secure, the pictorial system simplified, the treatment of materials much more differentiated. His first cartoons for the Brussels tapestry manufactories were produced in the 1620s, and this was a sideline he would continue throughout his career and in which he would surpass the finest efforts of Rubens. Parallel to his large religious and mythological compositions he worked in a genre that Rubens and Van Dyck, aristocrats to the hilt, would never deign to touch: pictures of peasants at their ease. These carried further and went beyond Pieter Bruegel's "proverb-pictures" and are sometimes distressingly coarse, as if a refined painter were doing his best to make his means appropriate to the subject. But in all his works, in a truly Baroque manner he broke down the theoretical barriers between classical subjects and genre, introducing Flemish peasant notes into stories from Homer and Ovid and even into religious pictures. His late style carries a nervous urgency, as if every last inch must be filled with figures and no element can be allowed to rest but must be caught up in swirling and sweeping movement; *plus royaliste que le roi,* Jordaens ended by outdoing Rubens in Baroque vitality. Plate 134.

Juan de Flandes, born in Flanders, died before 16 December 1519 presumably in Palencia, Spain. From 1496 to 1504 this painter from the French and Flemish artistic sphere worked at the Spanish court. Details of his life before going to Spain are not known. Around 1500 for the oratory of Queen Isabella of Castile he painted forty-six small panels with scenes from the life of Christ which, in their miniature-like fineness and elegance, rank among the masterworks of early Netherlandish painting. Besides a few portraits, only the retables on the high altars in the Palencia and Salamanca cathedrals are ascribed to him with certainty. Plate 43.

Justus van Gent (Joos van Wassenhove), born probably between 1435 and 1440, active between approximately 1460 and 1480 in Antwerp, Ghent, and Urbino. This painter of religious and profane subjects, who enriched the realistic art of the early Netherlandish school with the stylistic means of the early Italian Renaissance, is first documented in 1460 with his admission into the Antwerp guild. From 1464 he worked in Ghent, where around 1470 he painted a triptych with the *Road to Calvary* for a chapel in the cathedral. Soon afterward, however, he entered the service of

Federigo da Montefeltro, Duke of Urbino, and his only fully documented work is *The Institution of the Eucharist,* still in that Italian city. Plate 42.

Kalf, Willem, baptized 3 November 1619 in Rotterdam, buried 3 August 1693 in Amsterdam. The most important of seventeenth-century Dutch still-life painters began his career following the example of his teacher Franchoys Rijkhals with crowded and rather heteroclite still lifes painted in a hard style and with small pictures of kitchen or barn interiors in which the emphasis was on objects, not people. That approach was continued during and after his sojourn in Paris between 1642 and 1646. After settling in Amsterdam sometime between 1651 and 1653, he supplied the wealthy patricians with rich and elaborate display-piece still lifes in which every porcelain bowl, Venetian glass goblet, patterned table carpet, sliced ham, half-eaten melon takes on monumental splendor in brilliantly contrived compositions given virtuoso painterly treatment with glowing color and an intricate play of lighting effects that shape the objects but also dissolve them in a fulgent translucency. Kalf had a vast following including such considerable artists as Juriaen van Streek (1632-1687) and Willem van Aelst (1625/26-1683?). Plate 222.

Keyser, Thomas de, born 1596/97 in Amsterdam, buried there 7 June 1667. This very successful Dutch portrait painter and architect was the son and pupil of the sculptor and architect Hendrick de Keyser and, after virtually giving up painting in 1640 to work as stone merchant and builder, was himself appointed Amsterdam city architect in 1662. Besides a few genre pictures and narrative scenes with numerous figures, he did chiefly individual and group portraits, along with a few small-format equestrian portraits. The leading Amsterdam portraitist before Rembrandt, he had no small influence on that artist's early work, for example through his *Anatomy Lesson of Dr. Sebastian Egbertsz.* of 1619 (Amsterdam, Rijksmuseum). Later, however, the influence worked the other way, and Frans Hals too had his effect on Keyser. Plate 158.

Koninck, Philips, born 15 November 1619 in Amsterdam, buried there 6 October 1688. His first training was from his brother Jacob in Rotterdam around 1637, but in 1640 he returned to Amsterdam, where he remained for the rest of his life, and where he came under the decisive sway of Rembrandt (whether or not he was in fact his pupil). His earliest surviving paintings were not done until after 1647 and clearly show

his debt to Hercules Seghers and Rembrandt, to the former in the way of conceiving vast panoramic landscapes, to the latter in the use of heavy and broadly laid-on paint. His entirely personal treatment of the endless landscape was unique in Dutch art, but his production was not great and he appears to have abandoned painting prematurely for his commercial interest in shipping and other ventures. Plate 169.

Laer, Pieter van ("Il Bamboccio"), baptized 14 December 1599 in Haarlem, died there after 1642. Although his artistic beginnings are unknown, his early works suggest the influence of Esaias van de Velde, especially in the plastic treatment of figures. His interest never ceased to focus on the figure, whether human or animal. During his sojourn in Rome between 1625 and 1638 he introduced a kind of genre painting entirely new to Italy and which became known as *bambocciata* from the cruel nickname applied to his own crippled body, and these pictures brought him immediate fame. His realistic scenes of the folk, with beggars, artisans, street merchants, and brigands caught in subdued colors and sometimes verging on caricature, soon found numerous imitators. After his return north in 1639, his work played an important part in the rise of animal painting (hunt and shepherd scenes) in Haarlem. Plate 188.

Lastman, Pieter Pietersz., born 1583 in Amsterdam, buried there 4 April 1633. This history painter was of major influence before Rembrandt's time as one of the first to break free of the Dutch variety of Mannerism prevailing in his earlier years. Decisive in his development was his Italian sojourn from around 1603 to 1607, first in Venice where he encountered Hans Rottenhammer, then in Rome where it was chiefly Adam Elsheimer who influenced him, though Caravaggio and Annibale Carracci were not without some effect. Lastman dealt mostly with biblical subjects, many of which he was first to treat in painting. His pictures are built up of units worked out separately and rendered in gleaming colors with an oblique theatrical lighting, an approach taken over faithfully by Lastman's pupil Rembrandt in his early works. Plate 140.

Leyden, Lucas van, born around 1489 or 1494 in Leyden, died there in 1533. The work of this major Netherlandish engraver and painter occupies an exemplary position in the turn from the Late Middle Ages to the Renaissance in the North. After initial training from his father Huygh Jacobsz., when he entered the workshop of Cornelis Engebrechtsz. in 1508 he was equipped with a skill to go with his great

talent. His name appears frequently in Leyden documents between 1514 and 1529. Before 1526 he set out on travels through Zeeland, Flanders, and Brabant, accompanied part of the way by Jan Gossaert.

No straight-line stylistic development can be made out in Lucas' work. He experimented incessantly and reworked the most diversified ideas from others. Since most of his pictures are not dated, it is obviously difficult to settle on any chronological order, and it is only his copperplate engravings that give a continuous idea of his activity. The earliest dated engraving, the *Mohammed and the Monk Sergius* of 1508, already evidences an experienced and vital engraving technique that must have been preceded by a good deal of earlier work. Despite an initial lack of anatomical knowledge, Lucas attempted complicated overlappings and foreshortenings. In his *Ecce Homo* of 1510, one of his most mature and thoroughly worked out engravings, the architecture, rendered with accurate perspective, takes on an uncommon importance, and in the *Milkmaid* of the same year he created one of the earliest real genre prints. The painted *Self Portrait* of around 1511 (Braunschweig, Herzog-Anton-Ulrich-Museum) introduced yet another unprecedented theme into Dutch art.

In Antwerp in 1521 he met Albrecht Dürer, who drew a portrait of him (Lille, Musée des Beaux-Arts), but even before then the influence of the German master can be sensed in Lucas' depictions of the Madonna, a theme less frequent in the northern Netherlands. But it was only when he encountered Jan Gossaert that a really decisive change came about in his style, with the nude body in the most varied and often acrobatic movements becoming a major subject.

His late works show a touch of Italian influence, indebted above all to Marcantonio Raimondi and his engravings after Raphael. Plates 67, 68, 69, 70.

Leyster, Judith, baptized 28 July 1609 in Haarlem, died 18 February 1660 in Heemstede. An important but quite independent follower of Frans Hals, Judith Leyster came first under the influence of the Caravaggists, especially Terbrugghen, during a visit to Utrecht in 1628. Around 1630 she became a pupil of Hals. In 1636 she married the painter Jan Miense Molenaer, and their bond extended also to the way they both painted. Besides still lifes she did mostly portraits and genre scenes painted with free brushwork in harmonious coloring and strong side lighting. Plate 115.

Limbourg, the brothers Pol, Hermant, and Jehannequin, born between 1375 and 1385 in Nijmegen, died 1416 in Bourges. The work of these three Netherlandish-Burgundian miniaturists represent a high point of book illumination in the International Gothic period and are considered a step toward the art of Van Eyck. When their father died, Hermant and Jehannequin were apprenticed to the goldsmith Alebret de Bolure in Paris, where they remained until 1399. Imprisoned but ransomed in 1400 by Duke Philip the Bold of Burgundy, they entered their benefactor's service. In 1402 Pol and Jehannequin were given the task of illuminating a *très belle et notable Bible*. It is likely that after Philips died in 1404 the three painters were promptly taken on by Duke Jean de Berry in Bourges and Paris, though they are not documented in that connection before 1410. All three died in an epidemic (the plague, perhaps) in Bourges in 1416.

Pol is considered the leader of their fraternal partnership. Their indubitable masterwork, in which all three had a hand, comprises two magnificent books of hours for their last patron, *Les Belles Heures du Duc de Berry,* previously called *Les Heures d'Ailly* (New York, Metropolitan Museum of Art, The Cloisters), and *Les Très Riches Heures du Duc de Berry* (Chantilly, Musée Condé). The *Belles Heures* must date from around 1405-08. The aristocratic style of the figures, the composition, and the relationship between figure and landscape have prototypes in Burgundy but also, significantly, in fourteenth-century Italy. What is new is an intensified concern with natural details and a greater intimacy, and these expressive factors are carried further in the *Très Riches Heures* which seems to have been painted between 1413 and 1416. Plates 2, 3.

Maes, Everard Quirijnsz. van der, born 1577 in The Hague, died there in 1656. This history, portrait, and glass painter of the Hague school was a pupil of Carel van Mander and from 1604 member of the St. Luke's Guild in his native town, where he was kept busy decorating communal buildings. Commissioned by the local militia companies, he painted numerous full-length portraits and banners, with vivid use of color and very effective poses. Plate 107.

Massys, Jan (also Metsys), born c. 1508 in Antwerp, died there before 8 October 1575. A son of Quinten Massys, Jan like his brother Cornelis doubtless had his first training in his father's workshop as his earliest works suggest. Charged with heresy in 1544 he fled Antwerp, and while it is not known for certain where he spent the fourteen years of his exile many indications point to Italy, to Genoa in particular where the Raphael follower and Mannerist Perin del Vaga had left his mark, along with a visit to France where the Italo-French Mannerism of Fontainebleau was in full

sway. What Massys brought back to the Netherlands was an Italianizing Mannerist style of highly decorative, finely drawn figures breathing an erotic air only slightly touched at times by Flemish earthiness. Plates 75, 76.

Massys, Quinten, (also Quentin Massys, Metsys, Messys, Matsys), born 10 September 1465 or 1466 in Louvain, died 13 July or 16 September 1530 in Antwerp. Perhaps the major figure in Antwerp around the turn of the century, Massys worked in a style entirely distinct from that of the so-called Antwerp Mannerists. Although his early works have suggested it to some writers, nothing proves that he was a pupil of Dirk Bouts. In 1491 he was accepted as master in the Antwerp guild. His themes were mostly religious, and if at the outset his art still showed Late Gothic traits, in time his treatment of line became more flexible and his characteristic preference for complementary color relationships asserted itself.

Around the turn of the century he began to aim at more balanced compositions and greater differentiation in coloring, as is plain in his first major work, a triptych painted between 1507 and 1509 for the Louvain Confraternity of St. Anne (Brussels, Musées Royaux des Beaux-Arts). Its delicate local coloring and restrained rendering of shadows already point to his mature style, as does a feeling for spacious landscape with a high horizon. His second important altarpiece was done around 1510 and has episodes from the life of Saint John on the wings and a *Lamentation over the Dead Christ* as central panel (Antwerp, Koninklijk Museum voor Schone Kunsten). It evidences a return to the Late Gothic manner in the tight-packed relief-like succession of figures, yet the way its composition is staggered in depth is already related to the High Renaissance. From the point of view of color, this altarpiece marks a high point in Flemish art of the time. Massys' best known non-religious work, the painting of 1514 in which a woman watches while her husband weighs gold (Paris, the Louvre), is one of those proverb-pictures that became so frequent in the sixteenth century and can be interpreted as showing the link between false devotion and greed but is better read as an admonition to a just balance between worldly and spiritual things.

A special distinction of Massys is his convincing characterization of the humanistically educated Renaissance man, and indeed, in their harmonious linkage of figure and landscape works like his *Erasmus of Rotterdam* of 1517 (Rome, Galleria Corsini) and the *Portrait of a Man* of 1530 can be considered prime exemplars of the High Renaissance in the North. Among Massys' followers were his sons Cornelis and Jan, Marinus van Roemerswaele, Jan van Hemessen, and Joos van Cleve. Plates 61, 62, 81, 82.

Master of the St. Lucy Legend (also Bruges Master of 1480), active from 1480 to 1501 in Bruges and named for an altarpiece dated 1480 in the Jacobskerk there. His works show the influence of Memling and, in composition, a link with Rogier van der Weyden and Hugo van der Goes. His stiff, marionette-like figures have firmly closed contours and sterotyped faces, and his partiality to decorative details is evident in the flowers and plants in his foregrounds. Plate 44.

Master of the Virgo inter Virgines, active between 1485 and 1500 in Delft and named for a painting of the Virgin surrounded by female saints (Amsterdam, Rijksmuseum). His style is characterized by a delicately differentiated coloring, an active treatment of line, and expressive and somewhat fragile-looking figures deployed on a foreground stage with staggered views receding in the background like a series of stage flats. He seems to have had a large workshop and exerted much influence, and counts along with Geertgen tot Sint Jans among the major artists of his time. Plate 33.

Memling, Hans, born around 1433 supposedly in Seligenstadt-am-Main, died 11 August 1494 in Bruges. Although born in the German Middle Rhineland, Memling so fully assimilated the Netherlandish style of Rogier van der Weyden, Dirk Bouts, and Hugo van der Goes that he is always considered their compatriot, and in fact his name appears in the Bruges archives from January 1465 to his death. It can be assumed that he studied with Van der Weyden in Brussels, though there seems some likelihood that he worked with Stefan Lochner in Cologne before leaving Germany. In 1467 he became a master in the Bruges guild and soon prospered enough to be ranked in the second echelon of the wealthiest taxpayers and to belong to a confraternity of the cathedral, whose membership was limited to the most influential citizens, among them the Duke and Duchess of Burgundy themselves. In 1480 Memling could buy a stone house (a sign of conspicuous wealth) and two others. He had pupils in good number and kept up a busy workshop with permanent assistants.

The first work surely from his hand is a triptych done in 1468 for Sir John Donne of Kidwelly (London, National Gallery) which was probably commissioned in Bruges at the time of the marriage of Charles the Bold

to Margaret of York when the royal bride was attended by an escort of English gentlemen. Memling's international prestige was well launched. During those same years Angelo di Jacopo Tani, the Medici agent in Bruges, commissioned a large polyptych on the *Last Judgment* which was to have a stormy history: en route for Florence, the ship owned by the same Tommaso Portinari who commissioned Hugo van der Goes's masterwork was attacked on 27 April 1473 by a Danzig pirate who, perhaps to store up some credit towards his own last judgment, ended by donating his splendid prize to the cathedral of his native city (now Gdansk, Muzeum Pomorskie), where it came to be coveted by Tsar Peter the Great and looted by the less respectful Napoleon. In that work, Memling's personal style began to assert itself in both highly organized composition and effective characterization of the individual faces. Though most of the altarpieces and portraits Memling produced subsequently were for Bruges patrons, there were also commissions from Italy, Spain, Germany, and elsewhere, and his paintings often quickly made their way into royal or patrician chapels and collections abroad.

Memling was a master of diverse styles. In the *Seven Joys of Mary* from before 1480 (Munich, Alte Pinakothek) and the *Passion* (Turin, Galleria Sabauda) groups of tiny figures scattered through vast pseudo-Oriental landscapes and fantasy architecture act out complex episodes with almost naive yet highly mannered means. That narrative skill would culminate in the shrine of Saint Ursula of 1489 (Bruges, Memling Museum), a reliquary chest in the form of a Gothic church whose sides and roof are adorned with eight main pictures and six small roundels recounting the tale of that virgin saint and her thousand companions as told in the *Golden Legend* of Jacobus da Voragine which had appeared in Dutch translation just ten years earlier. Here all Late-Gothic rigidity is sloughed off to give full force to the actions of the many small but beautifully characterized figures which are treated with the perfection of a miniaturist. This was still an illustrative art, but Memling's last major work, the Passion polyptych done in 1491-94 for the chapel of two Lübeck brothers in the cathedral there (Lübeck, Sankt-Annen Museum), treats the Crucifixion and related scenes with a controlled narrative skill that has absorbed but also attenuated the tense drama typical of Rogier van der Weyden and, further, has unified action and setting into a compact and therefore so much more effective narration. In portraiture Memling was one of the first in Europe to make a *picture* out of a portrait, not merely painting a head against a neutral background but framing the subject between architectural elements, usually columns or pillars, and setting behind him an expanse of landscape which is sometimes suggestive of the homely Flemish countryside. Painted by Memling, the sitters, whether aristocrats or burghers, are no longer abstractions of a social estate but well characterized individuals, and this remains true when they appear as donors in the presence of the Virgin and saints.

Memling's art can be read as transitional between the Late Gothic and the Early Renaissance in the North. This is seen above all in the way the human figure takes on a new value, becoming statuesque and yet warm-blooded and familiar, with an inward repose that is conveyed by precise and yet flexible contours and a sense of the figure as a *shape* in a composition. It is seen too in Memling's efforts to achieve the kind of unified spatial depth in which every element in the painting belongs to a whole, a goal realized more completely by his follower Gerard David and, even more, in the sweeping landscapes of Joachim Patinir. Plates 34, 35, 36, 37.

Metsu, Gabriel, born January 1629 in Leyden, buried 24 October 1667 in Amsterdam. This Dutch genre, portrait, and narrative painter, the son of the painter Jacques Metsu, was one of the charter members of the Leyden St. Luke's Guild in 1648. With brief interruptions he remained in his native town until 1657 at the latest and then moved to Amsterdam. Although said to have studied with Gerard Dou, it is only in his later work that he shows any similar approach to genre, adopting in particular Dou's device of framing figures in a window, and to this was soon added some sort of influence from Delft painters like Vermeer and Pieter de Hooch. There is a quiet air about his pictures of mostly middle-class life, and often more than a touch of sentimentality at odds with the irony, sometimes affectionate, sometimes not, that distinguishes so much of the Dutch genre art. Plate 203.

Mieris the Elder, Frans van, born 16 April 1635, died there 12 March 1681. In portraits, genre scenes, and narrative pictures Mieris clung to the small-scale, minutely detailed style initiated in Leyden by Gerard Dou. Before entering Dou's workshop he had had training from the well-known glass painter Abraham Toorenvliet. In choice of themes, the technique of smooth surfaces, compositional forms (setting genre scenes in niches, frequent use of formats either oval or rounded at the top), and a scrupulously exact concern with fine details, Mieris shows his debt to Dou. His rendering of textiles such as velvet and silk and of carpets and furniture is masterly. As he grew older his

pictures became increasingly more finicky and studied and finally succumbed to a certain static classicism. Plate 204.

Momper, Joos de, born 1564 in Antwerp, died there 5 February 1635. Momper's landscapes are poised at the turn from fantasy to realism. For all his close stylistic and technical relationship with Jan Bruegel the Elder (who often painted the staffage figures for him, as did Bruegel's son also), his landscapes are, essentially, elaborately contrived inventions using a handful of shapes and motifs almost as formulas to be juggled at will. Member of an extended dynasty of painters, he was trained by his father Bartholomeus and admitted to the Antwerp guild in 1581. There is an undocumented possibility that Momper was in Italy between that date and 1590, perhaps studying in Treviso with his countryman Lodewijk Toeput ("Pozzoserrato"), which is thought to account for his changing from a traditional Flemish approach to landscape to a richer use of color and brushwork and a very personal yet Mannerist juggling with realistic and fantastic natural elements. He was the only major specialist in landscape, other than Jan Bruegel, to remain in Flanders during and after the troubles, and he was in great demand not only for his particular forte but also for such tasks as the designs for the triumphal entry of Archduke Ernst of Austria into Antwerp as governor of the Netherlands in 1594, tapestry cartoons for Archduke Albert of Austria the next year, and cycles of landscapes as decorations for two royal castles in Denmark. If through a large part of his career he continued to play variations on the traditional way of composing landscapes in three zones of diminishing color and vividness, in the course of time he arrived at a total unity less Mannerist than Baroque. Plate 96.

Mostaert, Jan, born around 1472/73 in Haarlem, died there in 1555/56. In its aristocratic attitude his work is closer to the Netherlandish art of the fifteenth century than to the Romanism of his contemporaries. The first documentary mention of Mostaert dates from 1498, in Haarlem. His early works were much influenced by Geertgen tot Sint Jans, and have occasionally been so attributed. His triptych with Passion scenes (Brussels Musées des Beaux-Arts) shows him also coming to terms with the art of the southern Netherlands, and it is thought that for a time he was court painter for the regent Margaret of Austria in Brussels or Mechelen. Plate 64.

Neer, Aert van der, born 1603/04 in Amsterdam, died there 9 November 1677. In his earlier years Neer worked as steward for a Gorinchem family, but shortly before 1633 returned to his native city resolved to make his way as a painter. For all his high hopes he was never much of a success in his lifetime. The winter and moonlight pictures in which he specialized were not to the popular taste, but he continued to turn out picture after picture in an attempt to survive as a painter. Like many other Dutch painters, he had to keep an inn for some years; like a number of them, he became bankrupt (in 1622). Unlike most of them, he did not paint with ease and, dire as was his financial need, he set himself high standards. An occasional picture strikes a lighter note, with some attention to winter sports and the like, but most are lonely scenes whose real protagonist is reflected light on snow or water, most often at sunset or night. As one would expect, with his predilection for setting suns and moonlight his prestige improved in the nineteenth century, notably among the German Romantic painters, and his pictures were sought after in the England of Byron and Shelley. Plate 163.

Netscher, Caspar, born 1635/36 in Heidelberg, died 15 January 1684 in The Hague. This genre painter and portraitist learned the rudiments of his art form Hermann Coster in Arnhem, then in 1655 went to Deventer to study with Gerard Terborch. After a sojourn in Bordeaux between 1659 and 1661 he settled in The Hague, where he remained from 1662 to his death. His early work was entirely under the influence of Terborch, but along with this his genre pictures done after 1660 reveal an indebtedness to such genre painters of Leyden and Delft as Gerard Dou, Gabriel Metsu, Pieter de Hooch, and Jan Vermeer. From 1670 Netscher concentrated on portrait painting and, as a purveyor of the characteristic forms and manner of Van Dyck's aristocratic style, enjoyed great favor in the social world of The Hague. Plate 195.

Orley, Barend van, born around 1488 in Brussels, died there in January 1541. His apprenticeship in the workshop of his father, Valentin van Orley, must have been completed before 1512, and by 1515 he was receiving commissions from the Brussels court of the regent Margaret of Austria who, three years later, made him her court painter. Although he fell into disgrace for Protestant sympathies in 1528, before the next two years were out the new regent, Mary of Hungary, welcomed him into her service. He worked also at the court of Hendrick III of Nassau for whom he produced a set of tapestry designs.

If his early works were still tied to the fiftheenth-century Flemish tradition, they nonetheless had first in-

timations of an Italian manner. Though, as is likely, he never went to Italy, he absorbed the new style through the engravings by Marcantonio Raimondi after works of Raphael and others and also, more at first hand, from the tapestry cartoons by Raphael sent to Brussels for weaving. By the time he came to his major polyptych, on the tribulations of Job and Lazarus (Brussels, Musées Royaux des Beaux-Arts), he could subject forms and figures poised between the Flemish and the Italianate to daring exploits of perspective for dramatic and emotional communication, and do so in an entirely original manner. There may be some significance also in his meeting with Dürer in Brussels in 1520 when "Master Barend, the painter, bade me home and set out a lavish meal that must have cost him more than ten florins." Late in his life his tapestry designs took on a pronounced monumentality and classical amplitude (The *Hunt of Maximilian* series, for example), and he also supplied impressive designs for stained-glass windows in the Brussels cathedral. Plate 65.

Ostade, Adriaen van, baptized 10 December 1610 in Haarlem, buried there 2 May 1685. This brother of Isaak van Ostade was among the most successful Dutch genre painters, draftsmen, and etchers of his time. His subjects were almost exclusively scenes of peasant life, and only a handful of biblical scenes, still lifes, allegories, and portraits survive to show another side of his art. Presumably he studied with Frans Hals around 1627, at the same time as Adriaen Brouwer whose pictures of peasants drinking and fighting seem to have made a deeper impression on the young Ostade than the more elegantly styled figures of his teacher. He became a member of the Haarlem painters' guild in 1634, at a time when he was producing small pictures of peasant interiors with tiny, energetically active, caricature-like figures. When around 1640 he began to exploit chiaroscuro, a warm brownish coloring, and a more individualistic treatment of figures, it was due to the influence of Rembrandt. Along with interiors he painted also outdoor scenes with animated groups, and his knack for catching figures in picturesque activities made him much in demand for supplying staffage for landscapes by other artists of note, among them Jacob van Ruisdael. His finest work was done between 1650 and 1670, when his interiors became more varied, his coloristic accents more forceful, his composition and chiaroscuro better balanced, and the rowdy boors of his earlier pictures made way for a more prosperous peasantry aspiring to the fine manners of the burghers. But it was the poor who made him rich, and by 1657, when he converted to Catholicism and married a Catholic woman of considerable means, the weaver's son had for long been a prosperous gentleman in his own right. Inventive to the end, he did not retire from painting, as so many other Dutch artists did after achieving a comfortable prosperity, but continued to turn out painting upon painting as well as drawings, watercolors, and etchings. Plate 199.

Ostade, Isaak van, baptized 2 June 1621 in Haarlem, buried there on 16 October 1649. Initally Isaak van Ostade was totally dependent for his style on his much older brother Adriaen who was his teacher, painting the same sort of genre pictures of peasant life. His early interiors were typically muted in coloring with little emphasis on local colors, and after 1640 everything became bathed in brownish ground tone when he, like his brother, came under the influence of Rembrandt. Around that same time, along with scenes on streets and roads in which inns have a prominent place he began to paint landscapes in which the figures became less significant. But it was in his very fine winter landscapes, held to a silvery gray tone, that he finally arrived at a style all his own. Plate 165.

Ouwater, Aelbert van, born around 1415 presumably in Oudewater near Gouda, died around 1475 in Haarlem. Only one painting by this artist, *The Raising of Lazarus,* has been identified, but it is evidence of his relation to the Haarlem school, and to Dirk Bouts in particular, as well as of his acquaintance with works by Jan van Eyck, Rogier van der Weyden, and Petrus Christus. Plate 27.

Patinir, Joachim, born around 1485 in either Bouvignes or Dinant near Namur, died before 5 October 1524 in Antwerp. The devotional pictures on traditional themes by this pioneering landscape artist were intended more for private than for church use, and in them the usual relationship between figure and background landscape became so tenuous that the religious personages and episodes seem almost arbitrary additions. Patinir was active in Antwerp from 1515 on, and there he found an international clientele. Nothing is known of his training or development, but his works show stylistic affinities with Gerard David, Hieronymus Bosch, and Quinten Massys (who supplied figures in some of his landscapes, it appears). After becoming a master in the Antwerp guild in 1515 he strove for greater spatial depth in his landscapes, with a group of figures often viewed close to and confined to a foreground plateau while an immense panorama, seen in bird's-eye view, stretches into a pale

blue distance. However it was only in his very last works that he arrived at a truly continuous unfolding of spatial depth. Though his treatment of overall composition and details was not at all untraditional, in color he found a very personal means for achieving his typically serene atmosphere and, in the late works, a unified landscape view. While retaining the traditional division into zones or color – reddish brown foreground, green midground, blue background – he differentiated them delicately while at the same time unifying them through a continuous play of color that links each new zone to the one before it. Plates 58, 59.

Post, Frans, born around 1612 in Leyden, buried there on 18 February 1680. This Dutch painter was the first European to record first-hand the Brazilian landscape. Together with his brother, the painter and architect Pieter Post who was probably also his teacher, and the painter Albert Eeckhout he accompanied Prince Johan Maurits of Nassau on his expedition to Brazil. Assigned to document the undertaking, he made topographically exact drawings as well as a few paintings distinguished by a simplifying stylized depiction of landscapes in delicate pastel tones. The bulk of his production, however, was done after his return to Haarlem in 1644 when he converted his travel sketches, various landscape motifs, and ethnographically interesting studies of the exotic flora and fauna and natives into mood-pictures in a somewhat flattish and almost naive style. Plate 168.

Potter, Paulus, baptized 20 November 1625 in Enkhuizen, buried 17 January 1654 in Amsterdam. Potter was the first seventeenth-century Dutch painter and engraver to specialize in pictures of animals, and is credited with creating the special type of Dutch landscape picture featuring animals. After being trained in Amsterdam by his father, Pieter Symonsz. Potter (c. 1597-1652), he found a decisive influence in a series of animal engravings by Pieter van Laer in 1636. In his new approach, animals were no longer treated as staffage but as the real subject of the picture. Although his best known work is the monumental life-sized *Young Bull* of 1647 (The Hague, Mauritshuis), his preference in fact went much more to the small cabinet picture. Potter died too soon to solve the particular spatial problem of the landscape with animals, the harmonious interpenetration of foreground and background, and it remained for Karel Dujardin and Adriaen van de Velde to perfect his rich and thoroughly vital style. Plate 167.

Pynacker, Adam, born 15 February 1622 in Pijnacker near Delft, buried 28 March 1673 in Amsterdam. Even if Pynacker did not spend three years in Italy as early accounts suppose, he was conclusively influenced by the Italianists Jan Both and Jan Asselijn. He is found in Delft in 1649, in Schiedam in 1657-58, and he finally settled in Amsterdam where, in a very alien clime, he continued to paint sun-drenched views of a real or imaginary Roman Campagna with large trees and ground plants depicted startlingly close-up in the foreground, flecked by a glistening silvery sheen and set against a shimmering haze in which the middle and distant landscape dissolves. This sensitive artist's most poetic expression comes in pictures of hilly shores of rivers or lakes literally bathed in an extraordinary calm. Everything is viewed steeply from below, never seen head-on but always on an off-center axis that leads into the distance. Plane succeeds plane horizontally, first a strip as narrow as a fallen tree trunk across the foreground, then gradually widening and becoming more open through veils of transparent light and color. *Plein-air* painting? Probably not, because the very idea of setting up an easel outdoors and copying "reality" was alien to the time and, indeed, unnecessary. But Turner, one suspects, was acquainted with these paintings (there were a number in London) and the Barbizon painters, who owed as much to Dutch landscape art as to nature, likewise. Plate 190.

Rembrandt Harmensz. van Rijn, born 15 July 1606 in Leyden, died 4 October 1669 in Amsterdam. Rembrandt was born in the university town of Leyden, which also had a flourishing textile trade. He was the son of a miller (the family name came from the location of their mill on a branch of the Rhine) who was the only member of his family to become Protestant, and his mother was a baker's daughter. The family was obviously prosperous enough to send the boy to the local Latin school when he showed ability – the other two sons had to go into trades – and then in 1620 to the university as student of ancient languages. It is not known why the fourteen-year-old soon thereafter renounced the academic life for an apprenticeship with Jacob Isaaksz. van Swanenburgh (1571-1638), a painter who had had some study in Italy but worked rather more in the tradition of the "hell pictures" of Bosch and Pieter Bruegel and also did architectural views. If the boy's three years with that provincial painter left no tangible influence, they obviously equipped him with the technical foundation to profit remarkably from a mere six months with his next teacher, the very succesful narrative painter Pieter Lastman who headed a thriving workshop in Amsterdam, and then perhaps from further study with

one of the Pynas brothers. Lastman and Jacob and Jan Pynas belonged to a group of Italianate painters in Amsterdam who had come under the influence of Adam Elsheimer in Rome and, it would seem, were able to transmit the essence of that German artist's style as well as their own to their young pupil. Added to which, the boy learned much from the engravings after Italian and earlier Netherlandish artists so plentiful in those years

Around 1624 or 1625 Rembrandt returned to Leyden, where he promptly found pupils and clients, sharing a workshop with Jan Lievens (1607-1674) who, though a year younger, was more advanced in his training. The two worked closely, and it is difficult sometimes to distinguish their paintings of those early years. The first of the lifelong series of Rembrandt's self-portraits date from this time, and it was then too that he became proficient in etching and initiated a prodigious output in that medium as well. Though still very much under the influence of the narrative art of his Amsterdam teachers, his paintings already show him learning the lesson of the Dutch Caravaggists but beginning to be his own man, with more concern for tonal gradations of light and dark than for the striking contrasts the Utrechters relied on.

The partnership with Lievens lasted until 1631, when that young hopeful went to try his luck in England and Rembrandt moved to Amsterdam. In that competitive environment of newly rich burghers, his first triumphs came not with narrative pictures but portraits. The *Anatomy Lesson of Dr. Nicolaes Tulp* of 1632 (The Hague, Mauritshuis) brought a new emotional climate to a specialized group-portrait subject already explored early in the century by Pieter Aertsen's son and by Thomas de Keyser. It brought the young man to public notice, and was followed by so many requests for portraits that he began to supplant the fashionable portraitists of the time. His success also won the miller's son an attractive wife in 1634, Saskia van Uylenburgh, daughter of the prosperous burgomaster of Leeuwarden, a most happy marriage though she died young. Of the children she bore him only Titus survived and even he died a year before his father. With new wealth, Rembrandt could begin to collect other artists' paintings. In his own work he began to produce large-format narrative paintings full of Baroque theatrical action and dramatic lighting such as the *Blinding of Samson* of 1636 (Frankfurt, Städelsches Kunstinstitut), but also landscapes much indebted to the example of Hercules Seghers, whose paintings he bought (and even repainted beyond recognition). Friendship with Constantijn Huygens, secretary to the Prince of Orange, led to a royal commission (the only one he would ever receive) for a cycle of *Passion* scenes (Munich, Alte Pinakothek).

An extravagant way of life, a poor head for business, a temporary decline in his creative powers, and the onset of a change in taste unfavorable to his somber art set the painter on a path of debts he would never quite escape from thenceforth. Those troubles were compounded by personal grief when his mother died in 1640 and his young wife only two years later. The year 1642 marked a turning point in his life and a new beginning in his art, though not immediately. First he was to paint the huge canvas improperly known as *The Night Watch,* one of seven group portraits of militia companies commissioned from the leading portrait painters of Amsterdam as decoration for the great hall in the new civic guard headquarters. Romantic fabrications of later times notwithstanding, Rembrandt's picture was deemed a success and he was paid what he asked. Strange as the mood of that painting may seem, it in no way represents the change in Rembrandt's style that had begun to take shape around 1639-40 but would not arrive at its full expression until the 1650s and 1660s. That change involved transmuting outward drama into inward tensions, the objective episode or external appearance of an individual into subjective meaning.

After Saskia's death the widower entered on an unfortunate liaison with Titus' nurse, which ended in a squalid court case for breach of promise and the burden of paying the woman an annuity for the rest of her life. But in 1649 Hendrickje Stoffels, an army sergeant's daughter, entered his life and home in a relationship which, in everything except the legal aspect (the poor woman was persecuted by the authorities as a "concubine"), was a perfectly stable marriage, complete with a daughter born in 1654. (He could not marry again without losing the considerable inheritance from Saskia.) By 1657, though, his misfortunes came to a head. His house and all his property, including his own paintings and those he had collected were put up for enforced sale. Placed under receivership, he nonetheless was sufficiently respected in the community to retain his personal freedom. Moreover, by a clever arrangement in which Hendrickje and Titus formed what we would call a corporative trust fund with ownership of all future works he might produce, he could continue to sell his pictures and enjoy the profits himself rather than having to devote them to paying off old debts. His financial reverses were grim, yet he continued to receive lucrative commissions, had a good number of students who brought him no small income, and could still even occasionally indulge his fancy for collecting.

The most eloquent testimony to the transformation in his life and person and art is in his self-portraits. No artist ever depicted himself more frequently. Over a hundred drawings, etchings, and paintings make almost a running film of all his changes in appearance and spirit through the years. Those of his final years are moving evidence of a man who in character and aspect seems almost to be coming apart at the seams. The facial features lose their firmness, the keen look has faded. But if he was defeated as a man, as a painter his art grew steadily in creative originality, depth, and sheer skill throughout the 1650s and 1660s, and most of the paintings for which he is best known date from those years. Yet when he was laid away in the Amsterdam Westkerk on 8 October 1669 at the age of sixty-three (not really old, though he had outlived both wives and his only son) the world took little notice: he was old-fashioned, and Dutch art had continued on its own felicitous, unsubjective, unemotional path. Nonetheless there were pupils to keep up his posthumous reputation. Artists as different as Gerard Dou, Ferdinand Bol, Govaert Flinck, Jan Victors, Gerbrandt van den Eeckhout, Carel Fabritius, and Aert de Gelder testify to his qualities as a teacher, though it is a striking fact that many of them took a very different way once they left the sphere of his dominant and dominating personality, sometimes for the better, sometimes not. To the end of the century other artists, without direct contact with the master, imitated especially his early dramatic style, among them Jacob de Wet (c. 1610-1671/72), Adriaen Verdoel (1620-1695), and Benjamin Cuyp. His late style, however, was less taken up, in part because of the decreasing number of pupils who sought him out, though Aert de Gelder for one did remain faithful to it.

In the course of his career Rembrandt's way of painting went through a number of decisive changes. In his early works he applied paint delicately, already with an evident delight in textures and the contest between light and shadow, and with a passionate feeling for line (sometimes emphasized by drawing in the paint with the wooden tip of the brush) and a broad palette which, except in the very first works, inclined already to a somberness and preference for deep hues. During the next two decades he worked increasingly with large undefined areas of dark colors against which forms and figures stand out thanks to their more precise contours, lighter coloring, and greater luminosity, yet already the key image is threatened with being swallowed up in darkness. The great change of the early 1640s affected the technique as well as the spirit of his work. More and more, in a consistent progress

toward the late style, his colors, though still dark, took on greater warmth and were used so richly that they seem to soak into and stain every fiber of the canvas. He increasingly used a thick impasto with a body and life of its own, making surfaces as fascinating as a contour map viewed through a hand lens; surfaces were so broken up and textured that the eye senses almost tactilely the substance of the paint itself. A golden glow (the result of innumerable fine glazes and varnishing) came to permeate the picture. Composition was distilled down, more and more confined to a few figures in the simplest poses and physical relationships, figures that are solid and massy and almost too full-fleshed. Only in his last decade did his contours dissolve and his already restricted palette become more so. The mysterious glow began to take over the all-engulfing role played before by darkness: paint shimmers, holds light.

Rembrandt was a prodigious artist who produced something like 2,300 works – about 500 paintings, 300 etchings, 1,500 drawins – and most of them from his own hand, unlike Rubens. Yet in his time he was an exception, and still is. The mainstream of Dutch art flowed in different channels, as the reader of this book will have seen. His influence was not so much immediate as deferred and had its finest results not among the handful of painters in his time who learned from his lessons or example but in the eighteenth and nineteenth centuries, in Germany with artists from Januarius Zick to Lenbach, in England from Sir Joshua Reynolds through generations of Royal Academicians. Plates 141, 142, 143, 144, 145, 147, 148, 149, 150, 151, 152, 153.

Rubens, Peter Paul, born 28 June 1577 in Siegen, Westphalia, died 30 May 1640 in Antwerp. His father was a Calvinist jurist forced to flee from Antwerp. Soon after Peter Paul's birth the family moved to Cologne when Jan Rubens was named to a leading court position. The father turned back to his Catholic faith shortly before his death in 1587 after which the mother with her two young sons (Philip was to become a distinguished scholar) returned to Antwerp. There Peter Paul became a page in the service of the Countess de Lalaing – a good start toward his later parallel career as diplomat. There too, in the 1590s, the youth had his first lessons in art from the landscape painter Tobias Verhaecht (1561-1631), then with the narrative and portrait painter Adam van Noort (1562-1641), finally between 1596 and 1600 with the widely traveled, Italian-influenced classicist Otto van Veen. At twenty-two Rubens became free master in the Antwerp guild. We know little of his work before

his real career began in 1600 with a sojourn of eight years in Italy divided between Venice, Mantua, Florence, Rome, and Genoa. Though the Italian journey began as a study trip, documents of 1601 show him as court painter to Vincenzo Gonzaga, a position he would hold for the remainder of his Italian years though he was seldom in Mantua. But his way was set. Thenceforth he would work for the highest royal powers of the Church, seldom for the prosperous commoners who were the best patrons for most of the Netherlandish art in that century. He would be "prince of painters," instrument of the Counter-Reformation, exemplar of the Baroque.

In Rome in 1601 and 1602 he painted three altarpieces ordered by the Netherlands regent Archduke Albert of Austria for his titular church of Santa Croce in Gerusalemme, works still rather clumsy and even gloomy. He had much to learn, but the process was rapid. When, already entrusted with delicate diplomatic missions, he was sent by the Gonzagas in 1603 with gifts to King Philips III of Spain and his ministers, the royal collection proved a revelation, especially the Venetian holdings, which were of a quality surpassing what a young artist could see in Venice without access to private palaces. Fired with enthusiasm, in Spain he produced his most important work to date, the *Equestrian Portrait of the Duke of Lerma* (Madrid, The Prado), in which he created a type of portrait with few precedents in painting, especially in the treatment of the horse as dominant dramatic pictorial element symbolizing the regal dignity and heroic virtues of the horseman. Although he himself would not often return to this type, it pointed the way to the spectacular examples by Van Dyck and Velázquez. In Mantua he could study another great collection with works by Mantegna, Correggio, and Mannerists like Giulio Romano. In the very large *Gonzaga Family in Adoration of the Holy Trinity* (Mantua, Palazzo Ducale) he painted for his Mantuan patrons the influence of both Raphael and Michelangelo is strong as regards the holy figures while, in the likenesses of the Gonzagas, one sees the impression left on the young artist by the huge official canvases in the Venetian ducal palace; and already there is a special pomp that was his alone. He accompanied the Gonzagas to Genoa in 1606, where he painted a number of official portraits, managing to draw also many of the most notable palaces which, in 1622, he would publish in engraving. His most important task in Italy, however, was in Rome in 1605, the high altar of the Oratorians' Chiesa Nuova (now Grenoble, Musée des Beaux-Arts), a work in which his

new Baroque style was given free rein and, for the first time, all the disparate Italian influences were brought into a personal unity. By the time he had to return home in 1608 the Venetians had made a lasting impact on him with their rich color, public pomp and circumstance, and self-assured way of dealing with compositions on the largest scale. The Bolognese Carracci had given him a new grace and elegance, Caravaggio a new feeling for the shaping of forms by contrasts in light and dark. Rome and its Michelangelos gave him a sense of the mightiness potential in the nude body but also a first-hand acquaintance with ancient classical sculpture from which, for the rest of his life, he would draw inspiration as well as models for so many of his entirely unclassical figures. From the Northerners resident in Rome, Elsheimer and Brill, he had gleaned a new approach to nature.

Returning to bourgeois commercial Antwerp at the age of thirty-one after having frequented the great of the world, Rubens was deluged with commissions. They could only be fulfilled by setting up a large workshop of assistants which he soon got to running factory-smooth and that would be able to get the best from talents like Jordaens, Van Dyck, and Snyders. Within a year the Regents named him court painter with the privilege of continuing to live in Antwerp, and that same year he married Isabella Brant, the eighteen-year-old daughter of a legal official. Two great assignments put all his new powers to the test, a *Raising of the Cross* in 1610-11 and a *Descent from the Cross* in 1611-14 (both now Antwerp Cathedral), the first with its audacious composition, Michelangelesque figures, and *horror vacui*, the second with a greater concentration and almost classical equilibrium despite its emphasis on the diagonal: the two paths that his subsequent stylistic development would take. The first of a number of major cycles was produced in 1618, oil sketches commissioned by a group of Genoese patricians for a tapestry cycle on the history of the Roman consul Decius Mus (Vaduz, Collection of the Reigning Prince of Liechtenstein). While these demonstrate Rubens' remarkable store of classical and archaeological erudition, it remains an unanswered question whether the designs and their execution were not entrusted, in whole or in part, to the precocious Van Dyck. On 29 March 1620 Rubens signed a contract with the Jesuit to decorate their Antwerp church, an enormous undertaking – thirty-nine ceiling paintings and three full-size altarpieces – which strained the resources of his workshop. With this he proved to himself and future patrons his ability to carry through such a demanding project, and to the Jesuits that they had at last found the artist who could create

the imagery to communicate their often intellectually knotty ideas.

The most flattering of his commissions, though it proved also the most challenging and eventually frustrating, came in 1621 with the contract for a cycle of large canvases on the life of Maria de' Medici, the widowed and much harassed queen of France. That royal patroness became his fast friend, he her loyal supporter who championed her in high places even years later when she was driven into exile. Here his powers of narration were put to the test. The burden of the twenty-four paintings was political, and their designing and execution were constantly harried by intrigues taxing even his diplomatic talent and patience. That was the same year that he began to be involved, overtly, in top-level diplomatic negotiations, and Richelieu and Louis XIII had reason to worry about the *entente cordiale* between the Queen and her painter.

There were personal trials though: the death of his oldest daughter Clara Serena in 1623, of Isabella Brant in 1626, the onset of the gout that would lame him for the rest of his days. In his fifties Rubens began to look to a quieter life. First, though, there was another major missions, this time to England. The peace treaty between that Protestant kingdom and Catholic Spain owed much to him. As a reward he was knighted by Charles I (he had already been ennobled by the King of Spain in 1624), given an honorary degree at Cambridge, and sent home laden with gifts. The real break came only in 1633 with the unsuccesful negotiations between the Southern Netherlands and Holland. Discouraged, he asked to be relieved of such duties. Further, with the death of the regent Isabella in the same year his closest personal tie to politics was lost. Then too, in 1630 he had taken a second wife, the sixteen-year-old Helena Fourment, who came from a prosperous burgher family and was a relative of his first wife. Besides the three children from the first marriage, he now fathered another five, though not all of the eight survived. Already owner of eight houses in Antwerp, among them one that any patrician could envy and doubtless did, in 1635 he purchased for 93,000 guilders a palatial domain and country house at Steen with its magnificent parks and allées.

The great tasks in painting never let up. Besides a crowded succession of mythologies, *galant* genre scenes, religious pictures, and portraits not only of royals but also of his friends and associated among the humanists and of his well-fleshed young wife, clothed or not, there were designs in 1627 for another major tapestry cycle, *The Triumph of the Eucharist*, ordered by the regent Isabella for the Discalced Carmelites in Madrid and in which the master Baroque painter could deploy all his skill and knowledge in devising allegorical images for this statement of Counter-Reformatory principles. But this was capped by the set of monumental ceiling paintings on even more complex political allegories glorifying Charles I in his royal banqueting hall at Whitehall. Here the painter exercised his own royal prerogative and prepared the canvases at home in Antwerp without returning to London, not even to see their installation when he finished them in 1634. In that year a new regent was named for the Netherlands, Cardinal-Infante Ferdinand, brother to the Spanish king. For his entry into Antwerp on 17 April 1635 Rubens and his workshop were charged with designing all the vast panoply of decorations in every form and medium that celebrated this presumably joyous event with a complexity of symbols, allegorical motifs, mythological allusions, and emblems no longer easy for us to unravel. Some of the sketches have been preserved (in Vienna, Dresden, and Leningrad), and when Rubens was confirmed as court painter in the following year the new regent made him a gift of certain of them. Though this kind of art is ephemeral, executed in materials not selected to last, we know the triumphal arched that were the main adornment of the ceremony through forty copperplate engravings published by Theodoor van Thulden in 1641 and 1642. The last great commission was for something rather gayer and bucolic, a cycle of paintings illustrating the *Metamorphoses* of Ovid along with a complement of hunt and animal pictures, a total of 130 paintings, mostly small, to decorate the Torre de la Parada, the hunting lodge of King Philip IV of Spain. Not all were executed by Rubens himself (many were done by Jordaens) but some fifty sketches from his hand survive along with about forty of the paintings (dispersed in Madrid, Brussels, Bayonne, and elsewhere) and they make a charming farewell from a painter whose grandiosities can, it can be confessed, be at times exhausting.

For all the incessant work and his crippling illness Rubens' last years in the company of an attractive young wife were happy, and he even made time to paint landscapes for his own pleasure. His painting became freer and at the same time even richer, with a new sensuousness freed at last of the strain of grossness that runs through much of his enormous production of something like 3000 works. He could look back on a life in which sovereigns accepted him as equal, on a career in which he had imposed his mark on Flemish art so powerfully that few could escape an

influence which, except with rare talents like Jordaens and Van Dyck, could lie like a heavy hand on others' creative gifts. It was in later generations and in other countries – most especially in France in the centuries of Watteau, Fragonard, and Delacroix (even Cézanne tried his hand at it) – that his extraordinarily universal yet personal genius inspired styles very different and yet indebted to his. Plates 119-121, 122, 123, 124, 125, 125a, 126, 127, 128, 129, 136.

Ruisdael, Jacob van, born 1628/29 in Haarlem, buried there on 14 March 1682. Dutch landscape painting reached its highest point in the work of this artist trained first by his farther, Isaack van Ruisdael, and soon thereafter by his uncle Salomon van Ruysdael and by Cornelis Vroom. He was admitted to the Haarlem guild in 1648, but his first known works, views of wooded dune landscapes in the vicinity of Haarlem, date from two years earlier. After 1650, with his friend Nicolaes Berchem who often painted the staffage figures in his landscapes, he traveled in the border regions of Holland and Germany where he came to know the heavily wooded hilly landscapes with castles, watermills, rivers, and gnarled trees that would be his subject fot the rest of his life. As a consequence of that journey he painted numerous views of Bentheim Castle in which faithful depiction is limited to the castle itself, while everything around it is transformed into an imaginary setting redolent of a romantically heroic mood. Another favorite topographical subject throughout his life was the distant view of the broad flatlands around Haarlem. That his interest, like that of the other Dutch landscapists, had little to do with real scenes is testified by the dramatic role in his compositions assigned to great tree trunks either rising heroically at one side or shattered and lying athwart the foreground.

After Ruisdael settled permanently in Amsterdam around 1656 his compositions took on greater spatial depth and became more balanced, with the most diverse landscape formations plastically modeled through carefully observed gradations of light and shade. The sky with its cloud formations took on an ever more important function, mirroring the silhouette of the terrain and accentuating key motifs here and there. But, as with his fellow Dutch landscapists, rendering of reality was not the aim. Thus, typically, in his *Jewish Cemetery* (the version of around 1660-70 in Detroit, Institute of Arts, that of 1670 in Dresden, Gemäldegalerie) dead trees, ruins, and a storm convey the moral message of the uncertainty and impermanence of all things earthly.

The gloomy and sometimes even tragic drama of much of Ruisdael's mature work is indebted to the Norwegian experience of Allaert van Everdingen. His own art had a lasting influence that extended into the nineteenth century, especially on such a Romantic painter as Caspar David Friedrich. Of his immediate followers, the most gifted was Hobbema. Plates 174, 175, 176, 177.

Ruysdael, Salomon van, born between 1600 and 1603 in Naarden in Gooiland southeast of Amsterdam, buried in Haarlem 3 November 1670. As landscape painter, Ruysdael, together with Jan van Goyen, set the direction of the tonalistic phase of Dutch nature painting in which broken tones are subtly and carefully juxtaposed and attuned, but his work was not without importance also for the rise of the classical style after 1650. He is recorded as entering the Haarlem guild in 1623, but nothing is known of his training. His earliest surviving pictures date from 1626-27 and show a close relationship with those of Esaias van de Velde, and there was influence too from the dune landscape pictures of Pieter de Molyn.

Only around 1631-32 did Ruysdael find his personal style. His major theme became the riverscape laid out on a diagonal scheme, and the pictures of that phase are easily confused with those of Jan van Goyen.

In everything he did there is a peaceful, gently balanced mood and composition as well as meticulous treatment of details, and all of it in cool greens, yellows, and grays. After 1640 he often turned to marine painting, though mostly of freshwater expanses. The similarity to Van Goyen declined around 1645 when Ruysdael, with the rise of the new classical landscape style, drew closer to his nephew Jacob. Entirely exceptional among his works, there are a few still lifes after 1660. Plate 170.

Saenredam, Pieter Jansz., born 9 June 1597 in Assendelft near Haarlem, buried 31 May 1665 in Haarlem. In the work of this major architectural painter, draftsman, and etcher, the accurate and no longer fanciful depiction of buildings became a new specialty. Working with his own ingenious method for precise rendering of his subject, from around 1640 he achieved a convincing spatial illusionism and at the same time brought new emphasis to details, using increasingly lighter colors and exploiting light in his interiors to bring out the architectonic elements. Yet simple comparison with the original buildings shows how imaginative and free his approach was. His influence on Dutch architectural painting was of key im-

portance, especially on painters like Emanuel de Witte. Plates 185, 186.

Savery, Roelant, born 1576 in Kortrijk, died 25 February 1639 in Utrecht. This Flemish painter of landscapes, animal pictures, and still lifes brought to Holland the Late Mannerist Flemish style that had developed under the influence of Gillis van Coninxloo. Savery worked not only in such commercial and middle-class centers as Amsterdam and Utrecht but also at the imperial courts of Vienna and Prague where he was court painter to Rudolph II. On his trips undertaken at the Emperor's behest he studied the mountainous regions of Bohemia and the Tyrol. To motifs gleaned there he added his observations of exotic animals in Rudolph's zoological gardens, so that one finds among his works not only flower pieces but also bizarre landscapes and fantastic views swarming with exotic birds and animals (even the now extinct dodo!). Unlike those of his contemporaries, Savery's paintings of flowers and animals rarely so much as hint at the usual quasi-religious *vanitas* symbolism and are mostly willful fantasies to the Emperor's taste, though sometimes in their very Mannerist way contrasting the serene idyll of the animal world with the cruelty of humankind as embodied in biblical or mythological episodes acted out by tiny, often almost unnoticeable figures. His drawings likewise are of some importance. Plate 100.

Scorel, Jan van, born 1 August 1495 in Schoorl near Alkmaar, died 6 December 1562 in Utrecht. Painter, architect, engineer, humanist, even at one point papal official, Scorel was among the major representatives of the current that introduced the ideas of the Italian Renaissance and an appreciation of Antique art into the northern Netherlands. After completing Latin school he was apprenticed to Cornelis Buys the Elder (d. before 1524) in Alkmaar and by 1517/18 was already active in Utrecht in a style indebted to Jan Joest van Calcar. In 1519 he set out on a voyage that took him through Carinthia, then to Jerusalem, and finally to Italy. In this period he brought a new clarity to his artistic means and came to view nature as a well-ordered world-landscape.

In Rome, where the Dutch Pope Hadrian VI made him curator of the collection of antiquities in the Belvedere, he studied the works of Raphael, Michelangelo, Marcello Fogolino, and Andrea Previtali. After returning to Utrecht in 1524, between 1525 and 1527 he painted a Palm Sunday triptych (Utrecht, Centraal Museum) which unites an almost exact topographical rendering with unmistakable

reminiscenes of Michelangelo in the arrangement of the figures. His subsequent *Presentation in the Temple* (Vienna, Kunsthistorisches Museum) testifies to his full mastery of the Italian Renaissance style. As a portraitist perhaps his finest achievement is that of his wife *Agatha van Schoonhoven* done in 1519 (Rome, Galleria Doria). Although his altarpiece of 1540 showing the history of the True Cross (Breda, Groote Kerk) boasts a daring form of composition, it already suggests a certain fatigue in execution. Among Scorel's most important pupils were Anthonis Mor and Maerten van Heemskerck, the latter being also his close collaborator. Plates 73, 74.

Seghers, Daniel, born 3 December 1590 in Antwerp, died there 2 November 1661. After his father died, his mother converted back to the Calvinist faith in which she was born and took the eleven-year-old to live in Holland. With five years of training as an artist behind him, Seghers returned to Antwerp in 1610 to study with Jan Bruegel, who not only taught him his own skills but saw to his reconversion to Catholicism. Three years after being admitted to the guild as master in 1611, the young artist joined a Jesuit sodality and then the Society itself whereupon he went off to Rome for two years during which he was given complete freedom to paint, even collaborating with no one less than Domenichino on one of those religious images enclosed in a garland of flowers (Paris, The Louvre) that were to be his chief contribution to art and lifelong preoccupation. Back in Antwerp, his flower paintings brought him and his religious house such fame that he was visited by the great of the world, not only the powers regnant in the Low Countries but even Charles II of England, and by admiring artists like Rubens and Jordaens. His pictures were produced not for money – attempts to buy them always ended in embarrassment – but as gifts to be given by the Order to royalty and Church dignitaries, and the artist was lavishly rewarded with personal gifts of jeweled gold crosses and the like, sometimes of such value as to embarrass *him*. Most of his flower pieces took the form of a garland around a cartouche framing a religious image, classical subject, epitaph, or portrait executed by other artists, often of the importance of Rubens. Plate 217.

Seghers, Hercules, born about 1589/90 probably in Haarlem, died before 1638 in The Hague or Amsterdam. As painter and etcher he was the most important and most advanced Dutch landscapist before Rembrandt, who in fact admired him greatly and acquired several of his works which did not fail to have

their influence on his own. Seghers was a pioneer in etching as well, experimenting in techniques and materials that pointed the way to modern color engraving. Chronically impoverished and, it is reported, just as chronically drunk (his death was attributed to falling down stairs one night when he returned home in more inebriated condition than usual), the cost of such experiments depleted his means disastrously.

Seghers studied with Gillis van Coninxloo in Amsterdam until 1606, learning much from the works of Adam Elsheimer and Joos de Momper. His landscapes are mostly in bird's-eye perspective, and figures are either absent or insignificant. Few artists have matched him, especially in his late works, in the art of conveying such moods as loneliness or melancholy in landscape. His influence extended not only to Rembrandt but also to artists like Jan van de Velde, Salomon van Ruysdael, Jan van Goyen, and Aert de Gelder, and in the expression of feeling he can be considered a forerunner of a Romantic like Caspar David Friedrich. Plate 146.

Snyders, Frans, (also Snijders) baptized 11 November 1579 in Antwerp, died there 19 August 1657. Snyders ranks as the chief master in the monumental style of Flemish still-life and animal painting that took its cue from Rubens. His teachers were Pieter Bruegel the Younger and Hendrik van Balen, and he became a protégé of Jan Bruegel, who ensured him the favor of the art-loving Cardinal Federico Borromeo during his sojourn in Italy between 1602 and 1609. A still-life painter from the start, Snyders reached his artictic maturity about 1617 under the influence of both Rubens and Abraham Janssens for whose paintings he supplied still-life details. It was Snyders who created in Flanders an equivalent in animal pictures and still lifes of the monumental style of Rubens with its broad compositions and vivid color. He was responsible for a new type of picture in which those two specialties were combined, with dead game and fowl piled on tables with rich tableware in the presence of live monkeys, birds, or dogs. In addition, he developed further the hunting picture and was himself responsible for the animals so conspicuous (often irrelevantly, one thinks) in many of Rubens' most famous compositions. His followers include Paul de Vos (1596-1678), Adriaen van Utrecht (1599-1652/53), and his most gifted pupil Jan Fyt (1611-61) who, in originality of concept and treatment as well as sensitivity to color and texture, often surpassed his teacher. Plate 132.

Steen, Jan, born 1626 in Leyden, buried there 3 February 1678. The life of this much appreciated genre and subject painter is not well documented. As oldest son of a brewer Jan Steen could afford to enroll in 1646 in the glorious local university. Yet two years later he is found among the founding members of the Leyden painters' guild. There is much argument over whether he studied with the German artist Nikolaus Knüpfer in Utrecht between 1640 and 1646, but he does seem to have worked with Adriaen van Ostade in Haarlem and Jan van Goyen in The Hague where he is in fact documented between 1649 and 1654. He married one of Van Goyen's daughters and in 1654 leased a brewery in Delft which, however, he was forced to give up three years later for lack of succes. From 1661 to 1670 he was in Haarlem, then after the death of his wife he returned to Leyden where he joined the guild of which he eventually became an officer and dean.

Steen's rich and many-sided work includes biblical, mythological, and historical subjects besides the genre scenes on which his fame rests, but no real portraits or independent landscapes. There is a good pinch of irony in his works, especially those in which human habits and weaknesses are the main subject, notably in tavern or family scenes and in pictures illustrating proverbs or allegories (which were understandable to everyone at the time though they may remain enigmatic for us). For their animation and vitality these pictures are indebted to the free brushwork and lively coloring Steen took over from Frans Hals. Although most noted for his robust and somewhat obvious scenes of ordinary life, he was capable occasionally of more circumspect and quieter pictures whose elegance recalls even such a fine artist as Pieter de Hooch. Plates 196, 197, 198.

Sweerts, Michiel, born 1624 in Brussels, died 1664 in Goa. Sweerts was influenced on the one hand by Pieter van Laer, on the other by Caravaggio. He lived in Rome between 1646 and 1656 where he produced numerous pictures of folk life. When he returned to Brussels it was to produce mainly portraits and etchings. After a brief stay in Amsterdam he left for the Orient with a group of missionaries, and it was there that, much too early, this sensitive and often touching artist ended his life when abandoned by the missionaries, who disapproved of his character. Plate 192.

Teniers, David the Younger, baptized 15 December 1610 in Antwerp, died 25 April 1690 in Brussels. A major Flemish genre painter, Teniers left an enormous body of works which has been padded out even more with wrongly attributed paintings by his school, contemporary copies, and graphic reproductions right through the eighteenth and nineteenth centuries. In his own time and the next century his peasant scenes even

found their way into tapestries of fine manufacture. He learned his art from his father, David Teniers the Elder (1582-1649), and in 1632 or 1633 he became master in Antwerp, in 1645 dean of the local guild. In 1651 he moved to Brussels where Archduke Leopold Wilhelm had appointed him court painter and curator of the art collections.

His earliest genre pictures, such as the *Peasant Festivity* of 1637 (Madrid, The Prado), were done under the influence of Adriaen Brouwer, his first landscapes under that of Jan Bruegel (his father-in-law) and Paul Bril. Around 1640 he found his own style, with a brighter overall tone and warmer coloring. His range of subjects expanded beyond peasant scenes to include magicians and witches, doctors and alchemists, and sometimes the human figures were replaced by costumed cats and monkeys. But he also dealt with biblical, mythological, and literary subjects, allegories, contemporary events, and individual and group portraits, and highly detailed views of the art galleries of which he was curator. Grown wealthy and full of ambition in his late years, his reputation kept up while his art declined. Plate 133.

Terborch, Gerard (Gerrit ter Borch), born in late December 1617 in Zwolle, died 8 December 1681 in Deventer. With him, beginning around 1650, Dutch interior and genre painting for the first time took on its specific character. In his interior scenes, which are limited to a few figures and are much in the manner of the "fine style" of Leyden, the emphasis is on rendering fine materials with changing light reflections. A static treatment of the setting or, individual portraits, a monochrome background lends his pictures a certain dignity and repose in which an insightful psychology replaced narrative incident and serves to convey the thought behind the picture.

Terborch's first training was with his father, then between 1633 and 1635 with the landscape artist Pieter de Molyn in Haarlem. After traveling in England, Italy, and Spain, Terborch returned to Holland in 1640 to produce pictures whose themes were much indebted to such genre painters as Pieter Codde, Jacob Duck, and Willem Cornelisz. Duyster. After moving about several times he finally settled down in Deventer in 1654 where he soon produced two of his best known works, the mistitled *Parental Admonition* now recognized as a brothel scene (two versions: Amsterdam, Rijksmuseum, and Berlin-Dahlem, Gemäldegalerie) and the *Lady Washing Her Hands* of around 1655 (Dresden, Gemäldegalerie). Around 1660 portraiture again came to the fore with him, though his full-figure likenesses retained certain genre-like

traits. In these he showed members of the distinguished burgher society in conversation or making music, the gentlemen assuming dignified poses, the ladies in their finest gowns. His refined approach was carried further by his favorite pupil Caspar Netscher and others. Plates 200, 201.

Terbrugghen, Hendrick, born 1588 in the vicinity of Deventer, buried 9 November 1629 in Utrecht. Along with Dirk van Baburen and Gerard van Honthorst this genre and figure painter ranks as the major Caravaggist of the Utrecht school. As a boy he had his first lessons in painting from Abraham Bloemaert, the leading master of the late phase of Netherlandish Mannerism, then from 1604 to 1614 was in Italy, chiefly in Rome, where he became deeply impressed by Caravaggio. He returned to Utrecht and entered the guild there in 1616. At first his art was poorly received. The first picture known to be from his hand, a *Crowning with Thorns* (Copenhagen, Statens Museum für Kunst) dates from 1620, and the next year he produced a *Calling of Saint Matthew* (Le Havre, Musée des Beaux-Arts), paintings still marked by Mannerist traits but already pointing to a power of conception and expression new in Dutch art. Whatever the subject – Old or New Testament episodes, scenes of martyrdom, young musicians, soldiers, women of dubious virtue – in his mature works the figures take on an unprecedented monumentality and powerful expressive force. The naturalistic aspect becomes almost abstracted, raised to a new poetic level through a subtly nuanced chiaroscuro which is more delicate and lighter in color-spectrum than that of his original inspirer Caravaggio. Plates 104, 106.

Valckenborch, Lucas van, born around 1530-35 in Louvain, died 2 February 1597 in Frankfurt am Main. Among the other notable members of this family – a veritable dynasty of artists in the sixteenth and seventeenth centuries – were Lucas' uncles Frederick and Maarten and his cousin Gillis. Lucas earned the title of master at Mechelen in 1564 but because of his Calvinist sympathies was forced to flee to Liège and Aachen. This, however, did not prevent his returning to Flanders around 1570 and, seven years later, entering the service at Brussels of such a high imperial and Catholic potentate as the archduke Matthias. Four years later he accompanied his royal master to his residence in Linz in Austria and remained there until not long before his death, when he moved to Frankfurt. Mostly in small format, his landscapes – sometimes in blinding white-dotted snowstorms – and his open-air scenes with peasants

working in the fields or the nobility playing in their gardens involve mostly panoramic vistas viewed from below, thus with a high horizon, though almost always they have a factitious hilltop viewing platform in the immediate foreground peopled by often quite entertaining groups of figures. Some of these landscapes are pure fantasy, others are so topographically accurate as to serve as documents for the onetime appearance of cities like Brussels or Linz. If only a few of his pictures can be described as "pure" genre, most allot an extensive place to figures and scenes that, in the next generations, would become a familiar part of the full-blown Dutch genre art. Plate 97.

Veen, Otto van, born 1556 in Leyden, died 6 May 1629 in Brussels. This Flemish painter and engraver studied in Leyden and Liège and spent five years in Italy where, though much influenced by Federigo Zuccari, he scarcely succumbed to the lure of Mannerism but, instead, developed a classicistic style of great gravity out of an initial admiration for Correggio, as in the *Mystic Marriage of Saint Catherine* of 1589. In Brussels he enjoyed the patronage of the regent Alessandro Farnese. From 1596 to 1600 he lived in Antwerp, where the young Rubens was his pupil. His later life became embittered when he saw his large clientele rushing to that new and more up-to-date talent, and Rubens himself deplored the loss of their friendship and did his unavailing best to bridge the gap (his teacher was "not at home" when he called). Although Van Veen produced a number of large altarpieces, it was the engravings in his emblem books that left an enduring mark on the imagery and symbolic content of Netherlandish painting for the next century and a half. Plate 118.

Velde, Adriaen van de, baptized 30 November 1636 in Amsterdam, buried there 21 January 1672. A brother of Willem van de Velde the Younger, Adriaen was a prolific painter of landscapes and animal pictures as well as engraver. He studied with his father, then with Jan Wynants (1631/32-1684) in Haarlem where he also came much under the influence of Wouwerman. Although his country landscapes and a certain precision in form suggest some acquaintance with Italy, it was most likely gleaned from the sketches and paintings of other artists who had been there. Equally skilled as small-figure painter – he did an occasional religious or mythological picture – he provided staffage figures for Wynants, Koninck, Ruisdael, Van der Heyden, and Hobbema. Initially his coloring was cool, his pictorial structures simple, his lighting regular and even, but after 1660 the tones became

warmer, the lighting more richly contrasted, and the compositions more animated. Plate 172.

Velde, Esaias van de, born around 1591 in Amsterdam, buried 18 November 1630 in The Hague. Son of the Antwerp painter Anthony van de Velde (born around 1557). He was trained by Jan van Goyen and Salomon van Ruysdael. Yet his early works show him picking and choosing eclectically from the entire range of Flemish and Dutch Mannerists, from Jan Bruegel to Lastman, from the Frankenthalers to Momper. With maturity he specialized in tonally treated landscapes but also produced genre and battle scenes and supplied staffage figures for other artists's pictures. Resident in Haarlem from 1610 to 1618, he left his mark on the local school before finally settling in The Hague. Plate 162.

Velde, Jan Jansz. van de, born 1619/20 in Haarlem died 1663 or later in, perhaps, Enkhuizen. A member of the highly ramified Haarlem family of artists of that name, he was a son of the engraver Jan van de Velde (around 1593-1641) and was doubtless trained in his native town. His early works already evidence an exceptional proficiency in rendering phenomena of light, and in his mature style all colors are tuned to a basic monochrome. He painted the same objects repeatedly, and his compositions were always simple. Plate 218.

Velde the Younger, Willem van de, baptized 18 December 1633 in Leyden, died 6 April 1707 in London. This major Dutch marine painter was the son of a like-named father (around 1611-1693), who pursued the same specialty, and a brother of landscapist Adriaen van de Velde. He learned his art and all the technical matters concerning ships and navigation from his father and from Simon de Vlieger. In 1673 he and his father were named court painters to Charles II of England. His painterly virtuosity and exceptional feeling for the atmosphere of air and sea explain the admiration given to his works by Turner. Plate 183.

Venne, Adriaen Pietersz. van de, born 1589 in Delft, died 12 November 1662 in The Hague. Painter draftsman, and poet, he was apprenticed to a goldsmith in Leyden, then to the grisaille painter Jeronimus van Diest. He may have been active in Antwerp at one time, but worked chiefly in Middelburg and The Hague, entering the guild of the latter in 1625 and becoming its dean in 1637. A specialist in portraiture and genre scenes of folk life, and in at least two cases the author of complex political allegories, in the

course of time he increasingly abandoned strong local coloring for grisaille. Plate 160.

Vermeer, Jan, baptized 31 October 1632 in Delft, buried there 15 December 1675. Son of an innkeeper and picture dealer in Delft, a town stil prosperous but already in decline compared with its neighbors, Jan Vermeer was made master in the guild in 1653 but – sign of things to come – was already in arrears in his dues. In the same year, although himself a Calvinist he married a young woman from a wealthy Catholic family of Gouda, first with a civil and then a Catholic ceremony. Some writers take this to suggest that he embraced the old faith – a supposition given some support by the overtly Catholic symbolism of his last major painting, the *Allegory of the Christian Faith* of around 1670 (New York. Metropolitan Museum of Art) – but this is contradicted by his burial in the Calvinist Oude Kerk in Delft. With his father's death in 1655 Vermeer took over both paternal businesses but seems never to have done well in either. Nor, indeed, in his own profession. He worked slowly and produced little, though perhaps this was because of the time he had to devote to other activities than painting in order to support a rapidly growing family. He was forever in debt, forever taking loans both petty and important; five months before he died there was a final one, for the considerable sum of 1,000 florins. Yet we know too little of his life and his way of working to be able to explain such a limited production – a mere thirty-six pictures certain to be from his own hand, plus a few others. Jan Steen was an innkeeper too, and likewise never too solvent, yet he left enough paintings for every museum in the world today. But in 1663, Vermeer's busiest period, when Balthasar de Monconys, counselor to the French crown, visited Delft he found not a single picture in Vermeer's studio and only one in the house of a neighbor, a baker who had in fact paid a very good price for it (600 florins as against the 100 Rembrandt received for the so-called *Night Watch*). In 1696, long after his death, twenty-one of his paintings (including those most famous today) appeared in a single art auction, which suggests that they had all come from one collection, probably that of some Delft citizen, and that the artist sold few if any pictures outside his native town. Be that as it may, most of his story consists of no more than sums inherited and sums borrowed. His wife reported, after his death, that when the French sacked Holland in 1672 her husband "was able to paint little or nothing," and was forced to sell off his dealer's stock of pictures at a loss for ready cash. He died at the young age of forty-three, leaving eight under-age children of a total

of eleven. A year later his widow had to file a declaration of insolvency but fought to withhold his works from forced sale, though two of them (now among the most famous) had to be surrendered to pay off the baker and another to repay a loan from her own mother.

His teachers are not known, though Leonaert Bramer (1596-1674), a master at a highly personal dramatic use of chiaroscuro which is only superficially like Rembrandt's, did intercede with Vermeer's wife's family in favor of the inter-faith marriage and may have taught him. His early works, up to about 1660, show influence from the Utrecht Caravaggists and then, some think, from Carel Fabritius (among Vermeer's possessions at his death were three paintings by that highly individualistic Rembrandt pupil). From the start, even with a mythological subject like the *Diana and her Companions* of 1654 (The Hague, Mauritshuis), his way was set toward assimilating all subjects to the contemporary Dutch bourgeois milieu.

Yet only the early *Procuress* (Dresden, Gemäldegalerie) among all of his works has a tinge of that super-vitality and lust-for-life often associated with Dutch genre painting. Thereafter, even in scenes of dubious morality, there is an all-pervading calm, an intimate repose, a classical control of every element and aspect of composition and technique: the utterly serene *Little Street* or the *View of Delft* (his only outdoors pictures after that first *Diana*) are fixed forever in an instant's silent immobility, but so too are his gentlemen callers, woman making music or reading letters, housemaids pouring milk. This immobility – a later age would sense something Surrealist in it – introduce a troubling ambiguity into the relations between the couples conversing in neat parlors and into the simplest actions performed by isolated personages – weighing pearls, studying maps, playing the guitar or virginals, making lace, or simply looking out at us with an air of infinite yet challenging secrecy. Little or nothing in these pictures is as it seems. The simplest act or relationship conceals a moralizing or allegorical meaning, whose clue is often to be found in the pictures or maps on the walls. Ostensibly ladies and gentlemen, more often than not the personages are not at all what they seem, and there is often an undercurrent of sexual innuendo difficult to define but easy to sense.

A large part of this aesthetic ambiguity comes purely from the means of art: from the compression of space into the angle of a room where light streams in from a window in a wall perpendicular to us (so consistently at the left that even when he does not paint this window wall we know it is there); from, at the

same time, an enigmatic expansion of that same small space by making figures or objects in the foreground so large with respect to those in the background that they cannot belong to the same system of perspective and never cease to worry us once we become aware of the anomaly; from a light whose sourced is always obvious, yet which takes on an unreality from the way it is diffused through the room to make a crystalline atmosphere; from paint which is applied meticulously and with a supersensitivity to the finest gradations and differences of texture in materials, yet breaks color into light by a pointillism where dewlike droplets of lighter-hued paint dot a color surface, make it glisten as if itself it contained the light, create broken reflections one senses more than sees, and, in the only landscape by Vermeer, the *View of Delft,* make us feel the moistness that permeates the Dutch atmosphere in cloud or sun. A unique artist, not one to have pupils or followers, he remained long forgotten or little appreciated. How rare an artist he is, and how refined, is clear when one thinks that it took a Marcel Proust to restore him to his rightful place in Netherlandish art. Plates 208, 209, 210, 211, 212, 213, 214.

Vermeyen, Jan Cornelisz., born around 1500 in Beverwijk near Haarlem, died 1559 in Brussels. A pupil of Jan Gossaert in Utrecht, Vermeyen was appointed court painter to the regent Margaret of Austria in Malines in 1525. Later he went with Emperor Charles V on the Tunis expedition and, at his orders, to Spain also. From 1545 to 1548 he worked on the cartoons for a tapestry series on the Tunis venture (Vienna, Kunsthistorisches Museum). His style is marked by an animated use of light and shade along with firm modeling. He portrayed rulers and notables but also painted narrative and genre pictures and did much important engraving. Plate 84.

Verspronck, Johannes Cornelisz., born 1567 in Haarlem, buried there 30 June 1662. After the first lessons in painting from his father Cornelis Engelsz., he had subsequent training from Frans Hals. In the course of the 1640s his initially somewhat graceless treatment of forms and his brilliant and strong coloring became rather more refined, and in his late style there is much of Rembrandt's influence and a subtly gradated chiaroscuro. Plate 116.

Vos, Cornelis de, born 1584 in Hulst in Zeeland, died 9 May 1651 in Antwerp. He was a brother of the animal painter Paul de Vos and brother-in-law of Frans Snyders, and while he did narrative paintings his special gift was for portraiture, of children in par-

ticular. He had a masterly feeling for bringing out nuances of character, and characteristically gave much emphasis to his sitter's gaze. Plate 135.

Weenix, Jan, born after 1640 in Amsterdam, buried there 19 September 1719. Son of the brilliant landscapist and dead-game still life painter Jan Baptist Weenix who had worked in Italy and was closely associated with Nicolaes Berchem, Jan Weenix profited from his father's instruction. Together with his cousin Melchior d'Hondecoeter he became the leading and most successfull painter of dead-game still lifes in his generation. His works show an astonishing realism of detail linked with broad treatment of composition. In 1664 he joined the St. Luke's Guild in Utrecht where he is documented for the next four years, then moved to Amsterdam and came very much under the influence of the painstaking approach of the still-life painter Willem van Aelst. Between 1702 and 1712 he produced a unique achievement, an enormous ensemble of very large game pieces to decorate the castle at Bensberg of the Elector Palatine Jan Willem (now Munich, Alte Pinakothek and Bayerische Staatsgemäldesammlungen). Plate 223.

Weyden, Rogier van der, born 1399/1400 in Tournai, died 18 June 1464 in Brussels. In range of undertakings and subjects Van der Weyden scarcely went beyond the traditional framework laid down by Jan van Eyck, painting chiefly altarpieces, small diptychs, devotional pictures, and half-length portraits. In 1427 he began study with Robert Campin in Tournai and five years later was admitted to the local guild as free master. Soon thereafter he moved to Brussels, his wife's birthplace, without however breaking off entirely with Tournai. In his new home he carried out commissions for the city, court, monasteries, prosperous patricians, and Italian merchants. In 1450, a Holy Year, he traveled to Rome and there received lasting impressions of Italian painting. He himself attained no small prosperity, and in his lifetime enjoyed international repute. The first sure work from his hand, and the basis for all further attributions, is a *Descent from the Cross* of around 1435 (Madrid, The Prado), though his earliest works are thought to be two paintings of the *Virgin and Child* from 1430/32 (Lugano, Thyssen Collection; Vienna, Kunsthistorisches Museum). Along with influence from Campin, certain traits of Van Eyck are recognizable, particularly the important role allotted to the architectural framework and to certain motifs. The latter influence is obvious also in the way Rogier simply took over the entire plan of the *Virgin with the Chancellor Rolin* for his *Saint*

Luke Painting the Virgin which survives only in replicas (the best in Boston, Museum of Fine Arts).

The *Descent from the Cross* (Madrid, The Prado) is the earliest expression of Rogier's entirely individual approach and can be taken as key to all of his subsequent output. A significant further innovation in overall conception appears in an altarpiece done for the monastery of Miraflores near Burgos (Berlin-Dahlem, Gemäldegalerie). New here is the linkage of landscape elements with ecclesiastical architecture reduced to mere framework, while the figures are brought forward into the most immediate and shallow plane. A similar conception, dating however from after 1450, is found in a triptych with scenes from the life of John the Baptist (Berlin-Dahlem, Gemäldegalerie).

The Italian journey of 1450 brought a change in Rogier's work. A direct and deep-ranging change in style weakened his ties to the Netherlandish tradition, as can be seen in a *Crucifixion* triptych (Vienna, Kunsthistorisches Museum) and the large polyptych on the *Last Judgment* commissioned by the chancellor Nicolas Rolin (Beaune, Hôtel-Dieu), but also in other works of the time such as the so-called Braque Altarpiece (Paris, The Louvre), the so-called *Medici Madonna)* Frankfurt, Städelsches Kunstinstitut), and especially the *Entombment of Christ* (Florence, The Uffizi).

Among the most important works by Rogier are two triptychs on the theme of the Nativity. The earliest, the so-called Bladelin or Middelburg Altarpiece (Berlin-Dahlem, Gemäldegalerie) must date from before 1450. The central panel shows Joseph and Mary and the donor adoring the Child, the left wing has the Tiburtine Sibyl revealing the Mother of God to Emperor Augustus, on the right wing the three Magi are told of the birth of Christ by a star in child's guise: thus an allusion to the worldwide significance – East and West – of the Coming. A number of iconological aspects are brought together: a Romanesque column as symbol of the Old Covenant, a burning candle whose flame is dimmed by the divine light, a view of Middelburg Castle in the background, and so on. In the Columba Altarpiece (Munich, Alte Pinakothek), dating from around 1460 and therefore among the artist's last works, certain compositional problems still troublesome in the Middelburg Altarpiece – a clumsy relationship between manger and landscape, the donor's position in the picture – are masterfully solved. Almost nothing survives of whatever non-religious painting was done in the Netherlands of this period, and Van der Weyden's works are no exception, though we do have a number of truly great portraits.

Rogier's virtually classical treatment of form explains why this art was taken as model throughout Europe and why many of the types of figures he created were widely imitated. Hugo van der Goes, Dirk Bouts, and Hans Memling were all indebted to him. Plates 18, 19, 20, 21, 23, 24, 25, 26.

Witte, Emanuel de , born around 1617 in Alkmaar, died early in 1692 in Amsterdam. De Witte brought the specialized depiction of church interiors to a high point, conveying the religious atmosphere by skillfully harmonizing architectural elements, figure groups, and lighting along with an extremely refined use of color. The most difficult problems of perspective did not daunt him, and he adroitly combined features of numerous churches into what was pure invention (except in the case of the Amsterdam Oude Kerk, which he rendered faithfully), and in this he differed from Saenredam. De Witte is found in Delft from 1641 to about 1650 or 1651. He began as apprentice or master student of the Delft still-life painter Evert van Aelst (1602-1657), and in his early years, between 1644 and 1647, painted a number of portraits (most of them in Rotterdam, Museum Boymans-van Beuningen). Only late in that decade, under the influence of the older Delft architectural painters Gerard Houckgeest and Hendrick van Vliet, did he begin to concern himself with that specialty. Sometime around 1650 he moved to Amsterdam where his fortunes did not prosper. Increasingly crushed by debts, he ended his life by throwing himself into a canal. Besides church and synagogue interiors he produced some pictures of Amsterdam business life and of fish markets. Plate 187.

Wouwerman, Philips, baptized 24 May 1619 in Haarlem, died there 19 May 1668. A highly successful painter of horses and battles, he left behind more than a thousand pictures. His first lessons were with his father, the history painter Paulus Joosten Wouwerman, and he may then have studied with Frans Hals. At first he concentrated on peasant genre pictures but gradually expanded his range to include horsemen, battles, camp scenes, and episodes on county roads. At the same time he more and more abandoned his initial brownish tones in favor of lighter colors. No doubt a decisive influence in his career came from Pieter van Laer who returned to Haarlem in 1638. Almost a trademark in Wouwerman's pictures is the inclusion of a white horse. Plate 166.

Wtewael, Joachim Antonisz., born around 1566 in Utrecht, died there 1 August 1636. After studying with

Joos de Beer (1550/51-c. 1591) in Utrecht, from 1586 to 1588 the young painter had the good fortune to live in Padua, where he could acquaint himself with the Venetian masters living and dead. For the next two years he was in Saint-Malo in France, though what he did or could do there is not known, and certainly that sojourn in a busy port town left no imprint on his art. Returned to Utrecht, he became a leading spirit in the local Mannerist school influenced by Spranger, Goltzius, and Cornelis van Haarlem, a style he continued to practice even after the fashion turned to Caravaggism. In his mostly biblical and mythological pictures (often designed as fine cabinet pieces in small format and on copper) he carried the erotic side of Mannerism to a point of exacerbation, with extreme poses frozen at the point of highest intensity and painted with utter meticulousness in clashing metallic and acid colors. Plate 103.

Suggestions for further reading

THIS SHORT LIST OF SUGGESTIONS for further reading is restricted, as much as possible, to books in English, though with full awareness that many major sources are in consequence omitted.

A

Introduction: The Golden Age of Netherlandish Painting

1 *Art in Seventeenth Century Holland*, exhibition catalogue, National Gallery, London, 1976.
2 BARBOUR, V., *Capitalism of Amsterdam in the Seventeenth Century*, Baltimore, 1950.
3 BENGTSSON, A. and OMBERG, A., *Structural Changes in Dutch 17th Century Landscape, Still Life and Architectural Painting* (Figura I), Stockholm, 1950.
4 BERNT, W., *The Netherlandish Painters of the Seventeenth Century*, London, 1970, 2 vols.
5 BLUM, S. N., *Early Netherlandish Triptychs. A Study in Patronage*, Berkeley-Los Angeles, 1969.
6 BODE, W., *Great Masters of Dutch and Flemish Painting*, London, 1909, reprinted 1967.
7 CUTTLER, C. D., *Northern Painting from Pucelle to Bruegel*, New York, 1968.
8 *Dutch Painting of the Golden Age*, exhibition catalogue, Metropolitan Museum of Art, New York, 1954.
9 *Flanders in the Fifteenth Century*, exhibition catalogue, Detroit Institute of Art, 1960.
10 FRIEDLÄNDER, M. J., *Early Netherlandish Painting*, with a preface by E. Panofsky and comments and notes by N. Veronee-Verhaegen, Leyden, 1967-76, 14 vols.
11 FRIEDLÄNDER, M. J., *From Van Eyck to Bruegel*, London, 1969.
12 FRIEDLÄNDER, M. J., *Landscape, Portrait, Still-Life. Their Origin and Development*, Oxford, 1949.
13 FROMENTIN, E., *The Masters of Past Time*, London, 1948.
14 GELDER, J. G. VAN, *Dutch Drawings and Prints*, New York, 1959.
15 GELDER, J. G. VAN, *Holland by Dutch Artists in Paintings, Drawings, Woodcuts, Engravings, and Etchings*, Amsterdam, 1959.
16 GELDER, J. G. VAN, "Two Aspects of the Dutch Baroque, Reason and Emotion" in *De Artibus Opuscula LX: Essays in Honor of Erwin Panofsky*, New York, 1961.
17 GEYL, P., *The Netherlands in the 17th Century*, London, 1961-64, 2 vols.
18 GEYL, P., *The Revolt in the Netherlands (1555-1609)*, London, 1958.
19 HOFSTEDE DE GROOT, C., *Beschreibendes und kritisches Verzeichnis der Werke der hervorragendsten holländischen Maler des XVII. Jahrhunderts*, Esslinge, 1907-28, 10 vols.; vols. I-VIII translated as *Catalogue Raisonné of the Works of the Most Eminent Dutch Painters of the Seventeenth Century*, London, 1908-27, 8 vols.
20 HUIZINGA, J., *Dutch Civilization in the Seventeenth Century and Other Essays*, New York, 1969.
21 HUIZINGA, J., *The Waning of the Middle Ages*, London, 1955.
22 JACOBS, A., *Seventeenth Century Dutch and Flemish Painters, A Collector's Guide*, Assen-Amsterdam, 1976.
23 KNIPPING, J. B., *Iconography of the Counter Reformation in the Netherlands. Heaven on Earth*, Leyden, 1974, 2 vols.
24 KUILE, E. H. TER and GERSON, H., *Art and Architecture in Belgium, 1600-1800*, Baltimore, 1960.
25 LASSAIGNE, J. and DELEVOY, R., *Flemish Painting*, Geneva, 1956.
26 LASSAIGNE, J. and DELEVOY, R., *Flemish Painting: From Bosch to Rubens*, Geneva, 1958.
27 *Life in Seventeenth Century Holland*, exhibition catalogue, Wadsworth Atheneum, Hartford, 1950-51.
28 MANDER, C. VAN, *Dutch and Flemish Painters*, New York, 1936.
29 MARTIN, W., *Dutch Painting of the Great Period, 1650-1697*, London-New York, 1951.
30 *Middeleeuwse Kunst der Noordelijke Nederlanden* [*Dutch Art in the Middle Ages*], exhibition catalogue, Rijksmuseum, Amsterdam, 1958 [with English synopsis].
31 MILLNER KAHR, M., *Dutch Painting in the Seventeenth Century*, New York, 1978.
32 MUSPER, H. T., *Early Netherlandish Painting Van Eyck to Bosch*, New York, 1980.
33 NASH, T. M., *The Age of Rembrandt and Vermeer. Dutch Painting in the Seventeenth Century*, London, 1972.
34 PANOFSKY, E., *Early Netherlandish Painting*, Cambridge, Mass., 1954, 2 vols.
35 PRICE, J. L., *Culture and Society in the Dutch Republic During the 17th Century*, London, 1974.
36 PUYVELDE, L. VAN, *Flemish Painting from Van Eyck to Metsys*, New York, 1970.
37 PUYVELDE, L. VAN, *The Flemish Primitives*, Brussels, 1948.
38 POPHAM, A., *Drawings of the Early Flemish School*, London, 1926.
39 REGIN, D., *Traders, Artists, Burghers. A Cultural History of Amsterdam in the 17th Century*, Assen-Amsterdam, 1976.
40 RICHARDSON, F. P., "The Romantic Prelude to Dutch Realism," *Art Quarterly*, III, pp. 40 ff.
41 ROSENBERG, J., SLIVE, S. and KUILE, E. H. TER, *Dutch Art and Architecture*, Baltimore, 1966.
42 *Seventeenth Century Painters of Haarlem*, exhibition catalogue, Allentown Art Museum, Allentown, Penn., 1965.
43 STECHOW, W., *Northern Renaissance Art, 1400-1600* (Sources and Documents in the History of Art), Englewood Cliffs, N. J., 1966.
44 *The Secular Spirit: Life and Art at the End of the Middle Ages*, exhibition catalogue, Metropolitan Museum of Art, New York, 1975.
45 TIMMERS, J. J. M., *A History of Dutch Art and Life*, London, 1959.
46 VON DER OSTEN, G., and VEY, H., *Painting and Sculpture in Germany and the Netherlands 1500 to 1600*, Baltimore, 1969.
47 WHINNEY, M., *Early Flemish Painting*, London, 1968.
48 WILENSKI, R. H., *Flemish Painters*, London, 1962, 2 vols.
49 WRIGHT, C., *The Dutch Painters. 100 Seventeenth Century Masters*, London, 1978.
50 ZUMTHOR, R., *Daily Life in Rembrandt's Holland*, London, 1962.

B

Early Panel Painters in the Southern Netherlands

1 BALDASS, L. VON, *Jan Van Eyck*, New York, 1952.
2 BAXANDALL, M., "Bartholomaeus Facius on Painting," *Journal of the Warburg and Courtaluld Institutes*, XXVII, 1964, pp. 90 ff.
3 BRAND PHILIP, L., *The Ghent Altarpiece and the Art of Jan van Eyck*, Princeton, N.J., 1972; revised and reprinted 1980.
4 BROCKWELL, M. W., *The Van Eyck Problem*, Westport, Conn., 1971.
5 CONWAY, M., *The Van Eycks and their Followers*, London, 1921.
6 DAVIES, M., *Rogier van der Weyden*, London, 1972.
7 DELAISSÉ, L. M. J., *A Century of Dutch Manuscript Illumination,* Berkeley-Los Angeles, 1968.
8 DHANENS, E., *Van Eyck*, New York, 1980.
9 FEDER, T. H., "A Reexamination through Documents of the First Fifty Years of Rogier van der Weyden's Life," *Art Bulletin*, XLVIII, 1966, pp. 416-31.
10 FRINTA, M. S., *The Genius of Robert Campin*, The Hague, 1966.
11 LOGRON, J., *Les Très Riches Heures*, London, 1969.
12 MEISS, M., *French Painting in the Time of Jean de Berry*, Vol. III: *The Limbourgs and Their Contemporaries*, New York, 1964.
13 MEISS, M., *The Belles Heures of Jean, Duc de Berry*, New York, 1974.
14 PANOFSKY, E., "Jan van Eyck's Arnolfini Portrait" in C. Gilbert, ed., *Renaissance Art*, New York, 1970, pp. 1-20.
15 SCHULZ, A., "The Columba Altarpiece and Rogier van der Weyden's Stylistic Development," *Münchner Jahrbuch der bildenden Kunst*, XXII, 1971, pp. 63-116.

16 *The Complete Paintings of Van Eyck*, introduction by R. Hughes, with notes and catalogue by G. T. Faggin, New York, 1968.
17 TOVELL, R. M., *Flemish Artists of the Valois Court*, Toronto, 1950.
18 TOVELL, R. M., *Roger van der Weyden and the Flémalle Enigma*, Toronto, 1955.
19 VOGELSANG, W., *Rogier van der Weyden, Pietà: Form and Color,* New York, [1949].
20 WEALE, W. H. J., *Hubert and Jan van Eyck*, London, 1908.
21 WEALE, W. H. J. and BROCKWELL, M. W., *The Van Eycks and Their Art*, London, 1912.
See also **A** 5, 7, 9, 10 (Vols. I, II), 11, 12, 13, 21, 25, 28, 32, 34, 36, 37, 38, 43, 44, 47, 48.

C

The Northern Netherlands in the Fifteenth Century

1 BOON, K. G., *Geertgen tot Sint Jans*, Amsterdam, 1967 (in Dutch).
2 *Dieric Bouts*, exhibition catalogue, Brussels, 1957 (in French).
3 SCHÖNE, W., *Dieric Bouts und seine Schule*, Berlin, 1938.
See also **A** 5, 7, 9, 10 (Vols. II, V), 11, 12, 13, 25, 28, 30, 32, 34, 36, 37, 38, 43, 47, 48.

D

The End of the Century: Ghent and Bruges

1 BERMEJO, E., *Juan de Flandes*, Madrid, 1964 (in Spanish).
2 *Gerard David*, exhibition catalogue, Bruges, 1949 (in French and Flemish).
3 LAVALLEYE, J., *Juste de Gand*, Louvain, 1936 (in French).
4 MCFARLANE, K. B., *Hans Memling*, New York, 1972.
5 THOMPSON, C. and CAMPBELL, L., *Hugo van der Goes and the Trinity Panels in Edinburgh*, Edinburgh, 1974.
6 WEALE, W. H. J., *Hans Memling*, London, 1901.
7 WINKLER, F., *Hugo van der Goes*, Berlin, 1964 (in German).
See also **A** 5, 7, 9, 10 (Vols. III, IV, VI), 11, 12, 13, 25, 28, 32, 34, 36, 37, 38, 43, 44, 47, 48.

E

Hieronymus Bosch

1 BALDASS, L. VON, *Hieronymus Bosch*, New York, 1960.
2 BOSMAN, A., *Hieronymus Bosch*, London, 1963.

3 COMBE, J., *Hieronymus Bosch*, London, 1946.
4 DELEVOY, R. L., *Bosch,* Geneva, 1960.
5 FRAENGER, W., *The Millennium of Hieronymus Bosch. Outlines of a New Interpretation*, London, 1952.
6 GIBSON, W. S., *Hieronymus Bosch*, New York, 1971.
8 SNYDER, J., ed., *Bosch in Perspective*, Englewood Cliffs, N. J. 1973.
9 *The Complete Paintings of Bosch*, introduction by G. Martin, notes and catalogue by M. Cinotti, New York, 1969.
10 TOLNAY, C. DE, *Hieronymus Bosch*, London, 1966.
11 WERTHEIM AYMÈS, C. A., *The Pictorial Language of Hieronymus Bosch*, Horsham (Sussex), 1975.
See also **A** 7, 10 (Vol. V), 11, 26, 28, 30, 32, 43.

F

The Sixteenth Century: The Rise of New Centers and Styles

1 BANGS, J. D., *Cornelis Engebrechtsz's Leiden*, Assen, 1979.
2 DE BOSQUE, A., *Quentin Metsys*, Brussels, 1975 (in French).
3 GIBSON, W. S., *The Paintings of Cornelis Engebrechtsz* (Outstanding Dissertations in the Fine Arts), New York-London, 1977.
4 GLÜCK, G., "Mabuse and the Development of the Flemish Renaissance," *Art Quarterly*, VIII, 1945, pp 116-138.
5 KOCH, R. A., *Joachim Patenir*, Princeton, 1968.
6 MOXEY, K. P. F., *Pieter Aertsen, Joachim Beuckelaer, and the Rise of Secular Painting in the Context of the Reformation* (Outstanding Dissertations in Fine Arts), New York and London, 1977.
7 WALLEN, B., "The Portraits of Jan van Hemessen," *Oud Holland*, LXXXVI, 1971, pp. 80 ff.
See also **A** 7, 10 (Vols. VII, VIII, IX, X, XI, XII, XIII), 11, 13, 24, 26, 28, 30, 43, 46,; **H** 6, 7.

G

Portraiture

1 CNATTINQUIS, B., *Maerten van Heemskerck's St. Lawrence Altarpiece in Linköping Cathedral: Studies in Its Mannerist Style*, Stockholm, 1973.
2 VELDEMAN, J. M., *Maarten van Heemskerck and Dutch Mannerism in the Sixteenth Century*, Maarssen, 1977.
See also **A** 10 (Vols. VII, VIII, IX, X, XII, XIII), 26, 28, 36, 43, 46; **H** 6; **J** 1.

H

Pieter Bruegel

1 *Bruegel: A Dynasty of Painters*, exhibition catalogue, Palais des Beaux-Arts, Brussels, 1980.
2 CLAESSENS, B. and ROUSSEAU, J., *Bruegel*, New York, 1981.
3 GIBSON, W. S., *Bruegel*, London, 1977.
4 GROSSMANN, F., *Bruegel, the Paintings*, London, 1966.
5 KLEIN, H. A., *Graphic Worlds of Pieter Bruegel the Elder*, New York, 1963.
6 *Le Siècle de Bruegel. La Peinture en Belgique au XVIᵉ siècle*, exhibition catalogue, Musées royaux des Beaux-Arts, Brussels, 1963 (in French).
7 LAVALLEYE, J., *Pieter Bruegel the Elder and Lucas van Leyden. The Complete Engravings, Etchings, and Woodcuts*, New York, 1967.
8 MÜNZ, L., *Pieter Bruegel the Elder, the Drawings*, New York 1961.
9 RIGGS, T. A., *Hieronymus Cock, Printmaker and Publisher* (Outstanding Dissertations in the Fine Arts), New York and London, 1977.
10 STECHOW, W., *Pieter Bruegel*, New York, 1974.
11 *The Complete Paintings of Bruegel*, introduction by R. Hughes, notes and catalogue by P. Bianconi, New York, 1970.
See also **A** 7, 10 (Vol. XIV), 11, 26, 28, 43, 46, 48.

I

Flemish Landscape Painting

1 ERTZ, K., *Jan Bruegel der Ältere (1568-1625). Die Gemälde mit kritischen Oeuvrekatalog*, Cologne, 1979.
2 MARLIER, G., *Pieter Bruegel le Jeune*, Brussels, 1965 (in French).
3 WINKELMANN-RHEIN, G., *The Paintings and Drawings of Jan "Flower" Bruegel*, New York, 1969.
See also **A** 3, 10 (Vol. VIII), 24, 26, 41, 46, 48; **F** 5; **H** 1, 6; **R** 7.

J

Mannerism and Caravaggism in Haarlem and Utrecht

1 *Dutch Mannerism: Apogee and Epilogue*, exhibition catalogue, Vassar College Art Gallery, Poughkeepsie, N. Y., 1970.
2 FAGGIN, G., *Il Manierismo di Haarlem* (Maestri del Colore), Milan, 1966.
3 *Hendrick Terbrugghen in America*, exhibition catalogue, Dayton Art Institute and Museum of Art, Baltimore, 1965-66.
4 JUDSON, J. R., *Gerrit von Honthorst*, The Hague, 1959.
5 LOWENTHAL, A. W., "Wtewael's Moses and Dutch Mannerism" in *Studies in the History of Art,*

VI, National Gallery, Washington, 1974, pp. 125 ff.

6 NICOLSON, B., *Hendrick Terbrugghen*, London, 1958.

7 NICOLSON, B., *The International Caravaggesque Movement. List of Pictures by Caravaggio and His Followers throughout Europe*, London, 1979.

8 REZNIČEK, E. K. J., "Realism as 'Side Road or Byway' in Dutch Art" in *Studies in Western Art*, Vol. II, Princeton, 1963, pp. 247-253.

9 SCHNEIDER, A. VON, *I Seguaci del Caravaggio nei Paesi Bassi* (Maestri del Colore), Milan, 1966.

10 SPEAR, R. F., *Caravaggio and His Followers*, New York, 1975.

11 STECHOW, W., "Terbrugghen's St. Sebastian," *Allen Memorial Art Museum Bulletin*, XI, 1954, pp. 145-149.

See also **A** 1, 4, 8, 22, 26, 31, 41, 46, 49; **G** 1, 2.

K
Frans Hals

1 *Frans Hals*, ed. S. Slive, exhibition catalogue, Frans Halsmuseum, Haarlem, 1962.

2 GRIMM, G., *Frans Hals. Entwicklung, Werkanalyse, Gesamtkatalog*, Berlin, 1972.

3 SLIVE, S., *Frans Hals*, London-New York, 1970-74, 3 vols.

4 TRIVAS, N. S., *The Paintings of Frans Hals*, New York, 1949.

See also **A** 1, 4, 6, 8, 19, 22, 31, 41, 42, 49.

L
Peter Paul Rubens

1 ALPERS, S., *The Decoration for the "Torre de la Parada"* (Corpus Rubenianum Ludwig Burchard IX), Brussels, 1971.

2 BAUDOUIN, F., *P. P. Rubens*, New York, 1977.

3 GLEN, T. L., *Rubens and the Counter Reformation. Studies in His Religious Paintings between 1609 and 1620* (Outstanding Dissertations in the Fine Arts), New York-London, 1977.

4 HAVERKAMP-BEGEMANN, E., *The Achilles Series* (Corpus Rubenianum Ludwig Burchard X), Brussels, 1975.

5 HELD, J. S., Rubens, *Selected Drawings*, London, 1959.

6 HEMER, F., *Portraits*, Vol. I (Corpus Rubenianum Ludwig Burchard XIX), Brussels, 1977.

7 JAFFÉ, M., *Rubens and Italy*, Oxford, 1977.

8 JUDSON, J. R. and VELDE, C. VAN DE, *Book Illustrations and Titlepages* (Corpus Rubenianum Ludwig Burchard XXI), Brussels, 197 .

9 MAGURN, R. S., ed. and trans., *The Letters of Peter Paul Rubens*, Cambridge, Mass., 1955.

10 MARTIN, J. R., *The Ceiling Paintings of the Jesuit Church* (Corpus Rubenianum Ludwig Burchard I), Brussels, 1968.

11 MARTIN, J. R., *The Decoration for the "Introitus Ferdinandi"* (Corpus Rubenianum Ludwig Burchard XVI), Brussels, 1972.

12 MARTIN, J. R., *Rubens - The Antwerp Altarpieces. The Raising of the Cross and the Descent from the Cross*, London, 1969.

13 MILLAR, O., *The Whitehall Ceiling*, London-New York, 1958.

14 NORRIS, J. A. and HELD, J. S., *Rubens in America*, New York-Antwerp, 1947.

15 PALME, P., *Triumph of Peace*, Stockholm, 1956.

16 POORTER, N. DE, *The Eucharist Series* (Corpus Rubenianum Ludwig Burchard II), Brussels, 1977.

17 *Rubens before 1620*, ed. J. R. Martin, exhibition catalogue, Art Museum, Princeton, N. J. 1972.

18 *Rubens e Firenze*, with papers by L. Berti, M. Chiarini, M. Gregori, M. Jaffè, K. Langedijk, S. Meloni Trkulja, M. van der Meulen, R. F. Millen, et al., Florence 1981 (in English, French, and Italian).

19 STECHOW, W., *Rubens and the Classical Tradition*, Cambridge, Mass., 1968.

20 THUILLIER, J. and FOUCART, J., *Rubens' Life of Marie de' Medici*, New York,1967.

21 VLIEGHE, H., *Saints* (Corpus Rubenianum Ludwig Burchard VIII), Brussels, 1973, 2 vols.

22 WEDGWOOD, C. V., *The Political Career of P. P. Rubens*, London, 1975.

See also **A** 13, 22, 24, 26, 48; **M** 8.

M
Flemish Masters around Rubens

1 CUST, L., *Anthony van Dyck*, London, 1900.

2 DAVISON, J., *David Teniers the Younger*, London, 1980.

3 D'HULST, R. A., *Jordaens Drawings*, Brussels, 1964, 4 vols.

4 *Jacob Jordaens*, ed. M. Jaffé, exhibition catalogue, The National Gallery of Canada, Ottawa, 1968.

5 JAFFÉ, M., *Van Dyck's Antwerp Sketchbook*, London, 1966, 2 vols.

6 KNUTTEL, G., *Adriaen Brouwer*, The Hague, 1962.

7 LEE, R. W., "Van Dyck, Tasso, and the Antique" in *Studies in Western Art*, Vol. II, Princeton, N. J., 1963.

8 *Le siècle de Rubens*, exhibition catalogue, Musées Royaux des Beaux-Arts, Brussels, 1965 (in French).

9 *Sir Anthony van Dyck*, exhibition catalogue, Agnew's, London, 1968.

10 STRONG, R., *Van Dyck. Charles I on Horseback*, London, 1972.

11 *Van Dyck as Religious Artist*, eds. J. R. Martin and G. Feigenbaum, exhibition catalogue, Art Museum, Princeton, N. J., 1979.

12 WATERHOUSE, E. K., *Painting in Britain 1530-1790*, Baltimore, 1953.

See also **A** 13, 22, 24, 48; **H** 1; **L** 1, 10, 11

N
Rembrandt and His Influence

1 BENESCH, O., *The Drawings of Rembrandt. A Critical and Chronological Catalogue*, London, 1954-57, 6 vols.

2 BOON, K. G., *Rembrandt, the Complete Etchings*, New York, 1963.

3 BREDIUS, A., *Rembrandt. Paintings*, revised by H. Gerson, London-New York, 1969.

4 CLARK, K., *An Introduction to Rembrandt*, London, 1978.

5 CLARK, K., *Rembrandt and the Italian Renaissance*, New York, 1966.

6 GERSON, H., *Rembrandt. Paintings*, Amsterdam, 1968.

7 GERSON, H., *Seven Letters by Rembrandt*, The Hague, 1961.

8 HAAK, B., *Rembrandt: His Life, His Work, His Time,* New York, 1969.

9 HECKSCHER, W. S., *Rembrandt's Anatomy of Dr. Nicolaes Tulp. An Iconographical Study*, New York, 1958.

10 HELD, J. S., *Rembrandt's "Aristotle" and other Rembrandt Studies*, Princeton, N. J., 1969.

11 *Jan Lievens*, exhibition catalogue, Herzog-Anton-Ulrich-Museum, Braunschweig, 1979 (in German).

12 LANDSBERGER, F., *Rembrandt, the Jews and the Bible*, Philadelphia, 1946.

13 LAURIE, A. P., *The Brush-Work of Rembrandt and His School*, London, 1931.

14 MOLTKE, J. W. VON, *Govaert Flinck*, Amsterdam, 1965.

15 *Rembrandt and His Pupils*, exhibition catalogue, Museum of Fine Arts, Montreal and Art Gallery, Toronto, 1969.

16 ROSENBERG, J., *Rembrandt, Life and Work*, revised ed., Ithaca, N.Y., 1980.

17 SLIVE, S., *Drawings of Rembrandt, with a Selection of Drawings by His Pupils,* New York, 1965, 2 vols.

18 SLIVE, S., *Rembrandt and His Critics 1630-1730*, The Hague, 1953.

19 STRAUSS, W. L. and MEULEN, M. VAN DER, *The Rembrandt Documents*, New York, 1979.

20 VALENTINER, W. R., "Carel and Barend Fabritius," *The Art Bulletin,* XIV, 3, 1932, pp. 197-241.

21 VISSER 'T HOOFT, W. A., *Rembrandt and the Gospel*, New York, 1960.
22 WHITE, C., *Rembrandt and His World*, London, 1964.
23 WHITE, C., *Rembrandt as an Etcher*, University Park, Penn., 1969, 2 vols.
See also **A** 1, 4, 6, 8, 13, 19, 22, 29, 31, 33, 39, 41, 45, 49, 50; **O** 16

O
Dutch Landscape Painting

1 BECK, H.U., *Jan van Goyen*, Amsterdam, 1972, 2 vols. (in German).
2 BENGTSSON, A., *Studies on the Rise of Realistic Lanscape Painting in Holland, 1610-1625* (Figura III), Stockholm, 1952.
3 BURKE, J. D., *Jan Both, Paintings, Drawings and Prints* (Outstanding Dissertations in the Fine Arts), New-York-London, 1976.
4 COLLINS, C., *Hercules Seghers*, Chicago, 1953.
5 DAVIES, A. I., *Allart van Everdingen* (Outstanding Dissertations in Fine Arts), New York-London, 1978.
6 HAVERKAMP-BEGEMANN, E., *Hercules Seghers: The Complete Etchings*, Amsterdam, 1973.
7 *Jan van Goyen 1596-1656, Poet of the Dutch Landscape*, exhibition catalogue, Alan Jacobs Gallery, London, 1977.
8 *Landscape Artists in Italy: Dutch Seventeenth Century Landscape Artists*, ed. W. Stechow, exhibition catalogue, The University of Michigan Museum of Art, Ann Arbor, 1964.
9 MANKE, I., *Emanuel de Witte 1617-1692*, Amsterdam, 1963 (in German).
10 *Pieter Jansz. Saenredam*, exhibition catalogue, Centraal Museum, Utrecht, 1961 (in Dutch).
11 PRESTON, R., *The Seventeenth Century Marine Painters of the Netherlands*, Leigh-on-Sea, 1974.
12 REISS, S., *Aelbert Cuyp*, London, 1975.
13 ROBINSON, M., *Van de Velde Drawings. A Catalogue of Drawings in the National Maritime Museum Made by the Elder and the Younger Willem van de Velde*, Cambridge, 1958, 2 vols.
14 RUSSELL, M., *Jan van de Capelle*, Leigh-on-Sea, 1975.
15 SOUSA-LEÃO, J., *Frans Post, 1612-1680*, Amsterdam, 1973.
16 STECHOW, W., *Dutch Landscape Painting of the Seventeenth Century*, London, 1966.
17 WADDINGHAM, M. R., *I paesaggisti nordici italianizzanti del XVII secolo* (Maestri del Colore), Milan, 1966, 2 vols. (in Italian but with numerous color plates).
18 WAGNER, H., *Jan van der Heyden*, Amsterdam, 1971 (in German).
19 WALSH, J., "The Dutch Marine Painters Jan and Julius Porcellis," *The Burlington Magainze*, D, 1974, pp. 653 ff, 734 ff.
See also **A** 1, 3, 4, 6, 8, 13, 14, 15, 19, 22, 29, 31, 33, 41, 49, 50; **N** 3, 6, 8

P
Genre Painting

1 BAKER, C. H., *Peeter de Hooch*, London, 1925.
2 GUDLAUGSSON, S. J., *Gerard ter Borch*, The Hague, 1959, 2 vols. (in Dutch).
3 HAVERKAMP-BEGEMANN, E., *Willem Buytewech*, Amsterdam, 1959 (in Dutch).
4 KIRSCHENBAUM, B. D., *The Religious and Historical Paintings of Jan Steen*, New York, 1977.
5 LEGRAND, F. C., *Les peintres flamandes de genre au XVII^e siècle*, Paris-Brussels, 1963.
6 MARTEN, W., *Gerard Dou*, London, 1902.
7 ROBINSON, F. W., *Gabriel Metsu. A Study in His Place in Dutch Genre Painting of the Golden Age*, New York, 1974.
8 SUTTON, P.C., *Pieter de Hooch*, Ithaca, N.Y., 1980.
9 VRIES, L. De, *Jan Steen*, Weert, 1976 (in Dutch).
10 *Willem Buytewech*, exhibition catalogue, Museum Boymans-van Beuningen, Rotterdam and Institut Néerlandais, Paris, 1975 (in Dutch and French).
See also **A** 1, 3, 4, 6, 8, 13, 15, 19, 22, 29, 31, 33, 35, 39, 41, 45, 49, 50; **O** 9.

Q
Jan Vermeer of Delft

1 GOLDSCHEIDER, L., *Jan Vermeer*, London, 1967.
2 GOWING, L., *Vermeer*, New York, 1970.
3 HALE, P. L., *Vermeer*, London, 1937.
4 SEYMOUR, C., "Dark Chamber and Light-Filled Room," *The Art Bulletin*, XLVI, S. 1964, pp. 323-31.
5 SWIILENS, P. T. A., *Jan Vermeer. Painter of Delft*, Brussels, 1950.
6 *The Complete Paintings of Vermeer*, introduction by J. Jacob, notes and catalogue by P. Bianconi, New York, 1970.
7 VRIES, A. B. DE, *Jan Vermeer van Delft*, New York, 1948.
8 WHEELOCK, A. K., *Perspective, Optics, and Delft Artists around 1650* (Outstanding Dissertations in the Fine Arts), New York-London, 1977.
See also **A** 1, 3, 4, 6, 8, 15, 19, 22, 27, 29, 31, 33, 35, 41, 45, 49, 50.

R
Still Life

1 BERGSTROM, L., *Dutch Still-Life Painting in the Seventeenth Century*, London, 1956.
2 BOL, L. J., *The Bosschaert Dynasty, Painters of Flowers and Fruit*, Leigh-on-Sea, 1960.
3 GRANT, M. H., *Jan van Huysum*, Leigh-on-Sea, 1954.
4 GRANT, M. H., *Rachel Ruysch*, Leigh-on-Sea, 1956.
5 GREINDL, E., *Les peintres flamands de nature morte au XVII^e siècle*, Brussels, 1956.
6 GRISEBACH, L., *Willem Kalf, 1619-93*, Berlin, 1974 (in German).
7 HAIRS, M. L., *Les peintres flamands de fleurs au XVII^e siècle*, Paris-Brussels, 1965.
8 MITCHELL, P., *European Flower Painters*, London, 1973.
9 PAVIÈRE, S. H., *A Dictionary of Flower, Fruit and Still-Life Painters*, Leigh-on-Sea, 1973.
10 STERLING, C., *Still-Life Painting from Antiquity to the Present Time*, Paris-New York, 1959.
11 WARNER, R., *Dutch and Flemish Flower and Fruit Paintings of the XVIIth and XVIIIth Centuries*, London, 1928.
12 WHITE, C., *The Flower Drawings of Jan Van Huysum*, Leigh-on-Sea, 1964.
See also **A** 1, 3, 4, 8, 19, 24, 27, 29, 32, 33, 41, 48, 49; **H** 1, 6; **I** 1, 3; **M** 8.

This reading list was specially prepared for this edition by Ronald Forsyth Millen.

Index